CRITICAL LANDSCAPES

CRITICAL LANDSCAPES

Art, Space, Politics

EDITED BY

Emily Eliza Scott and Kirsten Swenson

UNIVERSITY OF CALIFORNIA PRESS

University of California Press, one of the most distinguished university presses in the United States, enriches lives around the world by advancing scholarship in the humanities, social sciences, and natural sciences. Its activities are supported by the UC Press Foundation and by philanthropic contributions from individuals and institutions. For more information, visit www.ucpress.edu.

University of California Press
Oakland, California

Library of Congress Cataloging-in-Publication Data

Critical landscapes : art, space, politics / edited by Emily Eliza Scott and Kirsten Swenson.
 pages cm
 Includes bibliographical references.
 ISBN 978-0-520-28548-4 (cloth : alk. paper)
 ISBN 978-0-520-28549-1 (pbk. : alk. paper)
 ISBN 978-0-520-96131-9 (ebook)
 1. Landscapes in art. 2. Landscape architecture. 3. Art—Political aspects. 4. Land use—Political aspects. 5. Cultural landscapes. I. Scott, Emily Eliza, 1971– editor. II. Swenson, Kirsten, editor.
 N8213.C75 2015
 704.9′43609051—dc23

 2015004623

Manufactured in the United States of America
24 23 22 21 20 19 18 17 16 15
10 9 8 7 6 5 4 3 2 1

CONTENTS

ILLUSTRATIONS

INTRODUCTION

Contemporary Art and the Politics of Land Use

Emily Eliza Scott and Kirsten Swenson

*We cut the word in half, as if it was a sculpture, separated, divided it. The word
"mark" now becomes a verb, something that marks the land, and in that marking
the term means how the land is used, how a land differentiates itself from another
land by the way it is being and has been marked—land marked by colonization,
land marked by war, by millions of reasons. These marking processes are what
constitutes and defines the changing status of a land.*

GUILLERMO CALZADILLA, *ON LAND MARK* (2001–5)
BY ALLORA & CALZADILLA[1]

A groundswell of art since the turn of the millennium has engaged the politics of land
use, addressing topics from the widespread privatization of public spaces and resources
to anthropogenic climate change, borderland conflicts, the Occupy movement, and the
rhetoric of "sustainable development." Some of the most compelling artists today are
forging new representational and performative practices to reveal the social significance
of hidden, or normalized, features inscribed in the land. Their work pivots around a set
of evolving questions: In what ways is land, formed over the course of geological time,
also contemporary, or formed by the conditions of the present? How do environmental
and economic structures correlate? Can art spur more nuanced ways of thinking about
and interacting with the land? How might art contribute to the expansion of spatial and
environmental justice?

Certain artists negotiate the legacy of 1960s and 1970s Land art or the conditions of
the global art world, while others actively eschew art-world reference points, choosing
instead to position their work relative to disciplines such as cultural geography or urban
planning, community-based activism, or even official land management agencies. This
critical mass of land-focused practices, keyed to the geopolitics of the past two decades,
constitutes a significant strand of contemporary art that has occasioned a likewise impor-
tant body of scholarship, itself often borrowing ideas and methods from diverse fields.

The artists and writers included in *Critical Landscapes* take land to be neither pre-given—fixed, neutral, or *natural*—nor as something to which we have unmediated access. Rather, they approach it as an outcome and an index of complex procedures. Here, the writings of the French Marxist philosopher Henri Lefebvre are a key influence. In his landmark book *The Production of Space* (originally published in 1974 and translated into English in 1991), Lefebvre traces the transformation of space under capitalism and, in so doing, theorizes space itself as a product of social relations and processes. More recently, and extending from Lefebvre, the art historian Rosalyn Deutsche has argued that space is "political, inseparable from the conflictual and uneven social relations that structure specific societies at specific historical moments."[2] She attacks smooth, coherent images of social space forwarded by "authoritarian strategies" (whether put forth by politicians, wilderness advocates, city planners, real estate developers, or Romantic landscape painters) for their concealment of the "conflict, heterogeneity, and particularity" that goes into the making of all social spaces, and calls for a "democratic spatial politics" that begins with the recognition that all spaces are "produced and structured by conflicts."[3] The art surveyed in the following pages centers on questions of power and the role of visual representation (or a lack thereof) in struggles over land and its potential meanings and uses. In many cases, as Julian Myers-Szupinska observes in the opening essay, artists seek to "reveal the production of space" in order to detonate it, or to open ways for it to be "produced *otherwise*."

This volume is organized into four sections: "Against the Abstraction of Space," "Land Claims: Space and Subjectivity," "Geographies of Global Capitalism," and "Urbanization With No Outside." These groupings are intended as loose aggregates, rather than clear delineations, with many overlapping ideas and issues. Each section includes full-length essays as well as brief entries on individual artworks, some of which are written by the artists themselves and others by scholars from a range of disciplines. While the theoretical framework, history, and artistic precedents touched upon in the following introduction reflect the primarily North American vantage point of the editors, *Critical Landscapes* incorporates work happening around the globe. Many artists do not share common reference points, having instead developed practices in response to local or regional contexts.

FROM LANDSCAPE TO LAND USE

The term "landscape" has a long-standing association in modern art history with the pictorial, with formal composition, and with the aesthetic.[4] The art in *Critical Landscapes*, on the other hand, approaches land largely in terms of its "use value," its utilization by humans for practical and ideological purposes. This is not to say that it turns away from the aesthetic altogether. Rather, problems of representation itself are a dominant concern. Distinct from traditional modes of landscape representation, at least in the West (e.g.,

associated with German Romanticism, the American Hudson River School, the ecotourism industry today), the work examined herein foregrounds the economic, social, and political status of land rather than allowing this to be disguised by formal concerns.

The concept of landscape has, in fact, been hitched from the beginning to aspects of human use—labor, property, domestication, jurisdiction, and so on—with a dialectic between humans and the land at its core. Derived from the Dutch word *landschap,* landscape by definition acknowledges the mutual "shaping" of land and people. According to many scholarly interpretations, it furthermore denotes a view or composition of the world, one that implicitly coheres customs and laws for human coexistence with the land, or a domain for civic life. The art historian Svetlana Alpers, in her analysis of seventeenth-century Northern Renaissance art, for instance, examines the "mapping impulse" embodied in early Dutch landscape painting, identifying continuities between contemporaneous artistic and cartographic practices on the basis of their shared investment in acute topographic detail, an imperative itself underpinned by financial and territorial interests.[5] (This in the same period that the Dutch were at the forefront of a burgeoning global shipping trade, and simultaneously undertook one of the largest-scale engineering projects in history by constructing massive *polders* to protect their low-lying lands from the sea; both land and its painterly depiction, in other words, were thoroughly constructed in this context.)

Art history's emphasis on the visual dimension of landscape, and on seeing more generally, has been called into recent question by the anthropologist Tim Ingold, among others. Ingold attributes this entire disciplinary orientation—a profound mis-orientation, in his opinion—to a simple etymological error, albeit one that has had far-reaching consequences:

> Of early medieval provenance, ["landscape"] referred originally to an area of land bound into the everyday practices and customary usages of an agrarian community. However, its subsequent incorporation into the language of painterly depiction—above all through the tradition of Dutch art that developed in the seventeenth century—has led generations of scholars to mistake the connotations of the suffix *-scape* for a particular "scopic regime" of detailed and disinterested observation. They have, it seems, been fooled by a superficial resemblance between *scape* and *scope* that is, in fact, entirely fortuitous and has no foundation in etymology. "Scope" comes from the classical Greek *skopos*—literally "the target of the bowman, the mark towards which he gazes as he aims"—from which is derived the verb *skopein,* "to look." "Scape," quite to the contrary, comes from Old English *sceppan* or *skyppan,* meaning "to shape." Medieval shapers of the land were not painters but farmers, whose purpose was not to render the material world in appearance rather than substance, but to wrest a living from the earth. . . . Nevertheless, the equation of the shape of the land with its look—of the *scaped* with the *scopic*—has become firmly lodged in the vocabulary of modernist art history. Landscape has thus come to be identified with scenery and with an art of description that would see the world spread out on a canvas, much as in the subsequent development of both cartography and photography, it would come to be projected onto a plate or screen, or the pages of an atlas.[6]

In line with Ingold's corrective, much of the art and writing in *Critical Landscapes* reflects a move beyond, or sometimes even against, the "art of description," and a renewed focus on the material rather than the primarily visual aspects of land, often with special attention to issues of labor.

Many artists herein take familiar sights/sites and make them strange or legible in new ways in an attempt to undo what seems "natural," or to highlight the ideological workings of landscape. Others explicitly address the conundrums entailed in representing any particular place with attunement to the inevitable intricacies, paradoxes, and contingencies at play. In certain cases, artworks involve "reading" the ways that land has been marked, or used; in others, artists create new markings, or material interventions, in the landscape itself. At play is an overall shift from representation toward presentation, or performance, one might say. Indeed, the question seems to hover in the background of whether or not painting and photography—as media that collapse the worldly into the static and the two-dimensional—are capable of relaying the frictions, layers, and interrelations of landscape. Are there inherent limits to using media that, in essence, translate their subject into a scene?

The cultural theorist Raymond Williams, in his 1980 essay "Ideas of Nature," cites a fundamental divide between those who approach landscape as a product of nature versus human shaping: "A considerable part of what we call the natural landscape . . . is the product of human design and human labour, and in admiring it as natural it matters very much whether we suppress that fact of labour or acknowledge it."[7] The landscape photography of Ansel Adams, at least within the past half-century of American art, perhaps best demonstrates the impulse to suppress, or evacuate, the "fact of labour" that goes into landscape's making. Adams's exquisitely composed black-and-white pictures feature sweeping landscapes of the American West, typically devoid of any hint of human presence. The scenes are monumental, conjuring a seemingly original moment—and one that is specifically American, yoking the birth of American national identity to the vision of an unpeopled, wild, Western frontier. (Here, Williams's reminder of the etymological link between *nature, native,* and *nation*—all derived from the Latin *natus,* meaning "to be born"—is useful.[8]) Formally, Adams's images hark back to the sublime depictions of the nineteenth-century Hudson River School painters while simultaneously harnessing the deep tonal contrasts of twentieth-century modernist "straight" photography to extreme dramatic effect.

Already in the 1960s and 1970s, certain artists sought to counter Adams's representational schema and the Romantic notions of landscape it embodied, many of them taking up industrial and otherwise visibly impacted landscapes in order to do so.[9] Those photographers who participated in the prominent 1975 exhibition *New Topographics: Photographs of a Man-Altered Landscape* at the George Eastman House in Rochester, New York, adjusted their frame of view (in some cases, we can imagine, only ever so slightly) to capture those marks erased by Adams. They portrayed the mundane, unglamorous processes of suburbanization, industry, and everyday habitation in the American West—

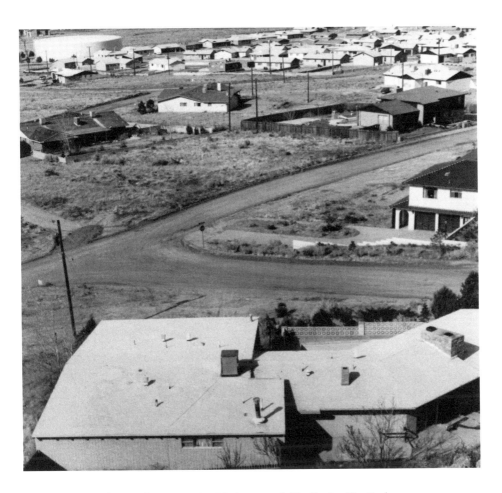

1. Joe Deal, *Untitled View, Albuquerque, New Mexico,* 1975. © The Estate of Joe Deal, courtesy Robert Mann Gallery, New York.

underscoring the human-land dialectic of landscapes in formation (figure 1).[10] Meanwhile, the American artist Robert Smithson wrote about the "dialectical landscape" in the last published essay of his life, and from the mid-1960s onward preferred explicitly "disrupted," or "pulverized," sites to those that evoked a sense of untouched beauty.[11] He was critical of the ecology movement quickly gaining steam at the time and derided a budding "wilderness cult" for its reductive division between the human and non-human worlds, arguing, "Spiritualism widens the split between man and nature."[12] (Ansel Adams's widely circulated images were both an illustration and driver of such a wilderness ethic in the period.) Smithson insisted upon the importance of confronting contemporary environments in all their messy complexity: "The artist cannot turn his back on the contradictions that inhabit our landscapes."[13]

A number of critically engaged artists today likewise turn to the American West as one among other sites of heightened contestation. Differently from their predecessors,

however, they approach it as a locus for dramatic erasures and dislocations, elucidating links between long-standing myths of a national frontier and the systematic militarization and colonization of space there. Their works often foreground the ways that landscape, when taken as an embodiment or extension of "nature," has served to sanitize, obscure, and/or *naturalize* spatial conflicts. Julia Bryan-Wilson, for instance, considers artists' negotiation of atomic legacies in the American West and Japan, dwelling on the relationship between wastelands and the fragility and identity of the body. Jeannine Tang, through the artist Andrea Geyer, digs deeply into the politics of representation relative to indigenous land rights in the American West, while Kelly C. Baum brings landscape into focus through the lens of eco-feminism.

Many artworks emphasize not the visible landscape, but *invisibility*—that which is not immediately apparent to the eye. For the constitutive forces of landscape are most often hidden from view, eluding our ability to know by standing onsite and looking alone. Sarah Kanouse, in her essay on critical touristic practices by artists, takes the point further, claiming: The "visual dimension of a site often conceals the 'production of space' by historical and contemporary economic, social, and ecological agents, and is often designed to do so." The projects she analyzes seek to illuminate instances and mechanisms of erasure, or the "behind the scenes," of landscape. Of course, the land, in its liveliness and constant flux, itself possesses a peculiar power to obscure. In other words, the very entity that bears the imprint of—gives spatial form to—various social, political, economic, biological, geological, and climatic operations, also erodes evidence of its own production. As the geographer Jessica Dubow has eloquently noted, the "problem" with landscape lies in its tendency to absorb "the events played out on its surface" and thereby to *"outlive* history," to allow "history to decompose."[14]

The Center for Land Use Interpretation (CLUI) has been a touchstone for many land-based artistic practices in the last decade, and is an early and critical source for the concepts of land developed in this volume (figure 2). In 1994, nearly twenty years after Smithson's untimely death, CLUI was founded by Matthew Coolidge on principles articulated by Smithson—an understanding of landscape as a transitional and historical expression of human values. A nonprofit organization based primarily in Los Angeles, CLUI comprises a shifting configuration of multidisciplinary researchers, some affiliated with CLUI over the long haul, and others by way of participation in an individual project. Although the organization has received significant funding from and exposure within art contexts, the word "art" is not used in the group's mission statement, which says, in part: "We believe that the manmade landscape is a cultural inscription that can be read to better understand who we are and what we are doing."[15]

In reading the "cultural inscription" that is the Earth's surface, CLUI has over the years established a sprawling framework for documenting and interpreting the built environment, primarily but not exclusively in the United States. The group creates guided tours, exhibitions, research stations, artist residency programs, informational

2. The Center for Land Use Interpretation photo archive.

displays, lectures, publications, and an online database, all devoted to investigating "the language of land use and teaching it to others."[16] Its research concentrates on places that are both everyday and overlooked, places that constitute the simultaneously strange and banal landscape of contemporary life. For example, CLUI's 2006 book *Overlook: Exploring the Internal Fringes of America with the Center for Land Use Interpretation* surveys such wide-ranging sites as show caves, towns drowned by dam construction, mock cities designed for police drills, miniature models of the Earth's surface, and nuclear proving grounds. Past tours in the Los Angeles area have visited landfills and other highlights of the city's "landscape of waste"; Terminal Island, whose ownership is split between the Ports of Los Angeles and Long Beach, which together comprise the fifth busiest port complex in the world; and exurban gravel pits where the foundational materials of the urban environment are extracted. In its own words, CLUI targets those places "left unexplored by scholars, scientists, and other specialists."[17]

CLUI's Land Use Database, a free resource available to the public through its website, is the destination for much of its ever-accumulating, collaboratively collected, and often esoteric data. The database is comprised of photographs and textual descriptions showcasing more than a thousand "unusual and exemplary" sites throughout the United States. All content is generated by CLUI rather than aggregated from existing sources, thus avoiding representations of landscape already in circulation that originate from invested corporations, government agencies, or individuals. Considered "the informational bedrock"[18]

of the organization, the database not only provides source material for CLUI's programming, exhibits, and publications, but also enables others "to explore remotely, to search obliquely, and to make creative collisions and juxtapositions that render new meanings and explanations of America—and of the many ways of looking at it."[19]

CLUI's endeavors are rooted in methods originally associated with non-art disciplines, including geography, architecture, urban planning, and the social sciences (e.g., economics, political science, sociology, and anthropology). Indeed, CLUI is emblematic of the research orientation of much contemporary art. It is moreover an oft-cited example of an organization that has successfully operated outside the conventional bounds of "the art world" (museum and gallery displays are the exception rather than the main format for its work) by refusing to recognize disciplinary boundaries and avoiding well-worn institutional models. Many of the artists and artist collectives included in this volume follow CLUI's lead in avoiding the ghettoizing term "art" to characterize their activities of careful observation, data collection, and general concern with producing accurate representations of the conditions that form the environments in which we live. Their interventions, mappings, and temporary and permanent modifications of the land often involve strategies and roles that are continuous with policy making, tourism, habitation, and land stewardship. As the curator Nato Thompson wrote in the catalogue for the 2008 exhibition *Experimental Geography*, the work of CLUI and others' "radical approaches to landscape, cartography, and urbanism" has widened the frame of art to the point where "we must begin to understand the mechanisms of power, finance, and geopolitical structures that produce the culture around us."[20]

Throughout its extensive activities, CLUI adopts an appearance of administrative neutrality. It maintains a position of non-alliance with activist groups as well as the industries and government agencies whose "geo-transformative activities" it tracks, even as its quasi-bureaucratic self-presentation mirrors these same bodies. For instance, a promotional blurb for its 1996 pamphlet "The Nevada Test Site: A Guide to America's Nuclear Proving Ground" enthusiastically declares: "Praised by both anti-nuclear activists and Department of Energy officials!"[21] Consistent with its ambiguous ideological stance, the group employs documentary-style photography as one of its primary mediums. (Photography has a long history, of course, in relation to the visual documentation of land, from its central role in nineteenth-century topographic surveys propelled by various scientific and colonial agendas, to the instrumental role of aerial photography in World War I and onward, to the vast archive produced by the U.S. Farm Security Administration in the 1930s and 1940s that was used to shore up support for the New Deal during the Great Depression, to current photojournalistic exposés on environmental devastation around the world.) When confronting familiar representational formats employed by CLUI—the photographic field essay, the observation log, the touristic guidebook, the government database, the corporate annual report—we are meant to forget about the individual artist or author, the interested viewpoint. As Coolidge writes in the introduction to *Overlook*, "It's my hope that, after reading this book, you forget about us What matters is that

. . . after encountering any of our programming . . . you come away with a widened sense of awareness of the physical world that surrounds you."[22] CLUI seeks to disappear, but its disappearance is a reminder of the ideological positions that shape all representations of the land.

In contrast to CLUI's neutral posture, many artists included in *Critical Landscapes* aim to transform the very issues and conditions that they take up in their work as an active mode of political engagement. They not only engage spatial politics as their subject, in other words, but also self-reflexively exercise political agency in space. The artist-geographer Trevor Paglen coined the term "experimental geography" to describe and encourage such spatial practices. In his essay reprinted in this volume, he elaborates:

> If one takes the production of space seriously, the concept applies not only to "objects" of study or criticism, but to the ways one's own actions participate in the production of space. . . . Taking this head-on, incorporating it into one's practice, is what I mean by "experimental geography." . . . To move beyond critical reflection, critique alone, political "attitudes," into the realm of practice. To experiment with creating new spaces, new ways of being.

As Paglen indicates, the approaches to landscape implied by "experimental geography" are premised on the possibility of actual interventions within material and political realities.

Today, the forces that produce landscape are more decentralized, dematerialized, and de-linked from the actual ground than ever before. More accurately, distances have widened between the places where decisions regarding land use are *made* and where they are *enacted*. Whereas Ingold's medieval worker-shapers, who "with foot, axe, and plough . . . trod, hacked, and scratched their lines into the earth," performing labor that was "close-up, in an immediate, muscular and visceral engagement with wood, grass, and soil," in our own day and age, a whole series of geographically dispersed factors and agents, some virtual and others "analog" (e.g., international trade and patenting laws, migrant worker streams, stock market figures, transportation systems) prefigure any moment before foot or plough pierces ground.[23]

Globalization is not a new phenomenon; it dates back centuries or even millennia to the early exchange of goods and ideas between geographically distant populations. Since the 1980s and 1990s, however, various neoliberal economic policies such as the deregulation of financial markets, together with the expansion of multinational corporations and advancements in telecommunication technologies, have ushered in an era in which the global economy operates with unprecedented power and swiftness. The present moment, we might say, is distinguished by the degree to which to which finance orders space. The sociologist Saskia Sassen has described "finance [as] the engine of our time"— a vast force that is "flattening everything around us" as it "grabs more and more terrain"

amid an ongoing shift from a world organized largely by national territories to one of global connectivity and jurisdiction.[24]

In tandem with the ascendance of free-market ideology and the global implementation of its growth economy, more and more people are migrating to densely populated areas for work (sometimes at will, other times by force), including to quickly proliferating "megacities" with more than ten million inhabitants. Some scholars have gone so far as to describe this trend in terms of a "planetary urbanism," or urbanization with no outside, wherein territories are newly entwined with one another, and units previously used to analyze patterns of development, such as "the city," are no longer tenable.[25] Sassen furthermore reminds us that this accelerated, all-encompassing urbanization involves the displacement, or "systemic expulsion," of humans on a massive scale resulting from a number of practices and processes, among them: mega-development projects such as the construction of dams in China; desertification owing to deforestation and over-farming; and neocolonial land grabs, wherein large tracts of land, especially in sub-Saharan Africa, are sold off to foreign investors. (In this final case, an exponential privatization of resources, including land, is under way.) As places become ever more interlinked via flows of labor and capital, it is increasingly impossible to tease apart the urban from the non-urban, or *here* from *there*.

Global capitalism is not a smooth, seamless, or evenly distributed phenomenon, but—to the contrary—one that has arguably contributed to growing disparity and precarity around the world. Critical geographers have been especially helpful in theorizing the "uneven development" that is endemic to globalized advanced capitalism, whereby the landscape is organized according to strategic targeting by capital, and violence (to land, humans, and nonhumans) is often shifted from one place to another, and in the process further from common view.[26] This type of relational thinking quickly brings questions of justice to the fore. The literary and postcolonial theorist Rob Nixon furthermore elaborates upon the "slow violence" entailed in environmental disasters (e.g., long-term contamination owing to extractive industries, the severing of ties between indigenous communities and their homelands and ways of life) that unfold across vast scales and in forms and temporalities that are often hard to perceive, compounding their intensity. This, he describes, is "a violence that occurs gradually and out of sight, a violence of delayed destruction that is dispersed across time and space, an attritional violence that is typically not viewed as violence at all."[27]

A number of projects within this book highlight the socially uneven production and distribution of various environmental crises, including the disproportionate impact of climate change on poor regions of the world. As such, they resonate with, if not at times directly participate in, the environmental justice movement that has, since the 1980s, waged an incisive critique of mainstream environmentalism's failure to adequately acknowledge issues of social inequality. Ashley Dawson, for instance, analyzes critical documentary practices by artists who track the "accumulation by dispossession" endemic to advanced capitalism. He concludes, making clear his own ethical-political orientation:

"Documenting the transnational networks of power that characterize contemporary imperialism and thereby contributing to bonds of solidarity between the dispossessed in the global North and South is *the* key task for contemporary artist-activists."[28] The art historian T. J. Demos, in his curatorial essay for the 2010 exhibition *Uneven Geographies* (reprinted here), meanwhile heralds artworks that not only "chart the operations of globalization" but also "situate us critically and creatively in relation to [its] uneven developments" and thereby "open up other modes of globalization." Such work, he claims, aspires to produce new spatial-political configurations by envisioning "imaginative possibilities for a world—and a more even geography—of social justice, experimental creativity, and political inclusion." More broadly, artists associated with "critical spatial practice" (and "experimental geography," too) aim to intervene in worldly conditions, for example by working against the abstraction and cooptation of space in the service of finance.[29]

The relationship between the global economy and the environment is a tangled one. Take, for instance, the patenting of genetically modified seed varieties by a multinational agrochemical and agricultural biotechnology giant like Monsanto, which has emerged in concert with recent changes to international patent and trade laws. In the eyes of the philosopher-activist Vandana Shiva, this phenomenon amounts to nothing less than the "corporate control of life."[30] It has drastically transformed agriculture around the world, resulting in the widespread contamination of wild seed stocks, the homogenization of vast tracts of land via "mono-cropping," and extreme economic and social turmoil in places such as India, where local farmers are now barred from continuing generations-old practices without going through the channels of corporate seed "providers." (Shiva and others point to the bitter irony, or double-insidiousness, of the fact that biotech companies have appropriated knowledge built over millennia by the very indigenous peoples from whom they now reap a profit.) The rise of corporatized, de-diversified agriculture coincides with a growing nostalgia for the agrarian past, before pesticides and fertilizers were needed to grow "conventional" produce, as reflected in the current explosion of urban gardening movements as well as markets for organic, artisanal, and slow foods among a largely affluent and "progressive" demographic in the United States, Europe, and elsewhere.

Contemporary urbanism, including the ascendance of speculative real estate practices as a dominant structuring force, is similarly shot through with seeming paradoxes. Within a speculative model of development, oriented toward the potential future uses of land and property, the production of space takes on new guises. In countless urban "renewal" projects, the incorporation of nature (e.g., the addition of parks or other "green space," lakefront development, the "revitalization" of river ways) and, more generally, an imperative of "sustainability," are cornerstones. (The geographer Neil Smith speaks of this in terms of "nature as accumulation strategy."[31]) Such gentrification efforts, while purportedly ecological in character, are of course also (if not ultimately) meant to generate revenue, whether by boosting tourism or attracting potential new investors, businesses, and

inhabitants; they always involve some degree of displacement, too. If "greenwashing" is prevalent in the current development and marketing of cities, we might also consider "art-washing," wherein art and the "culture class" associated with it are likewise instrumentalized to drive up real estate values. The American artist and critic Martha Rosler bluntly states: "The artist's assigned role in urban planning is to gentrify space for the rich."[32] The artists and scholars in this volume address the local ramifications of such complex dynamics. Janet Kraynak's essay, which focuses on Rirkrit Tiravanija's ongoing, collaborative project in Thailand, The Land, in particular dwells on the fundamental contradiction of dominant notions of "sustainability" since the 1990s that perpetuate an economic growth model rather than calling it into question as the very source of environmental degradation. Ying Zhou presents a series of case studies that register the transformation of Shanghai in conjunction with economic liberalization since the early 1990s. The Chinese government has deployed culture, and specifically contemporary art, to elevate land values and project to the West an open-minded attitude toward artistic expression, but in reality, seeding culture has meant the eviction of poorer communities from newly desirable urban spaces.

· · ·

The artists Helen Mayer Harrison and Newton Harrison, long considered pioneers in the realm of land and environmental art, have spent the last four decades developing research-intensive projects on climate change, globalization, and biological "survival." Since 2000, for instance, a series of their artworks has investigated the multifold effects of global warming—from rising sea levels and drought to the transformation of forests and agricultural land—on the European peninsula, as well as the need for new, and more collective, forms of governance in the face of such urgencies.[33] Already in 1978, in conjunction with a piece called *The Lagoon Cycle* (1974–84), the Harrisons wrote:

> It is said that if all the ice melted, the oceans would rise about 300 feet. So we drew a line, as best we could, at the 300-foot level and thought about how the land would shrink as the ocean grew. . . . As the waters rise slowly in the Red Sea and the Dead Sea, the Caspian, the North, the Baltic, and the Black, the ocean gyres will redraw themselves, as will the currents and the tides, and over time, gracefully, this raising tide will flow up every river that once flowed down to the sea. . . . And the flood plains that are farmed upon and lived upon will become marshes or swamps or bogs or beds for swollen rivers or even shallow inland seas. And the tropics will become uninhabitable. . . . And most life, known and unknown, will have to go elsewhere than now. . . . And, in this new beginning, this continuous re-beginning, will you feed me when my lands can no longer produce? And will I house you when your lands are covered with water?[34]

This passage, and the Harrisons' art more generally, highlights a number of crucial connections: between land and water, between seemingly distant places, and—perhaps most importantly—between the ecological and the social, political, economic, legal, and ethical.

It is also highly prescient for our present moment, when environmental issues are increasingly characterized by their networked intricacy and spatial reach, and clearly defined causality is rare. In the Indian Ocean, the low-lying atolls comprising the Maldives are indeed being swallowed as waters rise, leading to "the complete disappearance of a nation state beneath the ocean," something "unprecedented in modern times."[35] The type of human migration, or environmental diaspora, ensuing from this will become more and more common in the coming years and decades. Meanwhile, with the rapid melting of polar ice, the Arctic has become a geopolitical hotspot as northern countries vie to stake claims on potential new routes for shipping and oil exploration. The impossibility of disentangling the human from the "natural" is made especially clear, perhaps, in the case of catastrophic events such as the 2010 explosion of British Petroleum's Deepwater Horizon oil rig in the Gulf of Mexico or the 2011 Tōhoku earthquake and tsunami in Japan, which led to the partial meltdown of the Fukushima Daiichi Nuclear Power Plant. Here, immediate and spectacular devastation has been coupled with tolls that unfold slowly, lie beyond our ability to fully assess, and involve an aspect of uncontainability reminiscent of atomic radiation from the height of the Cold War era.

A number of earth scientists, philosophers, and others have begun to adopt the term "Anthropocene" to describe our present epoch, with humans understood to be a newly geological force, possessing the power to shape not only the land, but also the planet at the scale of its Earth systems. At the same time, there is a surge of interest across multiple disciplines in the material world and its agency. This extends to thinking about the land as something that is not only acted upon, but that also acts, structures, and exerts force along the lines of the Harrisons' ocean gyres, tides, swamps, and bogs, which draw and redraw the conditions upon which the biological, the social, and the political rest. How might art and other critical spatial practices stir our sensitivities to human-nature entanglements and imaginaries, thereby opening the way for new modes of response and engagement, new forms of making and marking, new sets of relations, and new ways of being?

NOTES

1. Guillermo Calzadilla, interview by Hans Ulrich Olbrist, 2003/2009, in *Allora & Calzadilla* (Zurich: J. R. P. Ringier, 2010), 14.

2. Rosalyn Deutsche, *Evictions: Art and Spatial Politics* (Cambridge, Massachusetts, and London: MIT Press, 1996), xiii. See also Henri Lefebvre, *The Production of Space,* trans. Donald Nicholson-Smith (Oxford and Cambridge: Blackwell, 1991).

3. Ibid., xiii–xiv, xxiv.

4. Some artists, historians, and critics have opted to abandon "landscape" in favor of a term such as "territory," which carries immediate geopolitical connotations. Examples include Mark Dorrian and Gillian Rose, eds., *Deterritorializations* (London: Black Dog Publishing, 2003) and the architectural historian Alessandra Ponte's "The Map and the Territory," in *The House of Light and Entropy* (London: Architectural Association, 2014), 169–221.

5. Svetlana Alpers, "The Mapping Impulse in Dutch Art," in *The Art of Describing: Dutch Art in the Seventeenth Century* (Chicago: University of Chicago Press, 1983), 119–168.

6. Tim Ingold, "Landscape or Weather-World?," in *Being Alive: Essays on Movement, Knowledge, and Description* (London: Routledge, 2011), 126–27.

7. Raymond Williams, "Ideas of Nature," in *Problems of Materialism and Culture* (London: Verso, 1980), 78.

8. Raymond Williams, "Nature," in *Keywords* (Oxford: Oxford University Press, 1980), 219.

9. Emily Eliza Scott, "Wasteland: American Landscapes in/and 1960s Art" (PhD dissertation, UCLA, 2010).

10. This important exhibition has been restaged and revisited multiple times, most recently in 2009 by the George Eastman House and the Center for Creative Photography in Tucson; that show proceeded to travel to ten venues across the United States and Europe.

11. Robert Smithson, "Frederick Law Olmsted and the Dialectical Landscape" (1973), in Jack Flam, ed., *Robert Smithson: The Collected Writings* (Berkeley: University of California Press, 1996), 157–171.

12. Ibid., 163.

13. Ibid., 164.

14. Jessica Dubow in "The Art Seminar," a roundtable discussion reproduced in *Landscape Theory*, eds. Rachael Ziady DeLue and James Elkins (London: Routledge, 2008), 100.

15. http://www.clui.org/section/about-center.

16. Matthew Coolidge and Sarah Simons, eds., *Overlook: Exploring the Internal Fringes of America with the Center for Land Use Interpretation* (New York: Metropolis Books, 2006), 16.

17. Ibid., 16–17.

18. Ibid., 17.

19. Ibid., 25.

20. Nato Thompson, *Experimental Geography: Radical Approaches to Landscape, Cartography, and Urbanism* (New York: Independent Curators International, 2008), 15.

21. This example is cited in Sarah Kanouse, "Touring the Archive, Archiving the Tour: Image, Text, and Experience with the Center for Land Use Interpretation," *Art Journal* 64, no. 2 (summer 2005): 85.

22. Matthew Coolidge and Sarah Simons, *Overlook*, 15.

23. Tim Ingold, "Landscape or Weather-World?," 126–27.

24. Saskia Sassen, keynote lecture presented at the "Thinking the Contemporary Landscape: Positions and Oppositions" conference (Herrenhausen Gardens, Hannover, Germany, June 21, 2013). Also see T. J. Demos on the "naturalization of finance" and "financialization of nature" in "The Post-Natural Condition: Art After Nature," *Artforum* (April 2012): 191–97.

25. See, for example, Neil Brenner and Christian Schmid, *Implosions/Explosions: Toward a Study of Planetary Urbanism* (Berlin: Jovis, 2014) and Mike Davis, *Planet of Slums* (London: Verso, 2007).

26. The writings of the geographers Neil Smith and David Harvey, beginning in the 1980s, are foundational here.

27. Rob Nixon, *Slow Violence and the Environmentalism of the Poor* (Cambridge, Massachusetts: Harvard University Press, 2013), 2.

28. Ashley Dawson, "New Modes of Anti-Imperialism," in *Exceptional State: Contemporary U.S. Culture and the New Imperialism,* eds. Ashley Dawson and Malini Johar Schueller (Durham, North Carolina: Duke University Press, 2009), 250.

29. The term "critical spatial practice" was coined by the art and architectural historian Jane Rendell. See Jane Rendell, *Art and Architecture: A Place Between* (London: I. B. Tauris, 2006).

30. Vandana Shiva, "The Corporate Control of Life," in *dOCUMENTA (13): 100 Notes—100 Thoughts* series #012 (Ostfildern, Germany: Hatje Cantz, 2012).

31. Neil Smith, "Nature as Accumulation Strategy," *Socialist Register* (2006): 16–36.

32. Martha Rosler, "Imagination Retakes the Streets," in *What Is Critical Spatial Practice?,* eds. Nikolaus Hirsch and Markus Miessen (Berlin: Sternberg Press, 2012), 120. Also see Rosler's three-part series "Culture Class: Art, Creativity, Urbanism," which was published in the online journal *e-flux* in 2010–11, and is now collected in *Culture Class* (Berlin: Sternberg Press, 2013).

33. For instance Helen Mayer Harrison and Newton Harrison, *Greenhouse Britain* (2007–9) and *Force Majeure* (2000–). See http://theharrisonstudio.net/.

34. Helen Mayer Harrison and Newton Harrison, *The Ocean Is a Great Draftsman* (1978). This short text was part of an installation *The Lagoon Cycle* (1974–84), and specifically associated with *The Seventh Lagoon: The Ring of Fire the Ring of Water*, exhibited at the Johnson Museum of Cornell University and the Los Angeles County Museum of Art. It also appears in *The Book of the Lagoons*, a handmade, limited-edition folio self-published by the artists in 1984. See http://theharrisonstudio.net/.

35. http://www.contingentmovementsarchive.com. The Contingent Movement Archive was built in association with the Maldives Pavilion at the 55th Venice Biennale in 2013.

AGAINST THE ABSTRACTION OF SPACE

The ordinary practitioners of the city live "down below," below the thresholds at which visibility begins. They walk—an elementary form of this experience of the city; they are walkers, Wandersmänner, whose bodies follow the thicks and thins of an urban "text" they write without being able to read it. . . . The networks of these moving, intersecting writings compose a manifold story that has neither author nor spectator, shaped out of fragments of trajectories and alterations of spaces: in relation to representations, it remains daily and indefinitely other.

MICHEL DE CERTEAU (1984)[1]

． ． ．

The 1974 text *La production de l'espace* by the French philosopher Henri Lefebvre was published in an English translation in 1991, and soon incited a new understanding among geographers, architectural theorists, sociologists, philosophers, artists, and art historians of space as a social and political concept—something that produces and is produced by economic and social relationships rather than being solely a physical domain. Here, essays by Julian Myers-Szupinska and Trevor Paglen elucidate Lefebvre's theory of "the production of space," demonstrating its significance for a "spatial turn" in art and critical practices since the 1990s. The artists' tours discussed by Sarah Kanouse engage participants in a direct, embodied experience of physical sites, including the Los Angeles River and the Foreign Trade Zone, in order to illuminate the abstract economic, social, and power relations that operate within these sites, the significance of which most inhabitants or visitors are initially unaware.

The artists' projects presented here likewise make concrete and immediate the abstract economic, social, and power relations that produce lived realities within specific locations around the globe, from the Sahara Desert to the city of Detroit. If such relations remain unexpressed, those who populate these spaces, or consume these sites as tourists or visitors, participate unwittingly in the dynamics of power and control that shape a site. By revealing the forces at work in given sites, these artists activate the possibility of a newly empowered relationship to one's environment. Artists practicing forms of "experimental geography" are engaged with "creating new spaces, new ways of being," as Paglen writes.

NOTES

1. Michel de Certeau, "Walking in the City," in *The Practice of Everyday Life* (Berkeley: University of California Press, 1984), 93.

SOURCES FOR FURTHER READING

Crampton, Jeremy W., and Stuart Elden. *Space, Knowledge and Power: Foucault and Geography.* Hampshire, England: Ashgate, 2007.

De Certeau, Michel. "Walking in the City." In *The Practice of Everyday Life.* Berkeley, Los Angeles, and London: University of California Press, 1984, 91–110.

Deutsche, Rosalyn. *Evictions: Art and Spatial Politics.* Cambridge, Massachusetts: MIT Press, 1996.

Jameson, Frederic. *Postmodernism, or, The Cultural Logic of Late Capitalism.* Durham, North Carolina: Duke University Press, 1990.

Kwon, Miwon. *One Place After Another: Site-Specific Art and Locational Identity.* Cambridge, Massachusetts: MIT Press, 2002.

Latour, Bruno. *Politics of Nature: How to Bring the Sciences into Democracy*. Cambridge, Massachusetts: Harvard University Press, 2004.

Lefebvre, Henri. *The Production of Space*. Translated by Donald Nicholson-Smith. Oxford, England, and Cambridge, England: Blackwell, 1991.

Rendell, Jane. *Art and Architecture: A Place Between*. London and New York: I. B. Tauris, 2007.

Thompson, Nato, ed. *Experimental Geography: Radical Approaches to Landscape, Cartography, and Urbanism*. New York: Independent Curators International, 2008.

Thompson, Nato, and Gregory Sholette. *The Interventionists: Users' Manual for the Creative Disruption of Everyday Life*. Boston: MASS MoCA, 2006.

1

JULIAN MYERS-SZUPINSKA

After the Production of Space

Here sits a book: not the thickest book I own, but perhaps the thickest book I've read stem to stern, multiple times. I own two copies. The one before me carries notations and underlining from encounters in different eras. Some scribbles, from my first reading in one of Anne Wagner's seminars in the history of art at the University of California, Berkeley, carry a tone of doubt and frustration; later readings evidence dog-eared pages where I aimed to return and read more closely. The spine carries heavy creases, and blue Post-it notes peep from worn edges. I've carried this book into reading groups and classes, and on long trips; it has a formidable psychic weight all out of proportion to its relatively average size and design.

The book is Henri Lefebvre's *The Production of Space,* in its English translation by the erstwhile English Situationist Donald Nicholson-Smith.[1] Lefebvre's original appeared in the writer's native French via Editions Anthropos in 1974; after strong advocacy by the leftist geographer David Harvey, among others, the English edition was published in 1991—the year I left a trailer home in the backwater of Frederick County, Virginia, for my first year of university. "Its appearance was *the* event within critical human geography in the 1990s," writes Lefebvre scholar Andrew Merrifield, "sparking a thorough reevaluation of social and spatial theory, just when apologists for a globalizing neoliberalism proclaimed 'the end of geography.'"[2] And the book's impact was felt beyond the discipline of geography, sending ripples through the history of art. It sat comfortably on a shelf with, and influenced deeply, a "spatial turn" in 1990s writing in and about art, including Martha Rosler's "In the Place of the Public" (1994), Rosalyn Deutsche's *Evictions* (1996),

Miwon Kwon's "One Place After Another: Notes on Site Specificity" (1997), and Anthony Vidler's *Warped Space* (2000), among many others.[3] Based in the United States, these writers, artists, historians, and theorists were, Merrifield writes, "living through the very productive process [Lefebvre's] book underscored."[4] (For my part, this would have been the moment I'd encountered not only a theory of urban space, but cities.)

That productive process was the ongoing transformation of the built environment, and of everyday life, by forces Lefebvre's book names in various ways, but primarily as *abstract space:* a phrase that, like his title, already contained the force of argument. "Not so many years ago," he wrote, "the word 'space' had a strictly geometrical meaning: The idea it evoked was simply that of an empty area."[5] This space, whose origins Lefebvre locates in the thinking of the French philosopher René Descartes, was mathematical in nature, abstract: "a mental thing."[6] Its connotations were those of "logical coherence, practical consistency, self-regulation and the relation of the parts to the whole, the engendering of like by like in a set of spaces, the logic of container *versus* contents, and so on."[7] Space, that is to say, was initially the province of mathematicians and philosophers, the habitat of an "absolute Knowledge" separated from everyday life by an "abyss."[8]

Around 1910, though, this arrangement, already under enormous pressure, finally shattered.[9] Abstract space came crashing into social life. Lefebvre locates this epoch-making schism precisely, in a moment that calls up the formative experiences of his teenage years (he was born in 1901): World War I and the advent in Europe of modernized warfare; the Russian Revolution and the tumultuous establishment of a Communist state; and (moving now to the specialized realm of culture) the radical intervention of Cubism and the rejection of tonality in music. "Such were the shocks and onslaughts suffered by this space" that only fragments of the older reality remained: "a feeble pedagogical reality . . . within a conservative educational system."[10]

Paul Klee's *Uncomposed in Space* (1929, figure 3) stares blankly up from the cover of my book, as if to give form to how this new world might look (or feel). Strange, incomplete volumes hover against a flattened recession of space, some of them taking quasi-human shape. In the foreground, one form sprouts a torso and head, while another, a corpse, lies prone; isolated, spidery figures clamber over blank surfaces of indeterminate scale. And in the place where perspectivalism would locate its vanishing point, a tall, pitch-black rectangle: void, surface, or mirror? As social life falls to pieces, Klee imagines, geometry comes to claim its due.[11] Through the work of a class of politicians, technocrats, and urbanists, social life—a life that played out in public marketplaces, private rooms, and street corners, and in the texture of love, labor, and political struggle—became increasingly abstracted from itself, constructed from above according to models and concepts from this alien, mental realm of "homogenizing rationality."[12] (Lefebvre's book is pointedly averse to giving these planners faces and proper names; a figure such as Robert Moses, whose redevelopment schemes had casually demolished neighborhoods and landmarks in New York in favor of high-rises, freeways, and tourist spectacles,

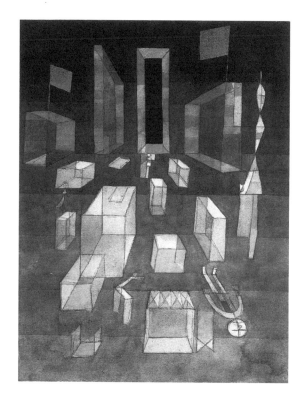

3. Paul Klee, *Uncomposed in Space*, 1929. Watercolor, pen, chalk, and pencil on paper on cardboard, 31.7 × 24.5 cm. Franz Marc Museum, Kochel am See, Dauerleihgabe aus Privatbesitz

doesn't appear in its pages. Lefebvre attacks their thinking, their "fake lucidity,"[13] their generic type, but not their historical specificity.)

Encoded in the title of Lefebvre's book is his insight into just how this new abstraction came to be. Space is not empty, a "void packed like a parcel with various contents," a sort of blank precondition for whatever might take place within it. Space is a *product*; it is produced socially. As Lefebvre writes, "space has taken on, within the present mode of production, within society as it actually is, a sort of reality of its own, a reality clearly distinct from, yet much like, those assumed in the same global process by commodities, money, and capital."[14] Social and political forces had engendered a space of capitalist production (of commodities, spectacle, and power) and reproduction (of the family, of labor power, and of the social relations of production) in the place of older forms of life.[15] We might think here of the suburbanization of America after World War II: The urbanized working class are "disaggregated" to produce the suburban nuclear family as a reproductive unit;[16] the supermarket and the shopping mall replace the confusion of the marketplace and city square; and so on. Social space was rewritten according to the logics of capitalist exchange, in the process making it "productive" in a new way: of both economic value and social life.

The term "production" itself carries specific, complicated meanings in this context. In a general way, for Lefebvre production means human creativity, inventiveness, or

imagination, as it comes (through labor) to modify what exists in the world. "There is nothing," he writes, "in history or in society, which does not have to be achieved and produced."[17] But under capitalism, he argues, this concept is "narrowed" such that "works in the broad sense are no longer part of the picture." Production therefore comes to refer more strictly to the manufacture of commodities, and, in their exchange and consumption, the creation of economic value. It comes, moreover, to denote *mass* production, and the division of labor: "Whereas a *work* has something irreplaceable and unique about it, a *product* can be reproduced exactly, and is in fact the result of repetitive acts and gestures."[18]

To say that space is produced, then, means that it embodies and enacts the contradictions of Taylorized factory production; it will be dual or *dialectical* in nature, which is to say, it will embody simultaneously two incompatible truths.[19] Abstract space gains an expansive, "global" dynamic, expanding everywhere, incorporating all the earlier enclaves of historical or spatial difference (the countryside, the desert, geographically remote regions, as well as private and imagined spaces, each colonized in turn).[20] It becomes an interconnecting, totalizing force, and the very precondition for imagining a global or planetary unity. At the same time, and according to the same logic of production, space is fractured into "a multiplicity of procedures and processes" according to the division of labor: industrialized agriculture, administrative subdivision, technical specialization, and real estate speculation. (This last figure might evoke the "tranches" or divisions of real estate debt that played a central role in the 2008 financial collapse.)

"The ways in which space is thus carved up are reminiscent of the ways in which the body is cut to pieces in images,"[21] Lefebvre writes. And here we might call up again Klee's painting, as representing a space somehow "whole and broken, global and fractured, at one and the same time."[22] To help us grasp this contradictory picture of modern space is one of the book's primary tasks.

Lefebvre's other task, more political than analytical, is to compel his readers to resist this historical development. A logic of sameness, repetition, and reproducibility had extended, over the course of the twentieth century, ever more pervasively into social life itself, colonizing and displacing the human creativity from which it was built. And through the managerial culture of urbanism and planning, production had transformed space itself, rendering cities—once the space of the unexpected—homogenized, quantifiable, and interchangeable: spaces that are "reproducible and the product of repetitive actions," spaces "made with the visible in mind: the visibility of people and things, of spaces and of whatever is contained by them."[23]

This, as Lefebvre understands it, is a catastrophe. With precise rage, he articulates just what is wrong with this urban regime of visibility and exchangeability: "People look, and take sight, take seeing, for life itself. We build on the basis of papers and plans. We buy on the basis of images. Sight and seeing, which in the Western tradition once epitomized intelligibility, have turned into a trap: the means whereby, in social space, diversity may be simulated and a travesty of enlightenment and intelligibility ensconced under the sign of transparency."[24]

Space had been dominated, even "enslaved," by the forces that had begotten it;[25] its very produced nature was concealed through ideological trickery, made to seem transparent and given. But inasmuch as space had "taken on . . . a sort of reality of its own" and was "clearly distinct from . . . commodities, money, and capital," it contained the seeds of resistance, too. To reveal the production of space as such—and this is what Lefebvre's book aims to do—might open the potential that this space could be prized away from those forces, appropriated from them, produced otherwise: *socialized*.

This is what had been attempted in the urban revolts of the 1960s in Watts, Newark, Detroit, and Paris, as well as in Latin America (these, at least, are Lefebvre's references). The reforms and peasant revolts of the first part of the twentieth century had served the ends of abstract space—they had, Lefebvre argues, "smoothed out and in a sense automatized the previously existing space of historic peoples and cities."[26] The revolutionary movements of the 1960s, of workers and students, had marked a potential "new departure" through resistance in the streets and the occupation of factories.[27] Yet through the threat or reality of extreme military force, alongside the misrepresentations of the media, this "reappropriation of space" had largely been forestalled.[28] Written in the aftermath of these events, Lefebvre's book aimed to circumvent defeat by producing a theory of capitalist space and its discontents, and, in so doing, to "detonate this state of affairs."[29]

The detonation Lefebvre imagined, however, has not appeared in the four decades since its publication, or at least not on the terms that he imagined it (though it will be the job of this essay's succeeding pages to account for what other explosions and shocks might have occurred). Nevertheless, his intuition that urban life would now be a vital ground of (leftist) contestation seems accurate enough in light of recent urbanized warfare and political struggle, from the Arab Spring to civil unrest in Paris (2005), Athens and Thessaloniki (2010–), Barcelona, Madrid, and London (2011), Istanbul (2013), Kiev (2014), and Occupy protests worldwide (2011–). For many, not least for artists and collectives who have taken up land use and space as central concerns, his critical language has retained much of its descriptive force. No doubt their copies of *The Production of Space* are as worn and dog-eared as mine. Lefebvre's thinking similarly courses through the writings of Fredric Jameson, in particular in the spatial reckoning in his watershed 1991 book *Postmodernism, or, The Cultural Logic of Late Capitalism*, which draws on Lefebvre to argue that the forms and aesthetics of a period have to be thought in terms of its modes of production.[30] Lefebvre retains vivid argumentative force in the contemporary writing of David Harvey, whose 2012 *Rebel Cities* frames its history of urban resistances with Lefebvre's urban turn.[31]

If *Rebel Cities* argues for the continued relevance of Lefebvre's thinking, however, it also points to what has changed in the urban situation since the early 1970s. Factories, whose Taylorized labor served as the model for Lefebvre's thinking about production, "have either disappeared or been so diminished as to decimate the classical industrial working class"[32]—a class that was imagined as a necessary participant in any organized anticapitalist resistance. Dispersed to suburbs and urban peripheries, or their labor

outsourced to other nations, workers today often lack the very spaces (shop floors, working-class neighborhoods) where class struggle might once have been articulated, where it might have discovered its "irreducible social specificity."[33] Labor, too, has changed dramatically: "The ever-expanding labor of making and sustaining urban life," Harvey writes, "is increasingly done by insecure, often part-time and disorganized low-paid labor. The so-called 'precariat' has displaced the traditional 'proletariat.'"[34] The dispersal and disorganization of these workers presents huge difficulties for political organizing of any kind, he acknowledges, much less some strong vision of urban revolution.[35] One needs to know *who* might have reasons to resist and *where* (in what space) their resistance might emerge, before one decides on *how.*

So too has the "abstract space" enacted by a bureaucratic, managerial class of city planners and architects, the frequent objects of Lefebvre's attacks, given way in the last four decades to a newly dominant dynamic of financial speculation and entrepreneurialism.[36] This produces a profound alienation between a real space (of social life) and that of economic value. If a historical managerial class meant, through planning, to "smooth out and automatize" urban space, financial speculation seems by contrast to produce something quite different: a space of constant, nervous construction and demolition, less a cynical version of Le Corbusier's unrealized *Radiant City* (1924) than Robert Smithson's *Hotel Palenque* (1969–72) at an urban scale.[37] The dilapidated remains of managerial modernism persist, of course, but now overlaid with speculation's ruins-in-reverse, sign-buildings that appear out of date before they're even complete. The production of space in Lefebvre's moment meant making visible the fragmentation and separation beneath the total image of the city, whereas the task of the twenty-first century might be instead to grasp the totality (the logic of capitalist speculation) behind the disjunctive junkspace.[38]

What might account for this shift in spatial dynamic? For most of the twentieth century, urbanism and architecture proceeded as Lefebvre set out, by imposing abstraction (in the paradigmatic geometrical form of the plan) on lived space. As we have seen, this he traced to a certain dream of capitalist production. The 1970s, however, marked a dramatic shift in the world of production itself, from the systemic and rationalized production of commodities through factory labor to what Harvey has described (in an earlier text, *The Condition of Postmodernity*, 1989) as "a series of novel experiments in the realms of industrial organization as well as in political and social life."[39] These experiments play out at the level of work (the shift to part-time or service-oriented labor mentioned above) and the spaces of production; he describes a new "time-space compression" of industry marked by instantaneous communication over "an ever wider and variegated space."[40] The geography of capitalism is no longer centralized, he argues, but increasingly scattered and dispersed. Production is ever more tightly organized, but its "plan" accords to language or communication rather than vision.

After *The Production of Space* (or, rather, as Lefebvre was writing his book), production itself was changing dramatically. "There has been a dual movement," Harvey wrote in

1989, referring to developments that began in the early 1970s, "on the one hand towards the formation of financial conglomerates and brokers of extraordinary global power, and, on the other hand, a rapid proliferation and decentralization of financial activities and flows through the creation of new financial instruments and markets."[41] These transactions occur in an increasingly abstract(ed) space, in the numerology of the stock market and the non-space of leveraged assets, and in the communicative mediations of financial algorithms rather than the false transparency of the urban plan.[42] This is an increasingly non-optical, aniconic realm of digits, codes, and programs. Think of the HTML coding that subtends every website, or the binary code behind a digital photograph—codes that shape our space and social life, though in ways that are hard to think about, let alone map or represent.[43] The grids and collapsing infrastructure of urban life sit on top of this dazzling complex of values like a perverse scrap heap. If the problem for Lefebvre was an abstraction of space imposed from above, today lived space is hemmed in between abstraction above and digits below, with concrete space as a zone of transaction between the two.

Attending to the ways that these abstractions draw upon, and become again, concrete material things is one way that art might contribute to the project of representing and mapping this quandary. One example of just how this project of concretion might work is a 2007 video by the Swedish artists Goldin+Senneby, titled *After Microsoft* (figure 4). The work was produced as the multinational software corporation Microsoft prepared to phase out its famous desktop theme Luna, a photograph of a green hill and road under bright blue skies, which had served as the default desktop image for millions of computers sold for more than a decade. "The most distributed image ever is being phased out," their narration begins. "What remains is a hill in Sonoma Valley, California."[44] The project then traces the circumstances under which the photographer, Charles O'Rear, pulled over on Highway 12 to capture the image, and, by way of interviews with the Microsoft design team and the owners of the land, how the image of this place in the world came to naturalize the global brand.

The irony the artists discovered was that the land had only presented this verdant landscape as a result of the complex interaction of land prices and natural forces: "With property prices in Sonoma reaching $75,000 per acre for bare land," the narrator relates, "most hills were being developed into vineyards or homes. On this hill, grapevines had been planted. But in the early '90s a Phylloxera bug infested the grapes and made them unusable. The entire vineyard had to be pulled out. For a few years the hill was covered with grass. Green at the time of the photograph."[45] Discovered late in the Microsoft product development cycle, the photograph fortuitously matched the brand's predetermined color scheme of blue and green, and "the reality of real life" (as the video puts it) thereby came to serve as an aesthetic alibi for globalized production. In Goldin+Senneby's later photograph, which serves as *After Microsoft*'s sole image, the hill has been replanted. The trellis stakes and brown grapevines that now cover its contour mark both the landscape's reentry into artisanal production and the value of the real estate as such. As the original

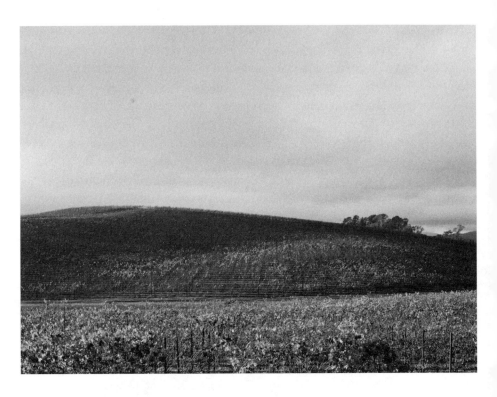

4. Goldin+Senneby, *After Microsoft (Photograph of the hill at the Bliss location, Sonoma Valley, CA)*, 2006. Digital image. Courtesy Goldin+Senneby by CreativeCommons license.

photograph became obsolete through the fashion cycle of branding, the land entered other circuits of value production.

"Theory contributes to the dismantling of existing society by exposing what gnaws at it from within, from the core of its 'prosperity,'" Lefebvre writes.[46] Yet to make visible the exigencies and paradoxes of image, branding, and production, as Goldin+Senneby have, gets us not much closer to the "detonation" of space Lefebvre imagined. Nor will attending in a documentary aesthetic (as many artists now do) to the black holes and no-places that are the persistent anterior to the speculative production and consumption of space—the pictures of abandoned malls and war-torn landscapes, forced migration, famine, and unemployment that now course through an international exhibition culture, the politically minded obverse of Microsoft's globally distributed image of a verdant Sonoma hillock.[47]

No: "Detonations," should they arrive, will take a form only suggested in the book's conclusion: "The transformation of society," Lefebvre writes, "presupposes a collective ownership and management of space founded on the permanent participation of the 'interested parties,' with their multiple, varied, and even contradictory interests"—that is, in the project of reclaiming space for a commons that truly includes *everyone*.[48] This project preserves a role for art, though perhaps only in the sense of art's transformation

5. Andrew Kenower, *Biblioteca Popular Victor Martínez*, 2012. Digital image. Courtesy Andrew Kenower.

into life: "On the horizon, then, at the furthest edge of the possible, it is a matter of producing the space of the human species—the collective (generic) work of the species—on the model of what used to be called 'art.'"[49] If this struggle now needs to come to terms with a redoubled and differentiated enemy, an "abstraction" that has taken new, speculative forms, our resources—social life, the ground of social reproduction, human creativity—remain much the same. And in this metamorphosis, little is certain except that "we are concerned with nothing that even remotely resembles a system."[50]

If Lefebvre was working in this passage to avoid being too proscriptive about what form future struggles might take, even a sympathetic reader might find his imaginings rather too utopian and vague. So perhaps a particular case might help us focus in on what, exactly, he seems to be proposing, and therefore how Lefebvre's thinking can be put to use in present struggles over space. On August 13, 2012, Occupy activists entered a vacant building at 1449 Miller Avenue in East Oakland and established the Biblioteca Popular Victor Martínez. One of eight Oakland public libraries decommissioned in the late 1970s (under the California ballot initiative Proposition 13, which limited property taxes and had the effect of decreasing funding to public services), the building had in the decades since closure hovered between outright abandonment and a purgatory of city redevelopment schemes (figure 5).[51] Renaming it in honor of a local poet, the activists cleared the building of trash and mattresses and gathered hundreds of donated books for public use on shelves that had long been empty. The occupation of the building was cut

short by the arrival of the Oakland Police minutes before midnight, representing a city obtusely committed to guarding, through force, the building's vacancy—and, thereby, its speculative value in an endless merry-go-round of bureaucratic finagling.[52]

This story speaks to the particular nature of the abstraction of space in our present, in which abjection and disuse play as central a role as clapped-together new developments: as a reserve or future value, in much the same way as unemployed people, in the Marxist formulation, constitute a "reserve army" leveraged against workers currently employed. Speculative urbanism, this is to say, demands inoperative spaces alongside productive ones. But so too does the skirmish in East Oakland indicate the continued value of Lefebvre's ideas in our present: the central importance of reclaiming for collective ownership the spaces that production and speculation hope to enclose. And if the argument of my essay is that this battle will need to be fought on multiple fronts alongside occupation—aimed simultaneously at the convoluted non-spaces of the financial market and at the aniconicity of digital code—I am still happy to picture my foxed copy of *The Production of Space* finding a useful spot on the shelves of some Biblioteca Popular or other.

NOTES

1. Henri Lefebvre, *The Production of Space*, trans. Donald Nicholson-Smith (Oxford: Blackwell, 1991). Originally published as *La production de l'espace* (Paris: Editions Anthropos, 1974).

2. Andrew Merrifield, *Henri Lefebvre: A Critical Introduction* (New York: Routledge, 2006), 103.

3. Martha Rosler, "In the Place of the Public: Observations of a Frequent Flyer," *Assemblage* 25 (December 1994): 44–79; Rosalyn Deutsche, *Evictions: Art and Spatial Politics* (Cambridge, Massachusetts: MIT Press, 1996) (though it should be noted that Deutsche's uses of Lefebvre began in the 1980s, predating the English translation; see for example "Uneven Development: Public Art in New York City," published in *October* in 1988); Miwon Kwon, "One Place After Another: Notes on Site Specificity," *October* 80 (spring 1997): 85–110; and Anthony Vidler, *Warped Space: Art, Architecture and Anxiety in Modern Culture* (Cambridge, Massachusetts: MIT Press, 2000).

4. Andrew Merrifield, *Henri Lefebvre*, 103. Merrifield notes (by way of an email exchange with Donald Nicholson-Smith) that the French edition of *La production de l'espace* had (in 2006) sold between three and four thousand copies, while *The Production of Space* had by the same date sold nearly twenty thousand, indicating an important geographical dimension to the book's reception. Drawing on a conversation with Lefebvre scholar Rémi Hess, in the same publication Merrifield relates that South Korea "is a big Lefebvrian importer, where his texts sell like radical hotcakes."

5. Henri Lefebvre, *The Production of Space*, 1.

6. Ibid., 3.

7. Ibid.

8. Ibid., 8.

9. Ibid., 25.

10. Ibid.

11. Klee was a professor at the Bauhaus in Dessau when he painted *Uncomposed in Space,* and it is possible that these volumes meant to call up that institution's revised values under its new director, Hannes Meyer. As Gerhard Kadow (a student at the time) described it, "Technological inventions, often used in lavish profusion, served the single purpose of enabling men in a group to live without friction. . . . The spiritually expressive qualities of form, however, were neglected; the final entity, seemingly externally and internally so complete, was robbed of form. The living organism was given no face." Gerhard Kadow, "Paul Klee and Dessau in 1929," *College Art Journal* 9, no. 1 (autumn 1949): 34.

12. Henri Lefebvre, *The Production of Space,* 102.

13. Ibid., 318.

14. Ibid., 26.

15. Ibid.

16. Marina Vishmidt, "Permanent Reproductive Crisis: An Interview with Silvia Federici," *Mute,* March 7, 2013, accessed March 20, 2013, http://www.metamute.org/editorial/articles /permanent-reproductive-crisis-interview-silvia-federici.

17. Henri Lefebvre, *The Production of Space,* 68.

18. Ibid., 70.

19. Ibid., 355.

20. "Late capitalism in general (and the 60s in particular) constitute a process in which the last surviving internal and external zones of precapitalism—the last vestiges of noncommodified or traditional space within and outside the advanced world—are now ultimately penetrated and colonized in their turn. Late capitalism can therefore be described as the moment in which the last vestiges of Nature which survived on into classical capitalism are at length eliminated: namely the Third World and the unconscious." Fredric Jameson, "Periodizing the 60s," in Sohnya Sayres, Anders Stephanson, Stanley Aronowitz, and Fredric Jameson, eds., *The 60s Without Apology* (Minneapolis: University of Minnesota Press, 1985), 207.

21. Henri Lefebvre, *The Production of Space,* 355.

22. Ibid., 356.

23. Ibid., 75.

24. Ibid., 75–76.

25. Ibid.

26. Ibid., 55.

27. Ibid., 66.

28. An incisive account of May 1968 in France is offered by Kristin Ross in her book *May '68 and Its Afterlives* (Chicago: University of Chicago Press, 2002). See in particular the chapter "Forms and Practices," 65–137. See also my account of the 1967 uprising in Detroit in Julian Myers and Edgar Arceneaux, *Hopelessness Freezes Time* (Basel, Switzerland: Museum für Gegenwartskunst, Kunstmuseum Basel, 2011).

29. Henri Lefebvre, *The Production of Space,* 24.

30. As Jameson put it soon after the publication of *Postmodernism,* "My idea on the postmodern was, first and foremost, that the aesthetics of this period and the forms it projects have to be seen in terms of a whole mode of production and not merely as a kind of style: One that has to do with more complete modernization and with the elimination of those older enclaves of historical difference that correspond to older kinds of agriculture and older modes

of life. As Henri Lefebvre puts it in *The Production of Space*, it is the urbanization of global reality: the tendential transformation of everything into something that one has to think of as urban. For example, we no longer have to do with agriculture but with agribusiness; in social terms, things like the capital and the provinces no longer obtain: There is a kind of standardization of everything. In all these senses, a new notion of homogeneous space seems to impose itself." See Fredric Jameson and Michael Speaks, "Envelopes and Enclaves: The Space of Post-Civil Society," *Assemblage* no. 17 (April 1992): 32. See also Fredric Jameson, *Postmodernism, or, The Cultural Logic of Late Capitalism* (Durham, North Carolina: Duke University Press, 1991), in particular the chapter "Spatial Equivalents in the World System," 97–129.

31. David Harvey, *Rebel Cities: From the Right to the City to the Urban Revolution* (New York: Verso 2012). See in particular his preface, "Henri Lefebvre's Vision," ix–xviii, and the chapter "Reclaiming the City for Anti-Capitalist Struggle," 115–53.

32. Ibid., xiv.

33. Jean Baudrillard, *Symbolic Exchange and Death*, trans. Iain Hamilton Grant (London: Sage Publications, 1993), 77, originally published as *L'Echange symbolique et la mort* (Paris: Editions Gallimard, 1976). One has to compare this dispersal to the relations between space and labor that applied before industrialization: "Prior to the rise of specifically capitalist relations of production, there did not exist a 'domestic sphere' in isolation from the sphere of production. Production of goods—even those produced for exchange—often occurred in or around the 'home' (the place where workers *lived*)." Maya Gonzalez, "Notes on the New Housing Question," *Endnotes*, April 2010, accessed January 10, 2013, http://endnotes.org.uk/articles/3.

34. David Harvey, *Rebel Cities*, xiv.

35. "Working-class forms of organization (such as the trade unions), for example, depended heavily upon the massing of workers within the factory for their viability, and find it peculiarly difficult to gain any purchase within family and domestic labor systems." David Harvey, *The Condition of Postmodernity: An Inquiry into the Conditions of Cultural Change* (Oxford: Blackwell, 1989), 153.

36. See David Harvey, "Flexible Accumulation Through Urbanization," in *The Urban Experience* (Baltimore: Johns Hopkins University Press, 1989), 272–78.

37. Robert Smithson, "Robert Smithson: *Hotel Palenque, 1969–72*," *Parkett* 43 (March 1995): 117–132. The article is a transcription of a lecture originally delivered to architecture students at the University of Utah in 1972.

38. "Junkspace is what remains after modernization has run its course, or, more precisely, what coagulates while modernization is in progress, its fallout. Modernization had a rational program: to share the blessings of science, universally. Junkspace is its apotheosis, or meltdown. . . . Although its individual parts are the outcome of brilliant inventions, lucidly planned by human intelligence, boosted by infinite computation, their sum spells the end of Enlightenment, its resurrection as farce, a low-grade purgatory." Rem Koolhaas, "Junkspace," *October* 100, "Obsolescence" (spring 2002): 175.

39. David Harvey, *The Condition of Postmodernity*, 145.

40. Ibid., 147.

41. Ibid., 160–61.

42. See Donald MacKenzie, *An Engine, Not a Camera: How Financial Models Shape Markets* (Cambridge, Massachusetts: MIT Press, 2006).

43. See Sven Lütticken, "Attending to Things (Some More Material Than Others)" and "Living With Abstraction," in *Idols of the Market: Modern Iconoclasm and the Fundamentalist Spectacle* (New York: Sternberg Press, 2009), 91–156.

44. Goldin+Senneby, "After Microsoft," transcript. Goldinsenneby.com, April 5, 2007, accessed January 8, 2013, http://www.goldinsenneby.com/gs/?p = 81.

45. Ibid.

46. Henri Lefebvre, *The Production of Space*, 420.

47. "Globalization has above all meant the association of space and spatial distance in production itself, whether in terms of outsourcing, of the uneven development of producing and consuming nations, or the migration of labor, as well as the black holes of unemployment, famine and unspeakable violence into which whole surfaces of the current globe suddenly fall." Fredric Jameson, *Valences of the Dialectic* (New York; Verso, 2009), 92.

48. Henri Lefebvre, *The Production of Space*, 422.

49. Ibid.

50. Ibid., 423.

51. "[The library] was owned by the Oakland Redevelopment Agency, whose members allocated money to it in their 2005 five-year plan, but no redevelopment of the building had begun when redevelopment agencies across California were dissolved last fall. It is now owned by the Redevelopment Successor Agency housed within the City of Oakland's Office of Neighborhood Investment, and, for all official purposes, remains vacant." Yael Chanoff, "A Week After Police Crack Down, People's Library Still Operating in East Oakland," *San Francisco Bay Guardian*, August 17, 2012, accessed January 10, 2013, http://www.sfbg.com/politics/2012/08/17 /week-after-police-crack-down-peoples-library-still-operating-east-oakland.

52. A photographic account of the library's occupation and eviction is offered by Aaron Bady and Andrew Kenower, "A Day in the Life of Biblioteca Popular Victor Martínez (People's Library), August 13th, 2012, East Oakland," *The New Inquiry,* August 14, 2012, accessed January 10, 2013, http://thenewinquiry.com/blogs/zunguzungu/a-day-in-the-life-of-biblioteca-popular-victor-martinez-peoples-library-august-13th-2012-east-oakland/.

2

TREVOR PAGLEN

Experimental Geography: From Cultural Production to the Production of Space[1]

This essay originally appeared in the catalogue accompanying the 2008 exhibition Experimental Geography: Radical Approaches to Landscape, Cartography, and Urbanism, *curated by Nato Thompson with Independent Curators International. Many contributors to our own volume likewise participated in this landmark show. The term "experimental geography" was coined by Paglen in 2002.*

When most people think about geography, they think about maps. Lots of maps. Maps with state capitals and national territories, maps showing mountains and rivers, forests and lakes, or maps showing population distributions and migration patterns. And, indeed, that isn't a wholly inaccurate idea of what the field is all about. It is true that modern geography and mapmaking were once inseparable.

Renaissance geographers like Henricus Martellus and Pedro Reinel, having rediscovered Greek texts on geography (most importantly Ptolemy's *Geography*), put the ancient knowledge to work in the service of the Spanish and Portuguese empires. Martellus's maps from the late fifteenth century updated the old Greek cartographic projections to include Marco Polo's explorations of the East as well as Portuguese forays along the African coast. Reinel's portolan maps are some of the oldest modern nautical charts. Cartography, it turned out, was an indispensable tool for imperial expansion: If new territories were to be controlled, they had to be mapped. Within a few decades, royal cartographers filled in blank spots on old maps. In 1500, Juan de la Cosa, who accompanied Columbus on three voyages as captain of the *Santa Maria*, produced the Mappa Mundi, the first

known map to depict the New World. Geography was such an important instrument of Portuguese and Spanish colonialism that early modern maps were some of these empires' greatest secrets. Anyone caught leaking a map to a foreign power could be punished by death.[2]

In our own time, another cartographic renaissance is taking place. In popular culture, free software applications like Google Earth and MapQuest have become almost indispensable parts of our everyday lives: We use online mapping applications to get directions to unfamiliar addresses and to virtually "explore" the globe with the aid of publicly available satellite imagery. Consumer global positioning systems (GPS) have made latitude and longitude coordinates a part of the cultural vernacular. In the arts, legions of cultural producers have been exercising the power to map. Gallery and museum exhibitions are dedicated to every variety of creative cartography; "locative media" has emerged as a form of techno-site-specificity; in the antiquities market, old maps have come to command historically unprecedented prices at auction. Academia, too, has been seized by the new powers of mapmaking: geographical information systems (GIS) has become a new lingua franca for collecting, collating, and representing data in fields as diverse as archaeology, biology, climatology, demography, and epidemiology, all the way to zoology. In many peoples' minds, a newfound interest in geography has seized popular culture, the arts, and the academy. But does the proliferation of mapping technologies and practices really point to a new geographic cultural *a priori?* Not necessarily. Although geography and cartography have common intellectual and practical ancestors, and are often located within the same departments at universities, they can suggest very different ways of seeing and understanding the world.

Contemporary geography has little more than a cursory relationship to all varieties of cartography. In fact, most critical geographers have a healthy skepticism for the "God's Eye" vantage points implicit in much cartographic practice. As useful as maps can be, they can only provide very rough guides to what constitutes a particular space.

Geography is a curiously and powerfully transdisciplinary discipline. In any given geography department, one is likely to find people studying everything from the pre-Holocene atmospheric chemistry of northern Greenland to the effects of sovereign wealth funds on Hong Kong real estate markets, and from methyl chloride emissions in coastal salt marshes to the racial politics of nineteenth-century California labor movements. In the postwar United States, university officials routinely equated the discipline's lack of systematic methodological and discursive norms with a lack of seriousness and rigor, a perception that led to numerous departments being closed for lack of institutional support.[3] The end of geography at Harvard was typical of what happened to the field: University officials at Harvard shut down its geography department in 1948, as CUNY geographer Neil Smith tells it, after being flummoxed by their "inability to extract a clear definition of the subject, to grasp the substance of geography, or to determine its boundaries with other disciplines." The academic brass "saw the field as hopelessly amorphous."[4] But this "hopeless amorphousness" is, in fact, the discipline's greatest strength.

No matter how diverse and transdisciplinary the field of geography may seem, and indeed is, a couple of axioms nevertheless unify the vast majority of contemporary geographers' work. These axioms hold as true for the "hard science" in university laboratories as for human geographers studying the unpredictable workings of culture and society. Geography's major theoretical underpinnings come from two related ideas: materialism and the production of space.

In the philosophical tradition, materialism is the simple idea that the world is made out of "stuff," and that, moreover, the world is only made out of "stuff." All phenomena, then, from atmospheric dynamics to Jackson Pollock paintings, arise out of the interactions of material in the world. In the Western tradition, philosophical materialism goes back to ancient Greek philosophers like Democritus, Anaxagoras, and Epicurus, whose conceptions of reality differed sharply from Plato's metaphysics. Later philosophers like Thomas Hobbes, David Hume, Ludwig Feuerbach, and Karl Marx would develop materialist philosophies in contradistinction to Cartesian dualism and German idealism. Methodologically, materialism suggests an empirical (although not necessarily positivistic) approach to understanding the world. In the contemporary intellectual climate, a materialist approach takes relationality for granted, but an analytic approach that insists on "stuff" can be a powerful way of circumventing or tempering the quasi-solipsistic tendencies found in some strains of vulgar poststructuralism.

Geography's second overarching axiom has to do with what we generally call "the production of space." Although the idea of the "production of space" is usually attributed to the geographer-philosopher Henri Lefebvre, whose 1974 book *La production de l'espace* introduced the term to large numbers of people, the ideas animating Lefebvre's work have a much longer history.[5] Like materialism, the production of space is a relatively easy, even obvious, idea, but it has profound implications. In a nutshell, the production of space says that humans create the world around them and that humans are, in turn, created by the world around them. In other words, the human condition is characterized by a feedback loop between human activity and our material surroundings. In this view, space is not a container for human activities to take place within, but is actively "produced" through human activity. The spaces humans produce, in turn, set powerful constraints upon subsequent activity.

To illustrate this idea, we can take the university where I'm presently writing this text. At first blush, the university might seem like little more than a collection of buildings, libraries, laboratories, and classrooms—distinct locations in space. That's what the university looks like on a map or on Google Earth. But this is an exceptionally partial view of the institution. The university is not an inert thing: It doesn't "happen" until students arrive to attend classes, professors lock themselves away to do research, administrative staff pays the bills and registers the students, state legislators appropriate money for campus operations, and maintenance crews keep the institution's physical infrastructure from falling apart. The university, then, cannot be separated from the people

who go about "producing" the institution day after day. But the university also sculpts human activity: The university's physical and bureaucratic structure creates conditions under which students attend lectures, read books, write papers, participate in discussions, and get grades. Human activity produces the university, but human activities are, in turn, shaped by the university. In these feedback loops, we see production of space at work.

Fine. But what does all of this have to do with art? What does this have to do with "cultural production?"

Contemporary geography's theoretical and methodological axioms don't have to stay within any disciplinary boundaries whatsoever (a source of much confusion at Harvard back in the mid-1940s). One can apply them to just about anything. Just as physical geographers implicitly use the idea of the production of space when they inquire into the relationship between human carbon emissions and receding Antarctic ice shelves, or when human geographers investigate the relationships between tourism and Tanzanian nature preserves, geography's axioms can guide all sorts of practice and inquiry, including art and culture. A geographic approach to art, however, would look quite different than most conventional art history and criticism. The difference in approach would arise from the ways various disciplines rely on different underlying conceptions of the world. A geographer looking into art would begin with very different premises than those of an art critic.

To speak very generally, the conceptual framework organizing much art history and criticism is one of "reading culture," where questions and problems of representation (and their consequences) are of primary concern. In the traditional model, the critic's task is to describe, elaborate upon, explain, interpret, evaluate, and critique pre-given cultural works. In a certain sense, the art critic's role is to act as a discerning consumer of culture. There's nothing at all wrong with this, but this model of art criticism must (again, in a broad sense) tacitly assume an ontology of "art" in order to have an intelligible starting point for a reading, critique, or discussion. A good geographer, however, might use her discipline's analytic axioms to approach the problem of "art" in a decidedly different way.

Instead of asking "What is art?" or "Is this art successful?" a good geographer might ask questions along the lines of "How is this space called 'art' produced?" In other words, what are the specific historical, economic, cultural, and discursive conjunctions that come together to form something called "art" and, moreover, to produce a space that we colloquially know as an "art world"? The geographic question is not "What is art?" but "How is art?" From a critical geographic perspective, the notion of a free-standing work of art would be seen as the fetishistic effect of a production process. Instead of approaching art from the vantage point of a consumer, a critical geographer might reframe the question of art in terms of spatial practice.[6]

We can take this line of thinking even further. Instead of using geographic axioms to come up with an alternative "interpretive" approach to art (as I suggested in the previous

paragraph), we can use them in a normative sense. Whether we're geographers, artists, writers, curators, critics, or anyone else, we can use geographic axioms self-reflexively to inform our own production.

If we accept Marx's argument that a fundamental characteristic of human existence is "the production of material life itself" (that humans produce their own existence in dialectical relation to the rest of the world),[7] and, following Lefebvre (and Marx) that production is a fundamentally spatial practice,[8] then cultural production (like all production) is a spatial practice. When I write an essay such as this, get it published in a catalogue and put on a shelf in a bookstore or museum, I'm participating in the production of space. The same is true for producing art: When I produce images and put them in a gallery or museum or sell them to collectors, I'm helping to produce a space some call the "art world." The same holds true for "geography": When I study geography, write about geography, teach geography, go to geography conferences, and take part in a geography department, I'm helping to produce a space called "geography." None of these examples is a metaphor: The "space" of culture isn't just Raymond Williams's "structure of feeling" but, as my friends Ruth Wilson Gilmore and Clayton Rosati underline, an "infrastructure of feeling."[9]

My point is that if one takes the production of space seriously, the concept applies not only to "objects" of study or criticism, but to the ways one's own actions participate in the production of space. Geography, then, is not just a method of inquiry, but necessarily entails the production of a space of inquiry. Geographers might study the production of space, but through that study, they're also producing space. Put simply, geographers don't just study geography, they create geographies. The same is true for any other field and any other form of practice. Taking this head-on, incorporating it into one's practice, is what I mean by "experimental geography."

Experimental geography means practices that take on the production of space in a self-reflexive way, practices that recognize that cultural production and the production of space cannot be separated from each other, and that cultural and intellectual production is a spatial practice. Moreover, experimental geography means not only seeing the production of space as an ontological condition, but actively experimenting with the production of space as an integral part of one's own practice. If human activities are inextricably spatial, then new forms of freedom and democracy can only emerge in dialectical relation to the production of new spaces. I deliberately use one of modernism's keywords, "experimental," for two reasons. First, to acknowledge and affirm the modernist notion that things can be better, that humans are capable of improving their own conditions, to keep cynicism and defeatism at an arm's length. Moreover, experimentation means production without guarantees, and producing new forms of space certainly comes without guarantees. Space is not deterministic, and the production of new spaces isn't easy.

In thinking about what experimental geography entails, especially in relation to cultural production, it's helpful to harken back to Walter Benjamin, who prefigured these ideas in a 1934 essay entitled "The Author as Producer." While he worked in exile from the Nazis in Paris during much of the 1930s, Benjamin's thoughts repeat-

edly turned to the question of cultural production. For Benjamin, cultural production's status as an intrinsically political endeavor was self-evident. The intellectual task he set for himself was to theorize how cultural production might be part of an overall anti-Fascist project. In his musings on the transformative possibilities of culture, Benjamin identified a key political moment in cultural works, happening in the production process.

In his "Author as Producer" essay, he prefigured contemporary geographic thought when he refused to assume that a cultural work exists as a thing unto itself: "The dialectical approach," he wrote, "has absolutely no use for such rigid, isolated things as work, novel, book. It has to insert them into the living social context."[10] Right there, Benjamin rejected the assumption that cultural works have any kind of ontological stability and instead suggested a relational way of thinking about cultural works. Benjamin went on to make a distinction between works that have an "attitude" toward politics and works that inhabit a "position" within them. "Rather than ask 'What is the *attitude* of a work to the relations of production of its time?'" he wrote, "I should like to ask, 'What is its *position* in them?'"[11] Benjamin, in other words, was identifying the relations of production that give rise to cultural work as a crucial political moment. For Benjamin, producing truly radical or libratory cultural works meant producing libratory spaces from which cultural works could emerge. Echoing Marx, he suggested that the task of transformative cultural production was to reconfigure the relations and apparatus of cultural production, to reinvent the "infrastructure" of feeling in ways designed to maximize human freedom. The actual "content" of the work was secondary.

Experimental geography expands Benjamin's call for cultural workers to move beyond "critique" as an end in itself and to take up a "position" within the politics of lived experience. Following Benjamin, experimental geography takes for granted the fact that there can be no "outside" of politics, because there can be no "outside" of the production of space (and the production of space is ipso facto political). Moreover, experimental geography is a call to take seriously, but ultimately move beyond, cultural theories that equate new enunciations and new subjectivities as sufficient political ends in themselves. When decoupled from the production of new spaces, they are far too easily assimilated into the endless cycles of destruction and reconstitution characterizing cultural neoliberalism, a repetition Benjamin dubbed "Hell."

The task of experimental geography, then, is to seize the opportunities that present themselves in the spatial practices of culture. To move beyond critical reflection, critique alone, and political "attitudes," into the realm of practice. To experiment with creating new spaces, new ways of being.

What's at stake? Quite literally, everything.

6. Trevor Paglen, *The Last Pictures and the Gold Artifact*, 2013. Etched gold-plated disk, 4 7/8 × 4 7/8 in. Courtesy the artist, Metro Pictures, Altman Siegel, and Galerie Thomas Zander.

Figure 6: In fall 2012, this "ultra-archival disc micro-etched with one hundred photographs and encased in a gold plated shell" entered orbit, departing Earth aboard a television satellite launched from Kazakhstan. The disc "will continue to slowly circle Earth until the Earth itself is no more." —http://creativetime.org/projects/the-last-pictures/

Figure 7 (opposite): From the series Limit Telephotography: "A number of classified military bases and installations are located in some of the remotest parts of the United States, hidden deep in Western deserts and buffered by dozens of miles of restricted land. Many of these sites are so remote, in fact, that there is nowhere on Earth where a civilian might be able to see them with an unaided eye. In order to produce images of these remote and hidden landscapes, therefore, some unorthodox viewing and imaging techniques are required.

Limit-telephotography involves photographing landscapes that cannot be seen with the unaided eye. The technique employs high-powered telescopes whose focal lengths range between 1300 mm and 7000 mm. At this level of magnification, hidden aspects of the landscape become apparent." —Paglen.com

Figure 8 (opposite): From the series The Other Night Sky: "The Other Night Sky is a project to track and photograph classified American satellites, space debris, and other obscure objects in Earth orbit. The project uses observational data produced by an international network of amateur "satellite observers to calculate the position and timing of overhead transits which are photographed with telescopes and large-format cameras and other imaging devices." —Paglen.com

7. Trevor Paglen, *Detachment 3, Air Force Flight Test Center, Groom Lake, NV; Distance approx. 26 miles*, 2008. Chromogenic print, 40 × 50 in. Courtesy the artist, Metro Pictures, Altman Siegel, and Galerie Thomas Zander.

8. Trevor Paglen, *KEYHOLE IMPROVED CRYSTAL from Glacier Point (Optical Reconnaissance Satellite; USA 224)*, 2011. Chromogenic print, 30 × 43 in. (76.2 × 109.2 cm). Courtesy the artist, Metro Pictures, Altman Siegel, and Galerie Thomas Zander.

NOTES

1. Many of the ideas in this essay have been developed over almost two decades of conversations with my longtime friend and interlocutor Nato Thompson.

2. See for example Miles Harvey, *The Islands of Lost Maps* (New York: Random House, 2000).

3. For an institutional history of geography in the United States, see William Koelsch, "Academic Geography, American Style: An Institutional Perspective," in *Geography: Discipline, Profession and Subject Since 1870*, ed. Gary S. Dunbar (Dordrecht, the Netherlands: Kluwer, 2001), 245–80.

4. Neil Smith, "Academic War Over the Field of Geography: The Elimination of Geography at Harvard, 1947–1951," *Annals of the Association of American Geographers* 77, no. 2. (June 1987): 155–72.

5. Lefebvre's analysis, like much critical geography, relies on a spatial reading of Marx.

6. In my opinion, Rosalyn Deutsche's book *Evictions* is the best example of what a critical art historical project along these lines might look like. I personally would love to see more art historians take this project up. See Rosalyn Deutsche, *Evictions: Art and Spatial Politics* (Cambridge, Massachusetts: MIT Press, 1996).

7. Karl Marx and Friedrich Engels, *The German Ideology*, ed. C. J. Arthur (New York: International Publishers, 1947), 48.

8. Henri Lefebvre, *The Production of Space*, trans. Donald Nicholson-Smith (Oxford: Blackwell, 1991).

9. See Ruth Wilson Gilmore, "Tossed Overboard: Katrina, Abandonment and the Infrastructure of Feeling" (conference paper presented at "Anxiety, Urgency, Outrage, Hope: A Conference on Political Feeling," University of Chicago, October 2007) and Clayton Rosati, "The Terror of Communication: Critical Infrastructure, Property, and the Culture of Security," presented at the American Studies Association National Meeting, Washington, DC, November 2005.

10. Walter Benjamin. *Reflections*, ed. Peter Memetz, trans. Edmund Jephcott (New York: Schocken, 1978), 222.

11. Ibid.

3

SARAH KANOUSE

Critical Day Trips: Tourism and Land-Based Practice

The critic Lucy Lippard opined in her groundbreaking 1999 book *On the Beaten Track,* "Since teaching people how to see is the artist's business, it seems odd that tourism as an activity (rather than as an image or a symbol) has piqued so few progressive artists' imaginations."[1] In the ensuing fifteen years, we have witnessed an explosion of artist-initiated tours, guidebooks, excursions, and routes. While they actually function as tours, these projects refuse to collapse into the financial and attention economies of tourism. Providing unusual content, existing in the margins of the marketplace, and often displaying a self-reflexivity about being "touristic," artists' tours have emerged as an accessible and effective way to bring audiences into critically inflected encounters with landscape.

The Los Angeles Urban Rangers' "L.A. River Ramble" asked visitors to complete one of three self-guided walks through downtown from the Museum of Contemporary Art's Geffen Contemporary to view the channelized, concrete-banked Los Angeles River, culminating in a brief talk delivered by a uniformed Ranger (figure 9).[2] The tone was informative, if slightly tongue in cheek. The Rangers performed sincerely as trustworthy individuals in familiar brown hats. The eight hundred people who attended the evening's tours were more than spectators, however. Tour guides need tourists, and the Rangers' performance depended on the willingness of the audience to play that uncast role. Viewers agreed to lay aside conventions of individual spectatorship and aesthetic contemplation to "act" as tourists, obliquely acknowledging how artistic spectatorship itself is often touristic in nature. While artist and audience usually fulfill distinct roles within participatory projects such as the River Ramble, the space traditionally maintained between art

9. Los Angeles Urban Rangers, "L.A. River Ramble," August 4, 2011. Program from the series *Public Access 101: Downtown L.A.* for "Engagement Party" at the Museum of Contemporary Art, Los Angeles. Photo by Harvey Opgenorth.

object and art viewer is collapsed. By depending on the participation of the audience to activate the experience, artists' tours can be seen as part of the "social turn" in contemporary art, in which the terms of spectatorship and meaning-making are renegotiated to accommodate some degree of improvisation and collaboration with the viewers.[3]

In addition to using participatory methods channeled through the forms of tourism, the L.A. Urban Rangers can be located within a cohort of contemporary research-based artists whose work ventures far from the art world—in terms of subject matter, methods, and audience—before circling back to it. The critic Brian Holmes describes these projects as "extradisciplinary investigations," a kind of engaged art practice rooted in the tradition of institutional critique yet exceeding it in scope and political ambition.

> The extradisciplinary ambition is to carry out rigorous investigation on terrains as far away from art as finance, biotech, geography, urbanism, psychiatry, the electromagnetic spectrum, etc., to bring forth on these terrains the "free play of the faculties" and the intersubjective experimentation that are characteristic of modern art, but also to try to identify, inside those same domains, the spectacular or instrumental uses so often made of the subversive liberty of aesthetic play.[4]

Holmes explains the relation of art as a discipline to work whose content exceeds the formalist limits traditionally assigned it under Modernism. By identifying what these practices share with aesthetic traditions—Kant's notion of the "free play of the faculties" and experimental approaches that channel the twentieth-century avant-garde— Holmes locates "extradisciplinary," research-based practice firmly in an art historical narrative while applauding it as a critical intervention within that very disciplinary tradition.

For the L.A. Urban Rangers, the tropes of twentieth-century National Parks–style family tourism are placed in the service of examining how nature and public space are perceived and managed in the city. While their early events drew primarily from art and urban studies audiences, their following today is far broader. Sponsored by MoCA, the Ramble event drew a mixture of art aficionados, conservationists, architects, historic preservationists, families attending MoCA's Free Thursday Night, and people curious about the city. In this case, the Rangers' relationship with the museum was tactical—a source of institutional support and audience—but their projects function quite well (and perhaps even better) when audiences don't perceive them as "merely" art. Holmes describes this approach as "occupying a field with a potential for shaking up society and then radiating outward from that specialized domain, with the explicitly formulated aim of effecting change in the discipline of art, in the discipline of cultural critique, and even the 'discipline' . . . of leftist activism."[5]

That the economic juggernaut of mass tourism could be one of those fields "with a potential for shaking up society" might be surprising. Taking into account gross receipts for leisure travel, lodging, dining, and sightseeing, tourism is often described as the world's largest industry. Tourism's economic dominance has only increased over the last three decades, as neoliberal globalization has shifted industrial operations to less-developed countries and stagnated wages. In the absence of meaningful alternatives, every slightly picturesque or exotic locale feels the pressure to reinvent itself as a destination for others' leisure, a situation that is ripe for abuse, corruption, and resentment. Described in less-than-flattering terms, the tourist is one of Zygmunt Bauman's four signal figures of postmodernity. Bauman writes:

> The tourist is a conscious and systematic seeker of experience, of a new and different experience . . . as the joys of the familiar wear off and cease to allure. The tourists want to immerse themselves in a strange and bizarre element . . . on condition, though, that it will not stick to the skin. . . . In the tourist's world the strange is tame, domesticated, and no longer frightens; shock comes in a package deal with safety.[6]

Bauman describes quite evocatively the insulated and privileged features that all too often prevent tourist experiences from resulting in a more nuanced awareness of geographical and political conditions or, at a minimum, a heightened sense of empathy. Yet if the tourist is indeed one of the "identity models" of late capitalism, as he claims,

it would seem essential to recuperate the tourist for progressive ends. Bauman's indictment feels totalizing and disabling: It is unclear how to move *through* rather than away from the problematics of tourism. Yet he offers an oblique (and probably unintentional) toehold. "The tourist's world is fully and exclusively structured by *aesthetic* criteria," he continues. "Tough and harsh realities resistant to aesthetic sculpting do not interfere here."[7] If touristic subjectivity is relentlessly aesthetic, could it not represent a site for artistic intervention? Aesthetic sculpting need not necessarily obscure "harsh realities" but could make them easier to grasp. Furthermore, politically engaged art practices of the past thirty years have staked out their own stances on the aesthetic, from the anti-aesthetic posture of much 1980s deconstructive art to positions that allow for the tactical deployment of beauty or perceive an inescapable "politics of aesthetics."[8] That tourism is aesthetic is not reason to dismiss it out of hand but rather to ask: Which (or whose) aesthetic? What does this aesthetic include and leave out? And, crucially, what does it do, how, and for whom?

At a moment where nearly every cultural form has been appropriated for artistic détournement, it is no surprise that the already highly performative domain of tourism has become both subject and form for contemporary art. Much of this activity may merely enlarge the scope of art as a discipline, much as capitalism continually expands to include areas of human activity that once existed outside it. But tourism has tremendous critical potential to operate in a transverse, "extradisciplinary" critical and creative space in which just as much is at stake outside the domain of art as within it. In what follows, I consider some of the aesthetic and political concerns evident in many critical artists' tours produced in the last fifteen years in the United States and Canada. Think of them as signposts offering directions, perhaps contradictory directions, to this terrain. May they provide points of departure for your own journey.

MATERIALIZING METHODS

Though artists' tours are clearly about something "out there" in the field, they are developed by people whose training in the arts has encouraged self-reflexivity in relation to form and content. Contemporary art prizes the conceptual alignment of method and product: Form is not a neutral carrier of content, and the method of production is a constitutive feature of the product. Because artists employ an almost infinite range of forms and strategies in their work, the choice to produce a tour is made neither automatically nor lightly. This intentionality and self-reflexivity is one of the basic features distinguishing artists' tours from conventional tourism.

Nevertheless, artists' tours are full of content and often explicitly claim to provide an alternative point of view to mainstream tourism, making it easy to overlook their position in relation to form and method. Artists who present tour experiences for an audience do so after a period of site-based inquiry that moves fluidly and frequently between experiences "in the field" and textual/archival research. Information is checked against the land-

scape, while the landscape is reread in a research process that may not end before presentation to an audience but continues as mutual discovery on the tour.

Many artists' tours reflect the processes of their own creation while acknowledging that they remain open and incomplete, subject to audience experience, inflection, and reinterpretation. For example, Rozalinda Borcilă offers group tours as part of her ongoing research into the geography of the Foreign Trade Zone (FTZ). Established during the New Deal as areas within U.S. ports that are, for tariff purposes, considered legally outside national borders, the FTZ program has expanded into an elaborate set of networks and corridors for the shipping, warehousing, and refining of products outside the juridical purview of the United States but atop its physical territory. In addition to sharing her research, Borcilă opened the daylong event to participants, who collectively negotiated the day's route according to their own interests as they intersected with the FTZ.[9] During the tour, participants—ranging from university arts faculty to political organizers without college degrees—developed "spotting skills" to identify the physical markers of this abstract legal entity and asked questions Borcilă had never considered.[10] In this way, the event was as much a group seminar as a tour, designed to mutually grow an understanding of how global economic processes shape geographies underfoot.

Borcilă's work on Foreign Trade Zones points to the central feature of landscape long theorized by scholars: that the visual dimension of a site often conceals the "production of space" by historical and contemporary economic, social, and ecological agents, and is often designed to do so.[11] If artists increasingly have been drawn to the field of geography for its dialectical understanding of space and culture—that humans shape the Earth and are in turn shaped by it—artistic self-reflexivity and the more politicized forms of participatory practice offer creative methods that account for these dialectical processes.[12] Mobile technologies such as smartphones, tablet computers, and other location-aware devices enable artists to create media-rich tours that allow participants to access archival material in the field and overlay imagery on a live view of the site in ways that denaturalizes its physical appearance and makes explicit the forces that produced it. Elliot Anderson's "Silicon Monuments," for example, is an augmented reality app for the iPhone that allows users to explore twenty-nine sites in Silicon Valley heavily polluted by the computer industry, annotating their mundane present-day appearances with archival images, 3D animations, and interviews with workers and community members affected by the area's toxic legacy (figure 10). While new-media tours afford the most explicit layering of visual and textual material, even simple guided tours can bring together the representational, discursive, and material strategies required to unpack space and make landscape more legible.

SEEING TOURISM

A corollary effect of the critical tour's methodological self-reflexivity is that the audience is often reminded, in various ways, of their own act of touring. This stands in marked

10. Elliot Anderson, "Silicon Monuments: The Reflecting Pool Monument" (screenshot) 2012. Augmented reality app for the iPhone/iPad at the former IBM Administration Building. © Elliot Anderson, 2012.

contrast with conventional tourism's admonitions to blend in with the locals, have an insider experience, or, at the very least, be inconspicuous enough to avoid pickpockets. Artists' tours often exhibit strategies that disrupt this desire for disappearance, intentionally tinkering with the conventions of the tour in ways that allow the contrivance and authority of the form to be better grasped and redirected.

The Center for Land Use Interpretation (CLUI), which has been organizing bus tours of "unusual and exemplary" sites for more than fifteen years, is the best-known arts group using the tour form to bring audiences into direct encounters with landscape. CLUI tours are tightly programmed affairs up to two days long, with long drives and nearly nonstop commentary and explanatory media. Staff and visiting experts provide interpretation of sites ranging from gravel pits to bombing ranges. These events use wry humor to crack the conventions of tourism and narration to prompt an examination of how views of landscape are socially and institutionally conditioned.[13]

Other artists who offer live tours dispense with the CLUI's formality or undercut their own authority as guides in gestures that both expose their authorship and provoke responses from their spectators. Jordan Dalton, a young artist who organizes tours of toxic sites in upstate New York, sometimes brings maps and documents that he hasn't fully read or doesn't completely understand and asks the people on his tour to help decipher the jargon of the Environmental Protection Agency.[14] CLUI collaborator Steve

Rowell builds downtime and silent walking into his independently organized tours to provide opportunities for reflection.[15] These artists recognize and encourage their audiences to negotiate many complex readings in the context of a tour.

Finally, the politics and economics of tourism can be important subjects of the self-reflexive artist tour. These projects often adopt a more lighthearted, interventionist approach and make short-term, quick-read incursions into the landscape. For example, the Critical Art Ensemble, working with local collaborators, initiated "Halifax Begs Your Pardon," an annotation of the city's tourism infrastructure—kiosks, parks, monuments, and ferries—with alternative information and points of view. Emphasizing the tendency of cities economically dependent on tourism to promote a selective and relentlessly upbeat public image, the group prepared alternative informational brochures and installed public apologies—in the form of "sorry bricks," "sorry flags," and apologetic LED screens—at sites where local knowledge contradicts the city's sunny narrative.[16] Examples include both the lighthearted and the deadly serious, for instance regret for the phallic shape of downtown kiosks mixed with an acknowledgment of the present-day discharge of raw sewage into the harbor, or an apology for the city founders' policy of scalping the indigenous Mi'kmaq people in the eighteenth century.

SENSORY DENSITY

If seeing tourism is an important characteristic of critical tours, it nonetheless risks reproducing a central feature of touristic experience that has come under sharp criticism: the tourist gaze. As influentially theorized by John Urry, the tourist gaze collects visible signifiers of difference in the form of vistas and photographs that are conditioned by existing cultural tropes that flatten and stereotype the places visited and viewed. These tropes are often conditioned by advertising and imaginatively consumed by tourists before their actual encounter with a place. The tourist gaze then becomes a means to confirm "certain pre-established notions or signs derived from various discourses of tourism and travel."[17] Drawing on the Foucauldian link between vision and power in the Western tradition and mindful of photography's tendency to appropriate and claim its subject, Urry cautions that the tourist gaze risks producing a sense of mastery over a place without ever really "seeing" it.

Sensitive to this danger, artists employing the tour as a form often enlarge the gaze to consider how one's view has been framed. For example, "Siting Expositions," an audio tour of Vancouver's False Creek by Ryan Griffis, Lize Mogel, and Sarah Ross released by Griffis's Temporary Travel Office, opens with a track instructing the audience to view the city from a particular vantage point and to consider how their view is conditioned by conventions of mapping and pictorial representations of urban development (figure 11).[18] The tour immediately historicizes touristic spectatorship in the same way it historicizes the landscape, suggesting that they are ongoing, linked processes. Similarly, the L.A. Urban Rangers' downloadable "Field Guide to the American Road Trip" includes a cutout of a windshield to allow any view to be mediated by the automobilized gaze.[19]

11. Ryan Griffis, Lize Mogel, and Sarah Ross, "Siting Expositions" audio tour, 2010. Photo by Lize Mogel.

As valuable as self-reflexive spectatorship might be, it may not be enough to fundamentally change the distanced relationship established by the tourist gaze. For the ironically disposed, "seeing tourism" may paradoxically produce an even more distanced position than more earnest forms of sightseeing. Some scholars have argued that the problem is not with vision itself but with a particular model of sight that forgets that it is fundamentally an embodied, physical process intimately entangled with the other senses. Donna Haraway in particular recognized the "embodied nature of all vision" and sought to "reclaim the sensory system that has been used to signify a leap out of the marked body and into the conquering gaze from nowhere."[20] Writing about activist "toxic tours," Phaedra C. Pezzullo discusses how sight produces very unreliable information; what is most notable about a place is often unlikely to be visually apparent. Noting that "there are some experiences, some memories, some knowledges that are not limited to sight," Pezzullo goes on to describe, in visceral terms, feeling overpowered by such sensations as odor and scale on one toxic tour.[21] Far from disembodied eyeballs, tourists experience and process a range of sense impressions—sound, odor, temperature, touch—in the course of a visit, which all become elements in the composition of the experience.

The sense of hearing in particular has a strong association with tourism, with the narrated audio guide one of its most enduring forms. While most audio tours annotate

or explain a landscape first encountered visually, they often employ musical and field sounds as well as the grain of the human voice to convey affective information not reducible to sight alone. Composed audio elements layer unpredictably but often effectively with the sights, smells, and sounds of the location. When the artists Amy Balkin and Kim Stringfellow composed "Invisible 5," a tour of environmental justice sites along California's Interstate 5 corridor, they designed the tracks to be heard at particular moments in the landscape.[22] Although the decision to distribute accessibly by CD and mp3 meant that synchronization is loose (in comparison to the precision of a GPS-triggered tour), the visual landscape still corresponds surprisingly well with the soundtrack. Emily Eliza Scott, coeditor of this volume, recounts of her experience with "Invisible 5": "At one point, a track opened with unidentified clanking sounds. I looked out the car window to discover a small flock of bobbing oil derricks aside the freeway. . . . Later, while Teresa De Anda, a local resident, described the problem of pesticide drift in her community, a small plane buzzed low over the ground to spray crops."[23] The loose sync of real-time events in the landscape with the pre-produced material suggests the scope and scale of polluting infrastructures in the Valley. The appearance of the crop duster becomes no longer merely an isolated event but one instance in a set of repeated practices that make up industrial agriculture.

In addition to audio tour projects, some artists engage with the live, ambient soundscape to explore hidden characteristics and structural features of a landscape. Andrea Polli's guided soundwalks help audiences tune into the "acoustic ecology" of a place. Ranging from forty-five to sixty minutes, these experiences emphasize the transition from one kind of landscape to another—highway to parkland, for instance, or urban street to bank interior—that can generate *situated* discussions about the movement of people, goods, and waste in cities under late capitalism that otherwise might remain abstract or entirely theoretical.[24] Other senses similarly combat the urge to abstract or remain distant from the subject. Noting that tourism "becomes really problematic . . . when you just look—when you can see the pain but you don't have to get your hands dirty," the artist Lize Mogel has begun exploring scent as a means of more directly involving her audience.[25] In her current body of work, "Sludge Economy," which addresses New York's racially unjust sanitation geographies, Mogel plans to bring her audience to sites where the stench of the waste infrastructures will physically embed them in a system that most keep out of sight, nose, and mind.

OPEN NARRATIVES, ANCHORED SITES

Artists' embrace of the tour as a form developed simultaneously with a critical reassessment of site-specificity in twentieth-century art. Miwon Kwon, for instance, has influentially argued that the notion of site became "unhinged" from the physical attributes of a specific place "to a discursive vector—ungrounded, fluid, virtual."[26] While noting that this movement corrects a tendency to romanticize and monumentalize a site, Kwon strikes

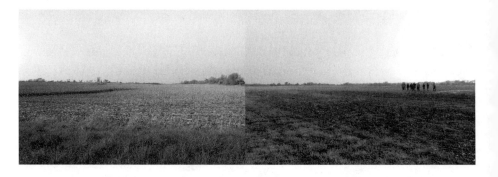

12. Rozalinda Borcilă, "Wanna Go Offshore?" tour, May 5, 2012. The tour included two sites in Crete, Illinois, separated by about one mile. On the left is a proposed future Foreign Trade Zone under sale contract with Centerpoint Properties; on the right a proposed immigrant detention center. Photos by Chelsea Goodwin Cossu and Stefano Cossu.

a note of caution regarding nomadic or fully discursive site-specific practice, questioning whether this deterritorialization merely recapitulates the logic of late capitalism. While she never mentions landscape-oriented artist tours in her 2002 book, Kwon ends with a metaphor that nonetheless evokes their potential to inhabit "a terrain between mobilization and specificity—to be *out* of place with punctuality and precision."[27]

Critical tours are explorations of the discursivity of site performed in situ. They are simultaneously "in the landscape" while exploring knowledge that may appear "out of place" in the sense of complicating and denaturalizing the site. Connections between concepts, images, histories, and places are produced through bodily movement; the insight metaphorically invoked as a "change in perspective" is, on the tour, both physical and perceptual. For the artist Ryan Griffis, the significance of this doubled spatial and narrative dimension cannot be overlooked: "Tours are a narrative form that is structured by a spatial experience. It's a way to have a narrative-based conversation, even if it is not conventional, that unfolds along with a movement through space, or some change in perspective based on a change in location."[28]

Artists' tours often draw attention to the *unfolding* of space while considering its discursive, dialectical composition. Rozalinda Borcilă's tour of Chicago's Foreign Trade Zones, for example, measured the physical distance between bureaucratically contiguous places, as a single FTZ can encompass sites separated by many miles, rendering them legally identical (figure 12). She invited immigrant organizers to help consider potential relationships between immigration detention facilities and Foreign Trade Zones as distinct border regimes that share infrastructural needs, rhetorical appeals, and administrative rationality. This conceptual montage, performed with bodily movement through space, allows the participant to experience what Miwon Kwon calls "the uneven condition of adjacencies and distances *between* one thing, one person, one place, one thought, one fragment *next* to another."[29]

Borcilă's emphasis on the passages between spaces and provocative proposal of connections among seemingly disparate phenomena is emblematic of critical tourism's refusal of tidy narrative closure. If conventional tourism tends to encapsulate places through closed narratives, the critical tour emphasizes the site, in all its messy specificity, in relation to much larger ecological, infrastructural, and political systems as well as other places, times, and forces. Even though we eventually still go home, "home" may not be what it once was. Many artists' tours include activities that explicitly implicate participants in the tour's subject. For example, one iteration of Lize Mogel's "Sludge Economy" involved a picnic atop a New York wastewater treatment plant that had been buried, landscaped, and turned into a public park. Mogel shared a map of the sewage system printed in icing on a sheet cake. Participants were asked to identify where their wastewater went and announce it to other "tourists" via nametags. Following Mogel's presentation, everyone happily dug into the cake. The gesture created a connection between invisible waste infrastructures and the homes and bodies of her audience that could resonate long after the day's events concluded.[30]

TOURISM AS COLLECTIVE TIME

If one criticism of tourism is that it is too brief and distracted to permit a meaningful experience, the tourist's experience may feel very different. Vacations are described as times to "slow down" and, like an old-fashioned clock, "unwind." Removed from our daily routines, our perception of time shifts and dilates. In the context of a hyper-accelerated, post-Fordist economy of just-in-time production and around-the-clock connectivity, taking the time to tour is both a luxury for the privileged and a measure of commitment. It represents a decision to be present in a particular place for a stretch of time. Tourism is often collective as well as time-based: For many people, the guided tour is a rare instance of thinking and perceiving in public with others. Even when the experience is private, as it often is when following an audio tour, there remains a cultural connection to others who have experienced this site before or will in the future. Some of the oft-derided rituals of mass tourism may more charitably be interpreted as way of sharing a culturally meaningful experience—one not less but rather more meaningful for the sake of repetition and mediation.

Along these lines, we can imagine how critical tourism might constitute and mobilize a public. Drawing on Henry Giroux's idea of "public time," Phaedra Pezzullo argues that toxic tours represent collective commitments to self-education, self-governance, and the passionate pursuit of social transformation. While many artists' tours do not aspire to the same concrete efficacy as those organized by environmental justice groups, they are dedicated to the embodied and social exploration of a world understood as ineluctably material, discursive, and political. Some demand a great deal of their participants in terms of time and the shaping of experience. Futurefarmers' "Free Soil Bus Tour," for instance, brought together twenty people for an overnight excursion inspired by the

histories and geographies of Silicon Valley's counterculture. Many "tourists" were also co-leaders who offered workshops on salt marsh ecology, demonstrated DIY technologies such as human waste composting and cooking with surplus engine heat, and led discussions. Overnight tours such as "Free Soil" and the longer CLUI excursions immerse participants in their worlds, crafting temporary micro-communities. Other tours explicitly ask participants to follow up on what they have experienced, extending the event into a longer duration and opening it to a larger public. Jordan Dalton has emphasized bringing other artists to contaminated sites with the explicit mission of creating a public, photographic record of sites for which most visual representations are maps, diagrams, and aerial imagery, rather than the view from the ground. A curated selection of these photographs will appear in a zine and website, along with maps and information about the sites' histories and the nature of the contamination.[31]

The collective witnessing and reporting of what was seen and perceived during a tour is central to Gregory Ulmer's definition of critical tourism. Noting that the English word "theorist" derives from the Greek *theoros*, whose original meaning meant one who toured the world and saw the sights, Ulmer and the collaborative Florida Research Ensemble propose the ancient Greek traveler Solon as the model of "an improved tourism" based on the notion of bearing witness. For Ulmer, this requires that the experience be collectivized through retelling and social transmission. Once shared and allowed to circulate in the public discourse, the observations, fragments of experience, and images gathered on tour contribute to a bottom-up *theoria*, a project of geographical and historical self-knowledge. Ulmer asks, rhetorically, "What might be the effect of this gaze, or of the circulation of this testimony preserved in home videos, snapshots, and anecdotes? A post-Columbian America cannot forget that adventurers are responsible for its existence, for better and for worse."[32] As tourists and tour guides who aspire to be critical, we should expect nothing less of ourselves.

NOTES

1. Lucy R. Lippard, *On the Beaten Track: Tourism, Art, and Place* (New York: The New Press, 1999), 4.

2. Los Angeles Urban Rangers, "L.A. River Ramble," August 3, 2011, http://laurbanrangers .org/site/downtownla. See documentation and media coverage at http://www.moca.org/party /rangers.

3. The "social turn" in contemporary art is currently a hotly debated topic, with much disagreement about basic terminology and the appropriate criteria for evaluation. The phrase "the social turn" is borrowed from Claire Bishop's highly critical essay "The Social Turn: Collaboration and Its Discontents." At the risk of opening a can of worms, I mention these debates to acknowledge that artists' tours are not a distinct genre but exist in the context of what in the United States is currently called "social practice"—a field of creative activity emphasizing direct experience and the negotiation of meaning with audiences. See also Tom Finkelpearl, ed., *What We Made: Conversations on Art and Social Cooperation* (Durham, North Carolina: Duke University Press, 2013); Claire Bishop, *Artificial Hells: Participatory Art and the Politics*

of Spectatorship (London: Verso, 2012); Grant H. Kester, *The One and the Many: Contemporary Collaborative Art in a Global Context* (Durham, North Carolina: Duke University Press, 2011); Blake Stimson and Gregory Sholette, eds., *Collectivism After Modernism: The Art of Social Imagination After 1945* (Minneapolis: University of Minnesota Press, 2007); Claire Bishop, "The Social Turn: Collaboration and Its Discontents," *Artforum* (February 2006): 178–83; and Grant H. Kester, *Conversation Pieces: Community and Communication in Modern Art* (Berkeley and Los Angeles: University of California Press, 2004).

4. Brian Holmes, "Extradisciplinary Investigations: Towards a New Critique of Institutions," *Transversal* no. 1 (2006), http://eipcp.net/transversal/0106/holmes/en.

5. Ibid.

6. Zygmunt Bauman, "From Pilgrim to Tourist," in *Questions of Cultural Identity,* eds. Stuart Hall and Paul du Gay (London: Sage Publications, 1996), 29–30.

7. Ibid., 30.

8. While rehearsing the decades-long debate on the politics of aesthetics is beyond the scope of this essay, readers may wish to consult Hal Foster, ed., *The Anti-Aesthetic: Essays on Postmodern Culture* (New York: New Press, 2002); Elaine Scarry, *On Beauty and Being Just* (Princeton, New Jersey: Princeton University Press, 2001); Jacques Rancière, *The Politics of Aesthetics: The Distribution of the Sensible,* trans. Gabriel Rockhill (New York: Continuum International Publishing Group, 2006); and a number of essays in a themed issue of *Art Journal* edited by James Meyer and Toni Ross, "Aesthetic/Anti-Aesthetic," *Art Journal* 63, no. 2 (July 1, 2004).

9. Rozalinda Borcilă, *Wanna Go Offshore?,* May 5, 2012.

10. Rozalinda Borcilă, interview by Sarah Kanouse, November 4, 2012.

11. I'm borrowing the now-familiar term from Henri Lefebvre, *The Production of Space* (Malden, Massachusetts: Wiley-Blackwell, 1991).

12. "Geography frees us from the textualist or representationalist approach towards cultural production and encourages us to think about materiality itself as an active historical agent." Trevor Paglen's talk at the Creative Time Summit, October 10, 2010, http://www.youtube.com/watch?v = XvkCIQ2ZEZk.

13. As if to emphasize self-reflexive viewing, CLUI's first book opens with a preamble featuring several full-bleed photographs of people looking at framed views and interpretive signage. Matthew Coolidge and Sarah Simons, eds., *Overlook: Exploring the Internal Fringes of America with the Center for Land Use Interpretation* (New York: Metropolis Books, 2006).

14. Jordan Dalton, interview by Sarah Kanouse, December 28, 2011.

15. Steve Rowell, interview by Sarah Kanouse, October 4, 2012.

16. Critical Art Ensemble, "Halifax Begs Your Pardon," 2002, http://critical-art.net/Original/halifax/Nova.swf.

17. John Urry, *The Tourist Gaze* (London: Sage, 2002), 13.

18. Ryan Griffis, Lize Mogel, and Sarah Ross, "Siting Expositions,"released in the collection *Stories in Reserve,* ed. Temporary Travel Office, 2010, http://temporarytraveloffice.net/stories/VancouverEvents.html. The author's own audio tour, *America Ponds,* was included in the same collection.

19. Los Angeles Urban Rangers, "Field Guide to the American Road Trip," 2006, http://laurbanrangers.org/site/tools/interstate-road-trip-specialist-field-kit.

20. Donna Haraway, "The Persistence of Vision," in *The Visual Culture Reader,* ed. Nicholas Mirzoeff (London: Routledge, 1998), 677.

21. Phaedra C. Pezzullo, *Toxic Tourism: Rhetorics of Pollution, Travel, and Environmental Justice* (Tuscaloosa, Alabama: University of Alabama Press, 2007), 29, 157.

22. Amy Balkin, Kim Stringfellow, and Tim Halbur, "Invisible-5" audio tour, 2006, http://www.invisible5.org/.

23. Emily Eliza Scott, "Field Effects: *Invisible-5's* Illumination of Peripheral Geographies," *Art Journal* 69, no. 4 (winter 2010): 39.

24. Andrea Polli, interview by Sarah Kanouse, October 2, 2012.

25. Lize Mogel, interview by Sarah Kanouse, December 28, 2011.

26. Miwon Kwon, *One Place After Another: Site-Specific Art and Locational Identity* (Cambridge, Massachusetts: MIT Press, 2002), 29–30.

27. Ibid., 166.

28. Ryan Griffis, interview by Sarah Kanouse, December 28, 2011.

29. Miwon Kwon, *One Place After Another,* 166.

30. Lize Mogel, interview. See also Lize Mogel, "This Picnic Stinks!" picnic and talk, 2010, http://whitney.org/Events/ThisPicnicStinks.

31. Jordan Dalton, interview.

32. Gregory L. Ulmer, "Metaphoric Rocks: A Psychogeography of Tourism and Monumentality (Hypermedia)," *Postmodern Culture* 4, no. 3 (1994), http://muse.jhu.edu.proxy.lib.uiowa.edu/journals/postmodern_culture/v004/4.3ulmer.html.

4

URSULA BIEMANN

Sahara Chronicle (2006–9)

While the Maghreb countries of Morocco, Algeria, Tunisia, and Libya have a long-standing history of migration to Europe, the sub-Saharan migration flow toward the north is a more recent phenomenon, coinciding with the consolidation of the European Union. Transit migration, departing from West Africa and using the Sahara desert as a giant transit space, is a large-scale collective experience that is best understood, perhaps, in its systemic dimension. Highly adjustable, these movements have generated prolific operational networks, systems of information, and social organization among fellow migrants and with local populations. Yet at the heart of the current geopolitics of human circulation lies an open struggle between the efforts to discipline unauthorized mobility and the desire for migratory self-determination.

Sahara Chronicle (2006–9) is a comprehensive video research undertaking that develops a notion of geography as both social practice and organizing system. The investigative project is a lively video-cartography of the clandestine trans-Saharan migration network operated through a complex of logistic nodes, border passages, and places of hiding, regrouping, hospitality, and detention. In a number of field trips to Morocco, Niger, Libya, Mauritania, and Senegal, I documented the vast migration system and its hot spots. I used the video camera as a cognitive tool to write counter-geographies—geographies that do not affirm and reinforce control regimes of borders and mobility, but on the contrary document the ways in which people subvert and transgress borders and obstacles that have been imposed on them. Hence, *Sahara Chronicle* takes a systemic approach to migration rather than one based on the migratory experience per se.

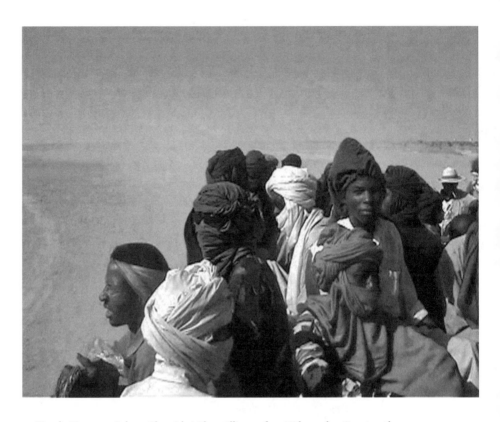

13. Ursula Biemann, *Sahara Chronicle* (video still), 2006–9. Video, color. Courtesy the artist.

Particular attention is given to Agadez, in the heart of Niger, capital of the Tuareg and an important traffic node for migration toward Libya and Algeria. The unresolved and forceful division of Tuareg territories, now redistributed among five nations, has turned Tuareg life into a transnational existence by definition. As nomadic tribes, they practice a very fluid kind of unbounded space that clashes with the laws of land ownership of national rulers. The Tuareg rebellion for independence in the 1990s was directly linked to the uranium mining that is taking place in their territory without benefiting them from the wealth generated. So they sought alternative economic opportunities and began to traffic in sub-Saharan migrants on their way north. The desert border is a vast terrain, and roving border patrols are few and far between. Deploying rebel tactics, they swarm out in jeeps at night and bypass the border checkpoints with their full charges of migrants before melting into the dark dunes.

With its loose interconnectedness and its widespread geography, *Sahara Chronicle* mirrors the migration network itself. The project consists of short video files that are exhibited simultaneously in space, some on monitors, others projected. It does not intend to construct a homogenous, overarching, contemporary narrative of a phenome-

non that has long roots in colonial Africa and is extremely diverse and fragile in its present social organization and human experience. No authorial voice, or any other narrative device, is used to tie the carefully chosen scenes together. The full structure of the migration network comes together solely in the mind of the exhibition visitor who mentally draws connecting lines between the traffic nodes at which migratory intensity is bundled. Implicating the minds of the viewers into the production of this virtual geography, as it were, is a way of using them as a psycho-social resource to complete and extend the work.

5

KIRSTEN SWENSON

on Francis Alÿs, *When Faith Moves Mountains* (2002)

The Mexico City–based Belgian artist Francis Alÿs organized *When Faith Moves Mountains* on the occasion of the third Bienal Iberoamericana in Lima, Peru, in 2002. He enlisted five hundred volunteers and equipped them with shovels. On a cloudless April day, the air thick with pollution from the Peruvian capital, the cohort formed a line at the base of a sand dune in the arid Ventanilla district to the north. The district is known for its shantytowns that are home to South American economic refugees and those who fled strongholds of the Maoist terrorist group Shining Path during Peru's recent civil war. Dust filled the air as the volunteers leaned into their shovels, committing themselves to the task of moving a mountain. And the mountain moved. Several inches, though no one could say for sure.

So the story goes. *When Faith Moves Mountains* was an absurd, grand gesture in the face of violent displacement and economic oppression. It attempted to remap a place of despair, changing the topography symbolically if not literally. Absent any verifiable transformation of the landscape, the significance of the historical event is its afterlife: the stories told within local communities and on the international art circuit about that April day when faith moved a mountain. This afterlife also takes the form of a three-channel video installation in the collection of the Guggenheim, a color photograph in the collection of the Museum of Modern Art, a fifteen-minute handheld video documentary freely available on Vimeo and YouTube, a two-hundred-page book with detailed photo documentation and written accounts, and more. Through this proliferation of media, a formerly invisible landscape has infiltrated all strata of representation, from elite cultural institutions to computer screens. Displacement and dispersal were the subject of the

14. Francis Alÿs, *When Faith Moves Mountains*, 2002. Documentation of an event created in collaboration with Cuauhtémoc Medina and Rafael Ortega, Lima, Peru. Courtesy David Zwirner, New York/London.

initial gesture, centered as it was on landless migrants at the economic margins. Displacement and dispersal are also its effect, as the location of the artwork dilates outward, dispersing among thousands of agents, storytellers who embroider meaning into a pointless act.

Alÿs learned the lessons of Land art well. Robert Smithson's monumental Earthwork *Spiral Jetty* (1970), sited on a remote periphery of the Great Salt Lake, became myth and lore through media representations, an eponymous film, and ultimately a complex of cultural production over the next decades (the much-discussed "Smithson effect"). The Earthwork's material formation was never quite the point. It was always already an image and a media phenomenon, embedded in Smithson's narratives intertwining natural history and science fiction. And if massive displacements of earth—Smithson's jetty, Michael Heizer's *Double Negative* (1967)—once seemed to defy the notion of art as commodity, by the 1990s Earthworks became fetishized all the same as sites of pilgrimage and objects of institutional stewardship.

When Faith Moves Mountains is "my attempt to deromanticize Land art," Alÿs has written. "Here, we have attempted to create a kind of Land art for the land-less."[1] *When Faith*

Moves Mountains redresses perceived failings of Land art: its remove from contemporary social and political concerns, its self-aggrandizing scale and temporality, its physical remoteness (art as "invitations for artistic safaris," as the artist Daniel Buren wrote in 1973).[2] Alÿs offers an antithetical Land art: shovels instead of bulldozers and dynamite, sand in place of rhyolite and basalt, an immediate political context rather than a dialectical relationship to the social.

The relationship of historical Land art, particularly the American triad of Smithson, Heizer, and Walter De Maria, to contemporary politics is a rich territory that Alÿs mines. Many caught their first glimpse of *Spiral Jetty* in color photographs on the walls of the Museum of Modern Art in the summer of 1970, part of the exhibition *Information*. As its curator, Kynaston McShine, wrote in his introduction to the show, "If you are living in the United States, you may fear that you will be shot at, either in the universities, in your bed, or more formally in Indochina. It may seem inappropriate, if not absurd, to get up in the morning, walk into a room, and apply dabs of paint from a little tube to a square of canvas."[3] From its inception, Land art was of the museum and the margins. It held the promise of a politics of the periphery, of wastelands as symbolic sites of opposition to centers of political and economic power. Though Alÿs imagined a Land art for the dispossessed, the narratives generated by *When Faith Moves Mountains* highlight similarly unresolved contradictions: the international Bienal in a war-torn and impoverished region, subaltern poverty and discarded spaces remediated by a European artist for representation in elite museums. The distance from Smithson is less than Alÿs thought.

NOTES

1. Francis Alÿs, "1000 Words: Francis Alÿs Talks About *When Faith Moves Mountains*," *Artforum* (summer 2002): 146.

2. Daniel Buren, "Critical Limits," in *Five Texts* (New York: John Weber Gallery, 1973).

3. Kynaston McShine, "Introduction to *Information*," in *Conceptual Art: A Critical Anthology*, eds. Alexander Alberro and Blake Stimson (Cambridge, Massachusetts: MIT Press, 1999), 212.

6

AMY BALKIN

A People's Archive of Sinking and Melting (2012–)

A People's Archive of Sinking and Melting is a collection of items contributed from places that may disappear owing to the combined physical, political, and economic impacts of climate change, including glacial melting, sea-level rise, coastal erosion, and desertification.[1] Through *common but differentiated* collections, contributed materials form an archive of the future anterior—what will have been.[2]

The materials in the archive mark the asymmetry of present or anticipated loss, standing in as proxies for the contributors' recognition of the geopolitical production (or spatial politics) of precarity and slow-onset dispossession. Together, the contributions form one material record among many, a collection of community-gathered evidence, a public record, and a midden.

The archive operates from the principle that any thing is equally valuable as a record of present or projected future disappearance of a place, as chosen by someone there. A contribution doesn't have to originate from that location—it can be anything that happens to be there, including detritus, flotsam, or jetsam.

As of January 2013, the archive contains contributions from Anvers Island (Antarctica), Greenland, Kivalina (Alaska), Nepal, New Orleans, New York City, Peru, Senegal, and Tuvalu. These include:

15. Amy Balkin et al., *A People's Archive of Sinking and Melting* (New Orleans Collection, 9.12/6002–21), 2012–. Items contributed by Pleasur'ne Thomas, Monique Dean, Tyjunaique McKenzie, Wynell Davis, LaShine Dickerson, Milissa Orzolek, Upper 9th Ward, New Orleans, Louisiana 29° 57' N, 090° 04' W R .U.B.A.R.B., May 19, 2012. Photo by Mary Lou Saxon, courtesy Amy Balkin.

MANGO PIT

Collected by Matt Swagler

Plage de Pointe des Almadies, Dakar, Sénégal

Lat: 14.74° N Long: -17.52° W

Location is: Sinking

2012

By July, mango harvesting season is wrapping up in Sénégal and the prices are rising. The city, situated on a massive peninsula, is surrounded by beaches and coasts that are home to many residents and support small-scale fishing, wildlife, and tourism. This beach, like most around Dakar, has very shallow stretches of sand and will surely be gone.

SELECTIONS FROM THE NEW ORLEANS COLLECTION

1. Empty Walls & Ceilings package
2. Plastic fork and knife

3. Blue string found in an abandoned lot

4. Plastic bag found at an abandoned church

5. Three shells. Often found in the soil in New Orleans

Contributor: R.U.B.A.R.B. (Wynell Davis, Monique Dean, LaShine Dickerson, Tyjunaique McKenzie, Milissa Orzolek, Pleasur'ne Thomas)

2239–2400 Piety Street, Upper 9th Ward, New Orleans, Louisiana, United States

Lat: 29° 59' N Long: 90° 15' W

Location is: Sinking

2012

Contributed artifacts were chosen to represent present-day life in the neighborhood. Location is sinking and would be underwater with a two-meter rise in sea level according to the Global Sea Level Rise Map on geology.com.

SNAP HOOK

Collected by Micaela Neus with Nandor Kovats

Palmer Station, Anvers Island, Antarctica

Lat: 64.7° S, Long: 64° W

Location is: Melting

2011

Found in the rocks around Palmer Station, possibly stolen by sheathbills for their nests in years past. I'm unclear about the exact use of this snap hook, which resembles hardware used on the inflatable boats (zodiacs) used by scientists and crew when collecting specimens from the islands surrounding Palmer Station.

With respect for all contributors and their imaginative efforts to look toward a troubled future with foresight, contributed items will be presented as *common but differentiated* collections. Based on the principle of fairness in the context of relative losses and damages associated with climate change impacts, political editing will determine where contributions from more industrialized, wealthier places versus those from poorer, more politically vulnerable ones will be situated for public presentation.

As an archive of the future anterior intended for the present, *A People's Archive of Sinking and Melting* is open for submissions. It also seeks sites for public presentation as well as a permanent home. Who should contribute to the archive, given the unequal distribution of impacts, varied timescales, and the personalized dangers of future and present climate and its politics? Anyone who lives in a disappearing place.

NOTES

1. The project website is *http://sinkingandmelting.tumblr.com/*.

2. United Nations Framework Convention on Climate Change Conference of the Parties; Decision 2/CP.19, Warsaw international mechanism for loss and damage associated with climate change impacts, http://unfccc.int/resource/docs/2013/cop19/eng/10a01.pdf. See also Kelly McManus, "The Principle of 'Common but Differentiated Responsibility,' and the UNFCCC," http://www.climaticoanalysis.org/wp-content/uploads/2009/12/kmcmanus_common-responsibilities.pdf.

7

RUTH ERICKSON

on The Otolith Group, *The Radiant* (2012)

The Radiant (2012) explores Japan's nuclear past, present, and future. It starts with the aftermath of March 11, 2012, when the Great Tōhoku Earthquake in northeast Japan triggered not only a tsunami that killed more than fifteen thousand people, but also a meltdown of the Fukushima Daiichi Nuclear Power Plant, which released radioactive particles into the air and water. Made by the London-based The Otolith Group and premiered at *Documenta 13*, the sixty-minute film pursues the artists' interest in temporality, visibility, and globalism while capturing the nature of radiation through the film's visual and material form.

Founded in 2002 by Anjalika Sagar and Kodwo Eshun, The Otolith Group has crafted a distinctive body of films that weave together archival and documentary footage with the highly abstract, the fictional, and the personal.[1] The group's approach to filmmaking—developing a set of ideas rather than following a conventional plot—continues the tradition of the "essay film." As Eshun has written, "We can think of the essay film as a space-time in which to realize the adventure of thinking."[2]

Early in *The Radiant*, the contemporary journalist May Shigenobu states, "The whole of Japan is becoming a guinea pig for the effects of nuclear radiation." This statement points to Japan's long history with nuclear "events" as well as the ongoing and untold future effects of this history. The Otolith Group explores relations between past and future through its use of archival footage. Clips of the U.S. military dropping atomic bombs on Hiroshima and Nagasaki in 1945 and the subsequent spread of lethal radiation into bodies and food supplies documents Japan's first nuclear catastrophe. Another

16. The Otolith Group, *The Radiant* (film still), 2012. Courtesy and © the artists.

segment of historical footage details the commission, construction, and activation of the Fukushima plant in 1971. These counterpoised historical documents—both feats of Western engineering—suggest how rapidly the trauma of a nuclear past is forgotten in the prospect of a nuclear future.

Issues of immateriality and invisibility emerge throughout the film. While thumbing through a stack of landscape photographs, the Japanese photographer Chihiro Minato discusses the Japanese word for "landscape," *fuukei*, which combines "air" or "wind" (*fuu*) with "scape" (*kei*). Interspersed with this scene is footage of a woman methodically taking apart a camera until she reaches its core lens. The segment creates a parallel between the landscape and the camera as bodies that register the immaterial and invisible (that is, air and light). Photography and landscape are thus metaphorically related to radiation, which is also absent to the eye and relies on surrogate bodies—the land, produce, animals, humans—to exhibit its damaging effects. By examining materials and tactics of detection, the film embodies radiation's capricious form and becomes itself a means of revelation.

Finally, the local, national, and global intertwine via uncontainable nuclear material. Within months of the meltdown, particles were detected as far away as Australia and California. The issue of culpability surfaces throughout the film, from a protest against the Japanese energy company TEPCO to the revelation of American investments in the Fukushima plant. One poignant segment juxtaposes footage of a Japanese man in a hazmat suit pointing directly at the camera with a clip from Vito Acconci's seminal video performance *Centers* (1971), which documents the artist pointing straight ahead at his own image on the monitor and, thus, also directly at the viewer. Both scenes evoke feedback circuits of the machine and the body intertwined in futile efforts to save one another. The pointing figures seem to implicate all of us—you and me, the Eastern and the Western—in our mounting and unsustainable demands for energy.

In documenting Japan's recent nuclear catastrophe, The Otolith Group composes a beautiful and harrowing essay film. The multifaceted work incarnates the ghostly qualities of nuclear radiation and radiates questions about our collective future.

NOTES

1. For further writing about films by The Otolith Group, see T. J. Demos, "The Right to Opacity: On The Otolith Group's *Nervus Rerum*," *October* 129 (summer 2009): 113–28, and T. J. Demos, "Moving Images of Globalization," *Grey Room* 37 (fall 2009): 6–29.

2. Kodwo Eshun, "The Art of the Essay Film," *DOT DOT DOT* 8 (October 2004): 53–59. Eshun cites Jean-Luc Godard, Chris Marker, and Harun Farocki, among others, as influences.

8

EDGAR ARCENEAUX AND JULIAN MYERS-SZUPINSKA

Mirror Travel in the Motor City (2005–)

Mirror Travel in the Motor City is the title of a long-term collaboration between the Los Angeles–based artist Edgar Arceneaux and the San Francisco–based art historian Julian Myers-Szupinska. The project—which borrows part of its title, as well as its historiographic method, from Robert Smithson's hallucinatory 1969 travelogue *Incidents of Mirror-Travel in the Yucatan*—is an art historical, theoretical, and artistic investigation into the repercussions in culture of the Detroit riots of 1967. These riots present a sort of Rashomon effect among those for whom they were transformative. For some they represent the definitive turning away, for Detroit and the nation, from a certain kind of life in the cities, and the curdling of a certain long-held hope among African Americans that modernity and industry might eventually bring prosperity and equal rights under the law. For others, the riots—the most extensive and destructive in American history up to that point—take a different cast, representing, alongside the 1965 Watts riots, the American "May '68." Indeed, some on the left still refer to 1967 as "The Great Uprising," and the French left of that moment took great inspiration from the urban struggles and political resistance of African Americans at the time.

This history of committed urban struggle in the United States is today half-forgotten, repressed, or demonized, not least among contemporary conservatives, for whom the 1960s remain an unforgettable wound. But, as the philosopher Slavoj Žižek often asserts, that which does not *exist*, that which is disavowed or repressed, will often *insist*, in phantasmatic form. And so Edgar and I have tracked down these phantasms in various artifacts of culture: in music, including Etta James, John Lee Hooker, Theo Parrish, Under-

17. Edgar Arceneaux, *American Natural History*, 2009. Acrylic and graphite on paper, 60 × 91 in. (153 × 228.5 cm). Courtesy Susanne Vielmetter Los Angeles Projects; photo by Lutz Bertram.

ground Resistance, and the mythologies of the electro group Drexciya; in art, in particular Michael Heizer's 1971 exhibition *Photographic and Actual Work* and the tumultuous installation of his Earthwork *Dragged Mass Displacement;* and in the ruins and monuments of existing Detroit, especially the unmarked site of the after-hours party where the 1967 riots began. Drawing connections that are both spatial and historical in nature, the project imagines its three key locations—the corner where the riots began, the lawn where Heizer's Earthwork was installed, and the fictions of the underground and submerged cultures put forward in Detroit techno music—as presenting a sort of allegory of a thwarted urban modernity.

Taking place in the public form of experimental lectures, artworks, exhibitions, and critical writing (most definitively in the 2011 publication *Hopelessness Freezes Time*), as well as the more or less private textures of research and cross-disciplinary dialogue, *Mirror Travel* aims to speak in a new language (that of artistic historiography) to the present of the city, and its persistent cycles of urban abandonment and renewal. By building connections among historical events, guerrilla monuments, Earthworks, iconoclasm, and "sonic fictions," it aims to create a counter-allegorical field from which new work might be realized—work that might unsettle the past that historicist allegory attempts to resolve.

LAND CLAIMS: SPACE AND SUBJECTIVITY

Occupying is not the same as demonstrating. Many protests of the past year—Tahrir Square, los indigenos, Occupy Wall Street, and others—made legible the fact that occupying makes novel territory, and thereby a bit of history, using what was previously considered merely ground. . . . In the sense in which I am using it, territory is a complex condition with embedded logics of power and of claim making, something that it takes work to create, and which cannot be reduced merely to the elementary facticity of ground or land.

SASKIA SASSEN (2012)[1]

· · ·

Expanding on the notion of space as a nexus of social, political, and economic relationships, the artists and writers presented here investigate landscape as an emblem of identity. Julia Bryan-Wilson highlights the work of Zoe Strauss and Hiroshi Sunairi, queer artists drawn to radioactive landscapes—the Nevada Test Site and the aftermath of the bombing of Hiroshima—noting that *"body* and *land* are complexly co-articulated, as both artists utilize bodies to register the invisible toxicity of the nuclear landscape and to make palpable the discursive dynamics of nuclear culture." Jeannine Tang takes on Andrea Geyer's layered discursive project *Spiral Lands,* an ongoing multimedia work that performs the complexity of representing landscapes of the American southwest, overlain with the histories of indigenous peoples and manifest destiny. Kelly C. Baum presents the intertwined histories of feminism and ecology since the 1970s through projects by Mierle Laderman Ukeles and Sigalit Landau, both of whom understand waste and processes of remediation ("the activity of cleaning, disposing, preserving, sanitizing, and restoring," Baum writes) as critical practices of contemporary life invested with gendered and cultural significance.

The individual artworks profiled in this section highlight diverse intersections of land and political identity. The fence demarcating the Mexican-American border, indigenous land rights, colonization and postcolonial reconstruction, and contested territories are urgent issues that heighten subjective and cultural dimensions of landscape—the investment of land with complex identity politics that play out through representational and aesthetic tactics alongside other forms of conflict.

NOTES

1. Saskia Sassen, "Imminent Domain: Saskia Sassen and Hans Haacke on the Spaces of Occupation," *Artforum* (January 2012): 85.

SOURCES FOR FURTHER READING

Anderson, Benedict. *Imagined Communities: Reflections on the Origin and Spread of Nationalism.* New York: Verso, 1983.

Apter, Emily. "The Aesthetics of Critical Habitats." *October* 99 (winter 2002): 21–44.

Baum, Kelly. "Nobody's Property." In *Nobody's Property: Art, Land, Space, 2000–2010,* 11–43. New Haven, Connecticut: Princeton University Art Museum, 2010.

Bright, Deborah. "Of Mother Nature and Marlboro Men." In *The Contest of Meaning: Critical Histories of Photography.* Edited by Richard Bolton, 125–44. Cambridge, Massachusetts: MIT Press, 1992.

Coles, Alex, ed. *Site-Specificity: The Ethnographic Turn. de-, dis-, ex-,* volume 4. London: Black Dog Publishing, 2000.

Dorrian, Mark, and Gillian Rose, eds. *Deterritorialisations: Revisioning Landscapes and Politics.* London and New York: Black Dog, 2003.

Enwezor, Okwui. *Intense Proximity: An Anthology of the Near and the Far.* Paris: Centre National des arts Plastiques Tour Atlantique, 2012.

Foster, Hal. "The Artist as Ethnographer." In *The Return of the Real: The Avant-Garde at the End of the Century,* 171–204. Cambridge, Massachusetts: MIT Press, 1996.

Franke, Anselm, and Eyal Weizman, eds. *Territories: Islands, Camps, and Other States of Utopia.* Berlin: KW Institute for Contemporary Art, 2003.

Haraway, Donna. "Situated Knowledges: The Science Question in Feminism and the Privilege of Partial Perspective." In *Simians, Cyborgs, and Women: The Reinvention of Nature,* 183–202. New York: Routledge, 1991.

Hinderliter, Beth et al., eds. *Communities of Sense: Rethinking Aesthetics and Politics.* Durham, North Carolina: Duke University Press, 2009.

Lippard, Lucy. *The Lure of the Local: Senses of Place in a Multicentered Society.* New York: The New Press, 1998.

Mbembe, Achille. *On the Postcolony.* Berkeley: University of California Press, 2001.

Mitchell, W. J. T. *Landscape and Power.* Chicago: University of Chicago Press, 1994.

9

JULIA BRYAN-WILSON

Aftermath: Two Queer Artists Respond to Nuclear Spaces

> *To some, sexuality may seem to be an unimportant topic, a frivolous
> diversion from the more critical problems of poverty, war, disease,
> racism, famine, or nuclear annihilation.*
>
> GAYLE RUBIN, *"THINKING SEX"* (1984)

Since the detonation of the bomb code-named Trinity in 1945 in New Mexico, artists have struggled with how to represent nuclear anxieties—not only the threat of death promised by a wartime catastrophe, but also the remnants of events such as bomb detonations in peacetime testing and radioactivity's distribution via leakage of waste materials. Radioactivity's devastation to the body and the environment is often resistant to direct depiction. How does one picture a seemingly invisible threat? This question has haunted artists who attempt to visualize the aftermath of nuclear radioactivity, a force of palpably destructive powers that doesn't always lend itself to representation.[1] Its effects often manifest only obliquely, or indirectly, perhaps decades later (or in subsequent generations) as delayed genetic damage or tumors. This extended, deferred temporality means that such a harm can be resistant to something like photography, which captures, almost by definition, only the moment of the here and now.[2]

A large archive of contemporary art and photography grapples with the problem of how to illustrate, in visual form, a looming threat so vast that during the Cold War it became an unimaginable horizon that structured all power relations.[3] The horror of the atomic bomb, as Hannah Arendt notes, was terrorizing precisely because of the uncontainable scope of its destruction, a scope that was almost "supernatural," with "eerily impressive symbolic power from the moment of its birth."[4] Artists have explored this "impressive symbolic power" for their own ends and purposes since 1945; more recently, some have examined the nuclear age with the distancing perspective of the remove of the intervening decades.

One well-known example is the work of the Japanese artist Takashi Murakami, in whose painting *Super Nova* (1999) mushrooms are transformed into a pop cartoon where thickets of eyes appear to grow, alarmingly, on every surface. Murakami uses imaginative excess to make evident the harm and danger of radioactivity, relying on almost campy exaggeration in order to heighten and augment nuclear perils both fantastic and factual. With its bright, animated colors, this might seem an unlikely comment on atomic damage, but Murakami has long used mutated mushrooms as a displaced metaphor for the atomic blast.[5] In his exhibition *Little Boy: The Arts of Japan's Exploding Subculture* at the Japan Society in New York in 2005, he made the claim that the persistent Japanese fascination with forms such as *anime* was a complex aftereffect of the political, social, economic, and psychological impact of the bombings of Hiroshima and Nagasaki.[6] Through *Little Boy*—named after the bomb the United States dropped on Hiroshima—he further proposes that one such aftereffect is a culture of widespread infantilization, emasculation, and stunted sexual development; he summons the widespread use of cartoon figures across Japan as proof of this ostensible national character.[7] His interest in this psychosexual response to atomic devastation, however, is focused entirely on compromised masculinity and exists wholly within a heteronormative frame.

Beyond Murakami, there are many other examples of artists since 1945 who have deployed a range of techniques to work through and comment on the connections between sexuality, radioactivity, and atomic aftermath, but this essay focuses on a small, and perhaps surprising, subset—self-identified queer artists—who are currently making work about what might be called, broadly, "nuclear culture."[8] My use of the word "queer" is intentionally capacious, referring not only to a sexual orientation, but also to a methodological orientation that deviates, that swerves, that turns normative realms of temporality and reproduction against themselves. I take Gayle Rubin's challenge in "Thinking Sex" to put sexuality *alongside* nuclear annihilation, to refuse to trivialize sex by dismissing it as "frivolous." (Rubin wrote this polemic in 1984, the same year that Walter Mondale, who ran on a platform that included a nuclear arms freeze, lost the U.S. presidential election to Cold War hawk Ronald Reagan by a landslide; that historical context, as well as the growing AIDS crisis, inflected her discussion of the urgency of rethinking sex.) Indeed, embodiment and corporeality are critically relevant to any analysis of nuclear culture and nuclear sites, given how deeply vulnerable to radioactivity human bodies are.

Exploring questions of atomic "aftermath" from a queer feminist perspective is also an attempt to counter Murakami's heterosexist and masculinist analysis. I focus on two younger queer contemporary artists, the Japan-born Hiroshi Sunairi and the U.S.-born Zoe Strauss, in order to conjecture about the relation between sexuality and nuclear landscapes—"landscapes" that are as much discursive sites as physical spaces. For Sunairi and Strauss, *body* and *land* are complexly co-articulated, as both artists utilize bodies to register the invisible toxicity of the nuclear landscape and to make palpable the discur-

sive dynamics of nuclear culture. In addition, this essay looks at these artists' ideations of futurity, taking up the apocalyptic strand of recent queer theory to ask what might be driving anxieties about imminence. What do we make of concerns about that which might soon occur, and what can these uncertainties tell us about how we imagine alternative futures?

. . .

In 2005, Hiroshi Sunairi began a participatory conceptual art piece entitled *Leur Existence—Tree Project*. For this work, Sunairi—who was born in 1972 in Hiroshima and moved to New York about a decade ago—began by collecting seeds from a select number of trees in Hiroshima, trees that had survived the August 6, 1945 atomic bombing by the United States.[9] These trees, known as *hibaku-jumoku* ("A-bombed trees" or "survivor trees"), including round leaf holly, persimmon, gingko, and jujube, are found throughout Hiroshima. About one hundred and fifty are known to still be alive from the time of the attack, and the city council takes care of them as part of its International Peace Promotion Department. After collecting the seeds, Sunairi distributed them to people throughout the world who were willing to tend the growing shoots. Working in concert with the city to secure his seeds, which were harvested from second- or third-generation *hibaku* trees, Sunairi has meticulously kept track of the participants in *Tree Project*; at the date of this writing, more than four hundred have participated, from twenty-three countries. He asks for regular updates about how the seedlings are doing and posts the information online. His website features grids of photos documenting people with plants in various states of growth, from tender, just-sprouted new stalks in terracotta pots to larger leafy trees already planted in the ground (figure 18).

On the surface of things, the project appears to be a straightforwardly optimistic one about perseverance, perhaps even veering toward the precious. As the artist writes, "Over sixty years ago, the city of Hiroshima was burnt to ashes by one nuclear bomb and people thought that nothing would grow for 75 years. However, sprouts sprung up from the remains of burnt trees and weeds came out of the ground. . . . This new life gave encouragement to the people who had lost hope."[10] But not all the seedling stories end with photos like the ones in this grid, with beaming green-thumbed couples proudly displaying their thriving new growth. Sunairi also chronicles plantings that did not take, seeds that went missing in the mail, forgotten waterings, and other failures. This is not a project of pure redemption, but one complicated by loss, always mindful of the inherent frailty of life and the inconsistency, sometimes irresponsibility, of human care.

Sunairi envisioned these plantings as a way to comment on the lasting transnational residues of wartime exchange, aware of the central role played by the atomic arms race in emergent formulations of globalization in the decades after the end of World War II. His transplanted seedlings mailed over vast distances—documentation of which is uploaded on the Internet for a much wider audience—echo the concurrent postwar development of international communications networks meant to facilitate exchanges

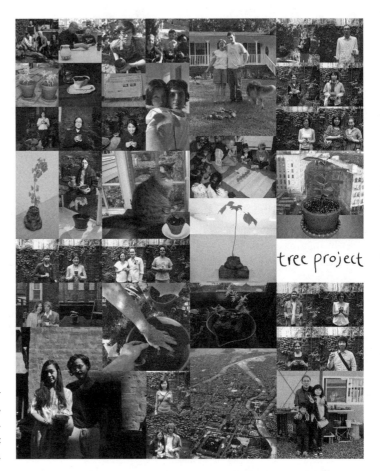

tree project

18. Hiroshi Sunairi (in collaboration with Tree Project Participants), Tree Project Poster, 2006–9. Collaged archival inkjet prints, 44 × 35 in. Courtesy the artist.

in moments of crisis. But Sunairi's project also became a meditation on the unknowability of genetic progression and questions of thwarted lineage. Since, as he has commented, he doesn't "specify the ending"—meaning that the owners might keep the seeds unplanted, as dormant life, or the plants might die. "There's no conclusion."[11] In other words, the project is also about the uncertain future, a future whose (literal) roots in the memory of catastrophe might, potentially, take hold in the present.

Sunairi has also made sculptural work related to this subject, including a piece entitled *A Night of Elephants,* which debuted at the Hiroshima City Museum of Contemporary Art in 2005 to commemorate the sixtieth anniversary of the atomic bombings of Japan (figure 19). For this installation, Sunairi made a metal frame of an elephant and stuffed it with pruned branches from *hibaku* trees (collaboratively gathered through the Hiroshima International Peace Promotion Department). Dramatically spotlit in a darkened gallery, the elephant is a contradictory figure: a biomorphic mass whose softly curved bulk is created out of stiff and bristly sticks. This piece is an attempt to grapple with the complex memory of the attack on Hiroshima, a memory that lingers

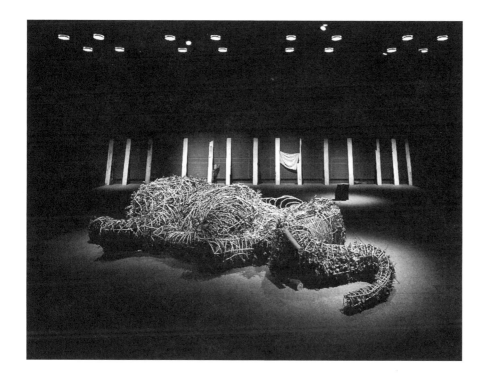

19. Hiroshi Sunairi, *A Night of Elephants*, 2005. Hibaku tree branches and leaves, metal, metal sheet, ceramic, and found objects, 36 × 144 × 144 in. Hiroshima City Museum of Contemporary Art.

but is also growing distant as its survivors age and pass away. "Hiroshima" has become a code word for geopolitical disaster, but the city officially tries to encourage other sorts of histories and narratives, unrelated to its atomic past, to promote itself as a tourist destination.

Because it is lying on the floor, it is unclear if Sunairi's elephant—an animal famous for mourning its dead that also, according to the saying, "never forgets"—has died, or is merely sleeping (elephants do occasionally lie down to sleep). The motif of the fallen elephant is mobilized not only to provide a container for cast-off, pruned branches (branches whose very existence registers that these *hibaku* trees are still growing, despite fears that they would be forever stunted), but also gives shape to a collective corporeal form that resonates with the multiple "bodies" of the trees. It makes a body out of landscape. Like trees, animals have limbs; like humans, seedlings are fragile and must be carefully tended. Sunairi's projects encourage such associative leaps, yet these bodies are not simplistically coded as "natural" but rather heavily mediated and charged by their relationship to past, present, and unknown futures.

. . .

Like Sunairi, the Philadelphia-based photographer Zoe Strauss was born in the early 1970s. Growing up in the shadow of Cold War fears, particularly as a young child in the 1980s during the Reagan presidency, she fixated on the American West as a mythic landscape where bombs are produced and assembled and nuclear power plants loom over the flat land: the Trinity site in New Mexico, the Hanford plutonium production nuclear weapons facility in Washington, the Nevada Test Site. From 2005 to 2009, she embarked on a series of trips to visit these places, photographing the land and former workers of some of the facilities. She also interviewed self-identified "downwinders"— residents of towns near nuclear test sites where from 1945 to 1968 aboveground tests were performed, with radioactive fallout raining down in surrounding areas.[12] Cancer rates in these places are far above average, but governmental compensation and admission of wrongdoing has been slow in coming.[13] Strauss uses her camera to try to provide an intimate counternarrative to these erasures. For instance, in one sequence of photographs, a woman in an American flag T-shirt holds up the results of a lab test showing no genetic mutation as a result of working at the Rocky Flats nuclear weapons facility near Denver, then lifts her shirt to show a reconstructed breast after a cancer-related mastectomy. Strauss contrasts the purportedly scientific evidence of the medical form with the incontrovertible display of illness upon her body. The artist—and the woman pictured—invite the viewer to linger on this evidence of medical intervention not with pity, but with empathy and anger.

In another of Strauss's photos from Rocky Flats, a former plant worker, Charlie Wolf, fingers a healed-over wound on his skull—the result of a surgery to remove a tumor in his brain (figure 20). Pressing her lens close to his head and shooting against a sky-blue background, Strauss makes his injured skin a surrogate landscape. A photo taken at the Trinity Site in New Mexico captures a somewhat nondescript plain of desert scrub, marked by an indentation—very like a scar—in the middle that could be a remnant of damage from test blasts decades ago (figure 21). Its ambiguity is telling; it is notable that the landscape does not "look radioactive"—as if there is such a thing without, say, a mushroom cloud blooming in the distance. One of the special problems faced by artists and activists interested in documenting lasting damage to the land caused by nuclear test bombs or by nuclear power accidents is that it can be challenging to depict the harm done to terrain that is both commercially and aesthetically devalued. This sort of topography has long been considered somewhat unproductive, lifeless, or useless, with disregard for its complex desert ecosystem and diverse animal life.

Strauss is particularly interested in the tourist circuit that has sprung up in the nuclear West. For instance, during the two days per year that it is open to the public, about two thousand visitors crowd the Trinity Site, where the first atomic bomb was exploded. In her pictures, Strauss turns her documentary gaze upon the act of photographing itself, for instance capturing children proudly displaying pieces of trinitite (glass made from sand fused by the scorching heat of the blast) to their mother, who bends at the waist to take a snapshot of their outstretched hands (figure 22). In another photo, a woman

20. Zoe Strauss, *Charlie Wolf (Rocky Flats, CO)*, 2009. Digital photograph. Courtesy the artist.

21. Zoe Strauss, *White Sands (Trinity Site, New Mexico)*, 2006. Digital photograph. Courtesy the artist.

22. Zoe Strauss, *Woman Taking Photo, Kids Holding Trinitite (Trinity Site, NM)*, 2006.
Digital photograph. Courtesy the artist.

smiles in front of the stone obelisk marking the site to pose for a camera that is outside the frame of Strauss's photo. In these images, Strauss asks questions about this perverse pilgrimage and the growing circuit of such grisly tourism (one that has recently included the still highly poisoned Chernobyl) as well as the conventionalized, so-called "nuclear family" that is often in evidence visiting these sites.

Strauss is also concerned with other kinds of family formations, ones that are distinctly queer. Both Sunairi and Strauss are queer artists working through questions of national memory and trauma. There are other queer artists for whom nuclear culture is at the center of their practice, including Lisi Raskin, whose work is based on research into Cold War culture and whose alter ego, the male scientist Dr. Wolfgang Hauptman, builds fallout shelters and conducts fictional experiments in missile silos. Another is the drag queen / performer Nuclia Waste, who has made work in dialogue with contaminated waste sites in Colorado.[14] The queer photographer Connie Samaras has trained her lens on militarized landscapes in the U.S. West and elsewhere. These do not just "happen" to be queer artists; they are also artists for whom queerness saturates, motors, and sustains their practice. Sunairi, in fact, first gained prominence as a performance artist in New York, making work that thematized sexual vulnerability, exposure, and exhibitionism. For instance, he invited the audience to document and join in his stripteases and performative S/M play in his 1999 pieces *Early Hiroshi* and *Tie Me Up*. In his

self-portraits, some of which he published in soft-core porn magazines as a critical comment on the Western fetishization of Asian bodies, he has presented himself as an idealized, nude, receptive boy. He has also made a collage of such images in the rough outline of an American map.

Queer sexuality has been at the center of both Strauss's and Sunairi's work since they entered public visibility. Both have also been recognized as moving away from concerns with rigid notions of identity-based "gay" art toward a more open-ended queer aesthetic. In 2003, Sunairi was named, along with others such as Assume Vivid Astro Focus, as at the forefront of a new cadre of young queer artists by the art critic Holland Cotter, who commented, "It seems clear that some new, multifarious version of 'gay art' is in formation, just in time for this post-criminal, premarital, passively resistant gay moment."[15] Sunairi was being hailed as a different sort of gay artist just before he turned his attention away from explicit examinations of sexuality toward questions of global Japanese representation as well as a different sort of audience-viewer exchange.

For Strauss, whose photographs of drag queens and pride parades have been featured in exhibitions at the Philadelphia Museum of Art, among other places, queerness is likewise a persistent subject as well as a kind of method of making, as she forges relationships with those she photographs. She is deeply concerned with questions of consent. Regardless of who or what her lens is trained upon, her camera is situated with an intimacy and at times a disarming candor and urgency, as well as an openness to her subjects that bespeaks a great porousness that could be called queer.[16] In the tenderness of the eyes behind a masked face in one photo, for instance, gender loses its substance and becomes somewhat unfixed. The bodies she documents are often marginal, whether for reasons of race, class, sexuality, or physical ability, and her gaze is remarkably compassionate, as is evident in her work with the downwinders.

Strauss's queer way of looking also inflects her images of radioactive landscapes. In an image taken in 2006, two women, tourists who have traveled to see the Trinity Site, form a somewhat ambiguous coupling (figure 23). Their physical proximity indicates their closeness, but do their matching physiognomies suggest sisters, friends, or a same-sex couple who have grown to resemble each other? They might prompt a vaguely butch/femme dynamic, as one has slightly longer hair and a more feminine shirt, but such a reading hovers just at the level of suggestion. Their hands are behind their backs, perhaps because they are hiding something—possibly pieces of trinitite, the possession of which is illegal—raising issues of the clandestine, concealment, and disclosure that resonate with the historically outlaw nature of queerness. Placed within a series that includes photographs of barbed-wire fences with "KEEP OUT" signs, Strauss's cluster of images suggests a narrative that links queer sexuality and the nuclear precisely around their shared coordinates regarding prohibition, secrecy, and codes both readable and explicit. Queer bodies are often subject to scrutiny, disciplining, and harsh criminalization, but queer desire has also found inventive, if oblique, ways to make itself known. Strauss's images,

23. Zoe Strauss, *White Sands (Trinity Site, New Mexico)*, 2006. Digital photograph. Courtesy the artist.

with their own sets of codes and secrets that implicate (and maybe even desire) bodies, further imply that nuclear landscapes might also be seen as critically queer.

·　　·　　·

Within U.S. culture, queerness has long been figured as a kind of toxic relation—one that might, like radioactivity, be sinister, contaminating, corrupting, and undetectable. There is a sort of "gossamer-y connection between queer identity, repressive homophobic McCarthyism, Cold War hysteria, and blacklisting," as Strauss has put it.[17] Perhaps the specific 1950s fear of homosexuality, for instance sex-crime panics and the hysteria around the "Lavender Scare," has had its own temporal delay (much like radiation) that is now being picked up and utilized by queer artists.[18] These painful pasts are thus being used to different effects in the present.

There has been, historically, a strong desire to ferret out perceived poisonous elements and threats to national security (both internal and external), and this includes those with non-normative sexualities. This fear, already very much alive in the McCarthy era, reached a different fever pitch during the early days of the HIV/AIDS crisis in the mid-to-late 1980s, when Senator Jesse Helms called for all gay men to be quarantined, and the conservative columnist William F. Buckley wrote in the *New York Times* that "everyone detected with AIDS should be tattooed in the upper forearm, to protect com-

mon needle users, and on the buttocks, to prevent the victimization of other homosexuals."[19] This demand for ocular evidence, for the status of infection or contagion to make itself visible on the body even if the body appeared "normal" or "healthy," is one that has threatened to delimit and control queer bodies in recent decades. And the quest to mark radioactivity is no less obsessed with detectability, as it seems imperative to warn not only those in the present about its dangers but to flag it as dangerous well into the future.[20] (Interestingly, in the popular imagination, radioactivity is often caricatured as luridly, aberrantly colored and thus extra-noticeable—for instance bright neon green, as in the comically misplaced rod from the Springfield nuclear power plant where Homer Simpson works. This palpably evidences the longing for radioactivity to be that perceptible. Despite the drive to render it visible, much of the detection of radioactivity is in fact done with sound, as in the clicking of the Geiger counter.)

In fact, one might conjecture that these two cultural rifts or threats—nuclear radioactivity and queerness—have strange points of convergence. At the very least, nuclear war has been heavily sexualized. As the queer theorist Peter Coviello has written, "It might be said that sexualization of nuclear warfare was evident from the moment of its conceptual inception, and took a form as blaringly unsubtle as simple naming, for instance the paternalistically named bomb Little Boy."[21] What is more, during the civil defense campaigns that reached their peak during the 1950s, the U.S. government encouraged the building of bomb shelters in backyards that would cocoon the normative family so that it might survive a Soviet attack that would wipe out towns as well as spew radioactivity far and wide to linger in the atmosphere for an unknown amount of time. One of the hallmarks of such radioactive contamination is its ability to cause birth defects in children and to render both men and women sterile; in other words, it figures in the public imagination as fundamentally eroding the capacity for childbearing, a block to (straight) reproductivity.

Queerness, of course, is also assumed to threaten reproductive futurity. It destabilizes the sanctity of the normative "nuclear family" precisely because of its ostensibly nongenerative sexuality. This is part of Lee Edelman's argument in his 2004 book *No Future: Queer Theory and the Death Drive*, in which he calls for a radical embrace of the negative potential of queerness to *not* figure a future.[22] He writes, "Rather than rejecting, with liberal discourse, this ascription of negativity to the queer, we might, as I argue, do better to consider accepting and even embracing it."[23] He goes on, polemically: "The future is mere repetition and just as lethal as the past. . . . What is queerest about us, queerest within us, and queerest despite us is this willingness to insist intransitively—to insist that the future stop here."[24]

Arguably, then, both queerness and the nuclear have the potential to foreclose our notions of the future, or, at the very least, provide a different model for thinking about temporality. This temporality also has spatial dimensions, as nuclear landscapes oscillate between prehistoric deserts and futuristically despoiled wastelands—hopelessly "unproductive" and unfertile. With this in mind, consider again the sprouts pushing up against

the soil in Sunairi's *Tree Project*. The act of giving away seeds and that of gathering branches for his *A Night of Elephants* speak to endurance in the face of a legacy of radioactivity that is still a persistent presence in his hometown.

But I would argue that Sunairi's works are also queer projects, as he stages an encounter with the trauma of Hiroshima but does not recapitulate the fear of a nuclear—or queer—apocalyptic endpoint. Taking the branches of many trees and merging them into one figure is a reversal of the normal arboreal scheme of replication. Instead, with his seedlings in pots and reclining elephant, Sunairi's works insist not upon disfiguration or obliteration, but on resiliency in the face of damage—of surprising elasticity, continuation, and regeneration. To sprout from a seed is also a queer way of reproducing, in the sense of plants auto-reproducing. It may seem quite a gap between his early soft-core porn pieces and the *Tree Project,* yet the connections between audience participation, the fragility of bodies (whether human, animal, or vegetable), and risk tie these early works into his later Hiroshima pieces. Likewise, Strauss's photographs urge us to think about survival in new ways, as in a photograph with a vibrant, almost surreal signpost at the side of an empty road reminding drivers to "STAY ALIVE."

· · ·

Stay alive. Given the alignment of queerness with AIDS since the mid-1980s in the United States, queer sexuality has been seen as its own kind of endpoint, not unlike nuclear catastrophe, a globally destructive force that forecloses or thwarts a sense of the future. The apocalyptic fears of imminent catastrophe—and also mordant thrills—that attend to both the nuclear age and the age of AIDS have perhaps dimmed with the end of the Cold War and the advent of life-extending antiretroviral drug cocktails, yet both the possibility of rogue nuclear missiles and the ongoing AIDS pandemic mean that both continue to signify as major termini in the public imaginary. The paired registers of threat (nuclear war and AIDS) have arguably waned since their high frenzy of the 1980s, although they persist, along with a more recent awareness of the potential catastrophe of climate change.

If we understand queerness as a way to mediate among and between bodies in non-normative ways, then radioactivity itself—its emission of ionizing particles, for instance, that then destabilize adjacent particles, is arguably queer. Radioactive decay occurs when (in a fitting twist on this queered nuclear family) the "parent radionuclide" breaks down, and sends out a rogue, single "daughter nuclide" that threatens to break up intact units. (It is critical that radioactivity not become overloaded with simply negative associations of harm; remember that there are radioactive treatments that, as much as they threaten, can also help cure.)

What is more, radioactivity does not honor conventional bodily integrity, but rather passes through us and within us. I have developed these ideas in close dialogue with Mel Y. Chen, who in the book *Animacies* theorizes how toxicity travels in queer routes through and among bodies.[25] Chen posits that the openness of bodies (via breath, via skin, and

so on) makes them permeable in unconventional ways; that is, we have polymorphous routes of absorbing matter *into* ourselves as well as expelling matter *out,* in a larger circuit of shared atmospheres and desires. There is also some relation between queer vulnerability and that of radioactive porosity. Indeed, when it comes to radioactive material, whose harm persists for many years on a scale of geologic rather than human time, those queer routes have temporal implications. As Shiloh Krupar notes about radioactive waste, it "continually crosses the boundaries of bodies, spilling into the cellular matter of humans and nonhumans, creeping into the future."[26]

The sexualization, or even queerness, of the nuclear and of the radioactive can be understood, then, in multiple ways—from the U.S. government's promiscuous disregard of fallout clouds, to porous national and bodily borders, to the forced heteronormativity of civil defense duck-and-cover propaganda. In the 1980s, the muscular saturation of nuclear weaponry, the potent power of it and the sheer ubiquity of phallic missile siloes ready to be deployed, was also figured as threateningly queer. Take, for instance, a passage from the book *Einstein's Monsters* by the British author Martin Amis, written in 1987: "The nuclear arsenal is not nowhere, it is everywhere. Every minute, in thousands of locations, in the oceans, in the heavens, there are reports, readings, dispatches, exercises, posturings, provocations. . . . The man with the cocked gun in his mouth may boast that he never thinks about the cocked gun. But he tastes it, all the time."[27] As Peter Coviello has brilliantly put it:

> One need not be a Freud or Lacan to unpack the sexual dynamics of this lurid and arresting figure. The effect Amis strives for here is clearly one of fascinated revulsion, and it is a revulsion at an intimate and sexualized abasement before power, at forced incorporation, at violating penetration. In a smoother if less vivid version, Amis might have written, power in the nuclear age is horrifying and unlivable because it makes me—or wants to make me—thoroughly, irredeemably queer.[28]

But what if we understood Amis's homophobic fears as one of the *strengths* of thinking through the nuclear queerly? If we take the nuclear and the queer as twinned in some ineffable manner, then perhaps we can reinvent a temporality, that is to say, a futurity, that is not reliant on paranoid fantasies of survival at all costs.

As William Haver argues in his 1996 book *The Body of This Death,* an engagement with AIDS as well as with the legacy of Hiroshima and Nagasaki, "demands an openness to the radical insecurity of a futurity for which we must refuse to be prepared, an openness to a revolution that would be at once political, economic, social, cultural, and intellectual."[29] I am not interested in recapitulating the cliché that such disasters are "unrepresentable," as young artists have been grappling with how to represent them for some decades now. Nor is it responsible to assert that HIV/AIDS and nuclear catastrophe are parallel, apocalyptic "endings." Instead, let's honor those attempts to imaginatively retell our histories in ways that also point toward a different kind of present.

24. Zoe Strauss, *Your Future Starts Here (Painted Over) (Las Vegas, NV)*, 2005. Digital photograph. Courtesy the artist.

In conclusion, it might be impossible to make the radioactive threat fully perceptible, as it often does not cause immediate ill effects to human, soil, and plant life, but rather produces lingering long-term genetic damage that is not always easy to picture. But that impossibility opens up other conceptual avenues, and contemporary artists such as Sunairi and Strauss seek to figure and represent our collective radioactive pasts within the current moment, as well as to project those legacies into a fraught and insecure future. They queerly engage nuclear culture (not just the bombings of World War II, but also current nuclear power) to interrogate visibility, turning especially to bodies as a way to give form to these inchoate subjects.

How can we image (and also imagine) troubled, but also potentially hopeful, futures? Sunairi and Strauss bear witness to moments of survival, to lasting grief and living through it, to more responsible and thoughtful stewardship of our scarred Earth. They make art about nuclear anxieties within a queer rubric that embraces uncertainties, failures, and weaknesses. To end with one last image: a photograph by Strauss that captures a sign that reads "Your Future Starts Here" against a cloudy sky shot with a few patches of blue (figure 24). At an angle in the bottom-right corner of the frame, next to a streetlight, the sign is almost completely decontextualized. Strauss's defamiliarizing perspective places us under the sign, looking up at it with no sense of what it is advertising or announcing, other than, perhaps, the clouds that are either gathering strength or dispersing. Here the future is a ghostly trace—dimmed, perhaps, or in disrepair, but still legible.

NOTES

I first wrote this paper as a talk for a panel called "Queer Bodies / Toxic Bodies," part of Crossroads 2010, the Association for Cultural Studies conference in Hong Kong. I thank Mel Y. Chen for co-organizing this session with me, and for our ongoing, exhilarating dialogues and mutual support. Much gratitude goes to Emily Eliza Scott and Kirsten Swenson for inviting me to publish this somewhat eccentric take on landscape in their volume.

Epigraph: Gayle S. Rubin, "Thinking Sex: Notes for a Radical Theory of the Politics of Sexuality," in *Pleasure and Danger: Exploring Female Sexuality,* ed. Carole Vance (Boston: Routledge & Kegan Paul), 267.

1. The literature on artistic and photographic responses to the atomic age is vast. See Kyo Maclear, *Beclouded Visions: Hiroshima-Nagasaki and the Art of Witness* (Albany, New York: SUNY Press, 1999). For a more diffuse U.S. perspective, see *Vital Forms: American Art and Design in the Atomic Age, 1940–1960,* eds. Brooke Karmin Rapaport, Kevin Stayton, et al. (New York: Brooklyn Museum of Art, 2001).

2. See *Camera Atomica: Photographing the Nuclear World,* ed. John O'Brian (London: Black Dog, 2015).

3. Akira Mizuna Lippit theorizes the problematic of atomic visibility vis-à-vis the idea of "shadow optics" and what he calls "a-vision" in *Atomic Light (Shadow Optics)* (Minneapolis: University of Minnesota Press, 2005).

4. Hannah Arendt, *The Promise of Politics,* ed. Jerome Kohn (New York: Schocken Books, 2005), 158.

5. There are many technical distinctions between atomic and thermonuclear (or hydrogen) bombs, but for the purposes of this essay, the terms will be used as adjectives and somewhat interchangeably.

6. Takashi Murakami, ed., *Little Boy: The Art of Japan's Exploding Subculture* (New Haven, Connecticut: Yale University Press, 2005).

7. Ibid. See also Takashi Murakami, "Impotence Culture—Anime," in *My Reality: Contemporary Art and the Culture of Japanese Animation,* ed. Jeff Fleming, trans. Ryusuke Hikawa (De Moines, Iowa, and New York: De Moines Art Center and Independent Curators International, 2001), 58–66.

8. Michael Leja has helpfully theorized connections between art, masculinity, and Cold War culture in his *Reframing Abstract Expressionism: Subjectivity and Painting in the 1940s* (New Haven, Connecticut: Yale University Press, 1997). For one sharp analysis of photography of nuclear power plants that places gender at the center, see Deborah Bright, "Of Mother Nature and Marlboro Men: An Inquiry Into the Cultural Meanings of Landscape Photography," in *The Contest of Meaning: Alternative Histories of Photography,* ed. Richard Bolton (Cambridge, Massachusetts: MIT Press, 1987), 125–43.

9. Sunairi first became interested in these seeds through the tree doctor Riki Horiguchi; for more on this project, see treeproject.blogspot.com. He exhibited this work in 2009 and 2012 at the New York Horticultural Society.

10. Sunairi, http://www.nyu-apastudies.org/MakingMemorySacred/?p = 109.

11. "Artists in Conversation: Hiroshi Sunairi and Yuken Terayu" lecture at New York University, March 27, 2008.

12. Here Strauss follows in the footsteps of important precedents such as the photojournalist Carole Gallagher, who produced a groundbreaking examination of downwinders in her *America Ground Zero: The Secret Nuclear War* (Cambridge, Massachusetts: MIT Press, 1993). Strauss, however, identifies as an artist rather than a journalist, and often takes more liberties with jarring, antirealist cropping and framing than does Gallagher.

13. See, for instance, Dennis Carroll, "Six Decades After Trinity Site Blast, Area Residents Living with Fallout with No Help from Government," *Sana Fe New Mexican*, April 17, 2011.

14. For more on how a nuclear imagination has impacted the work of Raskin, see Julia Bryan-Wilson, "The Nuclear Naive: An Interview with Lisi Raskin," *Lisi Raskin: Mobile Observation* (Annandale-on-Hudson, New York: Bard Center for Curatorial Studies, 2010), 9–17. For more on Nuclia Waste, see Shiloh Krupar, "Transnatural Ethics: Revisiting the Nuclear Cleanup of Rocky Flats, Colorado, Through the Queer Ecology of Nuclia Waste," *Cultural Geographies* 19, no. 3 (May 2012): 303–27.

15. Holland Cotter, "Art in Review: Paul. D.," *New York Times*, July 18, 2003.

16. For more on queer photography, see Deborah Bright, *The Passionate Camera: Photography and Bodies of Desire* (London and New York: Routledge, 1998).

17. Strauss, correspondence with the author, June 2, 2010.

18. For more on 1950s fears, see David K. Johnson, *The Lavender Scare: The Cold War Persecution of Gays and Lesbians in the Federal Government* (Chicago: University of Chicago Press, 2004).

19. William F. Buckley Jr., "Crucial Steps in Combating the AIDS Epidemic: Identify All the Carriers," *New York Times*, March 18, 1986.

20. For more on attempts by the U.S. government to mark radioactive waste dumps for the next 10,000 years, see Julia Bryan-Wilson, "Building a Marker of Nuclear Warning," in *Monuments and Memory, Made and Unmade*, eds. Robert Nelson and Margaret Olin (Chicago: University of Chicago Press, 2003), 183–204.

21. Peter Coviello, "Apocalypse from Now On," in *Queer Frontiers: Millennial Geographies, Genders, and Generations,* eds. Joseph A. Boone, Debra Silverman, Cindy Sarver, and Karin Quimby (Madison, Wisconsin: University of Wisconsin Press, 2000), 43.

22. Lee Edelman, *No Future: Queer Theory and the Death Drive* (Durham, North Carolina: Duke University Press, 2004).

23. Ibid., 4.

24. Ibid., 31.

25. Mel Y. Chen, *Animacies: Biopolitics, Racial Mattering, and Queer Affect* (Durham, North Carolina: Duke University Press, 2012).

26. Shiloh Krupar, "Transnatural Ethics," 319.

27. Martin Amis, *Einstein's Monsters* (New York: Vintage Books, 1987), 7.

28. Peter Coviello, "Apocalypse from Now On," 48.

29. William Haver, *The Body of This Death: Historicity and Sociality in the Time of AIDS* (Palo Alto, California: Stanford University Press, 1996).

10

JEANNINE TANG

Look Again: Subjectivity, Sovereignty, and Andrea Geyer's *Spiral Lands*

Welcome to Turtle Island.
Stand here at the edge.
Almost all thinking attributes to the land the virtues of We the People. But the properties of these
thoughts, like the properties of this gaze and these photographs, are not the properties of this land.
Look again. An underestimated potential lies in this vagueness. An uncertainty of image.[1]

We begin with an invitation to contemplate our perception of Turtle Island, the territories named by Native American tribes prior to their colonization as North America. By locating the spectator at the edge of Native American lands, and at the edge of the United States' declaration of political sovereignty "We the people of the United States,"[2] Andrea Geyer situates our viewing experience upon a precipice. *Spiral Lands* (2007–) is a photo-conceptual installation and performative project of three parts, or "chapters," in Geyer's examination of Native American land rights and identity formations within indigenous territories in the United States' Southwest. Each chapter pivots on a mode of address and its claims to authority—the question of photography, the scholarly researcher and the artist—to consider the desires and relations that contour how we perceive and lay claim to land.

Chapter 1 takes up the address of photography and the photographer through paired panels of photographs and texts (figures 25 and 26). Landscape photographs of a single site are clustered in nineteen sets of two or three images depicting grasslands and human-made markers upon the lands of the American Southwest. These lands are home to the Navajo and Hopi Nations and include, for example, a mountain near Mancos Canyon in

25. Andrea Geyer, *Spiral Lands / Chapter 1* (detail), 2007. Installation of fiber-based photographs and text; brochure with footnotes. Seventeen parts, 70 × 175 cm; two parts, 70 × 230 cm.

26. Andrea Geyer, *Spiral Lands / Chapter 1* (installation view, Documenta 12, Kassel), 2007. Installation of fiber-based photographs and text; brochure with footnotes. Seventeen parts, 70 × 175 cm; two parts, 70 × 230 cm.

southwestern Colorado, an aspen forest in the Jemez Mountains in New Mexico, and rock formations at the Rock with Wings in the Navajo Nation at San Juan County, northwestern New Mexico.[3] To the informed, Geyer's photographs are legible as key sites of Native American culture and political history; to those less informed, they appear as generic, picturesque images of the American landscape.[4]

The presentation of the photographic diptychs and triptychs emulates a spectator's double-take by picturing identical sites with variations in technique and perspective. Some photographs are nearly indistinguishable, their differences (shifting cloud formations, a fallen tree, a horse now absent) discernible only upon close scrutiny. Others picture differences dramatically, employing dissimilar crops, angles, zooms, and depths of field. In addition to dispelling the illusionism of the single photograph by way of comparison, these images cite earlier stereoscopic techniques by which photographic illusionism was produced.[5] This relay of difference and repetition refutes modern documentary realism (in which photographs stand as a decisive moment, trace, or index of reality) to instead emphasize a photographer's editorial viewpoint.[6] This position is nonetheless sensually apprehended, as Geyer's photography quotes the format of twentieth-century landscape photography (by figures such as Laura Gilpin and Timothy H. O'Sullivan) and its manifestation as an analog medium.[7] Shot with a medium-format camera, Geyer's photographs are printed on fiber-based paper in a selenium tone, emphasizing their density and texture, calling to mind nostalgic images of the deserted Southwest.

Scholars have criticized such popular depictions of indigenous lands, arguing that Anglo-European photographers depicted the Southwest in ways that invoked the sublime and the picturesque, thereby primitivizing or erasing indigenous people. This photographic lexicon was complicit in romanticizing the extinction of the indigenous, and justifying hostile appropriation of their lands and territories by depicting indigenous subjects as a purportedly "vanishing race."[8] Geyer's quotation of such photography expropriates its formal characteristics to contextualize their broader cultural systems and historical complicity with colonization. In the panels of *Spiral Lands,* installed at eye level running horizontally across gallery walls, the photographs are interdependent with texts, the latter printed in serif type, evoking the aesthetic of scholarly work and modernist museum display. Two photographs of a bare, apparently uninhabited plain are juxtaposed with a text that quotes, among other sources, James C. Faris's critique of modernist nineteenth-century social, scientific, and aesthetic endeavors and their visual dimensions; William Henry Jackson's 1894 introduction to "Wonder Place,"' glorifying the Natives' extermination; and texts elaborating the financing of Edward S. Curtis's famous photographic record of the "fast vanishing race" by business magnate J. P. Morgan, whose business investments contributed to indigenous dispossession while funding the visual "study" of their disappearing cultures.[9]

Chapter 1 not only registers the industrial investments that produced photographic justifications for colonizing indigenous peoples (and which profited from evidence of their disappearance), but also tracks the persistence of such rhetoric into the present

through narrating the photographs' afterlives. The photo-text panels of *Spiral Lands* are installed with brochures available to viewers on site. These brochures consist of footnotes to the panels, themselves consisting of multiple textual genres, both primary and secondary sources. Among these are Geyer's reflections on her experience as a researcher in the archives of Curtis's photographs, confronting the taxonomies that separate portfolios of landscape and portraiture photography, post-photographic distributions of knowledge that position Native lands as an uncultivated resource.[10] In *Spiral Lands,* acts of looking are deeply contextualized: Viewers are situated as participants within discursive institutional, archival, and visual techniques.[11] Photographs appear as texts among other (written and oral) texts, and as agents within a broader colonial cultural apparatus whose rhetoric of uninhabited landscape is here recontextualized amid other sources depicting both indigenous habitation and struggles to maintain sovereignty.

The texts that accompany Geyer's photographs are constellations of multiple genres across juridical and cultural contexts. In their entirety, they detail genocide, survival, and sovereignty through fragments of poetry, tourist guides, travel diaries, American Indian Movement manifestos, timelines of struggles for rights, excerpts from treaties, and a summary of American Indian theories of justice as indigenism.[12] This polyphony of voices also refutes modern Western forms of narrative textual authority and intellectual property that privilege written records in English and individual authorship. *Spiral Lands* additionally cites conversations, poems, songs, and projects for indigenous language preservation to account for precolonial forms of transmission that do not elevate writing over oral or pictorial records, and which favor collaborative and community production.[13] In generating—and studying—sources themselves, *Spiral Lands* examines an array of modern photographic practices (documentary, travelogue, personal) and the very mechanisms of their differentiated visibility.[14]

In writing about conceptual art practices in the 2000s, the art historian Mark Godfrey designates "the artist as historian" as a figure preoccupied with particular historical subjects while also contextualizing these subjects' mediums and forms within their political, economic, and social conditions.[15] This description aptly characterizes Geyer's work, which departs from two earlier trajectories of Conceptual art from the 1960s and 1970s that employed texts and performances to investigate questions of land. First, *Spiral Lands* critically regards earlier uses of land in the Southwest by artists such as Robert Smithson, who employed large tracts of indigenous land in Utah to produce Earthworks. While Smithson importantly contextualized distinct physical places (sites) by way of linguistic, photographic, fragmentary, and diagrammed forms (non-sites) that crucially rethought conventions of representation, he nonetheless disregarded their colonial modernity, preferring to emphasize instead their geological, pre-cultural, and postindustrial aspects.[16] (In a footnote, Geyer ponders, "Why did Robert Smithson in his writings on the *Spiral Jetty* never mention the local presence and meaning of the spiral?")[17] If Smithson's work was praised by critics such as Craig Owens for a reciprocal and allegorical treatment of land, image, and text, as well as postmodern embedding in context, *Spiral Lands* might

suggest that this earlier model, in ignoring the cultural politics of context, was neither sufficiently embedded nor adequately allegorical.[18]

Geyer's project extends feminist strands of Conceptual art by artists such as Mary Kelly, Martha Rosler, and Andrea Fraser, who have used sites of representation to implicate viewers in their spatial, institutional, and political circumstances. In Rosler's photo-textual series *The Bowery in two inadequate descriptive systems* (1974–75), a grid of photographs depicts walls, shutters, storefronts, doors, and fences. Individual images tightly frame the space in which a homeless or drunk person might rest, but without depicting their actual bodies.[19] Each photograph is paired with a text panel itemizing derogatory nineteenth-century and then-contemporary colloquialisms for inebriation—"aglow, glowing, lit, rosy," "drunk, derelict, bum." The sequence offers a "walk" down the Bowery in New York, a space of poverty in the 1970s frequented by photographers whose "find a bum" social documentary Rosler opposed for its exploitation of poverty and condescending claims of social concern.[20] Although quoting the method and shots of such photographs, Rosler's pairings of images and texts emphasize their inadequacy rather than their power of testimony. Criticizing the broader tendency of social documentary in the United States, its liberal concern and exploitative claims to representation—to include Edward S. Curtis's and Robert J. Flaherty's photographs of Native Americans, Dorothea Lange's and Diane Arbus's images of the poor or deviant—Rosler proposed other ways of seeing. The cultural theorist Emily Apter notes the series' dependency on feminist critiques of the body, its ethics of non-representation affording "non-misogynist homo-spectatorial or gyno-spectatorial conditions of looking."[21] If Rosler offered social documentary photography a more feminist viewing position, *Spiral Lands* adapts this question to suggest a decolonizing mode of apprehending the indigenous subject.

Spiral Lands is a project aimed at history that positions its viewers as witnesses.[22] Geyer's research draws heavily from numerous indigenous sources and authorities (such as poetry and testimony), producing an assemblage of colonial and anticolonial texts whose friction questions how sources are differentially constituted as legitimate documents of history, and differentially visible as claims for national personhood and self-determination. Geyer describes her documents as performative speech acts adjudicating indigenous claims for sovereignty, and calls them "poetic documents" or "documents by other means."[23] Geyer trained and worked as a photojournalist before turning to contemporary art, and remains critical of how the veracity of photojournalistic documents is often uncritically apprehended. For an artist of Geyer's generation, growing up in the 1970s and 1980s, the extensive structural critiques of photo-documentary's ideological contexts, as well as historical debates regarding professional journalistic ethics, were equally available for use.

Spiral Lands is also attuned to a broader turn in contemporary photographic theory since 1997 that has examined not the noun of the *photograph* (as earlier theorists Walter Benjamin, Susan Sontag, and Rosalind Krauss did in the 1930s and 1970s), but the verb-function of *photography*. Theorists such as Ariella Azoulay and Tom Keenan have focused

on the conditions surrounding photographic activity, the circulation of photography as a discourse, its traffic through institutions, and coordination of politicized spectators of orders both primary (photographers, subjects, bystanders) and secondary (archivists, researchers, reproducers).[24] Through such contextual and conceptual approaches to photography, *Spiral Lands* emphasizes the importance of visual representation for demands of territorial sovereignty.

The coordination of vision and spatial justice had previously occupied feminist theorists of public space. The urban theorist and art historian Rosalyn Deutsche has advocated for the importance of representation in the formation of political subjects, arguing that the classed, racialized, and gendered ways in which minoritarian groups receive unequal access to public space and democratic rights are, in part, arbitrated through images. Deutsche's position was contentious; other art historians and critics in the 1990s would advocate instead for an activist art of direct social engagement that "dispensed with the frame" of imagery and art institutions in order to "recover the public function of art," in the words of the cultural scholar George Yúdice.[25] In response, Deutsche concurred that it was deeply important to support activist art (particularly as public space became increasingly privatized under economic neoliberalism) while also arguing against the depoliticization of art appearing as images, or within the frame of galleries. The reductive opposition of art situated within cultural institutions versus art located outside risks consigning image-based or gallery-bound work to the non-public private sphere, while valorizing art engaged with direct action as emblematic of the public sphere. Such dualisms reinstate false divisions between the private and public spheres, as well as separate representation from its material contexts. As Deutsche put it, "Images are, precisely, public and political" and "vision and sexuality are public matters."[26]

Further, Deutsche argued against critics disparaging art practices concerned with problems of subjectivity. Art historians such as Thomas E. Crow argued that the social movements emphasizing gendered and racialized subjectivity had balkanized the public sphere into disparate groups, thus contributing to the public sphere's demise and compromising art's ability to participate in unified political struggle.[27] Such arguments depended on a coherent notion of the public, thereby establishing the very notion of the public and the political subject (the citizen) as certainties known in advance. Deutsche contended that the certainties of these concepts depended on exclusions to uphold their legitimacy; feminism would necessarily call into question such certainties by targeting the exclusions required to picture citizenship or publics as all-encompassing or foundational.[28] Such questioning was available in the work of feminist artists such as Barbara Kruger and Martha Rosler, whose work on the image would deconstruct representation in its effect upon subjects as both spectators and citizens within mediated urban spaces.[29]

In *Spiral Lands,* the image is simultaneously a problem for feminist and decolonizing strategies, particularly in Chapter 2's emphasis on scholarly authority (figure 27). When Geyer's photographs are shown in an installation as a projection of eighty black-and-

27. Andrea Geyer, *Spiral Lands / Chapter 2*, 2008. Installation in an educational setting with slide projection; 80 color and black-and-white slides; voice-over; brochure with footnotes, 50 min.

white and color slides of Chaco Canyon, a voice-over, and chairs, the situation mimics the scene of a classroom. Geyer has also performed Chapter 2 as a lecture, delivering her presentation in German-accented English and dressed in a masculine suit, signaling both the position of academic authority and its queer resignification.[30] Earlier uses of lectures and panels by artists such as Robert Smithson and Joseph Beuys drew attention to the architectural, positional, and pedagogical situations of speech.[31] The use of such formats by feminist Conceptual artists since the 1970s marshalled speech and lectures to interrogate institutional conventions establishing positions of power within professional and cultural contexts, implicating both artist and audience. The V-Girls, in particular, lampooned forms of address, representation, and dialogue instituting art historical authority at College Art Association conferences and journals such as *October*; and Andrea Fraser's tours as a museum docent or overenthusiastic visitor in the 1990s parodied how audiences arrive at positions of cultural knowledge within specific sites.[32]

This use of lecture formats to address problems of space has been amplified with the postwar embedding of artistic education within the university, particularly in the United States. In recent years, this trend has encouraged institutional collaboration across disciplines at specific venues.[33] Geyer herself has taught in numerous departments in the United States and Europe, participated in university residencies, and collaborated with scholars in anthropology, law, and political science. While not appearing as a scholar in these disciplines, Geyer is nonetheless informed by them, and extends earlier feminist critiques of academic and cultural mastery by personally delivering her texts to mark "the actual body of an accountable author."[34] In stressing her embodied authorship, Geyer foregrounds her performative position as a speaker within a museum to specify the epistemological apparatus of scholarly fascination that denied Native Americans intellectual authority. Her lecture text un-learns myths of scholarly impartiality while

disclosing the scholar's desires for identification with her subjects, and responsibility to history. Geyer's lecture also solicits an art audience's identification with the various positions of authoritative knowledge, referring to Jimmie Durham's essay "American Indian Culture" (1974), which criticized the white Left's tendency to appropriate the intellectual labor of the indigenous and the colonized, from which Geyer declares—in a gesture of alliance—"We are all to be held accountable."[35] If Geyer's lecture persona uses the personal pronoun "I am," it is to open it onto an array of authors (Sonya Atalay, James Clifford, Aby Warburg, the ethnographer, archaeologist, and historian), positioning a lecturer's position of academic mastery as dependent on the work of others.

The textuality of *Spiral Lands* prepares for the project's subsequent circulation in history. All three chapters will conclude in publication; when Chapter 1 is presented as an installation, brochures (in English and German) are included, and when Chapter 2 is presented as a performance, Geyer's lecture footnotes—of prodigious length—are distributed to the audience.[36] Her citations elaborate points, expand on quotes, and introduce additional bibliography. Jacques Derrida reminds us that the question of context is the importance "of its nonclosure . . . its irreducible opening."[37] The opening of context is the very precondition for context itself, and a responsibility transcending closure. This non-closure produces an ethico-political movement of citationality that *Spiral Lands* traces as an outward spiral. Being an audience to the piece perpetually opens onto other quotations, pages, venues, and contexts. Geyer's promiscuity of citation implicitly challenges the limitations of attention and comprehension embedded in conventions of contemporary exhibition spectatorship. *Spiral Lands* courts a gradual pace of slow looking and meticulous reading. The texts afford no linear chronicle and cathect to Native theories of spiraling time rather than European modernity's temporal teleology—the daily time of industrial production, the historical time of progress, and developmental progression of narrative—that imposed capitalist and colonial modes of apprehension. In tracking indigenous struggles for sovereignty persisting at uneven speeds, *Spiral Lands* is fittingly described as a "cycle" of works.[38] Wendy Brown writes of the importance of untimeliness for political theory and democratic thinking against "the very senses of time invoked to declare critique untimely," to contest the settled accounts of "what political tempo and temporality we should hew to." Brown calls for "a bid to reset time" and "think against times" deemed proper, as a "critical condition" of the present summoning our response.[39]

Sand Creek (1864/1981/2008), a collaborative piece made during the interval between Chapters 2 and 3 and coauthored with Simon J. Ortiz, a poet of Acoma Pueblo heritage, offers such a politics of untimeliness. Poems from Oritz's *Sand Creek* collection are sandblasted on glass overlaying Geyer's black-and-white landscape photographs, casting subtle shadows upon their surfaces (figures 28 and 29). Alternating between reading text and image reorients the figure-ground relationship. The two come together but are gently held apart, a dual narrative of collaboration constituted in aesthetic form.[40] Three dates are assigned to *Sand Creek*: 2008, the year of the collaboration; 1981, the year

28. Andrea Geyer and Simon J. Ortiz, *Sand Creek. 1864/1981/2008*. Three gelatin silver prints, wood frames, etched glass, 26 × 22.5 in each, framed. Photographs by Andrea Geyer, textual excerpts from Simon J. Ortiz, *Sand Creek* Published by Thunder's Mouth Press, Oak Park, New York.

Ortiz's *From Sand Creek* collection was published and his poetry honored at the White House; and 1864, when a massacre of Native Cheyenne people at Sand Creek horrendously violated previously recognized proclamations of peace.[41]

Dating *Sand Creek* thrice is a slight yet significant gesture, weaving together events of genocide, collaboration, and the honoring of a colleague. The convention of dating artworks to a series of years denotes their completion; it secures their span for historical records and their authenticity for acquisition. The re-temporalization of 1864/1981/2008 undoes the property and propriety of locating art in a singular period. The gesture is analogous to Wendy Brown's call for an "*ethic* of timeliness and untimeliness" both attuned to and aggressively violating "the self-conception of the times."[42] It is fitting that, as works of art emerging during the War on Terror, *Sand Creek* and *Spiral Lands* model the cyclical character of U.S. colonization in their various iterations, as instances of cultural alliance across times and among others.[43]

Prior to Chapter 3, Geyer and Ortiz took a road trip through the territories referenced by *Spiral Lands*. Following this trip, Geyer gave Ortiz a box of landscape photographs depicting the land around Acoma that they visited—its plains, vegetation, rock formations—without legible traces of human activity, save one. Ortiz selected photographs and wrote poems in response, taking up themes of nature, travel, listening, observation,

29. Andrea Geyer and Simon J. Ortiz, *Spiral Lands / Chapter 3* (detail), 2009. Gelatin silver print, wood frame, etched glass, 55 cm × 69 cm. Photographs by Andrea Geyer, textual excerpts from Simon J. Ortiz.

addiction, and memory through a strategic use of conversational fragments between unnamed personae, positing a dialogue with alterity. Here, a line from one of Ortiz's poems in Chapter 3 resonates with Geyer's treatment of representation: "I want to know but maybe I'm not to know. Being within the culture sometimes is: Not knowing and accepting it's okay. Knowing you're within is knowing enough."

Ortiz's poem "171/2" overlays Geyer's photograph depicting etchings on a stone surface. It is unclear whether this surface is a cave wall or a boulder. The photograph is cropped tightly, our gaze pressed close to marks filling the visual field, save a triangle of dark shadow denoting finitude or recess. Ortiz's poem traces inscriptions—"buffalos, mountain sheep, elk [. . .] even the fact of the conquistadors, conquistadors" to imply a shared historical condition that is "part of all that has taken place." Yet Ortiz refutes the ekphrasis of writing to the photograph, never fully sighting or citing photographic mean-

ing. His opening words indeterminately glimpse the character of the site, image, the reader's dependence on a poet's insight—as we unlearn a presumed right to see—"I've never been sure / What it is / A scene."

<p style="text-align:center">. . .</p>

It is a structuring paradox of *Spiral Lands,* and the Geyer-Ortiz collaboration, that desires for indigenous political sovereignty continually turn upon strategies of non-representation and anti-essentialist notions of identity that persistently un-ground a viewer's mastery of knowledge or presumption of visual or territorial entitlement. While partly deriving from deconstruction, these approaches are equally significant within Native political theory. According to Manuhuia Barcham, the essentializing presumption of a priori, "authentic" indigenous identity prohibits the advancement of indigenous land rights by concealing the dependencies of identity on material conditions and social processes of transformation.[44] Such essentialism has idealized Native subjects in primitivist ways, presuming their incompetence and neglecting the sophistication of their statecraft, governance, technologies, and approaches to gender and culture, thereby justifying the imposition of settler societies, territorial expansion, and colonization.[45]

In the field of culture, Jimmie Durham has similarly critiqued the rhetoric and policy of indigenous authenticity as inhibiting cultural and political recognition and rights to land.[46] Further, the Native feminist Andrea Smith recently advocated anti-foundationalist political analysis, foregrounding alliance practices over identity politics to advance goals of political sovereignty and nation building. Smith criticizes the tendency of allied activists to romanticize Native identities and expected modes of resistance, only to abandon political projects for sovereignty when such expectations fail to be met. Smith calls for political analysis that includes the relational flux of identities, the contradictions in political praxis, and tensions within competing forms of Native resistance. Only then is it possible to articulate "alterative notions of sovereignty that speak to alterative understandings of coalition building."[47] The building of such alternatives—and the unlearning of present forms of visual and political sovereignty—is a meticulous process. In *Spiral Lands,* it bears upon every image, text, source, and relationship.

Anti-foundationalist and deconstructive frameworks are thereby seen to strengthen, rather than undermine, allied efforts toward Native political sovereignty by accounting for their complexity.[48] The three chapters of *Spiral Lands* chart a progression from observation to engagement; Geyer herself has participated in Native conferences on the subject, meeting with both contention and acceptance.[49] Her collaboration with Ortiz, amid the numerous other authors whose works aggregate *Spiral Lands,* proposes an ethics of alliance that contextualizes one's efforts as always already interdependent with others in struggles for sovereignty. Such affective and collegial aspects of interdependent labor— toward shared goals but unknown ends—are perhaps most aptly characterized by Geyer as "uncertainty of image," and by Ortiz as "a form of maintenance of life."[50]

NOTES

1. Andrea Geyer, *Spiral Lands / Chapter 1* (London: Koenig Books, 2008), 6.

2. The Constitution of the United States begins with "We the people," a declaration of a sovereign people with rights of representation, territory, and governance. At its inception, the Constitution recognized the political sovereignty of indigenous Native American tribes but subsequently limited their defense, economic, and justice systems through constitutional amendments, federal regulation, and treaty violations, thereby defusing tribal self-determination and facilitating the dispossession of territories and rights. On the contradictions of the U.S.-Indian agreements within the United States Constitution, subsequent amendments, and treaty agreements and violations, see the essays in the collected volume *Native American Sovereignty*, ed. John R. Wunder (London and New York: Routledge, 1999).

3. My thanks to Andrea Geyer for her production notes labeling these sites and the text for her talk "Un-Learning Visual Regimes" delivered at the "Essentially Indigenous? Contemporary Native Arts Symposium" (National Museum of the American Indian, New York, May 5–6, 2011).

4. See Janet Catherine Berlo's excellent discussion of Navajo imagery and language in these photographs, and the broader historical context of the lands depicted, in her essay commissioned for Andrea Geyer's *Spiral Lands* project: "'Libraries of Meaning and of History': *Spiral Lands* and Indigenous American Lands," in Andrea Geyer, *Spiral Lands / Chapter 1*, i–xiii.

5. See Jonathan Crary, *Techniques of the Observer: On Vision and Modernity in the Nineteenth Century* (Cambridge, Massachusetts: MIT Press, 1990), 133.

6. On the presumed indexicality of photography and its greater effect on art, see Rosalind Krauss, "Notes on the Index: Seventies Art in America Part 2," *October* 4 (autumn 1977): 58–67. For early theories of documentary realism, see Elizabeth McCausland, "Documentary Photography," in *Photo Notes* (January 1939), reprinted in Liz Heron and Val Williams, eds., *Illuminations: Women Writing on Photography from the 1850s to the Present* (London: I. B. Tauris, 1996), 170–73; and John Grierson, "Postwar Patterns," *Hollywood Quarterly* 1, no. 2 (January 1946): 159–65.

7. For critical views on the canon of American landscape photography, see *America in View: Landscape Photography 1865 to Now* (Providence: Rhode Island School of Design, 2012); Deborah Bright, "Of Mother Nature and Marlboro Men," *Exposure* 23, no. 1 (winter 1985); and James C. Faris, *Navajo and Photography: A Critical History of the Representation of an American People* (Salt Lake City: University of Utah Press, 2003).

8. Criticisms of photographic depictions of Native Americans have been made in texts such as Christopher Lyman, *The Vanishing Race and Other Illusions: Photographs of Indians by Edward S. Curtis* (Washington, DC: Smithsonian Institution Press, 1982); Mick Gidley, "Introduction," in *Edward S. Curtis and the North American Indian Project in the Field* (Lincoln, Nebraska: University of Nebraska Press, 2003); James C. Faris, *Navajo and Photography*; James Clifford, "The Others: Beyond the 'Salvage' Paradigm," *Third Text* 3, no. 6 (1989); and especially the important contributions of Native artists and writers to *Partial Recall: With Essays on Photographs of Native North Americans*, ed. Lucy Lippard (New York: The New Press, 1993). I am grateful for the opportunity to have read, in advance, Nicholas Brown's essay on *The Vanishing Indian Repeat Photographic Project* (2011–) published in this volume. Brown's utilization

of "repeat photography" to link the rhetoric of the vanishing Indian to the vanishing glacier, and, consequently, earlier instances of settler colonialism to their ongoing effect (and resistance) in the present, shares a similar visual and political project with Geyer's.

9. Andrea Geyer, *Spiral Lands / Chapter 1*, 63.

10. Andrea Geyer, *Spiral Lands / Chapter 1*, 131, footnote 73. These footnotes are available to viewers as a printed brochure when *Spiral Lands* is installed in a gallery context.

11. Geyer describes this via Walter Benjamin's concept of the artist as producer. See Andrea Geyer and Carlos Motta, "Conversation: Andrea Geyer and Carlos Motta," in *Writing as Practice: Peripheral Community*, ed. Michi Jigarjian (New York: Secretary Press, 2012), 69; and Walter Benjamin, "The Author as Producer," *New Left Review* 1, no. 62 (July–August 1970).

12. William Bradford, "Beyond Reparations: An American Indian Theory of Justice," *Ohio State Law Journal* 66, no. 1 (2005): 1–104; also cited in Andrea Geyer, *Spiral Lands / Chapter 1*, 135, footnote 137. In Bradford's theory of justice as indigenism, theoretical paradigms of reparation are criticized for their inability to grapple with land theft, genocide, ethnocide, and self-determination, as well as for their limited attention to necessary and comprehensive structural legal reform. To achieve such reform, the following factors are outlined: the prioritization of remediation for the original inhabitants of lands in the United States; the deserving redress of past injustices against Native Americans; entitlements to restoration of lands for the dispossessed; and the transformation of the U.S. legal canon to balance both indigenous freedoms of self-determination (and freedom against interference toward) and corresponding rights of non-Indians.

13. Geyer cites, in particular, the conversations and writings of Navajo, Pueblo, and Hopi intellectuals. For critical analyses of the problems of applying intellectual property principles to indigenous Native American cultures for the above reasons, see Lawana L. Bryant, Katherine E. Lewis, Maia Puryear, and Alyssa Reiner, "Caught in the Middle: Intellectual Property and Indigenous Communities," *Landslide* 5, no. 4 (March–April 2013): 83–98. Also see Jane E. Anderson, "On Resolution | Intellectual Property and Indigenous Knowledge Disputes | Prologue," *Landscapes of Violence* 2, no. 1, article 4 (2012): 1–14.

14. Geyer has previously employed such intertextuality with regard to post-9/11 immigration issues in works such as *Interim* (2002) and *Parallax* (2003).

15. Mark Godfrey, "The Artist as Historian" *October* 120 (spring 2007): 168–69.

16. Robert Smithson, "A Provisional Theory of Non-Sites" (1968), in *Robert Smithson: The Collected Writings*, ed. Jack Flam (Berkeley: University of California Press).

17. See Geyer's remarks in *Spiral Lands / Chapter 1*, 129, footnote 73. Geyer's question is largely accurate. In Smithson's principal text on *Spiral Jetty*, the spiral is not identified as a culturally specific sign, but rather linked to the atomic construction of crystal lattices, and used metaphorically as a mode of apprehension consisting of perceptual reverberations (linking the spiral to "Brancusi's sketch of James Joyce as a 'spiral ear'" that would defy modern rationality.) In Smithson's writing, the image of the spiral often appears as an instance of pre-semiotic dissolution: "I was slipping out of myself again, dissolving into a unicellular being, trying to locate the nucleus at the end of the spiral." See Robert Smithson, "The Spiral Jetty" (1970), in *Robert Smithson: The Collected Writings*, ed. Nancy Holt (New York: New York University Press, 1979), 112–13. Smithson's subsequent treatment of land more generally was to propose Earthworks as exemplary cases of land recycling or reclamation of devalued industrial sites. Native American

buildings were used loosely as prior references for inspiration, without necessarily treating them as present concerns: "Ecology and industry are not one-way streets, rather they should be crossroads. Art can help to provide the needed dialectic between them. A lesson can be learned from the Indian cliff dwelling and the earthwork mounds. Here we see nature and necessity in consort." Robert Smithson, "Untitled 1971," in *Robert Smithson: The Collected Writings*, 220.

18. Craig Owens, "Earthwords" *October* 10 (autumn 1979): 120–30.

19. The piece was first shown publicly at the *Information* (1975) exhibition at the San Francisco Art Institute. *Martha Rosler: 3 works*, ed. Benjamin H. D. Buchloh (Halifax: Nova Scotia College of Art and Design University Press, originally published 1981).

20. Martha Rosler, "In, Around and Afterthoughts (on documentary photography)," in *3 works*, 75.

21. Martha Rosler, "Afterword: A History," in *3 works*, 94. My interpretation also leans on both Abigail Solomon-Godeau's interpretation of the piece as structural documentary critique and Emily Apter's discussion of its deployment of scopophilia. Abigail Solomon-Godeau, "Living with Contradictions: Critical Practices in the Age of Supply-Side Aesthetics," *Social Text* no. 21 (1989): 191–213; Emily Apter, "Review: Photography at the Dock: Essays on Photographic History, Institutions, and Practices by Abigail Solomon-Godeau," *The Art Bulletin* 74, no. 4 (December 1992): 692–94.

22. Geyer borrows Jalal Toufic's description of the witness for her work. See Jalal Toufic, *Oversensitivity* (Los Angeles: Sun and Moon Press, 1996; electronic reprint 2009), 50. "Whenever concerning an event, the survivor who underwent it feels, '[today] while knowing perfectly well that it corresponds to the facts, I no longer know if it is real,' in order to bear witness remembering is necessary but not enough. To bear witness is a double operation: the most scrupulous historical research, the archaeological excavation to reach the buried has to be complemented, because certain traumas are mute and black holes, having an event horizon, beyond which one cannot go and return, by the voice that appears *ex nihilo*."

23. Andrea Geyer and Sharon Hayes, "In Conversation with Sally Gutierrez and Ashley Hunt," in the exhibition catalogue *Andrea Geyer / Sharon Hayes*, ed. Cynthia Chris (Heidelberg, Germany: Kunstuseum St. Gallen and Gotesborgs Konsthall, 2009), 41. Geyer's work may be seen as participating in a broader debate on the limits of evidence, and the function of poetry as/within its categorizations. See Judith Butler's writing on poetry written by Guantanamo detainees in Judith Butler, *Frames of War: When Is Life Grievable?* (London and New York: Verso, 2009), 59. See parallel debates over political and cultural representation at the National Museum of the American Indian; or questions of interpretation around the controversial exhibition of frontier imagery in history painting.

24. Theorizations of documentary expanded following Catherine David's extensive focus on the genre's relationship to politics and colonialism in the 1997 exhibition *Documenta X*. Such theory may look to the definitive moment to glimpse what lies outside the frame (which the image nonetheless depends on), for instance, Allan Sekula's call for an "anti-photojournalism" of "no flash, no telephoto zoom lens . . . no pressure to grab at all cost the defining image of dramatic violence . . . that would instead move with the flow of protest, if need be." See Allan Sekula, "Waiting for Tear Gas," in *Five Days That Shook the World: Seattle and Beyond*, eds. Alexander Cockburn et al. (London: Verso, 2000). Sekula's conceptualization of "anti-photojournalism" was used to consider a range of recent experimental photography, media,

and film in Tom Keenan and Carlos Guerra's *Antiphotojournalism* (2010) at City of Barcelona, Institut de Cultura: La Virreina Centre de la Image. The turn toward photography as a civil practice of politicized spectators was most notably presented by Ariella Azoulay in "The Civil Contract of Photography" and "A Comment on the Photographs," in *The Civil Contract of Photography* (New York: Zone Books, 2008): 85–135. Also note Hito Steryl's discussion of photography's embedding within—and ability to transform—existing material arrangements. Hito Steryl, "A Language of Practice," in *The Green Room: Reconsidering the Documentary in Contemporary Art*, ed. Maria Lind (Berlin and New York: Sternberg Press, 2008), 231.

25. George Yudice, "For a Practical Aesthetics," *Social Text* no. 25/26 (1990): 135. Also Rosalyn Deutsche, "Agoraphobia," in *Evictions: Art and Spatial Politics* (Cambridge, Massachusetts: MIT Press, 1996): 312–13.

26. Rosalyn Deutsche, "Agoraphobia," 315–16.

27. See Crow's remarks in "Discussion: The Birth and Death of the Viewer: On the Public Function of Art," in *Discussions in Contemporary Culture*, ed. Hal Foster (Seattle: Bay Press, and New York: Dia Art Foundation, 1987), 24, and Rosalyn Deutsche's extended response in "Agoraphobia," 312–13, 370.

28. Rosalyn Deutsche, "Agoraphobia," 312.

29. See Nato Thompson, "Experimental Geography," in *Experimental Geography: Radical Approaches to Landscape, Cartography, and Urbanism* (Brooklyn: Melville House, 2009): 20–21; this book accompanies an exhibition organized by Independent Curators International that toured to multiple venues. Also Nato Thompson, *Living as Form: Socially Engaged Art from 1991–2011* (New York and Cambridge, Massachusetts: MIT Press, 2011), 21–23, accompanying the exhibition by Creative Time.

30. Andrea Geyer, *Spiral Lands / Chapter 2*, Modern Mondays lecture (Museum of Modern Art, New York, 2008).

31. See Robert Smithson, "Robert Smithson: Hotel Palenque (1972)" in *Parkett* 43 (1995). Also see Jennifer Roberts's examination of Smithson's expeditionary works for the importance of his critique of modernist theories of vision, and the limitations of his neutralization of historical time in the lecture at the Hotel Palenque (1972), in Jennifer L. Roberts, "Landscapes of Indifference: Robert Smithson and John Lloyd Stephens in Yucatán," *The Art Bulletin* 82, no. 3 (September 2000): 544–67. For a survey of postwar artist-lectures, including Joseph Beuys's staging of pedagogical formats within educational institutions (for instance his 1976 address upon receipt of an honorary doctorate degree from the Nova Scotia College of Art and Design in Halifax), see Patricia Miller, "Teaching as Art: The Contemporary Lecture-Performance," *PAJ: A Journal of Performance and Art* 33, no. 1 (January 2011): 13–27. Beuys also previously referred to the colonization of Native Americans in his lecture-performance *I Like America and America Likes Me* (1974). For a critical account of Beuys's identification with both victim and savior roles in this performance, and his inversion of victim-perpetrator positions, see Jan Verwoert, "The Boss: On the Unresolved Question of Authority in Joseph Beuys' Oeuvre and Public Image," *e-flux journal* 1, 2008. The distinctiveness of Geyer's non-identification with the victims of trauma, and stress upon positions of knowledge and accountability, may be seen in sharper relief by comparison with these precedents.

32. Martha Baer et al., "The V-Girls: A Conversation with *October*," *October* 51 (winter 1989): 115–43; Andrea Fraser, "Acknowledgements," in *Museum Highlights: The Writings of Andrea*

Fraser, ed. Alex Alberro (Cambridge, Massachusetts: MIT Press, 2005): xx; Julia Bryan-Wilson, "A Curriculum for Institutional Critique, or the Professionalization of Conceptual Art," in *New Institutionalism,* ed. Jonas Ekeberg (Oslo: Office of Contemporary Art, Norway, 2003), 89–109.

33. As Howard Singerman has pointed out, artists since the 1960s have had their education more deeply integrated within the site of the university. See Howard Singerman, *Art Subjects: Making Artists in the American University* (Berkeley and Los Angeles: University of California Press, 1999). In addition to taking up residency within or teaching at institutions of higher learning, thereby rendering facility with cross-disciplinary knowledge more available, this raises the possibility of their participation within diverse fields such as history, anthropology, area studies, and geography; awareness of the epistemological and methodological critiques available within these fields; and interlocution with scholars themselves. (These interdisciplinary engagements have been made available by specific faculty in MFA-granting institutions such as Columbia University, Parsons The New School, UCLA, and others). Geyer herself has participated in residencies at the New School via the Vera List Center and collaborated with scholars in its law, anthropology, and political science departments, and presently teaches there as well. Like the artists Martin Beck and Matthew Buckingham, Geyer not only cites relevant scholarship in her work, but has commissioned the production of scholarship and advances a field's existing literature. That is not to say that Geyer's lecture is an academic lecture, nor that she operates strictly as an academic. Rather, her investigation of scholarly authority supplements existing debates within an existing field to abstract problems of recognition, citation, and identification within, as they affect a viewer and an audience.

34. Andrea Geyer and Sharon Hayes, "In Conversation with Taisha Paggett and Yvonne Rainer," in the exhibition catalogue *Andrea Geyer / Sharon Hayes,* ed. Cynthia Chris (Heidelberg, Germany: Kunstuseum St. Gallen and Gotesborgs Konsthall, 2009), 23.

35. Jimmie Durham, "American Indian Culture: Traditionalism and Spiritualism in a Revolutionary Struggle" (1974), republished in Jimmie Durham, *A Certain Lack of Coherence: Writings on Art and Cultural Politics* (London: Kala Press, 1993), 1–22.

36. This scriptovisual method of inducing identification with a discursive position via image-text relations is drawn from Mary Kelly, an interlocutor of Geyer's. See Mary Kelly, *Post-Partum Document* (London: Routledge and Kegan Paul, 1983), xvii.

37. Jacques Derrida, "Afterword," in *Limited Inc.,* trans. Samuel Weber (Evanston, Illinois: Northwestern University Press, 1988), 152.

38. See Sharon Hayes and Andrea Geyer, *History Is Ours* exhibition catalogue (Heidelberg, Germany: Kunstmuseum St. Gallen and Göteborgs Kunsthalle, Kehrer, 2009), 113. Also see the artist's website with descriptions of the project at http://www.andreageyer.info/projects /spiral_lands/spiral_lands_2/SpiralLands2.htm.

39. Wendy Brown, "Untimeliness and Punctuality," first delivered as a lecture at the graduate symposium Critical Theory in Dark Times (2004). Republished in *Edgework: Critical Essays on Knowledge and Politics* (Princeton, New Jersey: Princeton University Press, 2005), 4, 12.

40. For Geyer's interest in "dual narratives" of psychic and political struggle in Yvonne Rainer's work, in reference to the poetic-activist and image-poetic tracks of *Spiral Lands,* see Andrea Geyer and Yvonne Rainer, "Yvonne Rainer: Filmmaker and Choreographer with Andrea Geyer," conversation recorded February 20, 2005, in *Artist and Influence* no. 24 (2005):

148. Geyer's treatment of authorship and dates may be perceived as an example of respecting cultural sovereignty, particularly in light of studies on how indigenous culture and intellectual sovereignty have been delegitimized by non-Native notions of authorship and property. For further examples of contemporary art engaged with issues of Native authenticity and foregrounding problems of intellectual sovereignty, see Eva Marie Garroutte, "Challenging Authenticity: Contemporary Artists' Contributions to American Indian Intellectual Sovereignty," in *Foundations of First People's Sovereignty: History, Education and Culture,* ed. Ulrike Wiethaus (New York: Peter Lang Publications, 2008), 225–42. For more on the interface between intellectual property and indigenous rights, see Jane Anderson, *Law, Knowledge, Culture: The Production of Indigenous Knowledge in Intellectual Property Law* (Cheltenham, England: Edward Elgar Press, 2009).

41. Simon J. Ortiz, *From Sand Creek* (New York: Thunder's Mouth Press, 1981), 2.

42. Wendy Brown, *Edgework,* 14.

43. Geyer often remarks on *Spiral Lands'*s emergence alongside the USA PATRIOT Act's antidemocratic suspension of civil liberties, and the denationalization of suspected terrorists without trial or deportation hearings. Crucially, activists have also connected indigenous dispossession and the increased policing of borders and immigration by the U.S. government under the War on Terror; the episodic, cyclical temporality of *Sand Creek* and *Spiral Lands* affords a critical response to unspooling iterations of U.S. colonization. Andrea Smith, "War on Terror Versus Native Sovereignty," *Solidarity* (July–August 2003), http://www.solidarity-us. org/site/node/588. Also see the ACLU's summary of the USA PATRIOT Act: "ACLU Fact Sheet on Patriot Act II," posted March 28, 2003, http://www.aclu.org/national-security/aclu-fact-sheet-patriot-act-ii.

44. Manuhuia Barcham "(De)Constructing the Politics of Indigeneity in Political Theory and the Rights of Indigenous Peoples," in *Political Theory and the Rights of Indigenous Peoples,* ed. Duncan Ivison (Cambridge, England: Cambridge University Press, 2002), 139–40.

45. David E. Wilkins and K. Tsianina Lomawaima, *Uneven Ground: American Indian Sovereignty and Federal Law* (Norman, Oklahoma: University of Oklahoma Press, 2001), 24. See Iris Marion Young, "Hybrid Democracy: Iroquois Federalism and the Postcolonial Project," in *Political Theory and the Rights of Indigenous Peoples,* 227–58; Jimmie Durham, "American Indian Culture," 1–22; and Scott Lauria Morgensen, "Unsettling Queer Politics: What Can Non-Natives Learn from Two-Spirit Organizing?" and Qwo-Li Driskill, "The Revolution Is for Everyone: Imagining an Emancipatory Future Through Queer Indigenous Critical Theories," in *Queer Indigenous Studies: Critical Interventions in Theory, Politics and Literature* (Tucson, Arizona: University of Arizona Press, 2011), 132–54, 211–22.

46. Jimmie Durham, "American Indian Culture," 1–22.

47. Andrea Smith, "Preface," in *Native Americans and the Christian Right: The Gendered Politics of Unlikely Alliances* (Durham, North Carolina: Duke University Press, 2008); and Wesley Thomas and Sabine Lang, eds., *Two-Spirit People* (Urbana, Illinois: University of Illinois Press, 1999), xi.

48. Andrea Smith, "Preface," xiv.

49. Andrea Geyer, "Un-Learning Visual Regimes."

50. Ortiz as cited in Andrea Geyer and Carlos Motta, "Conversation: Andrea Geyer and Carlos Motta," 70.

11

KELLY C. BAUM

Earthkeeping, Earthshaking

In 1981, the feminist art collective Heresies released the thirteenth issue of its eponymous journal, subtitled "Earthkeeping, Earthshaking." Devoted to the topic of feminism and ecology[1] and published on the heels of a groundbreaking conference at the University of Massachusetts ("Women and Life on Earth") and the equally historic Women's Pentagon Action,[2] both in 1980, this issue represents one of the few documented encounters between art, feminism, and ecology.[3] It also symbolizes a profound tension between two very disparate approaches to eco-feminism, a tension evidenced in the relationship between the issue's cover and its editorial statement.

On the front of the magazine, we see a striking photograph of a plume of steam, dirt, and lava projecting violently from Mount Saint Helens. This "hole into the interior and an opening out of that center," the editors write, is a "female image," one the Klickitat Indians christened Loo-Wit, "the old woman, keeper of fire." It is "both nurturing and destructive."[4] For the editors, this female image is clearly a feminist image—feminist precisely because it is female. Feminist artists such as Judy Chicago and Hannah Wilke developed just such an inventory of female images—mostly aestheticized depictions of the female anatomy—in order to reappraise their identification with nature and claim ownership over that which had been expropriated from them: namely, their bodies, their sexualities, and their power.[5] The editors had exactly this iconography in mind when they selected the photograph of Mount Saint Helens for *Heresies*. Despite their intentions, however, the message it sends is deeply ambivalent. Insofar as it elides feminist and female, equates politics and biology, and naturalizes both inequality and sexuality, the

photograph ultimately serves a conservative agenda, reiterating many of the patriarchal stereotypes that feminists have fought long and hard to contest.

Elsewhere in their statement, however, the editors all but admit that biology is a supremely unsuitable foundation on which to build a politics of gender and ecology. Indeed, a great deal of their remaining introduction contradicts the perspective epitomized by the cover. "Our province is both nature *and* culture," they insist, at which point they proceed to outline a catholic, multifaceted approach to environmentalism. Among their many fields of inquiry are rural and urban ecosystems; women, militarism, and "militant struggles for liberation"; the exploitation of third world resources and communities; monopoly capitalism; and, finally, the gutting of social services and environmental protections by President Ronald Reagan.[6] The friction between the cover and the second half of the editorial statement is palpable, but productive. If the photograph of Mount Saint Helens collapses the categories of women and nature, reducing each to a kind of atavistic, de-historicized parody of itself, much of the introduction works to particularize and contextualize eco-feminism. It also considers gender and ecology in relation to class and race. In so doing, the preface situates the struggle for gender and ecological justice within a broad coalition of social justice movements, including labor, civil rights, antiwar, antinuclear, anti-poverty, anti-capitalist, and anti-colonial.[7] What results is a heady brew. For these reasons and more, the 1981 issue of *Heresies* not only performs the distance separating two very disparate approaches to eco-feminism—one pacific and affirmative, the other oppositional and contestative—but also serves as an object lesson on the limits and promise of eco-feminism.[8]

The feminist and environmental movements emerged around the same time, building steam throughout the 1970s, but feminism did not develop an emphatic ecological consciousness until the late 1970s. What resulted from their marriage was eco-feminism, a politico-philosophical enterprise that advocates the joint liberation of women and nature. According to eco-feminists, women and nature are brutalized by the same structure—patriarchy—which privileges men over women and culture over nature. Insofar as it asserts the shared inferiority of both the female sex and the natural environment, the patriarchal belief system serves to sanction their mutual exploitation. This has important consequences for eco-feminism: Since the oppression of women and of nature complement and reinforce each other, their respective emancipations, too, must proceed in lockstep.[9]

No matter what their stripe, eco-feminists tend to posit an affinity between women and nature. For some, the two are linked in the patriarchal imagination alone,[10] but for others, women and nature share a bond that exceeds social and cultural programming. Women, they argue, have a natural kinship with nature because they are themselves more natural. Simply put, they are closer to nature than men. Biology is paramount: Women's capacity to give birth, for instance, affords them greater respect for life and an intuitive appreciation for the environment. Born housekeepers and child bearers, women are, as a result, born environmentalists as well. Such a perspective is deeply problematic,

30. Andrea Bowers, *Women's Pentagon Action, 1981*
(detail of woven web around Pentagon), 2003.
Graphite on paper, 8 × 10 in. Courtesy the artist and
Andrew Kreps Gallery, New York .

most importantly because it mystifies the domination of women and nature and depo-
liticizes both feminism and environmentalism. Instead of an incisive endeavor devoted
to the gender politics of ecology and the ecological politics of gender, eco-feminism
devolves into romantic, neoconservative poetics.

The history and legacy of first-generation eco-feminism plays a central role in the
work of the contemporary artist Andrea Bowers. In a suite of drawings begun in 2003,
Bowers represents some of the founding events of eco-feminism, all of them acts of civil
disobedience and all constellated around the environmental dangers posed by war, mili-
tarism, and nuclear technology, including the 1980 Women's Pentagon Action and a
1981 protest at the Diablo Nuclear Power Plant by Mothers for Peace (figure 30).[11] Each
drawing is based on a photograph, most of them lifted from newspapers. Although
highly realistic and meticulously rendered, they are not faithful imitations. Not every
photograph is reproduced in full, for instance, and even when it is, none of the original
contextual information remains. Nonetheless, the specific does not cede completely to
the general. The artist's titles ground us firmly in the 1980s, at the moment a ground-
breaking alliance emerged, uniting constituents from diverse backgrounds around a
common goal: environmental justice. The images that Bowers chooses to transcribe
emphasize this partnership's defining attributes: its emphasis on solidarity, nonviolence,
heterogeneity, collective effort, and shared responsibility. She also foregrounds its canny
mobilization of "women's work," as in the drawing that depicts a group of activists sitting
underneath the yarn web they wove around the entrance to the Pentagon.[12] Overall, Bow-
ers's drawings constitute acts of recovery, commemoration, and avowal—and deeply
recursive, self-conscious ones at that. Here the past is retrieved for, and from the perspec-
tive of, the present. That Bowers prioritizes drawing is significant. Drawing is a decidedly
bodily pursuit, enabling a bodily connection to its referent. Embodying the past as she
does allows Bowers to precipitate a concurrent process of empathy, investment, identifi-
cation, and politicization. The success of this process might not be guaranteed, but its
very existence suggests that eco-feminism is more than her drawings' thematic; it is their
intended result, as well.[13]

A wide range of art is reproduced in the 1981 issue of *Heresies,* all of it by women, and all of it on the subject of either nature or gender inequality. Scattered throughout the dozen or more profiles of female activists and environmental crusaders are examples of painting, drawing, theater, sculpture, assemblage, photography, lithography, Land art, landscape architecture, Body art, performance art, and community-based art. These projects are alternately ameliorative, demonstrative, diagnostic, investigatory, documentary, pedagogical, cartographic, participatory, collaborative, poetic, allegorical, or polemical in character. Many are interdisciplinary. Their subject matter is equally broad. Readers will find landscapes of various kinds, a few of which draw on goddess imagery (Georgiana Kettler). They will also find projects that yoke the female body to the Earth, physically and symbolically uniting woman and nature (Ana Mendieta, Faith Wilding, Barbara Strasen, Mary Beth Edelson). A few focus on restoration, remediation, and reclamation (Bonnie Sherk, Maryanne Caruthers-Akin, Harriet Feigenbaum, Phyllis Janto), while others highlight the detrimental effects of toxicity and pollution on animals as well as women and children (especially the poor) (Claudia Hollander, Cecilia Vicuña, Michelle Stuart,[14] Nina Wise, Lauren Elder). Issues such as abortion (Mary Linn Hughes, Barbara Margolies) and domesticity, technology, and child care (Joanne Leonard) are likewise broached.

Throughout this issue of *Heresies,* artist and eco-feminist share the page, but it is by no means clear that they also share a sense of purpose or political conviction. Indeed, the connection between the artists and environmental crusaders featured jointly is overall rather equivocal. On this point the editors are not much help. Not only do they avoid analyzing any of the works of art they illustrate, but they also fail to historicize or concretize the more general relationship between aesthetics, feminism, and environmentalism (a relationship they very much take for granted). Not even their introductory statement attempts to triangulate the three. (Such neglect might reflect a more general condition, that art seems to have played a minor role in brokering the summit between ecology and feminism, and that, unlike in the feminist movement, eco-feminism was not accompanied by a semi-autonomous, rigorously theorized body of art.) Instead of reasoned argument, the editors base their catalogue of art on an assumption: that the women artists they survey qualify as eco-feminists first and foremost because they are women. Insinuating that biology determines one's political affiliation, they fall into the same trap as more conservative eco-feminists.

If this is the *Heresies* issue's singular weakness, its primary strengths lie in its speculative approach to art, ecology, and feminism, and its expansive definition of eco-feminism and eco-feminist art, strengths that echo many of the characteristics of progressive eco-feminism. As the editors state in their introduction and then demonstrate through their diverse selection of work, feminists no more identify with feminism in exactly the same way as environmentalists do with environmentalism: Feminism means different things to different feminists, and the same for environmentalists and environmentalism. Some commitments might be spiritual and poetic in character, others material and political,

and still others more private than professional, impacting the individual but not necessarily the work she produces. Affiliation as a whole, the issue of *Heresies* implies, is an irreducibly complex, contingent activity.

Following from this, I would like to argue that what defines the most constructive encounters between art and eco-feminism—likewise the most fruitful encounters between ecology and feminism—is an investigatory spirit and a relative degree of eccentricity and heterogeneity. The exemplary work of eco-feminist art is not only hypothetical; it also pressures the very category of eco-feminist art, resulting in projects that are simultaneously critical and self-critical. In what follows, I sketch the outlines of what I call an "improper" history of eco-feminist art. My genealogy begins with an American artist featured briefly in *Heresies* 13—Mierle Laderman Ukeles—and ends with an Israeli artist from the generation following: Sigalit Landau. Both Ukeles and Landau think widely and idiosyncratically about gender, ecology, and justice. What counts as an ecosystem, they ask? To whom is the task of maintaining these ecosystems entrusted? Upon whom is it forced? Who is responsible for cleaning these ecosystems, for disposing of the decay and debris they generate? How is this labor distributed unequally across gender, class, race, and geopolitical lines? In what ways is dirt (as opposed to nature) similarly coded? Whose interests does the rhetoric of purity, sanitation, and hygiene serve? Whose are the most precarious ecosystems and why? What role do power inequities play? Insofar as ecology is defined broadly as the study of the relationships between organisms and their environments, the work Ukeles and Landau produce is emphatically ecological in character.[15] Their projects also make great progress in forming provisional unions between feminism and a broad range of social and environmental justice movements.[16]

Ukeles is represented in *Heresies* 13 by a call for proposals for the "Re-Raw Recovery Competition" cosponsored by the New York City Sanitation Department, with which the artist has been collaborating since 1977.[17] Ukeles's half-page square, designed to be cut out by interested parties, calls for "SITE PROJECTS for RECLAMATION of New York City's solid waste landfills . . . that *face* residential and commercial areas and thruways."[18] Even though the competition is open to just about anyone, including "artists, architects, landscape architects, environmentalists, earth dreamers, socio-political ecological creators, [and] sanitation workers," it is directed primarily to "FEMINIST/ECOLOGY/SITE/ CREATORS." Ukeles goes on to explain the project thus: "Garbage sanitary landfills are extraordinary urban sites composed of all the things we want to forget, public space-forms we have all made, sort of an inner-city outer-space. Envisioned as potential testing grounds for all kinds of site and earth creators, get into the real everyday context of New York City life."

"Re-Raw Recovery Competition" falls under the aegis of *Maintenance Art Works,* a series Ukeles began in 1969, the same year she published "Manifesto for Maintenance Art."[19] The latter sought to validate the most stigmatized, underpaid, monotonous forms of labor: what Ukeles called "maintenance" or the "back half of life."[20] Broadly speaking, maintenance refers to remediation—that is, to the activities of cleaning, disposing, pre-

serving, sanitizing, and restoring.[21] Maintenance workers are in the business of dirt, and their very proximity to waste renders them despoiled in the eyes of others.[22] To those sites requiring maintenance, Ukeles gave the name "system" or "maintenance system"; for my part, I prefer to think of them as ecosystems. The artist's brilliance was to admit into the category of ecosystem almost any site, whether domestic or urban, private or public, chemical or biological, and to reappraise the mostly unseen, debased labor force that sustained it. Publicizing and politicizing this labor force—comprised, as she well knew, mostly of women, people of color, and the lower and working classes—was the charge Ukeles assumed, and she did so initially by performing site-specific acts of maintenance (art). One of the earliest such projects occurred at the Wadsworth Atheneum in Hartford, Connecticut. Over the course of two days in July 1973, Ukeles polished a vitrine in one of the galleries, used diapers to wash the museum's steps, and trailed visitors as they entered the front court, eliminating whatever marks or detritus they left behind.[23] Insofar as its dependence on maintenance was disproportionate to the visibility and legitimacy it afforded actual maintenance workers, the Atheneum was just the sort of ecosystem that interested Ukeles.

Landau brings the model established by Ukeles even further afield. Besides scrutinizing the psychic, historical, and political economy of waste, Landau also expands the scope of remediation to include borders, nationality, and citizenship. In the process, she reframes both the category of dirt and the duty of maintenance.[24] For Landau, dirt constitutes any foreign body—any anomaly, any unassimilable other—that threatens the integrity or "health" of an ecosystem, whether national, municipal, anatomical, or museological. Maintenance, then, requires more of its workers than mere cleaning. It asks them to simultaneously police and fortify the boundaries between one ecosystem and another, especially the boundaries between inside and outside, self and alien. Insofar as containment is the goal of maintenance, according to Landau, its true enemy is less the pathogen than porosity, a condition the pathogen both exploits and precipitates. Inflecting dirt and maintenance the way she does allows Landau to investigate the broader geopolitical stakes of pollution and ecology, especially as they pertain to Israel and Palestine.

Take, for instance, Landau's 1995 exhibition *Temple Mount*, commissioned by the Israeli Museum in Jerusalem. Its centerpiece was *Wounded Territory*, a relief map of the Temple Mount, once the site of an ancient garbage dump and now the object of conflicting claims among Israelis and Palestinians.[25] *Wounded Territory* was comprised of five hundred mouse pads soaked in a potent stew of coffee, sugar, and chicken soup.[26] As it aged, this concoction spawned a thriving colony of fungi; alarmed, administrators insisted that Landau enclose the work in a Plexiglas vitrine. As if to acknowledge its status as an aesthetic biohazard, Landau inserted into the corner of *Wounded Territory* a basin of water, next to which she placed a bar of soap in the shape of a computer mouse. The purification ritual this gesture enabled was compromised, of course, by the proximity of the tainted mouse pads, which threatened to infect not only the soap, the water, and the visitor, but the museum as well. Pathogens circulated freely throughout Landau's

31. Sigalit Landau, *A Conversation with David Bugeleisen* (video still), 1995. Video, color, sound, 12 min. Courtesy the artist.

installation, at least until the curators stepped in and contained the sculpture within an impermeable bubble.

Wounded Territory was accompanied by several sculptures made of detritus and a video entitled *A Conversation with David Bugeleisen* (figure 31). The video consists of two parts. In the first, David Bugeleisen, the museum's conservator, details the threat presented by *Wounded Territory*. In the second, Landau infiltrates Jerusalem's sanitation network, traveling in one of the museum's garbage containers to and from a landfill in El-Azariya, a Palestinian neighborhood that has long accommodated Israeli trash and whose citizens often scavenge amid the refuse. Here, Landau not only leverages the long-standing identification of filth with marginality and difference, but also implicates an ecological injustice—the disproportionate siting of hazardous waste among poor, disenfranchised communities—within a broader constellation of social, political, and economic inequities. In the process, she analogizes two different maintenance systems: disposal and occupation. For her, both systems revolve around the eviction of foreign bodies from Israel and their isolation within the ever-shrinking borders of Palestine. These borders are far more permeable, and these maintenance systems more precarious, though, than we might expect. Indeed, if Landau's performance demonstrates anything, it is just how unstable the boundaries between Israel and Palestine actually are.[27] Generally speaking, remediation aims to re-territorialize that which is "out of place," as the anthropologist Mary Douglas once argued.[28] Landau, however, does the exact opposite: she deterritorializes the pathogen, allowing it to trespass. The result is a series of projects that tap the transgressive potential of waste and undermine the oppositional logic of Israel's twin maintenance systems.[29]

Mine has been a deliberately irreverent, speculative reading of art and eco-feminism, one that departs from the few existing texts on the subject, most of which focus on a relatively small group of women artists who utilize land or landscape-based imagery. I wanted, first, to create an alternative genealogy of eco-feminist art, one that dis-identified women and nature and prioritized the social relations of dirt, pollution, and sanitation. My larger goal was to foreground artists whose work models the original, democratic

promise of eco-feminism as exemplified in journals such as *Heresies,* and forges coalitions that incorporate but also exceed the categories of gender and ecology.

Still, the question of eco-feminism's promise in the present remains. What use value does eco-feminism have today? To this I answer: More than we can imagine. The battery of women and the exploitation of the environment are pervasive, systemic, and structural. As I write this coda, at the tail end of May 2014, several acts of misogynistic extremism and rank, vengeful sexism have taken center stage, including the abduction on April 25 of approximately 220 girls from a school in Chibok, Nigeria, by Boko Haram, a group of Islamic militants intent on (among other things) eradicating female education, and the shooting on May 23 of nineteen people in Santa Barbara, California, by Elliot Rodger, a self-described "alpha male" engaged in a retributive "war on women."[30] On March 31, just one month before the kidnappings in Chibok, the International Panel on Climate Change (IPCC) released its fifth major assessment, *Climate Change 2014: Impacts, Adaptation, and Vulnerability,* which summarizes the ongoing hazards posed by climate change to both human and natural systems.[31] Contained within this report is a discussion of the uneven distribution of climate precarity across gender and class lines. Ecological instability, the authors assert, frequently compounds existing inequities and insecurities, leaving poor women disproportionately vulnerable to the droughts, heat waves, forest dieback, floods, poverty, ill health, food scarcity, and civil wars that accompany climate change.[32] Women who live in rural communities, especially those in the Global South, face particular challenges. Insofar as they tend to serve as caregivers and small farmers, they rely on the very natural resources (water, food, vegetation, fuel wood) compromised by climate change. The "war on women" conducted by Boko Haram and Elliot Rodger might seem unrelated to the differential impact of climate change on women, but when we consider that climate change is primarily anthropogenic—the result of irresponsible stewardship and unbridled human development—parallels emerge. Indeed, Boko Haram's and Elliot Rodger's campaigns against women are authorized by the same ideology as ecological destruction, a worldview underwritten by entitlement (whether to women's bodies or the environment) and exceptionalism (whether of men or corporations).[33] More than this, they are symptomatic of the culture of brutality encompassing the globe today, one that sanctions violent masculinity alongside violent neoliberalism.[34] Few oppositional frameworks are better positioned than eco-feminism to grapple comprehensively with the dilemmas I have outlined here. With its twin commitment to the gender politics of ecology and the ecological politics of gender, eco-feminism lays the groundwork for precisely the critique of aggression and the orthodoxy of privilege and superiority that the twenty-first century so urgently requires.

NOTES

1. According to Catriona Sandilands, this issue of *Heresies* was one of the first anthologies to assemble writings on themes germane to both feminism and ecology. See her *The Good-Natured*

Feminist: Ecofeminism and the Quest for Democracy (Minneapolis: University of Minnesota Press, 1999), 17, 165–67.

2. Photographs from this protest are published on page 1 of *Heresies* 13 (1981). Pentagon Action Day represented the convergence of the feminist, environmental, peace, and antinuclear movements: On November 17, 1980, two thousand women descended on Washington, DC, to protest the threat that the military-industrial complex posed to both human and nonhuman life. Many of their actions were performative and symbolic in nature. For a transcript of the Unity Statement of the Women's Pentagon Action, visit http://www.wloe.org/WLOE-en /background/wpastatem.html (accessed December 7, 2012). For information about both the conference in Massachusetts and the Pentagon Action, see Carolyn Merchant, *Earthcare: Women and the Environment* (New York: Routledge, 1995), 149–52.

3. I was inspired to investigate art and eco-feminism for two reasons. The first was the passage of the Law of Mother Earth in Bolivia in April 2011. The law enshrines nature as an independent legal entity—more specifically, as a fully enfranchised *female* subject with equal protection under the law. The second was the relative lack of attention given to eco-feminism in recent books and exhibition catalogues on either feminist art or Land and environmental art. No substantial analyses of the collision of feminism and ecology appear, for instance, in Philipp Kaiser and Miwon Kwon, eds., *Ends of the Earth: Land Art to 1974* (Los Angeles: Museum of Contemporary Art, 2012); Francesco Manacorda and Ariella Yedgar, eds., *Radical Nature: Art and Architecture for a Changing Planet 1969–2009* (London: Barbican Art Gallery, 2009); Cornelia Butler, ed., *WACK!: Art and the Feminist Revolution* (Los Angeles: Museum of Contemporary Art, 2007); or Helena Reckitt, ed., *Art and Feminism* (London: Phaidon, 2001). I found this disregard rather curious and decided to begin to remedy it here. Jeffrey Kastner and Brian Wallis briefly address a few ecologically inflected feminist projects in *Land and Environmental Art* (London: Phaidon, 2005).

4. *Heresies* 13, preface.

5. At times, such imagery was also linked to the struggles of indigenous cultures, as was the case with some of Ana Mendieta's performances. Along with Lucy Lippard and others, Mendieta served on the editorial collective for the issue of *Heresies* under discussion.

6. *Heresies* 13, preface.

7. This more catholic approach to eco-feminism is reflected in the editors' choice of individuals to profile, including Rachel Carson, Karen Silkwood, Lois Gibbs, representatives from the India-based Manushi Collective, WARN (Women of All Red Nations), and Hattie Carthan, this last associated with the Brooklyn Magnolia Tree Earth Center. The editors also feature activists who focus on workplace safety, hunting, the fur industry, factory farming, and the politics of infant formula and breast-feeding.

8. See Joan L. Griscom, "On Healing the Nature/History Split in Feminist Thought," *Heresies* 13, 4–9.

9. The literature on eco-feminism is vast. Besides Sandilands's and Merchant's texts, a few of the most important studies include: Rosemary Radford Ruether, *New Woman New Earth: Sexist Ideologies and Human Liberation* (New York: Seabury Press, 1975); Maria Mies and Vandana Shiva, *Ecofeminism* (Halifax, Nova Scotia: Fernwood Publications, 1993); Karen J. Warren, ed., *Ecological Feminist Philosophies* (Bloomington, Indiana: Indiana University Press, 1996); and Greta Gaard, "Toward a Queer Ecofeminism," *Hypatia* 12 (winter 1997): 114–37.

10. See Sherry Ortner, "Is Female to Male as Nature Is to Culture?," in *Women, Culture, and Society,* eds. M. Z. Rosaldo and L. Lamphere (Stanford, California: Stanford University Press, 1974), 68–87.

11. Lucy Lippard discusses the motivations behind a 1987 protest against nuclear testing in Nevada on Mother's Day by a group named Pele, after the Hawaiian Earth goddess of volcanoes, in "Women Confront the Bomb," in *The Pink Glass Swan: Selected Essays on Feminist Art* (New York: New Press, 1995), 228–30.

12. This gesture, as well as the activists' more general recitation of women's work, resembles Faith Wilding's 1972 installation *Womb Room* in the Los Angeles–based *Womanhouse.* For more information, see Lydia Yee et al., *Division of Labor: "Women's Work" in Contemporary Art* (New York: Bronx Museum, 1995).

13. For more on Bowers, see Connie Butler et al., *Nothing Is Neutral: Andrea Bowers* (Los Angeles: California Institute of the Arts and REDCAT, 2006) and Claire Gilman, "Marking Politics: Drawing as Translation in Recent Art," *Art Journal* 69 (fall 2010): 114–27. Since 2003, Bowers has produced a great deal of work that integrates her feminist and environmental commitments and triangulates gender, ecology, justice, and indigeneity, including her 2009 exhibition at Andrew Kreps Gallery, New York, and her 2010 show at Susanne Vielmetter Los Angeles Projects.

14. Stuart, an artist well known for her long-standing interest in the environment as subject and material, was one of the founding members of the Heresies collective.

15. According to the Oxford English Dictionary, the word "ecology" derives from the Greek word *oikos*, for "house" or "dwelling," and the Greek suffix *logia*, for "study." Herein lies one source of the frequent elision of house-keeping and Earth-keeping. Importantly, "economics" shares the same Greek root as "ecology." "Nomics," in turn, derives from the Greek *nomos* (for "managing"). In a very strict etymological sense, then, "economics" refers to the management of the home. For my part, I'm interested in the political and symbolic implications of these linguistic coincidences, and they inform my reading of the art here.

16. Their approach to ecology and environmentalism places them squarely at the intersection of what T. J. Demos describes as two major currents within ecologically inflected art: systems ecology and political ecology (*Radical Nature,* 21–28). It also aligns them with Greta Gaard, for whom eco-feminism's ability to build coalitions constitutes one of its strengths. See her 1997 essay in *Hypatia.*

17. Ukeles is the Department of Sanitation's first and only artist in residence. See Jeffrey Kastner, "The Department of Sanitation's Artist in Residence," *New York Times,* May 19, 2002 (accessed November 17, 2012).

18. *Heresies* 13, 76. Ukeles is joined in this issue of *Heresies* by Christy Rupp, another "garbage girl" (so called by Lucy Lippard). See *Heresies* 13, 81, and Lippard's essay "The Garbage Girls," in *The Pink Glass Swan,* 258–65. Lippard is one of only a few art critics who have explored the relationship between feminism and ecology.

19. Mierle Laderman Ukeles, "Manifesto for Maintenance Art 1969! 'Care,' A Proposal for an Exhibition" (1969), accessed December 7, 2012, http://www.feldmangallery.com/media /pdfs/Ukeles_MANIFESTO.pdf. Excerpts from the manifesto, along with photographs of Ukeles performing household chores, appeared in *Artforum* 9 (January 1971): 40–45. Bowers has also addressed the subject of maintenance in a work about the ongoing preservation of the AIDS Memorial Quilt.

20. Sherry Buckberrough and Andrea Miller-Keller, *Mierle Laderman Ukeles / MATRIX 137* (Hartford, Connecticut: Wadsworth Atheneum, 1998), 2. Ukeles was by no means the only feminist artist to demonstrate an interest in the gender politics of domesticity and housework. See Helen Molesworth, "House Work and Art Work," *October* 92 (spring 2000): 71–97. The first issue of *Heresies* also included a trenchant essay on labor and women: Pat Sweeney, "Wages for Housework: The Strategy for Women's Liberation," *Heresies* no. 1 (January 1977): 104–6.

21. Maintenance is also the work that makes possible every other form of work.

22. The dirt, waste, and pollution in which maintenance workers traffic is of a different variety than the kind we typically associate with eco-art. It's not the by-product of an oil refinery, coal mining, illegal dumping, or development. It's not associated with extractive or productive industries per se. It is better characterized as refuse—residue of the body, consumption, and domesticity.

23. Ukeles's performance was part of the exhibition *c. 7,500*, curated by Lucy Lippard. Ukeles considers "maintenance" through both a feminist and an ecological lens, framing waste, dirt, and pollution as both domestic and environmental problems.

24. The contributors to a 2011 book also treat "dirt" as a broad category of biological and environmental material implicated in wide-ranging social, political, and economic relations, all of which are invested with extraordinary symbolic currency. The book features the work of several artists, including Ukeles. See Rosie Cox et al., *Dirt: The Filthy Reality of Everyday Life* (London: The Wellcome Trust, 2011).

25. Certain features have been removed from Landau's relief map in an effort to efface a contested symbol and enable conversation.

26. See Ariella Azoulay, *Death's Showcase: The Power of Image in Contemporary Democracy* (Cambridge, Massachusetts: MIT Press, 2001), 184. Azoulay also discusses Landau's 1995 project on pages 188–92.

27. Landau crossed the Green Line, a 1948 armistice line that separates West and East Jerusalem, twice while traveling to and from El-Azariya. The history and status of the Green Line is very complex. For more information, see Azoulay, *Death's Showcase*, 195–200.

28. See Frazer Ward, "Foreign and Familiar Bodies," in *Dirt and Domesticity: Constructions of the Feminine* (New York: Whitney Museum of American Art, 1992), 9. Frazer discusses the "social relations" of dirt as framed by a suite of American artists, using Mary Douglas, Julia Kristeva, and Georges Bataille as his guides. His approach has influenced my reading of Landau's work.

29. For more on Landau, see Jean de Loisy et al., *Sigalit Landau: One Man's Floor Is Another Man's Feelings* (Dijon, France: Les presses du réel, 2011) and Gabriele Horn and Ruth Ronen, eds., *Sigalit Landau* (Ostfildern, Germany: Hatje Cantz, 2008).

30. I borrow the phrases "vengeful sexism" and "misogynist extremism" from Laurie Penny's May 25, 2014, article in the *New Statesman*, "Let's Call the Isla Vista Killings What They Were: Misogynist Extremism," accessed May 28, 2014, http://www.newstatesman.com /lifestyle/2014/05/lets-call-isla-vista-killings-what-they-were-misogynist-extremism.

31. For a shortened version of this report created for policy makers, see http://ipcc-wg2 .gov/AR5/images/uploads/IPCC_WG2AR5_SPM_Approved.pdf (accessed May 28, 2014). For the complete report, see http://www.ipcc.ch/report/ar5/index.shtml.

32. The general deficit of rights that women face as well as their relative lack of access to wealth, resources, mobility, health care, and education make adjusting to climate change equally difficult. The IPCC's 2007 report includes a valuable summary of what it calls "gender aspects of vulnerability and adaptive capacity," http://www.ipcc.ch/publications_and_data/ar4/wg2/en/ch17s17-3-2-3.html. Eco-feminism underwrites several of the programs spotlighted by Momentum for Change: Women for Results, a program launched by the United Nations Climate Change Secretariat in December 2012. The program recognizes a range of groups run by and for women, many of them located in the Global South, that attempt to ameliorate the myriad threats that climate change poses to women and provide them with physical, environmental, and financial security. For more information, see http://unfccc.int/secretariat/momentum_for_change/items/7318.php (accessed May 28, 2014).

33. My use of "entitlement" here is indebted to Laurie Penny's article "Let's Call the Isla Vista Killings What They Were: Misogynist Extremism" as well as to Rebecca Solnit's thinking on the Santa Barbara murders. See her interview with Amy Goodman on *Democracy Now!*, accessed May 28, 2014, http://www.democracynow.org/2014/5/27/yesallwomen_rebecca_solnit_on_the_santa. Solnit has long been an activist in feminist, antiwar, and environmental coalitions, and her writing represents an especially exciting confluence of multiple areas of political engagement.

34. The Niger Delta, where Royal Dutch Shell has been drilling for oil for decades, exemplifies precisely the confluence of violence, entitlement, and exceptionalism I have in mind. Petroleum hydrocarbon pollution, soil and water contamination, and human rights abuses (including the rape and murder of local women) have all accompanied Shell's extraction of resources from this ecosystem—acts endorsed and supported by the Nigerian army. For more information, see http://platformlondon.org/wp-content/uploads/2011/10/Counting_the_Cost.pdf (accessed May 29, 2014).

12

NUIT BANAI

on Sigalit Landau, *DeadSee* (2005)

Since 2004, the Israeli artist Sigalit Landau has been producing artworks in the Dead Sea, the world's most saline body of water. Having the lowest elevation on land anywhere on Earth and bordered by Israel, Jordan, and the territories of the Palestinian Authorities, the Dead Sea is renowned for its valuable minerals and for being inhospitable to organic life. Landau has embraced this site of ecological and geopolitical extremes and transformed it into a physical and symbolic laboratory for the fabrication of uncanny objects, the exploration of the individual and collective body's relationship to a fraught landscape, and a poetic inspiration for potential cooperation in the region.

In one of Landau's most emblematic interventions, the 2005 video titled *DeadSee*, a spiral "raft" of five hundred watermelons, connected together by cord, slowly rotates counterclockwise. As the camera pans from cropped detail to panoramic bird's-eye view, Landau's naked body comes into view, a slither of pale skin inserted into the buoyant mass of green fruit. With her right arm reaching out toward an area of fleshy redness, a cluster of perfectly ripened watermelons whose rinds have been cut open, she becomes incorporated into the unfurling helix and eventually floats out of the frame.

Vividly intersecting with Robert Smithson's *Spiral Jetty* (1970), Landau's ephemeral environmental work denies the possibility of erecting, let alone preserving, a monument in the Dead Sea by replacing the mud, salt crystals, and basalt rock of the Great Salt Lake in Utah with even less heroic "native" materials. If both saline bodies of water are harsh natural environments, they function as framing devices that illuminate the lives and cultures that manage (often against all odds) to thrive in these regions, whether the

32. Sigalit Landau, *DeadSee* (video still), 2005. Video, 11:37 min. Courtesy the artist.

Native Americans and Mormons who settled in Utah, or the Jews and Arabs who make their home in the desert around the Dead Sea's perimeter. Specifically, Landau "riffs" on the reddish color of the Great Salt Lake, a result of the algae growing in the salty water, by intertwining her own body with ripened watermelons as a symbol of fertility. In the local context, watermelons connote indigenous identity and a sense of "belonging" (to the cycles of cultivating and harvesting the land) in both Arab and Israeli national mythologies. Yet if they contain feminine qualities, for instance their rounded shape and abundance of seeds, the act of choosing, transporting, and slicing a watermelon is traditionally a man's task in both Arab and Israeli cultures. Moreover, if they have functioned as symbols of the new Jewish homeland in many paintings from the 1920s to the present, their colors (red, black, and green) are also those of the Palestinian flag.

Any attempt to physically dominate this particularly fragile topography of the Dead Sea, a nod not only to the salt manufacturing plants that have cropped up along its shores but also to the recent development of industrially engineered watermelons that become even sweeter when grown with salt water, will thus have material repercussions on a shared symbolic and material resource that is vital to home-grown histories, identities, and cuisines. To continue in this vein, if the water's hyper-salinity makes prolonged immersion ultimately harmful for most types of living matter, it has also provoked a new species of watermelon that thrives in the salty environment. Meanwhile, the ongoing industrial exploitation of the Dead Sea's rich mineral deposits and political designs to desalinate and utilize it as a source of fresh water by all three of its territorial neighbors poses an imminent threat to its existence.

If *DeadSee*'s genealogy draws upon Robert Smithson's consideration of the tension between monument and anti-monument, site and non-site, Landau's bodily transaction with the Dead Sea and her negotiation of its sociopolitical, historical, and economic dimensions points to reciprocal relationships among physical, institutional, and discursive constellations of power. The body of the artist and the body of water in which it floats are highly complex and mediated systems and surfaces for inscription that are equally susceptible to extinction and evaporation, immediately through extended bathing in the Dead Sea, and, on a metaphorical level, in the current geopolitical situation. Yet, as Landau makes clear, by interweaving her body into the chain of watermelons and their plural symbolic connotations, the Dead Sea is not only a point on the map at which a wide network of past and present ideologies, aspirations, and subjectivities overlap, but also an imagined territory in which new realities might be envisioned and crystallized from a condition of acute crisis.

13

YAZAN KHALILI

What Is a Photograph? (2013)

I have been yearning to write about another landscape, the one that exists in a photograph I took in Sweden a couple of years ago, of three kids standing on a wooden dock in a gray lake. Green trees form a line that crosses the left side of the photo, water meets the horizon on the far right. In the foreground, there is green grass with spots of brown soil. The sky is light blue, but some cloud formations leave blotches of gray. The three kids are in the center of the photograph, one of them is lifting his arms and waving to me. They were screaming unintelligible words. I saw them, I heard them, and I took the photograph just before they disappeared into the water.

I have been wanting to write about that Swedish landscape. There is something about it that reminds me of the landscape here, in Palestine. Is it the three kids wanting to be photographed? Or is it the photograph itself that holds this memory?

The serenity of this photograph reminds me of the calmness of another photograph, one of a kid who suddenly came running into my frame just as I was taking a photograph of a landscape I came across some summers ago. He was aiming his rock at the soldiers who appear in a third photograph. I wanted to photograph the green olive trees that stood out in the middle of the dry yellow grass, the white limestone in the foreground, the faraway villages scattered on the hills in the distant horizon. I took the photo before he threw the rock, and before I ran away from the smell of the tear gas. He is bending his body, one leg behind the other, waving a robe with a rock in it aiming at the nowhere.

33. Yazan Khalili, *A photograph that reminds me of nothing*, 2011. Courtesy the artist.

I have been yearning to write about that Palestinian landscape as an event. The landscape itself in the photograph contains oppression and resistance simultaneously; we watch the landscape watching us through its surveillance cameras, lights, checkpoints, watchtowers, et cetera.[1] And the question becomes: How do we return the gaze? The three kids remind me of the Palestinian landscape, but not of the kid throwing the rock. They were watching me watching them, they performed for the camera, they were that calm landscape that is spread on the two photographs. But the Palestinian kid was not there to be part of a landscape, he was actually fighting against it. Doesn't it seem as if he is throwing his rock at the landscape itself? This same landscape that is watching him?

Anyway, I have been wanting to write about a fourth photograph, a photograph that reminds me of nothing . . .

NOTES

1. The Israeli occupation uses light to strengthen its control on the land and the visual consciousness/memory of the Palestinians, but at the same time, light itself becomes the visual manifestation of its brutality and desperate attempts to claim its ownership, not-belonging-to, of this "orientalized," "uptop-down looked at" landscape, modernizing it, becoming a method of conquering and reestablishing that belongs to a Western, developed world. Checkpoints, settlements, military bases, and highways look like human settlements on the moon, or like

a Star Trek ship that landed from nowhere. Their light is so strong that you can see them from far away at any time of the night, and so overwhelming that you can barely see anything else when close up. They make the Other become invisible. There is a kind of paradox of how light works in this space. It makes the occupied visible and invisible at the same time: visible to the occupier and invisible to modernity.

14

AARON BOBROW-STRAIN

on Allora & Calzadilla, *Land Mark (Foot Prints)* (2001–2)

The bodies appear as orange blurs on infrared scanners, picked up as they cross a secure perimeter. Military police arrive and video cameras roll. Shutters open and close on all sides. Evidence of the protestors' presence causes cease-fire signals to bend across air and ocean. But only later, after the "trespassers" have been cuffed and removed, do their physical traces on the land come into view: dozens of individual messages embossed in the damp sand of the Vieques Naval Bombing Range by rubber stamps attached to the protestors' shoes. One footstep has left a map of Vieques with the Range X-ed out. Another depicts what appears to be a plan for new housing on the island. One offers a small print manifesto about territorial rights; another simply reads, "*Ni una bomba mas.*"

For decades, residents of Puerto Rico's Vieques Island fought to halt the U.S. Navy's annihilation of their home. Faced with a season-less toxic rain of shells, bombs, napalm, depleted uranium munitions, and, in at least one documented case, germ warfare agents, neighbors of the Range countered with civil disobedience and ad hoc "emergency designs" that turned everyday objects into technologies of political resistance. In the 1970s, for example, fishermen welded great sea monsters out of scrap metal pieces. When floated with buoys and deployed like clawed spiral jetties, they tangled propellers and crippled naval operations.

In 2001, the Puerto Rico–based artists Jennifer Allora and Guillermo Calzadilla inserted themselves into this tradition of civil disobedience and emergency design. In collaboration with community groups, they invited activists to create personal messages of resistance, refusal, and territorial renewal. The artists then cast each protestor's text

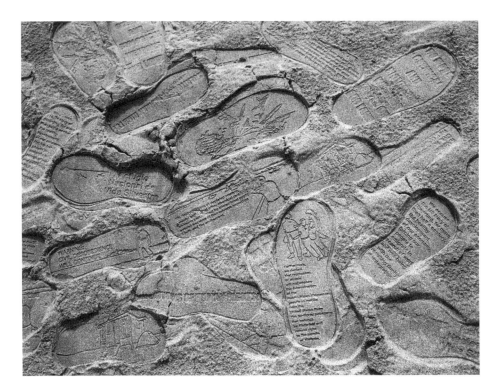

34. Allora & Calzadilla, *Land Mark (Foot Prints)*, 2001–2. Twelve digital chromogenic prints, 48.8 × 60.3 cm each. Courtesy the artists and Chantal Crousel Gallery, Paris, © Jennifer Allora & Guillermo Calzadilla.

and graphics as a rubber sole that could be attached to a shoe and worn during illegal incursions (read, territorial reclamations) on the Range.

In this way, ambulant printmakers marked territorial claims in the receptive ground, a political ecological interaction between body, earth, and colonialism. According to one source, the Vieques Range carries the scars of more craters per square meter than the surface of the moon. But Allora & Calzadilla were careful to distinguish *Land Mark (Foot Prints)* from that other famous territorial marking: Neil Armstrong's singular, permanent boot stamp on the windless plain of the Sea of Tranquility. The footprints of *Land Mark (Foot Prints)* were immediately perishable and mundane, not monumental. The ephemeral markings did not claim the Vieques Range as a conquest (or even a re-conquest), but simply made visible claims about the space's rightful place in the islanders' everyday geographies.

Unlike Armstrong's trace, with its universal aspirations, *Land Mark (Foot Prints)* did not claim Vieques in the name of "mankind," or even a homogenous "local" community. The protestors' feet made a diverse cacophony of impressions. Each footfall left a different individual's message, and each message sat in relation to many others. Competing

visions for Vieques's future landed alongside one another. One footprint occluded another, and multiple impressions combined to form something new. In this sense, *Land Mark (Foot Prints)* materialized a particular vision of radical social movements: Movements are not the product of unified identities or ideologies, but rather tentative and fragile assemblages of different positions worked out in practice. What *Land Mark (Foot Prints)* left on the beach (for a moment, at least) was the choreography of "one world in which many worlds fit."

POSTSCRIPT

In 2003, the U.S. Department of Defense ended operations on Vieques. Continual disruptions had made the bombing range too costly, while new technologies made it unnecessary. But the protests were not entirely successful. Instead of returning the Range to local control, federal authorities re-enclosed it, creating the Vieques National Wildlife Refuge. The battered landscape underwent a now-common military-to-wilderness conversion (see the following text by Shiloh Krupar). This bit of administrative magic did not, however, bring with it full remediation of the Refuge's toxic residues. Visitors today might consider donning space suits to protect themselves from uranium, lead, and PCBs before planting footprints in this brave new "nature."

SOURCES

Aldinger, Charles. "U.S. Admits Germ Warfare Tests During Cold War." *Reuters,* October 9, 2002.

Allora, Jennifer, and Guillermo Calzadilla. *Land Mark.* Paris: Palais de Tokyo, 2006.

McKee, Yates. "Wake, Vestige, Survival: Sustainability and the Politics of the Trace in Allora and Calzadilla's *Land Mark.*" *October* 133 (2010): 20–48.

Obrist, Hans Ulrich. "Allora and Calzadilla: Talk About Three Pieces in Vieques." *Artforum International* 43, no. 7 (2005): 205.

Scmelzer, Paul. "The Art of Response-Ability: An Interview with Jennifer Allora and Guillermo Calzadilla." *Eyeteeth,* April 7, 2004. http://eyeteeth.blogspot.com/ 2004/04/ art-of-response-ability-interview-with.html.

15

SHILOH KRUPAR

Where Eagles Dare (2013)

E A G L E

MEMO

TO: The Reader

FROM: The EAGLE Collective

CC: Shiloh R. Krupar Field Office

DATE: January 1, 2013

SUBJECT: Report on the Pedagogical Legacies of Military-to-Wildlife (M2W)
 Conversions

The Environmental Artist Garbage Landscape Engineers (EAGLE) have released a report on military-to-wildlife (M2W) conversions taking place in the United States. "M2W" refers to the decommissioning, remediation, and transfer of U.S. Department of Defense (DOD) and U.S. Department of Energy (DOE) land holdings to the U.S. Department of the Interior's Fish and Wildlife Service (FWS), which administers the National Wildlife Refuge System. The report investigates one specific M2W case: the Rocky Mountain Arsenal National Wildlife Refuge (RMANWR), a former U.S. Army chemical weapons manufacturing facility and Superfund site near Denver, Colorado. This arsenal played a historic role in

establishing U.S. military air power, and later became embroiled in numerous contamination incidents and court battles. Upon M2W conversion, the site was actively promoted as an urban sanctuary. It is now considered a model for other military sites and former defense areas.

The report is the culmination of decades of EAGLE subcontracting work at the arsenal, following the on-site discovery of twenty roosting bald eagles. Invoking the bald eagle as a national symbol, EAGLE—an agency of environmental forensics and human inquiry—has scavenged information and assembled evidentiary exhibits about M2W conversions, specifically the environmental education and knowledge supported by the RMANWR. The following are highlights of EAGLE findings.

EAGLE Report Overview

The M2W conversion of the RMANWR has involved:

Pedagogical investments in a creation story: in animals as signs of purity and the native, and in the moral landscape of nature preservation

· Highlight: The Bald Eagle and the Bison

The bald eagle was conscripted as the harbinger of a new origin story, rescuing purity in the service of the national imaginary. The material unsustainability of war, and spiral of environmental litigation, cleanup costs, and blame constituting Arsenal history, would now be balanced in social fantasy by the site's return to nature. Eagle presence was also instrumentalized to create a budget cleanup: Higher levels of contamination could remain in place; the land need only be fit for wildlife and the minimal human contact entailed by nature refuge reclassification of the site. Following the cultivated residency of the bald eagle, these megafauna were reintroduced to restore native prairie and authenticity, add cultural and historical value, and atone for the elimination of the bison from native heritage. The stockpile of genetically pure bison would return the land to a mythic origin, drawing on imperial nostalgia for the frontier and reversing the historic decimation of the animal and the forced removal of Plains-area American Indians who relied on the bison. Reflecting a deeply racialized ecology and mythic biogeography, bison reintroduction has transformed the M2W conversion of the RMANWR into a reenactment of settlement, but with a salvational ethic.

Strategic cultivation of nature spectacle and reinvestment in the land as a habitat island in a sea of suburban sprawl, as a store of Colorado state native values, and as consumable scenic value

· Highlight: The Rod and Gun Club Viewing Blind & Gateway to the Prairie

In spite of the treatment of nature as blastpad or dumping ground, military enclosure was reinterpreted as a benevolent gesture of environmental protection. The structural remains

of former Army recreational hunting provided mythic support for M2W conversion. Viewing blinds would now facilitate the consumption of nature as scenic experience and photo surface. The activities of nature scouting and online surveillance of the refuge make animals available for eco-consumption. Arsenal land and subaltern animals would become central figures in city improvement campaigns and economic boosterism. The town of Commerce City, near Denver and known for its foundry smokestacks, refineries, sugar beets, and stockyards, debuts the prairie gateway to the RMANWR: an extensive trail system, a new professional sports stadium, Colorado-lifestyle shopping, and a civic center. Despite water contamination and environmental racism associated with the arsenal's toxic plume, themed real estate developments ring the refuge, bearing the names Buffalo Highlands, Aspen Hills, and Eagle Creek.

Aggressive environmental education campaigns that secure the RMANWR's origin story and draw visitors to participate in the benevolent regime of wildlife management

· Highlight: Habitat Island Lesson Plans

The FWS invites thousands of schoolchildren to the RMANWR for supervised refuge animal hunts and wildlife watch workshops. Nature programming calls forth children's bodies as sites of value; learning is treated as an investment in certain ways of thinking and acting. The environmental campaigns surrounding the RMANWR ensure that children will be developed as subjects that enact desire for untouched nature and maintain the M2W moral landscape.

The M2W conversion process has sanitized the violent historical geographies of the military and frontier. Further, M2W conversions intensify existing moralism about saving wilderness in ways that depoliticize and obscure the ongoing socioecological, material transformations of sites such as the RMANWR. M2W conversions can only ever show evidence of successful recuperation, in order to maintain the disposal of responsibility for contamination and harm. M2W refuges are symbolic redefinitions of the state in terms of environmental protection; militarization continues under the sign of the advocacy of nature and its recuperation from humans, concealing that toxicity and exposures continue.

Action Required: The development of an environmental ethics that rejects the state's claim that nature is purity and responds to the M2W division of nature/human with a commitment to more uncertain materialities—to stewardship of the wastes and material remains of militarization.

16

NICHOLAS BROWN

The Vanishing Indian Repeat Photography Project (2011–)

In 1997, Al Gore delivered a speech about the perils of global climate change from the base of Glacier National Park's iconic Grinnell Glacier. In 2011, Stephen Colbert quipped, "Visitors will flock to Glacier National Park once it becomes Glacier National Water Park."[1] And the following year, two photographs of Grinnell Glacier—one from 1940 and the other from 2006—were shot into space as part of Trevor Paglen's *Last Pictures* project.[2] Clearly, vanishing glaciers have entered our collective imagination as one of the preeminent symbols of climate change.

One hundred years ago, however, the vanishing Indian, not the glacier, served as the park's icon. At the time of its creation in 1910, Glacier National Park, in partnership with the Great Northern Railway, marketed itself as the premier destination to see vanishing Indians.[3] "The Indian life is [a] distinctive feature which is attractive to the American tourist in these latter days of the rapid passing of the red man," observed the journalist Hoke Smith in 1913. "There probably is more Indian legend [at Glacier Park] than in any other area of 1,400 square miles upon the face of the earth," he boasted.[4] In 1926, a Great Northern advertising campaign featured a portrait by Winold Reiss of a prominent Blackfeet Indian beneath the heading: "Chief Two Guns White Calf Invites You to Glacier National Park."[5] By 1936, White Calf had disappeared from the railroad's promotional materials. In his place, glaciers beckoned prospective tourists to the region: "Sky-born glaciers—sixty of them—invite you to Glacier National Park on the Roof of the Rockies, where romantic lakes and shimmering waterfalls provide [a] setting . . . long to be remembered!"[6]

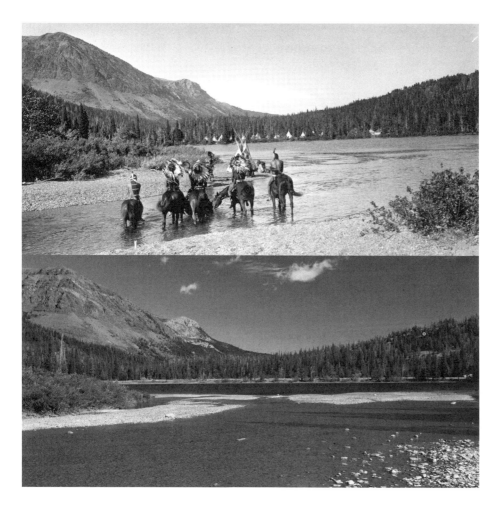

35. Top: R. E. "Ted" Marble, *Five Blackfeet on Horseback Crossing Stream at Two Medicine,* 1915. Glacier National Park Archives, HPF 1655. Bottom: Nicholas Brown, *Two Medicine,* 2011.

Today, the phenomenon of vanishing glaciers has spawned contests to rename Glacier National Park and fueled the rise of "doom tourism"—a form of ecotourism that highlights the devastating effects of global warming. In addition, the spectacle of vanishing glaciers has reproduced a strangely familiar rhetoric, in which the remaining glaciers are described as "feeble remnants," "degenerate relics," and "last vestiges."[7] This, of course, resonates with nineteenth-century accounts of an expanding empire. The inexorable decline of Indians was often described—in glacial terms—as a "wasting" or "melting away." The Indians would vanish, it was believed, "as the snow melts before the sunbeam," or "before the glow and heat of a Christian civilization."[8] Indians and glaciers, moreover, have served as "barometers," "harbingers," and "canaries in the coal mine," offering clues about our collective sense of justice during periods of profound change.

Just as photography was instrumental to preserving a record of a supposedly "vanishing race" in the nineteenth and early twentieth centuries, the practice of repeat photography has emerged as one of the most potent means of visualizing glacial recession in the twenty-first century.[9] Mimicking the U.S. Geological Survey's Repeat Photography Project, which has documented retreating glaciers in Glacier National Park since 1997, my *Vanishing Indian Repeat Photography Project* (VIRPP) calls attention to the continuity of the vanishing logic by linking the region's colonial past to its colonial present.

Like the USGS project, the VIRPP begins in the archives, where historical photographs depicting Indians in and around Glacier National Park are identified and cataloged. Next, in consultation with park staff and tribal members, the precise locations of the historical photographs are determined. Finally, new photographs are shot from exactly the same locations. The present-day photographs are then juxtaposed with the historical images in order to portray changes in the landscape. Indians are missing, of course, from the vast majority of these contemporary photographs. The Blackfeet warrior, for instance, dressed in full regalia and posing on horseback beside a placid lake in the historical photograph, has obviously moved on. Nevertheless, the glaring absence of Indians in the repeat photographs speaks, ironically, to an enduring and evolving presence. The project, in other words, testifies to indigenous "survivance," which the Anishinaabe writer Gerald Vizenor defines as a combination of survival and endurance.[10]

In addition, the project explores how photography and repeat photography establish and maintain baselines of authenticity. And it reveals the historical contingency of these baselines and temporal horizons, which are embedded in and legitimated through the practice of repeat photography. If the project challenges the myth of the vanishing Indian, it also suggests that the contemporary "endangered glacier narrative" is predicated on the historical vanishing Indian narrative.[11] Arguably, the trope of the vanishing Indian—or what Jean O'Brien calls "a narrative of Indian extinction"—has calibrated our vision, making it easier for us to see vanishing glaciers today.[12] Historicizing the vanishing glacier, thus, raises questions about the legibility of indigeneity in the present tense and the extent to which our expectations are constrained by "endangered authenticities" produced in the past tense.[13]

By focusing on the *continuity* of the vanishing logic, the VIRPP interprets colonization as an ongoing process rather than a historical event, which, in turn, sheds light on the structural dimensions of settler colonialism. Emphasizing structural continuities in this landscape of perpetual vanishing, therefore, challenges the tendency to bracket ongoing processes of colonization out of an equation that defines "the fierce urgency of now" exclusively in relation to climate change. Critically engaging Marx's theory of primitive accumulation, Glen Coulthard seeks to "make it more relevant to an analysis of colonial domination and indigenous resistance."[14] Reframing it as "an ongoing practice of dispossession," Coulthard recommends "shifting our analysis from primitive accumulation's

primary emphasis on the capital-relation to the colonial-relation."[15] By exploring the conjunction of vanishing glaciers and Indians at Glacier National Park, the VIRPP proposes a similar shift to the colonial-relation within the context of climate change. The project ruptures a temporal boundary that has kept the story of yesterday's vanishing Indian separate from that of today's vanishing glacier, insisting, instead, that we consider them as parts of the same story.

NOTES

1. *The Colbert Report,* February 28, 2011, accessible at http://www.colbertnation.com/the-colbert-report-videos/375740/february-28–2011/tip-wag———joe-reed———levi-s-ex-girl-friend-jeans.

2. Trevor Paglen, *The Last Pictures* (Berkeley: University of California Press, 2012). For additional details, see the project website, http://creativetime.org/projects/the-last-pictures/.

3. Mark David Spence, *Dispossessing the Wilderness: Indian Removal and the Making of the National Parks* (New York: Oxford University Press, 1999), 71–100.

4. Hoke Smith, "Wonders on Roof of Continent Make Glacier National Park Marvel Land," *Duluth Herald,* May 26, 1913.

5. M382 (roll 1, frame 40), Advertising and Publicity Department records, Great Northern Railway Company records, Minnesota Historical Society.

6. Ibid. (roll 2, frame 363).

7. Allen Salkin, "'Tourism of Doom' on Rise," *New York Times,* December 16, 2007.

8. Brian W. Dippie, *The Vanishing American: White Attitudes and U.S. Indian Policy* (Middletown, Connecticut: Wesleyan University Press, 1982), 13; Jean O'Brien, *Firsting and Lasting: Writing Indians out of Existence in New England* (Minneapolis: University of Minnesota Press, 2010), 97.

9. The anthropologist James Clifford describes the "salvage paradigm"—which links Indians and glaciers as objects of study—as "a pervasive ideological complex." James Clifford, "The Others: Beyond the 'Salvage' Paradigm," *Third Text* 3, no. 6 (1989): 73.

10. For examples from the USGS Northern Rocky Mountain Science Center's Repeat Photography Project, see the NOROCK website, http://nrmsc.usgs.gov/repeatphoto/. In contrast to absence or powerlessness, "survivance" affirms indigenous presence and agency in the past and present. In the preface to *Manifest Manners,* Gerald Vizenor defines "survivance" as "an active sense of presence, the continuance of native stories, not a mere reaction, or a survivable name. Native survivance stories are renunciations of dominance, tragedy, and victimry." Gerald Vizenor, *Manifest Manners: Narratives on Postindian Survivance* (Lincoln, Nebraska: University of Nebraska Press, 1999), vii.

11. The environmental historian Mark Carey identifies the recent emergence of an "endangered glacier narrative." Mark Carey, "The History of Ice: How Glaciers Became an Endangered Species," *Environmental History* 12, no. 3 (2007): 497–527.

12. Jean O'Brien, *Firsting and Lasting,* xiii.

13. James Clifford, *The Predicament of Culture: Twentieth-Century Ethnography, Literature, and Art* (Cambridge, Massachusetts: Harvard University Press, 1988), 5.

14. Glen Coulthard, "Subjects of Empire? Indigenous Peoples and the 'Politics of Recognition' in Canada" (PhD dissertation, University of Victoria, 2009), 12.

15. Ibid., 213–14. The shift is necessary, Coulthard argues, because the history and experience of dispossession, as opposed to proletarianization, "has been the dominant background structure shaping the character of the relationship between Indigenous peoples and the Canadian state," 19–20.

17

LORENZO PEZZANI

on The Decolonizing Architecture Art Residency,
Return to Jaffa (2012)

Return to Jaffa (2012) is a project by the Decolonizing Architecture Art Residency (DAAR), an art and architecture collective and residency program founded by Sandi Hilal, Alessandro Petti, and Eyal Weizman in Beit Sahour (Occupied Palestinian Territories).[1] It examines the transformation of the southern coastline of Tel Aviv as a way of engaging with the notion of the "right to return," which since 1948 has defined the diasporic and extraterritorial nature of Palestinian politics and cultural life. Traditionally indicating the right to return to the villages and lands from which Palestinians were violently expelled after the Nakba, return is understood by DAAR not only as a future ideal but also as a series of transformative material practices grounded in the present. *Return to Jaffa* acknowledges the impossibility of going back to an idealized past that does not exist anymore and, in the words of DAAR, chooses to engage with "the spatial regime of dislocation [associated with the figure of the refugee that] both reshapes the political space of the present and forces us to image a new political space yet to come."

Conceived in the context of a design studio led by DAAR at the Berlage Institute in Rotterdam, the project started with a careful examination of photographic documentation of the Tel Aviv seaside taken from the citadel of Jaffa, which has constituted since the late 1920s a privileged vantage point for the Zionist gaze to observe the expansion of Tel Aviv. Engrained in a variety of images, though, is also the concurrent erasure of the traces of Manshiyya, the Palestinian neighborhood which after the 1948 war has been gradually pulverized into meters of rubble now forming the artificial retaining walls of the Tel Aviv seafront. The few existing remnants of this past have been carefully

מנשייה מ יפו · المنشية من يافا

36. The Decolonizing Architecture Art Residency, *Return to Jaffa*, 2012. Participants: Sanne
Van Den Breemer, Patricia Fernandes, Gabriel A. Cuellar, Zhongqi Ren, Sai Shu, and Rizki
M. Supratman. Courtesy DAAR@Berlage in collaboration with Lieven De Cauter.

manicured to fit the polished landscape of the Tel Aviv beach, as in the case of three
houses analyzed by the project that have been incorporated into the structure of the
museum celebrating the Zionist paramilitary group that conquered Jaffa during the 1948
war.

In opposition to this process, *Return to Jaffa* envisions, in the form of a series of pho-
tomontages, the formation of a large foundation resulting from the breaking up of the
seafront rubble. From this platform, Manshiyya's buried foundations as well as the recent
Israeli construction will emerge, as a place suspended between destruction and construc-
tion. Considering that in an urban setting the return will inevitably mean "building on
the built," the archeological investigation of the buried or recycled traces of the former
buildings and cultivated terraces will become the construction material of a possible
future. As DAAR wrote, "ruins, in this context, are not only the fragments of what used
to be private, but also the first tracings of what can be common."

As with many of DAAR's other projects, *Return to Jaffa* mobilizes critical thinking,
spatial interventions, visual analysis, pedagogy, and legal procedures to open up a dead-
locked debate and excavate alternative scenarios for the colonial infrastructure of occupa-
tion.[2] As a response to the so-called peace industry and the rhetoric of solutions to the
Israeli-Palestinian conflict, it operates somewhere in between an arena of speculation,
which builds up visions and refuses shortsighted solutions, and a hands-on practice that
is engaged with social and political realities. It thus reclaims the transformative power

embedded in the term "decolonization," a word that should not be understood simply as reuse (i.e., an attempt to fit new functions into an empty shell), but rather as an ongoing process of profanation that could enable the discovery of a common use for what used to be an apparatus of separation and domination.

NOTES

1. *Return to Jaffa* was a project by DAAR@Berlage in collaboration with Lieven De Cauter. Participants: Sanne Van Den Breemer, Patricia Fernandes, Gabriel A. Cuellar, Zhongqi Ren, Sai Shu, Rizki M. Supratman.

2. As, for instance, in a project on the transformation of the Psagot settlement (*A Manual of Decolonization* [2008]), another investigating the former military base of Oush Grab (*Return to Nature* [2010]), and that engages with the now-derelict Palestinian Parliament building (*Common Assembly* [2011]).

18

CATHERINE D'IGNAZIO, AMBER DAY, AND NICOLE SIGGINS WITH THE INSTITUTE FOR INFINITELY SMALL THINGS

The Border Crossed Us (2011)

ON THE TOHONO O'ODHAM RESERVATION

There is a fence in Ofelia Rivas's backyard. It is a vehicle barrier that consists of eight- and ten-foot steel tubes placed several feet apart and linked with steel cables. It is a recent fence, authorized by George W. Bush's 2006 Secure Fence Act and erected by the Department of Homeland Security in 2008.

Ofelia lives on the Tohono O'odham reservation, the second-largest Indian reservation in the U.S. She is a traditional O'odham, and an activist for the environment and for youth empowerment through education in traditional O'odham ways. She was already fighting to keep her culture alive before the fence cut her people in half.

O'odham lands straddle the U.S.-Mexico border along seventy-five miles of harsh, beautiful, windswept desert. This was Tohono O'odham land long before it "belonged" to the U.S. or to Mexico. Around 15 percent of O'odham live on the Mexican side in small villages. Ofelia's father lives in one such village. It used to take her half an hour to reach him; now it's five hours with checkpoints and roundabout driving.

The new border fence divides the community, prevents tribe members from receiving critical health services, and subjects O'odham to racism and discrimination. It's not just the fence but the protocol of checks, detainments, and even wrongful arrests and abuses (including the arrest of spiritual leaders during ceremonial walks). The land is being occupied by a foreign invader and it is us—the Americans.

37. The Institute for Infinitely Small Things, *The Border Crossed Us*, 2011. Installation/
intervention. Courtesy the Institute for Infinitely Small Things.

IN NEW ENGLAND

The Border Crossed Us was a temporary public art installation in spring 2011 by the Insti-
tute for Infinitely Small Things, in consultation with Ofelia Rivas, that transplanted the
U.S.-Mexico border fence from southern Arizona to the University of Massachusetts at
Amherst campus.[1] The project was commissioned by the University Museum of Con-
temporary Art.

 The Border Crossed Us divided the university campus along its north-south boundary
with a three-hundred-foot to-scale photographic replica of the vehicle fence that runs
along the international boundary in southern Arizona. Visually it was designed to look
like a campus construction site, with temporary fencing, sandbags, and cones. As pho-
tographs generally wrap construction sites to advertise what is to come in the future, our
site advertised the fence in Arizona, planting a seed of doubt as to whether or not a true
fence might be under construction at that site.

 The fence ran between a parking garage and the campus center, blocking a popular
pedestrian crossing. Over the course of two weeks it served as a provocation, a touch-
stone for conversation, and a site for talks and performances. Along with the visual
intervention, *The Border Crossed Us* included sound—Ofelia's field recordings from the

construction of the fence mixed with her voice singing a song of welcome and hope to the students at UMass Amherst. These sounds emanated from a giant vent in the ground next to the fence. A nearby sign held a poster that changed each day. It was lettered in stark text with questions frequently posed at border checkpoints, such as "Why are you here?" "How did you get here?" "Are you a citizen?" "What color are you?" and "May I touch you?" Students were invited to text to a website their responses to these questions.

Along with the fence's insertion into daily life on campus, the project invited a delegation of Tohono O'odham, including a tribal elder and a youth, to speak about their experience. They led "tours" of the U.S.-Mexico border on the college campus. In addition, the Native American Studies Certificate Program in the Anthropology Department held a panel discussion on Borders and Indigenous Sovereignty as part of the campus's annual Native American Powwow. Border issues affect many other tribes, including the Mohawk and the Abenaki. The delegation of O'odham spoke along with others about these issues during the conference and participated in the powwow.

Finally, the Institute worked with anthropology and journalism faculty members to develop class assignments and reflection exercises to help students engage more deeply with the fence in their own community. The project asked people both geographically and experientially removed from the Tohono O'odham to momentarily experience the border, walk beside the fence, and feel the impact on their own landscape: to reflect, to judge, to justify, and to witness. In addition to the texting system where people could direct their immediate responses to the installation to the project website, students wrote longer essays for their classes. Many of these responses detailed real or perceived borders in their own lives and as experienced on the university campus. Some students detailed places in which they felt unfairly judged or out of place: "Anytime I walk near the engineering buildings, I feel slightly uncomfortable because I feel like I don't belong. I realize that the other people walking around probably have no idea I'm not a science person. But nonetheless I feel as if I don't fit in." Other students detailed ways in which they had personally crossed perceived borders on the college campus in subtle ways, for instance starting a game of basketball:

> Many times the courts become differentiated in regards to who is playing on the courts. The far courts usually are taken over by Asian students, the middle court is usually African Americans, and the third court is usually white kids. I don't know why this happens but me and my friends notice how this has happened several times. I think that it is just because people feel more comfortable being around others that are like them. My experience was when my friends and I went over to the court that was mostly Asian students and called the next game. It's not like it was a big deal but I believe that just the fact that we noticed the difference among the courts and were the first ones to play on another court, we crossed a border.

How does the international border in Arizona, seemingly remote from a college campus in New England, touch all of our lives? What happens when we divide a territory that the

community imagines as contiguous? We may imagine that the border is far away in a remote desert, but if the border can cross the Tohono O'odham, then the border can cross us.

NOTES

1. Ofelia Rivas, a Tohono O'odham traditional tribal elder, is an international human rights and indigenous rights activist, and founder of the O'odham VOICE Against the WALL and the O'odham Rights, Cultural and Environmental Justice Coalition.

GEOGRAPHIES OF GLOBAL CAPITALISM

We urgently need to rethink—politically, imaginatively, and theoretically—what I call "slow violence." By slow violence I mean a violence that occurs gradually and out of sight, a violence of delayed destruction that is dispersed across time and space, an attritional violence that is typically not viewed as violence at all. Violence is customarily conceived as an event or action that is immediate in time, explosive and spectacular in space, and as erupting into instant sensational visibility. We need, I believe, to engage a different kind of violence, a violence that is neither spectacular nor instantaneous, but rather incremental and accretive, its calamitous repercussions playing out across a range of temporal scales.

ROB NIXON (2011)[1]

· · ·

The world is not "flat," as the neoliberal journalist Tom Friedman famously contended in his 2005 image of globalization as a realm of opportunity opened up by new technologies of communication and production. Rather, it is "uneven." Globalization has created an ever more dramatic gulf between prosperity and poverty, its very structure predicated on the exploitation of a vast underclass in African nations, Asian megacities, and elsewhere—a status that the geographer David Harvey has termed "accumulation by dispossession." T. J. Demos presents a range of artworks that reveal concrete instances of dispossession within the abstract machinations of globalization. Ashley Dawson discusses the photographs of Edward Burtynsky and the film *The Forgotten Space* by Allan Sekula and Noël Burch, which draws attention to the byproducts and invisible superstructure of globalization: ruined landscapes and the passage of cargo ships on the high seas, transporting consumer goods from China to the United States within a system of environmental pollution and dehumanizing labor conditions.

The artists' projects in this section offer more examples of the imperative to give concrete form to globalization, a concept and structure so vast as to seem beyond comprehension and beyond representation. Carbon offset trading, the mining of heavy metals, labor conditions south of the United States–Mexico border, and the relentless search for fossil fuels are among the subjects taken on by artists in this section, who seek to distill in new, incisive aesthetic terms the human and environmental implications of our participation in a global economy.

NOTES

1. Rob Nixon, *Slow Violence and the Environmentalism of the Poor* (Cambridge, Massachusetts: Harvard University Press, 2011), 2.

SOURCES FOR FURTHER READING

Bhagat, Alexis, and Lize Mogel, eds. *An Atlas of Radical Cartography*. Los Angeles: Journal of Aesthetics & Protest, Press, 2007.

Crosby, Alfred. *Ecological Imperialism: The Biological Expansion of Europe, 900–1900.* Cambridge, England: Cambridge University Press, 2004.

Demos, T. J. *The Migrant Image: The Art and Politics of Documentary During Global Crisis.* Durham, North Carolina: Duke University Press, 2013.

Demos, T. J., and Alex Farquharson. *Uneven Geographies*. Nottingham, England: Nottingham Contemporary, 2010.

Ghosn, Rania, ed. *New Geographies, 2: Landscapes of Energy*. Cambridge, Massachusetts: Harvard Graduate School of Design/Harvard University Press, 2010.

Hardt, Michael, and Antonio Negri. *Empire*. Cambridge, Massachusetts: Harvard University Press, 2001.

Harley, J. B. "Deconstructing the Map." *Cartographica* 26 no. 2 (1989): 1–20.

Harvey, David. *Spaces of Global Capitalism: Toward a Theory of Uneven Geographical Development*. London: Verso, 2006.

Klein, Naomi. *This Changes Everything: Capitalism vs. The Climate*. New York: Simon and Schuster, 2014.

McKee, Yates. "Art and the Ends of Environmentalism: From Biosphere to the Right for Survival." In *Non-Governmental Politics*, edited by M. Feher, 539–61. New York: Zone, 2007.

Mitchell, Timothy. *Carbon Democracy: Political Power in the Age of Oil*. New York: Verso, 2011.

Nixon, Rob. *Slow Violence and the Environmentalism of the Poor*. Cambridge, Massachusetts: Harvard University Press, 2011.

Parenti, Michael, *Tropics of Chaos: Climate Change and the New Geography of Violence*. New York: Nation Books, 2011.

Peet, Richard, and Michael Watts, eds. *Liberation Ecologies: Environment, Development, and Social Movements*. London: Routledge, 2002.

Shiva, Vandana. *Earth Democracy: Justice, Sustainability, and Peace*. Boston: South End Press, 2005.

Smith, Neil. "Nature as Accumulation Strategy." *Socialist Register* (2006): 16–36.

Tsing, Anna. *Friction: An Ethnography of Global Connection*. Princeton, New Jersey: Princeton University Press, 2004.

Watts, Michael. "Petro-Violence: Community, Extraction, and Political Ecology of a Mythic Commodity." In *Violent Environments*, edited by Nancy Lee Peluso and Michael Watts. Ithaca, New York: Cornell University Press, 2001.

Williams, Evan Calder. *Combined and Uneven Apocalypse: Luciferian Marxism*. London: Zero Books, 2011.

19

T. J. DEMOS

Another World, and Another . . . :
Notes on *Uneven Geographies*

This essay is reproduced from the catalogue for Uneven Geographies: Art and Globalization,
*a 2010 exhibition at Nottingham Contemporary in England, curated by T. J. Demos and Alex
Farquharson. This show elucidated the relevance of critical geographical ideas within contem-
porary art, and ways that art might intervene into the injustices of globalized capitalism (www.
hottinghamcontemporary.org/art/uneven-geographics).*

What can contemporary art tell us of the geography of capitalism under globalization?
Steve McQueen's *Gravesend* (2007), which juxtaposes the mining of coltan in the Demo-
cratic Republic of the Congo with the scientific processing of the valuable mineral, used
in so many computer devices, in Derby, England, offers one striking response. Without
explicit commentary, the film's fleeting portrayal of toiling bodies and meditative land-
scapes not only reveals the disparity between the primitive conditions of manual labor in
Africa and the computerized automation of European industry; it also connects the com-
manding wealth of one part of the world to its dependence on the impoverished environ-
ment, mineral resources, and weak state controls in another. Ursula Biemann's *Sahara
Chronicle* (2006–7) and Yto Barrada's *Life Full of Holes—The Strait Project* (1998–2004)
both extend this recognition of economic and social inequality by showing the resulting
channels of migration that have proliferated in the deprived areas of sub-Saharan and
North Africa. In their photographs and video projects, multitudes attempt to escape from
underdeveloped regions and areas of political and military conflict, making their way
illegally to Europe via the Spanish enclave of Ceuta or across the Strait of Gibraltar.

Meanwhile, George Osodi's photographic cycle *Oil Rich Niger Delta* (2003–7) documents the Nigerian landscape, where the protected infrastructure of a billion-dollar oil industry sits amidst abject poverty, environmental degradation, and lawless militias. As the artist and photojournalist points out, oil accounts for about 95 percent of the country's exports, yet more than 70 percent of the population lives on less than one dollar a day.[1]

These projects reveal the globalization of "uneven development," as capitalism has come to divide the Global North from the South, producing and maintaining historically unprecedented relations of social, economic, and political inequality within and between nations worldwide. This reality utterly contradicts the triumphalist version of globalization that celebrates it as inaugurating a new era of free markets, social equality, and democratic inclusion—what neo-con journalist Thomas Friedman calls the "flat world" of horizontal, egalitarian consensus.[2] A far more convincing and critical approach to globalization has emerged in the discourse of geography, with the concept of uneven development first mobilized by scholars such as David Harvey and Neil Smith in the 1980s in relation to the emerging spatial conditions of advanced capitalism. Its relevance and accuracy as an optic of analysis has only increased since then—as demonstrated by many of the works in this exhibition—and we believe the term "uneven geographies" warrants continued use today,[3] but not without critical consideration and further elaboration.

It was Smith's text *Uneven Development,* published in 1984, that first systematically analyzed the spatial conditions of neoliberal capitalism. Initially conceptualized in Milton Friedman's Chicago School economics, the resulting policies of deregulated markets, privatization, and curtailed social spending—the key tenets of neoliberalism—were advanced with devastating results by Margaret Thatcher, Ronald Reagan, Augusto Pinochet, and Deng Xiaping in the late 1970s and 1980s, and subsequently consolidated and expanded worldwide in the 1990s and 2000s.[4] The consequence has been the spread of economic and political inequality across the globe. For Smith, uneven development issues from the dual and contradictory tendencies of capital to simultaneously promote "equalization" (the harmonization of levels and conditions of production) and "differentiation" (the accumulation and centralization of wealth).[5] Indeed, it is the tension between these two tendencies that has marked neoliberalism, leading to various crises over the course of capitalism's history, some of the recent outcomes of which are glimpsed in the works by McQueen, Biemann, Barrada, and Osodi.

·　　·　　·

Of course, this geographical analysis builds on earlier insights of economists and political theorists; as Smith acknowledges, the uneven development of capitalism was first observed in the nineteenth century by Karl Marx, who wrote presciently of the "new and international division of labor" that "converts one part of the globe into a chiefly agricultural field of production, for supplying the other part, which remains a chiefly industrial field," even while capital "extracts in every sphere of production equality in the conditions of the exploitation of labor."[6] In other words, Marx saw that expanding and international-

izing the division of labor would mean introducing the rule of exploitation worldwide. Such an outcome is clear in the most recent guise of capitalism's growing divisions between the developed world's economy of postindustrial services and experiences, and the underdeveloped world's floundering in cheap labor, environmental degradation, and resource exploitation.

While the circumstances of global economic development are no doubt more complex than this brief account allows, it is clear that "accumulation by dispossession"—to use Harvey's term, which emphasizes the causal and often brutal relations between systems of wealth and poverty[7]—has only intensified as of late. Indeed, one sees its violent manifestations in the military, financial, social, and environmental crises that have become a perverse instrument of what Naomi Klein calls "disaster capitalism"—think of the undemocratic economic reforms initiated during the transitionary period of post-Soviet republics in Eastern Europe, or more recently the forced privatization of Iraq's oil wealth that was one strategic outcome of Bush's war. Consider also the property development opportunities exploited in the wake of the tsunami that rocked Thailand, or, again, Israel's burgeoning disaster economy of security technology and services.[8] What each of these diverse contexts shares is the catastrophic conditions that invite emergency measures, making politically viable the introduction of neoliberal economic reforms without democratic accountability and enforced by military repression. As Klein writes, the world is in the grips of a "fundamentalist form of capitalism," which has "consistently been midwifed by the most brutal forms of coercion, inflicted on the collective body politic as well as on countless individual bodies."[9]

One contribution that artists in *Uneven Geographies* make to the discourse and politics of uneven development is the recognition of the increasing dominance of *differentiation* over *equalization* within global capitalism. They variously map the spaces of exception that exist beyond legality; show the dangerous passage of life around the militarized borders between North and South; and portray the impoverished circumstances that persist in the shadow of the energy and mining industries. By doing so, artists such as Barrada, Biemann, McQueen, and Osodi give expression to the precarious organization of life—including mechanisms of survival as well as modes of resistance—amidst fragmented territories divided between legality and lawlessness, security and violence, wealth and poverty. Indeed, as Mladen Stilinović's *Nobody Wants to See* (2009) makes clear, with its minimal sculptural materialization of a horrendous statistic with which we are all more or less familiar yet may not care much to think about, the three richest men in the world now own as much as 600 million of the poorest do. With such new extremes of wealth, the early twenty-first century has come to resemble the empires and dynasties of the nineteenth. Confronting such statistics as these, what recourse do we have in the realm of art?

．　　　．　　　．

One central ambition of *Uneven Geographies* is to assemble artistic practices that reinvent modes of representation that situate us critically and creatively in relation to the uneven

developments of globalization—what Marxist critic Fredric Jameson termed "the whole world system of present-day multinational capitalism."[10] In the early 1980s, and later in his 1995 book *The Geopolitical Aesthetic,* Jameson observed that the very complexity of advanced capitalism—its global financial landscape, networked communications technologies, transnational legal mechanisms, and spectacularized publicity—had rendered the languages of analysis and description insufficient, that is, inadequate "to think a system so vast that it cannot be encompassed by the natural and historically developed categories of perception with which human beings normally orient themselves."[11] Because global capitalism's "mechanisms and dynamics are not visible" and are far from natural or self-evident, they "stand as a fundamental representational problem—indeed, a problem of a historically new and original type."

To redress this disempowered situation, Jameson called for innovative methods of "cognitive mapping," which would "enable a situational representation on the part of the subject to that vaster and properly unrepresentable totality, which is the ensemble of society's structures as a whole."[12] By doing so, his hope was to regain a conceptual and experiential footing in relation to the *terrain vague* of globalization, and thereby find critical traction to represent and challenge those systems that exploit their status of economic allusiveness and democratic unaccountability for financial gain and political power.

Answering this call, *Uneven Geographies* gathers an array of models—those that we find most compelling and demanding of critical testing—that variously respond to and creatively intervene in this crisis of representation. One such approach is to perform and materialize the policies and reforms of neoliberalism in order to make them visible and invite their critical consideration, as in Yang Zhenzhong's *Spring Story* (2003), a video that depicts factory workers at Siemens Shanghai Mobile Communications Ltd who collectively reconstruct Deng Xiaoping's famous "Southern Campaign Speech" of the early 1990s. Each of the roughly fifteen hundred workers is shown reciting a single word, as the labor force in effect mass-produces the historic address that first articulated the Communist government's newfound support for the "special economic zones" and "foreign-funded enterprises," which became the signal building blocks of what Deng called "socialism with Chinese characteristics."

In a way, Yang's contracted-out performance, as well as Stilinović's critical materialization of neoliberal sociological facts, resonate with Cildo Meireles's *Insertions Into Ideological Circuits* (1970), one of the historical precedents included in the exhibition. Printing the phrase "Yankees Go Home" in white ink on recycled Coca-Cola bottles (so that the message would only appear when the bottles were refilled), and stamping the name of a murdered journalist on paper money between 1970 and 1976 (*Quem matou Herzog?*, or "Who killed [Vladimir] Herzog?"), which he then put back into circulation, the Brazilian artist injected his subversive interventions into the exchange of consumer items and currency during the years of the brutal dictatorship. He did so to protest imperialism and military repression alike, which were part of the early phase of the neoliberal market and political reforms in Latin America in the 1970s.

For his part, Yang Zhenzhong draws out a similarly subversive acknowledgment of neoliberal philosophy from the factory floor, as the video's simultaneous erasure and instrumentalization of individuality contradicts the claims of collective empowerment in Deng's speech, which pays mere lip service to his Communist forbearers: "The essence of socialism is the liberation and development of the productive forces, the elimination of exploitation and polarization, and the ultimate achievement of prosperity for all."[13] Yet Deng's reforms, as historian Hui Wang argues, have worked directly against those social-ist principles by leading to rising unemployment and declining social security, and to the cheap labor conditions that have attracted such multinational corporations as Siemens to set up shop in Shenzhen.[14] Once a mere village, Shenzhen is now a city of twenty million, and with its cheap and plentiful workforce it has attracted the German manu-facturer, which, with a global revenue of more than 76 billion Euros, employs more than four hundred thousand people in 190 countries.

. . .

Another approach that provides a direct response to the imperative to invent a new lan-guage to chart the operations of globalization is the experimental cartographic practice of Bureau d'Études. The French collective designs cybernetic flow charts in order to digitally map the workings and interconnections of world government and global capital, drawing information from diverse sources such as think tanks, weapons makers, and satellite companies. When included in art exhibitions (one of many sites of exchange for the group's activities), their diagrams are often enlarged and presented on walls, as well as condensed into freely available take-home posters. For critic and occasional collabora-tor Brian Holmes, Bureau d'Études contributes to the recent movement of autonomous, self-organized knowledge production, building new forms of resistance by mobilizing counter-information and imagining a radically different kind of map of the world, one that the artists call "a thinking map, but also a willing map and a feeling map."[15]

As well, *Uneven Geographies* includes Mark Lombardi's lyrical, hand-drawn diagrams of seldom recognized systems of governmental power, such as the complex connections between the worlds of global finance, corporations, political bodies, and international family dynasties, which the artist assembled from a database of fourteen thousand index cards of research material. Lombardi's interest was fueled by the deregulation policies of Reagan during the 1980s, which allowed savings and loan banks to offer unsecured loans, leading to massive corruption and money laundering in offshore accounts that implicated many in positions of power (including some of those high up in George Bush Sr.'s White House). In these graphic models that chart the networks of global capital, Lombardi's tendency toward geometric, gestural abstraction appears to conflict with the scientistic, information-dense paradigm of Bureau d'Études. The competing presenta-tions engage the aesthetics of knowledge production and political research in very differ-ent ways, yet each contributes to addressing the following question, which still lacks— perhaps necessarily so—a definitive answer: How can cartographic forms merge with

affective systems in order to motivate the desire for oppositional political becoming, social justice, and economic right? No doubt there must be many proposals to meet such a challenge.

These models, in their distinct ways, each reaffirm the significance of the cartographic experiments of Öyvind Fahlström, whose work comprises the second of the exhibition's historical inclusions. The Swedish pop-conceptualist's playful maps and games visualize a further possible intersection of the geopolitical and the geopoetic—what Brazilian cultural critic and psychoanalyst Suely Rolnik describes as an affective geography: at once ludic, imaginative, and politically informed. One of the exhibition's central inclusions is Fahlström's *Garden—A World Model* (1973), which includes statements decrying American economic imperialism printed upon the leaves of interconnected plantlike sculptures, as the artist joins the merging organic-geographical forms to political-economic processes. Rolnik relates Fahlström's playful diagrams to Deleuze and Guattari's call to let desire "circulate through history and geography, to organize formations of worlds and constellations of universes, to make continents drift."[16] In other words, we cannot be satisfied with the claim that there are no other alternatives to this world; in this regard, these artistic maps open up possible others, revealing other narratives for a potentially positive form of globalization based on more egalitarian geographies.

It is with a similar hope that we see Fahlstöm's cartographic imagination advanced in the work of other artists in the exhibition, as in Eduardo Abaroa's *Another World, and Another, and Another . . .* (2008). Here, mapmaking emphasizes geography's creative plurality, eliciting the complex morphology of spatial experience via heterogeneous textiles (including workers' garments), textures, and colors. Abaroa advances a non-cognitive aesthetic of multiplicity, as globes emerge from globes, worlds from worlds. His sculpture indicates the very impossibility to fully know or rest content with only one. In Abaroa's work, we encounter a speculative and pluri-sensory recognition that globalization is not simply a matter of rationalization and standardization; rather it evokes an unpredictable process of creative differentiation in ways that are not merely destructively economic.

·　　·　　·

Still, despite these cartographic ambitions, zones of exception persist in the geography of global capital that avoid detection and operate outside the borders of accountability, representation, and regulation. Such a situation allows the further accumulation of wealth by those individuals, corporations, and institutions intent on avoiding taxation—one imagines their invisible presence in the blank spaces between the icons, texts, and connective lines in the maps of Bureau d'Études and Lombardi. These are the financial bodies that exist beyond the information grid, the world of offshore banking that is the object of Goldin+Senneby's ongoing project *Headless*. Their focus is the apparently real company called Headless Ltd., registered in the Bahamas, which is one of the leading centers of offshore banking worldwide, with $1.5 trillion in liabilities. Searching for Head-

less Ltd., the artists act like shadowy CEOs; Goldin+Senneby employ their own specialists—economists, authors, curators—to implement their undeclared artistic designs. Doing so, they spin a web of intrigue and fiction, including reference to dissident Surrealist Georges Bataille's secret society Acéphale, or "headless," of the late 1930s, which represented an experiment with the anti-Fascist possibilities of collectivity.

Rather than attempt to map the offshore—which would be the aim of another politics, and another type of artistic investigation—the Swedish artists instead internalize its structure of exception as a source of fictionalization, which leads to several outlets. For instance, the exhibition also includes the remarkable *Fool's Cap, World Map,* an engraving from ca. 1580 borrowed from Oxford University's Ashmolean Museum, which shows the map of the world in the place of the fool's face, including an early representation of the "terra incognita" as it was imagined geographically in the sixteenth century. One of the earliest images that appears to parody geographical reason and its ambition to know the world, the map becomes the location of deceit and uncertainty as much as knowledge and science. Appropriately, then, a reproduction of the *Fool's Cap* also appears in Goldin+Senneby's recent film of a lecture by economic geographer Angus Cameron, adding to the project's other collaborative performances, various sculptural installations, and the production of the ongoing novel *Looking for Headless,* concerning the search for the offshore company in the Bahamas.

In relation to such zones of lawlessness, Giorgio Agamben has recently proposed the "state of exception" as a paradigm for current geopolitical developments. Referring to the creation of areas of legal exclusion—such as the prison at Guantanamo Bay—Agamben argues that new formations of executive sovereignty manifest themselves by stripping subjects of political rights, which, for Agamben, is becoming the norm worldwide, particularly in reference to the seemingly ubiquitous and spatially limitless "War on Terror."[17] But what falls out of this otherwise compelling analysis—which nonetheless resonates with McQueen's, Biemann's, and Osodi's imagery of those areas of the politically excluded—is the simultaneous construction of financial zones of exception that have facilitated the accumulation of wealth outside of public accountability and national regulation. It is this field of invisibility that Goldin+Senneby track and turn into a source of intrigue in their commissioned texts and lectures by their representatives, the indeterminate status of which—is it fiction or real?—mirrors the uncertain epistemology of the offshore. By mimicking the world of shell companies, economic evasion, and unaccountable institutions in their semi-fictional accounts, the artists blur the boundaries between the real and the imaginary, as if reappropriating the category of the offshore from the financial elite and redirecting it for shared creative and collaborative purposes.

. . .

One potential hazard of *Uneven Geographies* is that in focusing on uneven development today we risk simply reaffirming its existence in the realm of representation. It is for this reason that the exhibition's ambition has been to highlight numerous aesthetic

approaches—sociological as well as affective, documentary as much as performative. These approaches not only record, map, and explore forms of inequality related to neoliberal globalization, but also reveal the power of oppositional and creative energies that are already directed against its economic-political arrangements, and open up other modes of globalization. They thereby complicate and challenge the analysis of uneven geographies as an otherwise potentially disempowering fatalism.

Among these inclusions is the documentary commitment to draw attention to the resistance of mass movements of counter- or alter-globalization. For instance, consider Bruno Serralongue's many photographic projects, including his documentation of the events of the 2004 World Social Forum in Mumbai, which convened 2,500 conferences, seminars, and workshops—with tribals comprising 80 percent of the participants—under the slogan "Our world is not for sale." Opposed to the economic elitism of Davos's World Economic Forum, and mirroring many other such movements in the Global South, including notably the 1996 Intergalactical Meeting Against Neoliberalism in Chiapas, which Serralongue has also photographed, these events are translated by the photographer as anti-spectacular images. They reveal the slow processes of political engagement and the collective action of opposition—a veritable "globalization from below," which, in contrast to multinational corporate globalization, has presented a decentered, transnational "movement of movements" pledged to social justice, economic equality, and ecological sustainability. In bringing such movements into visibility, Serralongue challenges their near-erasure in the corporate media, adding to their oppositional energies by extending their appearance, and by implication their political demands, into the artistic sphere.

Working along similar lines in video, Dario Azzellini and Oliver Ressler's *Venezuela from Below* (2004) presents a recording of workers and activists speaking about their cooperatives and grassroots organizations in the socialist context of Hugo Chavez's Bolivarian Revolution in Venezuela. As an archive of those who speak from neoliberalism's nearly unrecognizable outside, the project gives voice to a multitude of people who attest to the newfound economic, social, and political opportunities realized recently—and ever precariously—in oil-rich Venezuela during a process of reforms that have led to remarkable gains in popular education, health care, and public housing, countering the effects of neoliberal privatization and its destruction of social welfare programs. A woman, for instance, speaks of her cooperative bank project, farmers talk about their participation in literacy campaigns, and oil workers discuss their refinery's resistance to sabotage operations. The self-expression of these revolutionary subjects represents the critical counter to the regimented factory workers and their instrumentalized collective mimicry of Chinese neoliberal policy in Yang Zhenzhong's *Spring Story*.

Supplementing these documentary engagements, *Uneven Geographies* also includes work that complicates the image as the purported truthful and objective carrier of self-evident meaning, as in Yto Barrada's *Life Full of Holes* and McQueen's *Gravesend* and *Unexploded*. These works generate a sense of semiotic multiplicity. Consider the shadowy

figures in McQueen's film, which makes allusion to Conrad's novella *Heart of Darkness* (1902) insofar as Marlow told his horrifying tale of journeying up the Congo River from a ship sitting on the Thames estuary in the English southeastern port of Gravesend. McQueen's poetic use of filmic ambiguity and metaphor, allusion and opacity, rescues figures in the Congo from their consignment to what anthropologist James Ferguson calls Africa's "old colonial role as provider of raw materials (especially mineral wealth)," the current situation of which McQueen also makes reference.[18]

Adding to this reinvention of documentary possibilities, Barrada's photographs and Biemann's videos also mobilize the indeterminacy of meaning, which opens up ways that desire might circulate beyond the authoritative pedagogy of conventional documentary film, challenging the fixity of representation. They thereby redirect the insecurity of African migration into an empowering potentiality (the discovery of a new life, the power to become something other) that liberates those subjects from their potential second-order oppression in the register of the image (following their victimhood on the ground). Biemann, for instance, seeks to present "an empowered vision of organized migration in which geopolitics is not strictly reserved for powerful nations who wish to dominate a region for its resources, but is instead a strategy that can equally be applied to a large movement of exiles or work migrants who target another territory for economic pleni-tude."[19] Such work indicates a post-representational politics, where the subject extends beyond a clear identity, the image beyond an instrumentalized political trajectory. These works redirect the possibilities of globalization toward ends other than uneven, and where such images might lead has yet to be determined.

With its diverse inclusions, *Uneven Geographies* charts the current conditions of neoliberal globalization, revealing its points of crisis and human costs, as well as proposes additional imaginative possibilities for a world—and a more even geography—of social justice, experimental creativity, and political inclusion. In this sense, the current status of globalization cannot be seen as a natural or inevitable historical outcome of modernity, but rather as a set of conflictual narratives with distinct political and economic stakes.[20] The exhibition thus aims to defamiliarize and repoliticize the term "globalization" by reanimating the relation between aesthetics and politics. Doing so, we hope to focus attention on artistic attempts to reconfigure the terrain of the sensible so as to contest the disparities of uneven development, and to gather powerful proposals for a socially just, egalitarian future.

NOTES

1. Artist's statement, http://www.georgeosodi.co.uk/Artist_statements/Entries/2009/3/11_oil_rich_niger_delta_2003–2007.html (accessed November 2009).

2. Thomas Friedman, *The World Is Flat: The Globalized World in the Twenty-First Century* (New York: Penguin, 2007).

3. As employed, for instance, by David Harvey in *Spaces of Global Capitalism: Toward a Theory of Uneven Geographical Development* (London: Verso, 2006).

4. In *A Brief History of Neoliberalism* (Oxford: Oxford University Press, 2005), 3, David Harvey defines neoliberalism as "a theory of political economic practices that proposes that human well-being can best be advanced by liberating individual entrepreneurial freedoms and skills within an institutional framework characterized by strong private property rights, free markets, and free trade."

5. See Neil Smith, "Toward a Theory of Uneven Development I: The Dialectic of Geographical Differentiation and Equalization," in *Uneven Development: Nature, Capital, and the Production of Space* (Oxford: Blackwell, 1990), 132ff.

6. Karl Marx and Frederick Engels, *The Communist Manifesto* (New York, 1955), 13; and Karl Marx, *Capital*, vol. I (New York, 1967), 451 and 397. Cited in Neil Smith, "Toward a Theory of Uneven Development I," 150 and 153.

7. See David Harvey, "Neo-Liberalism and the Restoration of Class Power," in *Spaces of Global Capitalism*, 7–68.

8. Naomi Klein, *The Shock Doctrine* (London: Penguin, 2007).

9. Ibid., 16.

10. Fredric Jameson, "The Cultural Logic of Late Capitalism," in *Postmodernism, or The Cultural Logic of Late Capitalism* (Durham, North Carolina: Duke University Press, 1992), 37.

11. Fredric Jameson, *The Geopolitical Aesthetic: Cinema and Space in the World System* (Indianapolis: Indiana University Press, 1995), 2 and 4: "It is ultimately always of the social totality itself that it is a question in representation, and never more so than in the present age of a multinational global corporate network."

12. Fredric Jameson, "The Cultural Logic of Late Capitalism," 51.

13. The English subtitles for the piece are available at http://www.shanghartgallery.com/galleryarchive/texts/id/909 (consulted May 2010).

14. Wang Hui, "The Year 1989 and the Historical Roots of Neoliberalism in China," *Positions* 12, no. 1 (spring 2004); see also Hui Wang, *China's New Order: Society, Politics, and Economy in Transition* (Cambridge, Massachusetts: Harvard University Press, 2003).

15. Brian Holmes, "Cartography of Excess (Bureau d'études, Multiplicity)," *Mute* (February 2003), http://www.metamute.org/en/node/6243.

16. Suely Rolnik, "Oyvind Fahlström's Changing Maps," in *Oyvind Fahlström: Another Space for Painting* (Barcelona: MACBA, 2001). She cites Gilles Deleuze and Félix Guattari, "Ce que les enfants dissent," in *Critique et Clinique* (Paris: Minuit, 1993), 82 (my translation).

17. Giorgio Agamben, *State of Exception*, trans. Kevin Attell (Chicago: University of Chicago Press, 2005). For their reference to the "state of exception," see Goldin+Senneby, *Looking for Headless*, 176.

18. James Ferguson, *Global Shadows: Africa in the Neoliberal World Order* (Durham, North Carolina: Duke University Press, 2006), 8. For more sustained analysis of works by McQueen and Barrada, see my recent essay "Moving Images of Globalization," *Grey Room* 37 (autumn 2009): 6–29.

19. Ursula Biemann, "*Agadez Chronicle:* Post-Colonial Politics of Space and Mobility in the Sahara," in *The Maghreb Connection: Movements of Life Across North Africa*, eds. Ursula Biemann and Brian Holmes (Barcelona: Actar, 2006), 67.

20. On these narrative conflicts, see Angus Cameron and Ronen Palan, *The Imagined Economies of Globalization* (London: Sage, 2003).

20

ASHLEY DAWSON

Documenting Accumulation by Dispossession

There is a long imperial genealogy to the social production of nature.[1] When European settlers began to colonize the Americas and, ultimately, many portions of Asia and Africa, they brought with them life forms and practices, from microbes to livestock husbandry, that had a transformative impact on the delicate ecological systems into which they intruded. If settler power was subtended by an immunological edge in sites such as the Americas, with smallpox and other diseases destroying nearly as many indigenous lives as warfare, it also relied crucially on ontological and epistemological distinctions in attitudes toward the land and labor. Native Americans, for example, as nomadic or semi-nomadic hunters, tended not to regard land as a form of private property and were not interested in animal husbandry. European settlers consequently regarded the indigenous as improvident aristocrats whose refusal to work the earth constituted effective abdication of land claims.[2] Representations of land and labor thus played a crucial role in histories of accumulation by dispossession and genocide over the last several centuries.

Far from being a closed chapter from the distant past, as Marx's term "primitive accumulation" might imply, forms of accumulation by dispossession have intensified in recent decades. Indeed, such enclosure of the global commons might be said to be a fundamental dynamic of the new imperialism.[3] Longtime imperial powers such as Britain and the United States are not the only players in this new version of what J. A. Hobson and Vladimir Lenin called inter-imperial competition.[4] In recent years, land grabs like those in African nations such as Liberia, which has sold off three tenths of its total landmass to wealthy developing nations such as Saudi Arabia, have revived concerns

about imperial enclosure.[5] Of equal concern is the continuing refusal of industrialized nations to curtail their excessive consumption of the global atmospheric commons through mounting greenhouse gas emissions, a refusal enacted annually at international meetings of the United Nations Framework Convention on Climate Change.[6]

Faced with quickening public debate about the global commons and accumulation by dispossession, artists, theorists, and researchers in interdisciplinary fields such as critical geography have turned to documenting what might be termed the political ecology of uneven flows.[7] Such work illuminates the movement of commodified natural resources such as animals, minerals, plants, and fossil fuels across national borders and around the world as part of today's global capitalist economy. Too often, the origins of natural resources embedded in everyday objects—think, for example, of coltan, a mineral used widely in cell phones and mined mainly in the Congo—not to mention the deplorable conditions of the workers who extract such resources, are invisible to the average consumer in the developed world. In addition, the political ecology of flow documented by contemporary visual artists and researchers in a variety of fields increasingly also refers to the movements of people, nonhuman animals, and landscape itself sparked by climate change. Take, for example, Subhankar Banerjee's ghostly aerial photographs of migrating caribou herds in the Arctic National Wildlife Refuge (ANWR), photographs that simultaneously depict the depletion of the herds, their changed migration patterns, and the transformation of the land as a result of climate change, all of which have serious implications for the Gwich'in indigenous people who depend on the caribou (figure 38).[8] Banerjee's photographs document the ways in which one of the world's most geographically isolated sites has been transformed by anthropogenic climate change, and suggest that the precarious ecology of ANWR offers a dramatic lesson for the rest of the world. If aesthetic representations of landscape once seemed to offer a stable and idealized alternative to the hurly-burly world of capitalist modernity, today artists are increasingly seeking to document the ways in which fossil fuel–powered capitalism is setting both fauna and flora in motion in unprecedented ways, underlining the inextricable implication of humanity with the natural world.[9]

In what follows, I discuss some of the strengths as well as the challenges faced by critical documentarians who trace and intervene in the combined and uneven developments that constitute our current, crisis-ridden, turbo-capitalist moment. One key dilemma faced by such artists is how to engage in what the critic Fredric Jameson calls cognitive mapping of contemporary forms of accumulation by dispossession without generating an overwhelming sense of resignation at the destructive powers of contemporary capitalist culture.[10] As Judith Halberstam and Lauren Berlant have recently argued, the dismal failure of emancipatory energies and political projects is so ubiquitous today that optimism has come to seem an opiate for the masses.[11] Particularly in the face of mounting climate chaos, it is easy to give in to a rhetoric of catastrophism that is severely disempowering in political terms.[12] As T. J. Demos puts it in the preceding chapter, "In focusing on uneven development today we risk simply reaffirming its exist-

38. Subhankar Banerjee,
Caribou Migration I, from
the series *Oil and the
Caribou (Arctic National
Wildlife Refuge),* 2002, 86 ×
68 in. Courtesy the artist.

ence in the realm of representation."[13] Demos and his colleagues seek to extricate themselves from this art of failure by focusing on a variety of aesthetic approaches that not only map the inequalities of uneven development but also "reveal the power of oppositional and creative energies that are already directed against its economic-political arrangements."[14] Contemporary capitalism's geographies are so savagely unequal, that is, that the visual arts are being pushed to develop new modes of representation to map the present and also limn alternative futures.

This essay focuses on visual artists and collectives intent on representing contemporary accumulation by dispossession. Such work is drawn ineluctably toward modes of representation that challenge established documentary tradition in a variety of ways. First of all, to document the political ecology of flow is to follow resources of various types across the borders of nation states, over oceans and other natural borders, and through the economic divides that segment the Global North and South. As a result, documentary work of this type involves multisite, process-based analysis that tends to deploy a variety of genres to trace accumulation by dispossession. Recognizing the networked nature of such flows, much documentary work also mobilizes creative collectives, linking artists

experimenting with a variety of genres to writers and theorists from heterogeneous disciplines, including, crucially, ethnography and geography. Finally, the interwoven character of people, places, and things in such documentary work catalyzes new forms of materialism that stress the complex, emergent character of globe-spanning networks of various kinds. Today, all that is solid is melting into air with unmatched rapidity, calling forth new forms of representation that seek to record and act upon the precarious world we inhabit.

GLOBAL COMMODITY FLOWS

There can be no more vital lubricant for the globe-spanning commodity chains of contemporary capitalism, among which the pilgrimages of the contemporary art circuit must be counted, than oil. This dark and viscous fluid, a concentrated product of millions of years of solar energy, powers the tanker ships, trains, and planes that disseminate people, objects, and ideas around the world with increasing frequency, volume, and speed. And yet, as the novelist Amitav Ghosh notes in his discussion of what he calls "petrofiction," the oil encounter has been almost completely mute.[15] Ghosh adduces a number of reasons for the relative invisibility of oil in representation, including the shroud of secrecy maintained by petroleum corporations and the apartheid-like conditions in which workers in the oil industry are kept in nations such as Saudi Arabia. Even more important for Ghosh, however, is the transnational character of the oil industry, and of the communities of workers who are employed by this industry. This is a world, he argues, that "poses a radical challenge not merely to the practice of writing as we know it, but to much of modern culture: to such notions as the idea of distinguishable and distinct civilizations."[16] To render oil visible in literature and the visual arts would be to make us aware of the taken-for-granted material substrate of the present, and, in the process, to expand definitions of culture out of their narrowly circumscribed, nationalistic boundaries.[17] This task seems more important than ever as shale gas saturates fossil fuel markets, and in the process, threatens drinking water supplies around the world.[18]

The bluntly titled series *Oil* (2009) by the Canadian photographer Edward Burtynsky responds to Ghosh's challenge by representing key stages in the production, consumption, and afterlife of this most pivotal contemporary commodity.[19] The landscapes in Burtynsky's photographs such as *Oil Fields #22, Highway #7,* and *Shipbreaking #2* are almost totally devoid of human figures. Yet the images are nonetheless diametrically opposed to the depopulation of the land that has characterized the landscape aesthetic.[20] Such representations of the natural world have frequently been complicit with colonialism: By erasing traces of human dwelling, the landscape aesthetic colludes with legal representations of land as uninhabited and therefore ripe for settlement by Europeans.[21] In Burtynsky's photographs, the human impact on nature is omnipresent. Indeed, the landscapes he captures are a kind of second nature, a wholesale transformation of the

planet on a scale that inspires both awe and dread. His images of massive refineries, abandoned oil fields, and slime-covered beaches lend concrete form to the notion that we have entered the Anthropocene age. Burtynsky's work might best be represented as bearing witness to the devastating human and ecological impact of the lifeblood of modernity.

It could perhaps be objected that Burtynsky perpetuates the erasure of those populations who are most damagingly affected by petroleum. Think, for example, of the inhabitants of the Niger River Delta featured in comparable photographic work such as Ed Kashi's *The Curse of Black Gold* (2008) and George Osodi's *Oil Rich Niger Delta* (2003–7).[22] In response to such a charge, it must be said that Burtynsky's "vacant" landscapes confront viewers with traces of the indelible and at times catastrophic impact of industrial civilization. Given the fact that his projects often juxtapose the oil-fueled spectacle of industrial culture with the sites of extraction and final dereliction of such products, many of which are in the Global South, Burtynsky's work raises serious questions about environmental and social justice. In addition, in largely eschewing representations of the human suffering caused by oil, Burtynsky avoids the thorny dilemmas of what T. J. Demos calls poverty pornography in humanitarian photojournalism.[23] As Demos argues in a discussion of Renzo Martens's 2008 film *Episode III: Enjoy Poverty*, the famine photography produced by many European and North American photojournalists "flows into a global image industry running on poverty as fuel, unleashing a vicious cycle of profit, objectification, and sympathy that perpetuates clichés of Africans as helpless victims mired in misery, reducing spectators to depoliticized charitable donors."[24] By focusing on the material structures and detritus of the global oil industry, Burtynsky avoids such objectifying representations, highlighting instead the systemic violence against the planet's life support systems carried out by contemporary capitalism.

If oil, the proverbial blood of the devil, animates the commodity flows that circulate the globe today, how exactly do these commodities, and the oil that fuels the global economy, get from place to place? Burtynsky's work is silent on this point; his photographs offer haunting images of nodes in a global network without articulating the interstitial tissues that link them. Tracing these interstices is precisely the project of Allan Sekula and Noël Burch's film *The Forgotten Space* (2012). In an account of the film published in *New Left Review*, Sekula and Burch write that the premise of their project is "that the oceans remain the crucial space of globalization: Nowhere is the disorientation, violence, and alienation of contemporary capitalism more manifest."[25] For Sekula and Burch, the invention of the cargo container in the United States during the 1950s revolutionized the space-time continuum not simply of transportation but also of the port cities and hinterlands through which staggering quantities of global commodities flow today. Focusing on four such cities—Rotterdam, Los Angeles, Hong Kong, and Bilbao— *The Forgotten Space* traces the ways in which the solidarity of dock workers and seafarers in port cities, which was integral to the building of social democracy, has been dissolved

by containerization and the "flag of convenience" system, which allows ships owned in rich countries to be registered in poor ones, a measure that has facilitated the destruction of maritime unions. By exploring these radical transformations in the maritime world, Sekula and Burch's highly poetic hybrid textual/visual document sets out to challenge myths concerning the frictionless character of the global economy: the notion that maritime trade is an outdated and anachronistic space of slow movement, surpassed by the lightning-swift flows of the information economy, and the equally purblind idea that the service sector has displaced the economy of heavy material fabrication and processing.[26]

If Burtynsky's photographs focus on the ghostly material artifacts of fossil-fueled globalization, Sekula and Burch's *The Forgotten Space* hinges on the key question: "Does the anonymity of the [container] box turn the sea into a lake of invisible drudgery?"[27] In each site where the film alights, the creative destruction wrought by containerization is laid bare through interviews with workers and other survivors of the maritime economy.[28] In Rotterdam, for instance, Sekula and Burch explore the impact of the automation of the port on workers whose radical union once led a heroic if quixotic strike against the Nazi invasion of Holland. Today, descendants of these workers toil in numbing isolation in a port that is almost totally automated; as the film puts it, the human labor that remains has become a literal appendage to the machine. Shifting to the port of Los Angeles, sited in Long Beach, a facility that became the paradigm for the new model of deskilled ports that has swept the world, Sekula and Burch interview the predominantly Latino truck drivers who haul containers from the port to the city. The massive transnational shipping companies that now dominate the globe have pushed these workers to operate as "independent contractors," a status that shifts all of the risk to the workers and leaves them without union benefits and a below-minimum wage.

In addition to documenting the precarious conditions of these workers, *The Forgotten Space* focuses on a homeless encampment in the shadow of the port, a site for those left derelict by the retreat of the social democratic provisions that characterized former port cities. In one particularly heartbreaking scene, an African American woman clutches a collection of dolls, substitutes for the children who have been taken away from her by the state. Since she lacks the economic means to travel to court hearings across the city, she cannot reclaim her family. Sekula and Burch might be seen as straying into the terrain of poverty pornography discussed by T. J. Demos in this portion of their film, but I would argue that the impact of the segment is very different. While we could certainly be provided with more information about the homeless people depicted here, they do not, as in the poverty pornography critiqued by Demos, serve as decontextualized images that can be mobilized by ultimately predatory freelance journalists and humanitarian organizations. *The Forgotten Space* embeds its representation of homeless people in a broader political economy of flows that helps viewers understand the transformations in the international division of labor that have left so many derelict. The human isolation surrounding the Los Angeles port facility is paralleled by the lives of the low-wage workers, many of them from Asian countries such as the Philippines, who live and labor

on the hulking container ships that ply our oceans for months on end, stopping only briefly in isolated ports. *The Forgotten Space* tracks the heavy toll of the just-in-time economy on such invisible workers while also exploring their attempts to carve out forms of community and affiliation in the face of the isolation and precariousness that is their condition.

The Forgotten Space is notable for the range of materials that it employs, materials that include descriptive documentary, interviews, archive stills and footage, and clips from old movies. Sekula and Burch use these diverse means of representation to produce an essayistic visual documentary that challenges some of the enduring conventions of the art world.[29] Most significantly, the film questions the art-versus-journalism binary that functions as grounds for exclusion of much politically engaged documentary work from the art world. As Sekula argued in an interview conducted shortly after *The Forgotten Space* was completed, in recent decades, much conceptual art has not simply embraced the deskilling of photography, but has sought to demonstrate that photographs don't tell the truth.[30] Against this postmodern turn and the retreat into radical, apolitical relativism that (at its worst) it has provoked, Sekula champions the heritage of documentary realism, with its links to radical democratic struggles. He argues against the photographic image as a fetishized dead archive, a "sarcophagus of meaning," and in favor of photographs that connect with viewers through the narrative structure of the photo essay.[31] Sekula conceives of his work as a form of visual and textual storytelling intended to open occluded vistas, provoke questions, and spark political dialogue.[32]

This mode, I would argue, is characteristic of some of the most incisive and exciting aesthetic work currently being produced. In his important work on postmodernism, Fredric Jameson argued that we live in a historical moment characterized by profound disorientation, by a sense of utter confusion caused by shifts in the international division of labor, which leads, as *The Forgotten Space* poignantly puts it, "factories to resemble ships, stealing away stealthily in the night, restlessly searching for ever cheaper labor."[33] In the face of such disorientation, Jameson prescribed cognitive mapping as an essential mode of critical and aesthetic engagement. Cognitive mapping, I would argue, involves attention to and visual documentation of the globe-spanning movements of people, things, and economic forces that have only accelerated since Jameson wrote. As I have argued before, documenting the transnational networks of power that characterize contemporary imperialism, and thereby contributing to bonds of solidarity between the dispossessed in the Global North and South, is *the* key task for contemporary artist-activists.[34] *The Forgotten Space* offers an incisive model for such critical documentary work.

MATTER IN MOTION AND NETWORKED RESEARCH COLLECTIVES

The adjective "glacial" no longer adequately references processes whose temporal duration and rate of change are so extended as to be nearly invisible. If glaciers once served as emblems of natural stasis and duration, today they increasingly serve as harbingers of

nature's accelerating, chaotic flux. Sitting in a darkened movie theater in New York, watching video footage of the "calving," or breakup, of a lower-Manhattan–size chunk of Greenland's Ilulissat Glacier in the 2012 movie *Chasing Ice*, I was overwhelmed by a combination of awe and terror before the massive power of the natural world that eighteenth-century British aesthetic philosophy labeled "the sublime." Ironically, during the last several decades, we have come to realize that this flux is anthropogenic: Industrial modernity is changing the basic climatic conditions whose relative stability over the last ten thousand years has been the crucible for the growth of human civilization. The subject-object dualism that subtended classic definitions of the sublime no longer holds. The natural world cannot be seen as an inert mass over which humans strive to gain mastery. Instead, the natural environment, we are coming to realize, is composed of a multitude of interlocking forces and systems. As industrialized cultures intervene with increasing force in such systems, we catalyze unforeseen and unpredictable processes that threaten the conditions that support human civilization.[35]

The photographer James Balog, who works at the intersection of art, science, and environmental documentary, is dedicated to chronicling the accelerating transformation of the world's glaciers.[36] As Balog puts it in *Chasing Ice*, the film that chronicles his work with the Extreme Ice Survey (EIS) over the last decade, glaciers are the canaries in the coal mine of climate change, their awe-inspiring collapse and disintegration allowing us to see climate change unfolding in graphic form.[37] For Balog, ice both records the distant past and also offers glimpses of the future we are preparing for ourselves and the planet: "In ice is the memory of the world. . . . On secret diamond faces, ice has written runic codes of time past foretelling a world that is still to come."[38] As these quotations suggest, Balog's work opens up fascinating questions concerning photography and temporality.

Balog's photographs explore the unsettling temporal dimensions of the image, which fixes the past in the present, with the focus shifted from the span of an individual life that characterizes portrait photography to that of geological, planetary time (figure 39). *Ice* is divided into four sections. The first and last—"Time Now" and "Ice Diamonds"—present photographs of ice that highlight the pure beauty of arrested form. The first section of the book contains large-scale images taken by Balog and his EIS team, shots of glaciers in locations such as Greenland, Iceland, the Himalayas, and the Andes. Their massive grandeur elicits a sense of the sublime that has become a central component in much contemporary environmental rhetoric. In calendars, leaflets, and books produced by environmental organizations such as Greenpeace, the aesthetic convention of the sublime is invoked through photographs similar to Balog's to induce a feeling of transcendence, with images of massive mountains typically used to destabilize the viewer as a bounded subject and spark a secular-religious affective intensity.[39] In the book's final section, Balog offers a contrast to this relatively traditional environmental visual rhetoric by photographing fragments of ice up close, finding "ice diamonds" in the beautiful organic forms that shards of ice assume under the impact of time and tide. These two sections of the book thus link the two dominant aesthetic forms theorized since the

39. James Balog, Greenland Ice Sheet, 14 July 2008. Bubbles of ancient air, possibly 15,000 years old, are released as the ice sheet melts. Courtesy James Balog / Extreme Ice Survey.

eighteenth century, the sublime and the beautiful, in an attempt to engage viewer empathy with these increasingly evanescent fragments of the natural world.

In the two middle sections of the book, "Time Passing" and "Transformation," Balog shifts from this relatively static lexicon in order to document the retreat, collapse, and disappearance of the world's great glaciers. In doing so, he sets out to help viewers *see* climate change. This strategy was developed in response to a crisis in the visual rhetoric of environmental discourse. During the 1960s and 1970s, environmental organizations had become heavily dependent on visual images that offered indexical proof of humans' pernicious impact on the environment, but, as scientific evidence for climate change began to accumulate in the following two decades, such organizations were confronted with a lack of visual proof of the environmental crisis. Scientists warned of the need to take preventative action, but, as Roland Barthes stressed, the photograph offers referential proof of the past in the present, rather than of the future.[40] Faced with this crisis, photographs such as Greenpeace's 1997 discourse-shifting aerial image of the crack in the Larsen B ice shelf in Antarctica have played a critical role in establishing visual proof of climate change. Balog's images in the "Time Passing" and "Transformation" sections of *Ice* extend this project of making climate change visible. "Time Passing" is composed of time-lapse images from a series of cameras set up by Balog and the EIS team in locations overlooking glaciers in various parts of the world. Shooting thousands of images

each year, these cameras provide a visual record of the death of the world's great glaciers, a mutation that Balog dramatizes by juxtaposing images in which the movement of the glaciers in relation to the surrounding landscape demonstrates the powerful impact of anthropogenic climate change. In the film *Chasing Ice,* such images take on even more power as viewers watch Balog flick through the time-lapse record captured by the EIS cameras; thus animated, the glaciers he photographs crawl up the sides of mountains and dive into the ocean like living creatures. In "Transformation," Balog zooms in from the panoramic field of the previous section to focus on the meltwater channels, crevasses, and moulins that open up in the surface of rapidly melting glaciers. Seen from up close, as millions of gallons of water flow out of the frozen glacial past into the rising oceans of the present, Balog's visual record of climate change portends a future of perilous flux.

If, as climatologists have taught us, the air bubbles trapped in glaciers preserve records of past millennia of the Earth's environment, the increasingly rapid disappearance of these living documents of the planet's history offers us a chilling image of a catastrophic future. As the anthropologist Marc Abélès has argued, we are undergoing a fundamental civilizational shift in our conception of time.[41] If the modern era was distinguished from the medieval by the shift from a static temporal structure characterized by the cyclical nature of history to a dynamic structure where the future is open and time is conceived of as accelerating and irreversible, today we are faced with a crisis in the model of progress that characterized modern conceptions of temporality.[42] In place of modernity's developmental temporality, today we live in an era of risk in which time is fragmented, incoherent, and, increasingly, apocalyptic. If, in other worlds, global capital has disintegrated stable experiences of place, it has also wrought similar disruptive changes in our experience of time. Balog's images of glaciers in motion crystallize this dawning sense of catastrophic time.

Wakening people to impending climate catastrophe is an important stage of political struggle, particularly in the United States, where climate change denial has been well funded by the fossil-fuel lobby. But apocalyptic thinking is not without problems. On a formal level, images of receding glaciers may generate a powerful, emotive sense of loss and hammer home the message that the climate is changing, but they do nothing to clarify the causes of climate change or to suggest concrete actions to viewers that may help them combat fossil-fueled capitalism. As Eddie Yuen argues, in the absence of a broader critique of the political and economic system in which climate change is embedded, apocalyptic environmental rhetoric concerning the climate is likely to facilitate right-wing nationalist responses to the environmental crisis rather than progressive, egalitarian ones.[43] Indeed, xenophobic movements in the United States are already deploying environmental arguments to legitimate their anti-immigrant rhetoric.[44] Given these dynamics, how can artist-activists maintain a focus on social justice while addressing the environmental transformations of our time?

One key problem that can be addressed by artistic practice in the present is the universalism that often circulates in discussions of climate change. Well-meaning scientists

and pundits often tell us that global warming is imperiling "humanity" or "the planet." But the increasingly grave impacts of climate change are not evenly distributed. Christian Parenti's recent book *Tropic of Chaos* is a powerful testament to the impact of climate-related conflicts on postcolonial nations already rendered unstable by the internecine warfare of the Cold War and the economic and political shocks of neoliberal structural adjustment programs.[45] Many conflicts in "failed states" around the world today, Parenti demonstrates, can be related to the fatal conjunction of climate change–fueled environmental crises with the enduring impact of previous "low-intensity" warfare. Documentation of these uneven geographies of climate change may challenge universalizing pronouncements about climate change's impact that are blind to issues of climate justice. Unless the struggle to cope with climate change is thoroughly informed by such social-justice perspectives, green capitalist solutions like those that have dominated international forums such as the UNFCCC process and, even worse, racist Malthusianism, are likely to dominate responses to climate chaos.[46]

MAPPING UNEVEN GEOGRAPHIES

Such questions underline the enduring centrality of uneven development as a theoretical lens for analyzing contemporary capitalist culture.[47] This is particularly the case given the current trend toward enclosure of the global commons. Among the most interesting efforts to engage with this dynamic is World of Matter, an international art, media, and research project dedicated to investigating the complex ecologies that subtend contemporary resource exploitation. World of Matter is organized by Supply Lines, a collective of artists intent on forging "a collaborative and interdisciplinary mode of geographical knowledge production, wherein thinkers and makers from a range of fields come together to produce new vocabularies to critically address current resource geographies."[48] Employing fieldwork methods borrowed from geographers, ethnographers, and radical journalists, Supply Lines collaborators have explored the transnational flows of resources such as oil, gold, water, and cotton in a project scheduled to culminate in 2014.

The project unites artist-activists whose work has long focused on the political ecology of flow. In previous work, for example, Supply Lines collaborator Ursula Biemann explored the transnational infrastructure surrounding Black Sea oil, paying particular attention to the correlations between flows of fossil fuel and flows of people.[49] In the multichannel installation *Black Sea Files* (2005), Biemann traces a counter-geography to the global oil industry: local farmers displaced by the laying of the Baku-Tbilisi-Ceyhan (BTC) pipeline, young women from Russia and the Caucasus who travel west along the same route as the pipeline and engage in sex work in order to survive, and the wasteland of abandoned oil extraction sites near Baku. As Biemann puts it, her videos from these various sites capture "a fragmented human geography," the debris of oil extraction's history and the overcrowded migration zones of its unequal present.[50]

The World of Matter project extends work by individual collaborators such as Biemann in order to render visible the uneven geographies of contemporary resource extraction and flow. To do so, members of the Supply Lines group such as Biemann and the photojournalist Uwe H. Martin work across multiple sites, challenging the dominant containment of culture within the borders of the nation-state. Martin's Land Grab (2005) project looks, for example, at the displacement of German dairy farmers by capital investment groups hunting for big returns from biofuels, or the Ethiopian government's sale of millions of acres of land to investors from the Middle East and East Asia while its own food aid–dependent population has spiraled.[51] Like Burtynsky, Sekula, and Balog, Supply Lines collaborators adopt a transnational framework in order to map the flows of material goods and the social, political, and economic contexts through which they travel. Unlike the former artists, however, Supply Lines engages in an explicitly collaborative practice that offers an alternative to the hierarchical, top-down capitalist institutions that tend to control such resource flows. World of Matter is intended to catalyze public debate about the enclosure of the global commons through novel forms of dissemination, including a digital platform featuring a multiplicity of interlinked documents and video clips that make apparent hitherto invisible links between disparate places, people, and events. As Emily Scott puts it in her introduction to World of Matter, "The structure of this project—an open-ended platform produced by a team of international practitioners conducting sustained aesthetic research on specific case studies—mirrors the subject at hand. How could one specialist, or even one discipline, begin to effectively broach such a vast topic?"[52]

In addition to embodying horizontal, collective, multidisciplinary, and multigenre research practices, the World of Matter project aims to challenge the anthropocentric viewpoint implicit in notions of "natural resources," as if nature was a purely passive material attendant on human needs and commodifying urges. Biemann explains this aspect of the project in the following terms: "The gradual shift in title from Supply Lines to World of Matter traces this move from a notion of resources understood as a system of supply lines for humans toward a deeper attention to the situated materialities of stuff like gold, rice, oil, fish, land, or water, and the complex multispecies entanglements within which they emerge."[53] This perspective on matter is linked strongly to new perspectives emerging in interdisciplinary fields stressing a vitalist outlook on the material world in which matter is conceived of as possessing its own modes of self-organization and transformation.[54] If matter is no longer thought of as passive, then human beings are no longer the sole agents characterized by cognition, intentionality, and freedom, a shift that throws into crisis the traditional assumption that humans' exclusive cognitive abilities give them the right and responsibility to master the natural world—and, in tandem, indigenous and colonized people, who tended to be treated as pre-rational beings subject to the same dismal instrumental fate as other species. The World of Matter project thus aims to challenge colonial ontologies that undergird contemporary forms of accumulation by dispossession as such practices affect people and other

complexly intertwined life forms in sites of resource extraction. This raises complex ethical, juridical, and institutional questions, which hinge on a crucial issue: What would it mean to accord rights to nature?[55] This demand has been central to contemporary political campaigns such as the movement for climate justice, but has yet to gain significant traction in international forums such as the United Nations. Much work remains to be done.

CONCLUSION: EXTREME EXTRACTION

The world is not about to run out of hydrocarbon energy sources, but discoveries of new energy supplies such as oil fields have become increasingly infrequent, and their supplies smaller, in recent years. Such scarcity has been one of the key factors driving energy prices higher. As the quality and quantity of conventional sources of fossil fuel has diminished, the energy industry has turned to increasingly inaccessible sources in often hostile and fragile environments. The technology required to extract oil, gas, and coal reserves from such inaccessible sources has grown ever more complex, expensive, and environmentally destructive. The increasing scarcity of easily exploitable energy reserves, in other words, explains the rise of extreme extractive industries such hydrofracturing, deep sea oil drilling, mountaintop coal removal, and tar sands oil extraction. These new modes of extreme extraction are bringing forms of environmental destruction heretofore confined to the Global South home to populations in the North who have for decades been relatively sheltered from the most aggressive efforts of the energy industry. Extreme extraction also significantly augments the release of greenhouse gases, intensifying climate change. For this reason, extreme extraction tends to go hand in hand with extreme weather and (un) natural disasters. Yet if extreme extraction brings the environmental chickens home to roost, it also galvanizes new transnational forms of solidarity. As the protests against the Keystone XL Pipeline over the last two years in Canada and the United States have demonstrated, extreme extraction is forging coalitions that cross ethnic, regional, and national borders. In tandem with catalyzing such new links, the struggle against extreme extraction is also provoking the American environmental movement to adopt increasingly militant modes of direct action—forms of struggle often pioneered by environmental activists in the Global South faced with the destruction of the natural world upon which their lives depend.[56]

The visual arts have a key role to play in struggles against extreme extraction. All too often, the sites at which such extraction occurs are forbiddingly inaccessible, and the impact of such extraction is often invisible. Indeed, even spectacular failures of the fossil fuel industry such as the explosion of the Deepwater Horizon drilling rig in the Gulf of Mexico have been covered up using industrial solvents and militarized language to obfuscate the enduring damage to marine ecosystems.[57] How, given what the environmental scholar Rob Nixon calls "attritional catastrophes," in which violence is displaced using temporal, geographical, technological, and rhetorical slights of hand, can

we galvanize public sentiment enough to catalyze political action around issues such as extreme extraction?[58] Speaking of the capacity of what he calls "writer-activists" to address such questions, Nixon argues that creative workers "may help us apprehend threats imaginatively that remain imperceptible to the senses, either because they are geographically remote, too vast or too minute in scale, or are played out across a time span that exceeds the instance of observation or even the physiological life of the human subject."[59]

If one of the key characteristics of slow violence is its imperceptibility, visual artists have access to particularly strategic resources in the struggle to make such violence visible. The truth claims associated with the visual image have been thoroughly deconstructed, but it seems undeniable that, given the hegemony of the image in modernity, the visual realm can generate unparalleled affecting experiences similar to what I underwent while watching *Chasing Ice*.[60] We live, after all, in the society of the spectacle. The artists on whom I have focused deploy a variety of genres, but all hinge crucially on offering visual documentation of the uneven impact of the traffic in plants, animals, people, and things that constitutes the diverse extractive economies of the present. While, as we have seen, use of the photographic image is not without problems, particularly inasmuch as it may dovetail with the exploitative mores of the contemporary aid industry, artist-activists such as Burtynsky, Sekula, Balog, and the Supply Lines collective deploy images within a critical documentary essayistic format that militates against aesthetic traditions predicated on representation of nature as opaque and passive, made to be manipulated by human beings. Using multi-genre, multi-sited fieldwork, these artist-activists assemble cognitive maps of the political ecology of flows in contemporary turbo-capitalism. To create cognitive maps that link the uneven geographies of contemporary turbo-capitalism is to offer a vision of transnational connection. It is precisely such forms of vision that we need in order to overcome the segmented spatial ideologies that separate us into competing nations and races today. To do so using modes of transnational collaboration and collective knowledge production is to enact the forms of solidarity that we must kindle and build if we are to halt turbo-capitalism's war on the planet.

NOTES

1. Alfred Crosby, *Ecological Imperialism: The Biological Expansion of Europe, 900–1900* (New York: Cambridge University Press, 2004) and Virginia Anderson, *Creatures of Empire: How Domestic Animals Transformed Early America* (New York: Oxford University Press, 2006).

2. Barbara Arneil, *John Locke and America: The Defense of English Colonialism* (New York: Oxford University Press, 1996).

3. On the intensification of accumulation by dispossession, see David Harvey, *The New Imperialism* (New York: Oxford University Press, 2005).

4. See J. A. Hobson, *Imperialism: A Study* (1902) and Vladimir Lenin, *Imperialism: The Highest Stage of Capitalism* (1917).

5. Damien McElroy, "Protest at the Great African Land Grab," *Telegraph,* October 4, 2012, accessed January 16, 2013, http://www.telegraph.co.uk/news/worldnews/africaandindianocean /liberia/9584931/Protest-at-the-great-African-land-grab.html.

6. See Ashley Dawson, "Durban and the Closing Door: Climate Apartheid," http://www. counterpunch.org/2011/12/26/durban-and-the-closing-door.

7. For examples of recent theoretical work alive to political ecology, see Jeffery Kastner, ed., *Land and Environmental Art* (Phaidon: London, 1998); Yates McKee, "Art and the Ends of Environmentalism," in *Nongovernmental Politics,* ed. Michel Feher (Zone: New York, 2007); and T. J. Demos, "The Politics of Sustainability: Art and Ecology," in *Radical Nature: Art and Architecture for a Changing Planet, 1969–2009* (Barbican: London, 2009).

8. Yates McKee, "Of Survival: Climate Change and Uncanny Landscape in the Photography of Subhankar Banerjee," in *Impasses of the Post–Global: Theory in the Era of Climate Change,* vol. 2, ed. Henry Sussman (Open Humanities Press, an Imprint of the University of Michigan Library, spring 2012).

9. On the hegemonic tradition of representing landscape as an apolitical alternative to the hectic life of the city, as well as on critical alternatives to that tradition, see Raymond Williams, *The Country and the City* (Oxford University Press: New York, 1975).

10. Frederic Jameson, *Postmodernism, Or the Cultural Logic of Late Capitalism* (Durham, North Carolina: Duke University Press, 1991), 51–52.

11. Judith Halberstam, *The Queer Art of Failure* (Durham, North Carolina: Duke University Press, 2011) and Laurent Berlant, *Cruel Optimism* (Durham, North Carolina: Duke University Press, 2011).

12. For a critique of environmental catastrophism, see Eddie Yuen, "The Politics of Failure Have Failed," in *Catastrophism: The Apocalyptic Politics of Collapse and Rebirth,* eds. Sasha Lilley, David McNally, Eddie Yuen, and James Davis, (Oakland: Spectre, 2012).

13. T. J. Demos, "Another World, and Another . . . Notes on Uneven Geographies," *Uneven Geographies Catalogue,* accessed March 30, 2013, http://www.nottinghamcontemporary.org /art/uneven-geographies.

14. Ibid.

15. Amitav Ghosh, "Petrofiction," *New Republic* 206, no. 9 (March 2, 1992): 29–34.

16. Ibid., 30–31.

17. This work of making oil visible is only just beginning on a scholarly level. A promising trendsetter is Stephane LeMenager, *Living Oil: Petroleum Culture in the American Century* (New York: Oxford University Press, 2014).

18. On the overproduction of shale gas, see Janusz Chojna, Miklos Losoncz, and Paavo Suni, "Shale Energy Shapes Global Energy Markets," *National Institute Economic Review* 226, no. 1 (November 2013): 40–45. The threat to drinking water from fracking has become well known through Josh Fox's film *Gasland* (2010).

19. For some of the key images in Edward Burtynsky's *Oil,* see the photographer's website, http://www.edwardburtynsky.com.

20. In this regard, Burtynsky's photographs contrast dramatically with those of Ansel Adams. The Shelburne Museum emphasized these contrasts in their exhibition *Ansel Adams and Edward Burtynsky: Constructed Landscapes* (2010). Images from the exhibition are featured at http://shelburnemuseum.org/exhibitions/adams-burt (accessed March 29, 2013).

21. For a discussion of colonial representational strategies that denude the land and/or treat the colonized as part of the landscape, see Mary Louis Pratt, *Imperial Eyes: Travel Writing and Transculturation* (New York: Routledge, 1992). For a discussion of the legal regimes subtending such measures, see Daniel Heller-Roazen, *The Enemy of All: Piracy and the Law of Nations* (New York: Zone Books, 2009).

22. See Ed Kashi and Mike Watts, *The Curse of the Black Gold* (New York: Powerhouse Books, 2010) and http://georgeosodi.photoshelter.com/gallery/OIL-RICH-NIGER-DELTA-2003–2007/Goooons8MS37FfZU/.

23. T. J. Demos, "Poverty Pornography, Humanitarianism, and Neo-Liberal Globalization: Notes on Some Paradoxes in Contemporary Art," *SMBA Newsletter* 121, http://www.smba.nl/en/newsletters.

24. Ibid.

25. Allan Sekula and Noël Burch, "The Forgotten Space: Notes for a Film," *New Left Review* 69 (May–June 2011), accessed January 22, 2013, http://newleftreview.org/II/69/allan-sekula-noel-burch-the-forgotten-space.

26. Ibid.

27. Allan Sekula and Noël Burch, *The Forgotten Space* (Icarus Films, 2010).

28. The term "creative destruction" derives, ultimately, from Karl Marx, but was highlighted by the Austrian economist Joseph Schumpeter in *Capitalism, Socialism, and Democracy* (1942). For a more recent use of the term to account for the material and cultural dynamics of neoliberalism, see David Harvey, "Neoliberalism as Creative Destruction," accessed January 26, 2013, http://ebookbrowse.com/neo-liberalism-as-creative-destruction-pdf-d83747842.

29. On the essay film, see Kodwo Eshun, "The Art of the Essay Film," *DOT DOT DOT* 8 (October 2004): 53–59.

30. Allan Sekula, Interview, Ràdio Web Macba 119 (January 27, 2011), accessed January 22, 2013, http://rwm.macba.cat/en/sonia/allan_sekula/capsula.

31. Ibid.

32. For an example of such dialogue, see the discussion between Sekula, the political geographer David Harvey, and the art critic Benjamin H. D. Buchloh following the film's premiere at the Cooper Union in 2011. Archival footage of this conversation is available at http://www.afterall.org/online/material-resistance-allan-sekula-s-forgotten-space.

33. Fredric Jameson, "Postmodernism, or The Cultural Logic of Late Capitalism," *New Left Review* 146, no. 1 (July–August 1984), http://newleftreview.org/I/146/fredric-jameson-postmodernism-or-the-cultural-logic-of-late-capitalism.

34. Ashley Dawson, "New Modes of Anti-Imperialism," in *Exceptional State: Contemporary U.S. Culture and the New Imperialism*, eds. Ashley Dawson and Malini Johar Schueller (Durham, North Carolina: Duke University Press, 2009), 250.

35. For a discussion of the radical new conceptions of matter emerging in both the natural sciences and certain branches of the humanities, see Diana Coole and Samantha Frost, eds., *New Materialisms: Ontology, Agency, and Politics* (Durham, North Carolina: Duke University Press, 2010).

36. Balog is an editor for *National Geographic*, but his photographs have been reproduced in popular publications such as *The New Yorker* and *Vanity Fair*, and he won Photomedia's

Person of the Year Award in 2011. His work thus straddles art, science, and popular photojournalism.

37. Jeff Orlowski, director, *Chasing Ice,* Exposure Productions, 2012.

38. James Balog, "Introduction," *Ice: Portraits of Vanishing Glaciers* (New York: Rizzoli, 2012).

39. On the visual rhetoric of environmental organizations such as Greenpeace, see Heather Dawkins, "Ecology, Images, and Scripto-Visual Rhetoric," in *Ecosee: Image, Rhetoric, Nature,* eds. Sidney Dobrin and Sean Morey (Albany, New York: SUNY Press, 2009), 79–94.

40. For a discussion of the crisis of environmental visual rhetoric prompted by climate change, see Julie Doyle, "Seeing the Climate?: The Problematic Status of Visual Evidence in Climate Change Campaigning," in *Ecosee,* 279–98.

41. Marc Abélès, *The Politics of Survival* (Durham, North Carolina: Duke University Press, 2010).

42. Ibid, 32.

43. Eddie Yuen, "The Politics of Failure Have Failed," 15–43.

44. See, for example, Andrew Ross's discussion of the anti-immigrant movement in Arizona in *Bird on Fire: Lessons from the World's Least Sustainable City* (New York: Oxford University Press, 2011).

45. Christian Parenti, *Tropic of Chaos: Climate Change and the New Geography of Violence* (New York: Nation Books, 2012).

46. For a discussion of revived Malthusian discourse in the context of apocalyptic environmental rhetoric, see Eddie Yuen, "The Politics of Failure Have Failed," 29–30.

47. See Neil Smith's *Uneven Development: Nature, Capital, and the Production of Space* (Athens, Georgia: University of Georgia Press, 2008).

48. *World of Matter* website, accessed January 27, 2013, http://www.geobodies.org /curatorial-projects/world-of-matter.

49. Ursula Biemann, *Mission Reports: Artistic Practice in the Field: Video Works 1998–2008* (Bristol, England: Arnolfi, 2008), 56.

50. Ibid., 64.

51. *Supply Lines: Visions of Global Resource Circulation* (July 2010), accessed January 27, 2013, http://www.ith-z.ch/fileadmin/autoren/ith_Forschung/Texte_Forschungsprojekte /Supply_Lines_dt_full_red__2_.pdf.

52. Ibid.

53. *World of Matter* website, accessed 27 January 2013, http://www.geobodies.org /curatorial-projects/world-of-matter.

54. Diana Coole and Samantha Frost, "Introduction," in *New Materialisms: Ontology, Agency, and Politics,* eds. Diana Coole and Samantha Frost (Durham, North Carolina: Duke University Press, 2010), 10.

55. For an extended discussion of this issue, see Cormac Cullinan, *Wild Law: A Manifesto for Earth Justice* (New York: Chelsea Green, 2011).

56. For an overview of the environmental movement through an international lens, see Ramachandra Guha, *Environmentalism: A Global History* (New York: Pearson, 1999).

57. Anne McClintock, "We Are All BP Now: Militarizing the Gulf Oil Crisis," *Counterpunch,* June 24, 2010, accessed January 28, 2013, http://www.counterpunch.org/2010/06/24 /militarizing-the-gulf-oil-crisis.

58. Rob Nixon, *Slow Violence and the Environmentalism of the Poor* (Cambridge, Massachusetts: Harvard University Press, 2012), 7.

59. Ibid., 15.

60. For a discussion of the hegemony of the visual, see David Michael Levin, ed., *Modernity and the Hegemony of Vision* (Berkeley: University of California Press, 1993).

21

DONGSEI KIM

on Teddy Cruz, *The Political Equator* (2005–11)

Teddy Cruz is one of the best-known contemporary architects to engage the topic of international borders—in his case, the one between San Diego in California and Tijuana in Mexico. Many others, such as Rem Koolhaas with his *Exodus, or the Voluntary Prisoners of Architecture* in 1972, and Morphosis with their *Berlin Wall Competition* in 1986, previously investigated the notion of borders in the context of the Cold War. Within that acute political tension, borders were often understood and hence represented as objects of inquiry or as metaphor by architects, which resulted in work that was often speculative or removed in nature, denying the profession's power to intervene concretely in the fierce geopolitics of its time.

With the fall of the Iron Curtain and the subsequent development of globalization ushered in by the formation of the European Union (1993), the North American Free Trade Association (1994), and the World Trade Organization (1995), the notion of a "borderless world" emerged. As a consequence, new ways of understanding and representing borders transpired. Architects increasingly mapped the impacts of expanding globalization such as flows of people migrating, and social changes on the ground using concrete data. With this, borders became more understood as a set of dynamic processes and flows that change over time, as opposed to abstract, static lines on a map.

Cruz's overall body of work between the United States and Mexico is exemplary of this shift, particularly the series of conferences he organized between 2005 and 2011 under the rubric of *The Political Equator*. He frames his own architectural output in terms of spatial practice.[1] His ability to engage multiple scales in dealing with borders is

40. Teddy Cruz, photograph from *The Political Equator 3: Border-Drain-Crossing*, June 4, 2011. Photo by Cynthia Hooper.

a unique feature that distinguishes his work from others who only operate at one particular scale.

In *The Political Equator*, Cruz operates across multiple scales. He maps processes and conflicts at a global scale that give birth to the imaginary "corridor of global conflict between the 30 and 36 degrees North Parallel," which in turn becomes the title of the project, framing the overall work.

At the same time, his project does not end up being just a conceptual mapping exercise at 10,000 feet above the ground. In the third manifestation of *The Political Equator*, in 2011, he revealed tensions embedded in the natural and social systems of border territories by engaging actual sites, at the scale of human experience. Conference participants, for example, took part in a "Border-Drain-Crossing" performance where they crossed the United States–Mexico border through a water drain. The journey started on the United States side of the border, a pristine and environmentally protected zone within the Tijuana River Estuary, and ended in a slum on the Mexican side. This process was documented with video, specifically using the point-of-view technique, which allowed viewers outside the actual performance to experience the border crossing through engaging the views of conference participants, making them complicit in this act.[2]

These experiential acts are informed by equally provocative mappings, which make these bodily acts significantly more potent. This multi-scale operation intensifies Cruz's

attempt to rethink these territories and the policies that enable certain detrimental exclusions that Cruz amplifies and reimagines.

NOTES

1. The Political Equator website: http://www.politicalequator.org/.
2. Teddy Cruz, "Political Equator 3: Reimagining the Border," *Domus*, June 24, 2011, http://www.domusweb.it/en/architecture/2011/06/24/political-equator-3-reimagining-the-border.html.

22

KELLY C. BAUM

on Santiago Sierra, *Sumisión* (*Submission, formerly Word of Fire*) (2006–7)

Sumisión (*Submission, formerly Word of Fire*) by the Spanish artist Santiago Sierra is an incisive and thrilling, if deeply problematic, meditation on the spatial politics of power. Sierra's case study is Anapra, a desert community located a few miles west of Ciudad Juárez, near the United States–Mexico border. Its residents, most of whom migrated to Anapra in search of work at nearby *maquiladoras,* suffer myriad injustices, most stemming from poverty, pollution, dislocation, disenfranchisement, globalization, unfair immigration practices, and drug and sexual violence.

Seeking to visualize the unequal social relations that shape this region of Mexico, Sierra choreographed an intervention into the Anapran desert in October 2006, about eleven months after House Bill H.R. 4437 made its way to the floor of the United States Congress and more than a million advocates for immigrants' rights took to the streets. (H.R. 4437 is better known as the Border Protection, Anti-Terrorism, and Illegal Immigration Control Act. The bill passed the U.S. House of Representatives on December 16, 2005, but not the Senate. Its provisions were so odious that millions were inspired to protest.) As he had done in the past, Sierra enlisted the services of the very people whose lives he sought to publicize, in this case a group of Anapran laborers. At his request, they "drew" the Spanish word for "submission" into the earth and lined the waist-deep depressions with concrete. These the artist planned (unsuccessfully) to fill with gasoline and set on fire on December 1, 2006, at the precise time of Felipe Calderón's inauguration as president of Mexico. As if to emphasize the work's accusatory tone, Sierra oriented his earth sign south, so that it "faced" Mexico City, home to Mexico's most influential politi-

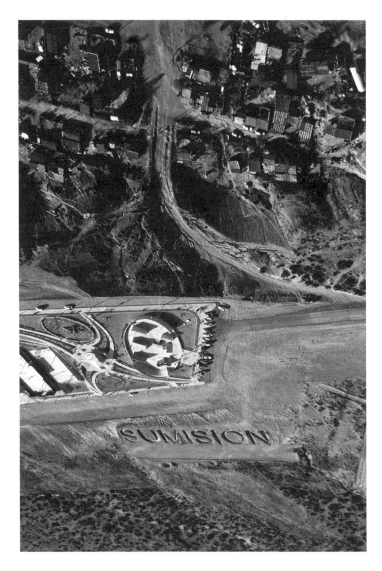

41. Santiago Sierra, *Sumisión (Submission, formerly Word of Fire)*, 2006–7. Two-channel digital slide projection, documentation of an action at Anapra, Ciudad Juárez, Mexico, October 2006–March 2007. Artwork © Santiago Sierra; photo courtesy Team Gallery, New York.

cians and oligarchs, the individuals most culpable (along with the United States government) for the dismal living conditions in Anapra.

Sierra's intervention survives in the form of a split-screen digital slideshow. One half shows "Sumisión" from the air, a perspective with contradictory connotations, from dominance and surveillance to mobility and freedom. The other half pairs images of the Anapran laborers with aerial photographs of nearby smokestacks, industrial parks, distribution centers, shantytowns, and the city of El Paso, Texas. Sierra's slideshow is no mere document, however. The majority of the images are characterized by oblique, even delirious points of view that scramble our sense of direction and make abstract what was once recognizable, thereby sacrificing much of the work's own evidentiary value. Unable

to orient ourselves spatially, we struggle to orient ourselves ethically as well. Whose side are we on, exactly? With whom do we identify when we can no longer determine what is north and what is south, what is up and what is down? Such are the moral and political predicaments Sierra stages. As with much of the artist's work, *Sumisión* is both revelatory and disruptive, but not necessarily constructive. Neither parody nor critique, exactly, the project represents something of a conundrum. It is politically charged, but not oppositional, stirring but not affective. Paradoxically, this is the source of its strengths as well as its weaknesses.

23

JAMES NISBET

on Simon Starling, *One Ton II* (2005)

Simon Starling's *One Ton II* (2005) recasts the status of materiality within the long-standing relationship of photography and energy circulation. Energy has played a fundamental—if largely tacit—role within photo-based media since the mid-nineteenth century, when light was reconceptualized from Sir Isaac Newton's theory of the particle stream to being understood, instead, as a form of energy. This revised notion of light prompted both a new understanding of the photograph as a latent image requiring chemical development and also of the formulation of ecology as the distribution of energy across the Earth's surface. After all, the basic notion of ecology as the interconnection of all living and nonliving things is inconceivable without an underlying force or current to feed the food chain and mediate the distribution of growth and decay within an environment. The radical revision of light as photoenergy in the nineteenth century provided just such an impetus.[1] A century and a half after this sweeping turn away from Newtonian light, *One Ton II* rather surprisingly returns to and recuperates its notion of the "particle" within photography, but in a manner more thoroughly attuned to the geopolitics of present-day energy expenditure.

One Ton II is a series of identical platinum-printed photographs of a mining pit in South Africa. It is the same mine that yielded the platinum required to produce the photographs, using that long-outmoded technique. One ton of ore, to be exact, supplied enough platinum for precisely five prints.[2] The significance of platinum printing for Starling's work lies partly in the fact that it does not require an emulsion, as does silver-gelatin printing, in which the metal particles are suspended in a solution. The platinum

42. Simon Starling, *One Ton II*, 2005. Five handmade platinum/palladium prints, 65 × 85 cm each. Courtesy the artist, CAC Málaga, and Casey Kaplan, NY; photo by José Luis Guitiérrez.

lies directly on the surface of the paper, appearing as matte and more directly visible than the silver particles of the latter process, thereby calling attention to the material presence of the precious metal in the photographic image. This sense of materiality aligns with a larger interest in Starling's practice with the photograph as a kind of sculptural object, which he describes as being "made up of hundreds of thousands of three-dimensional particles."[3] He has experimented with this provocative intersection of photography and sculpture in several projects over the past decade, including *Particle Projection (Loop)* (2007), wherein he obtained the shapes of individual particles using an electron microscope and then projected their forms onto a 35-millimeter film, and *The Nanjing Particles* (2008), for which he enlarged such magnified particles into two freestanding metal sculptures.[4]

The investment of Starling's work in the intersection of these media is not simply formal, however. *The Nanjing Particles* engages a complex dialogue about transnational labor between the United States and China in that it draws upon an episode in the late nineteenth century that brought seventy-five Chinese workers to western Massachusetts in response to a local labor dispute. In a similar vein with regard to global trade and labor, *One Ton II* addresses platinum as a metal quarried primarily in South Africa that is avail-

able internationally only as the result of significant refining. "The interesting thing about platinum," Starling notes, "is that it is absurdly energy intensive to produce. To make one ounce of metal you need twenty tons of ore."[5] As such, Starling's emphasis on the particles of this element that compose the surface of his photographs joins their sculptural quality directly to the politics of energy consumption. These are not neutral elements. They are charged by the contemporary traffic in energy—a network of transmission that incorporates photographic processes as equally as those of plant life, metallurgy, industrial labor, and global commodity exchange.

NOTES

1. I discuss these intersecting histories of photography, ecology, and energy at greater length in my recent essays "Atmospheric Cameras and Ecological Light in the Landscape Photographs of Eadweard Muybridge," *Photography and Culture* 6, no. 2 (July 2013): 131–56; and "A Brief Moment in the History of Photo-Energy: Walter De Maria's *Lightning Field*," *Grey Room* 50 (winter 2013): 66–89.

2. Platinum or palladium printing was popular during the late nineteenth century, dwindling only in the early twentieth, when silver gelatin printing gained traction in response to a multifold increase in the price of platinum.

3. Simon Starling, quoted in "Francesco Manacorda in Conversation with Simon Starling," in *Simon Starling*, eds. Dieter Roelstraete et al. (London and New York: Phaidon, 2012), 27.

4. See the exhibition catalogue *Simon Starling: The Nanjing Particles* (North Adams, Massachusetts: MASS MoCA, 2009).

5. Simon Starling, quoted in Phillip Kaiser, "Interview with Simon Starling," in *Simon Starling: Cuttings* (Berlin: Hatje Cantz, 2005), C16.

24

GIULIA PAOLETTI

on George Osodi, *Oil Rich Niger Delta* (2003–7)

A solitary man is standing in the middle of a wide street behind his black bike. Covering his face with a brightly colored umbrella, he seems unapproachable. In this quiet scene, the narrative tension is encapsulated in the umbrella trembling against the beaming orange sky. Yet this picture does not capture someone standing in the face of a powerful tempest. Rather, as the title reveals, it silhouettes a man engaged in a Don Quixote–esque struggle to shield himself from a gas flare in the Niger Delta.

With its 47,000 square miles, the Niger Delta is the second largest delta in the world and one of America's top oil suppliers. Since the first drillings in 1958, it has become Nigeria's largest source of revenue. Initial euphoria was incited by the economic boom, but it has become a curse, a "paradise lost." In the past five decades, 546 million gallons of oil were spilled into the Delta.[1] Newspapers and politicians have hardly addressed this environmental catastrophe.

In his *Oil Rich Niger Delta* series, the photographer and photojournalist George Osodi documents this land, the land of his birth. Since the beginning of his practice, Osodi has regarded "photography as the best way to create awareness, to tell a story that can impact change in society."[2] Despite the dire conditions he documents, rarely does he indulge in victimizing or shocking imagery. Rather, he uses aesthetic strategies—saturated colors and strong compositions—to "call the viewer," to "make him station," and then encourage him or her to confront the complexity of the image.[3] To approach the viewer, Osodi filters complex global dynamics through the daily reality of local inhabitants. He captures children, women, men, and militants of the Movement for the Emancipation of the Niger

43. George Osodi, *Gas Flare at Night,* from the series *Oil Rich Niger Delta,* 2006.

Delta (MEND)—whom he calls "the real people"—while those who live in the com-
pounds—the "unreal people"—remain invisible.[4] Osodi creates "environmental por-
traits," to use his term, by foregrounding ordinary subjects in extraordinary situations.
Through this dissonance between subject and environment, Osodi moves beyond stereo-
types of Africans' passivity to highlight their resistance.

NOTES

1. It is as if the 1989 Exxon Valdez incident in Alaska recurred every year for fifty years.
Julia Baird, "Oil's Shame in Africa," *Newsweek,* July 18, 2010; Adam Nossiter, "Far from Gulf,
a Spill Scourge 5 Decades Old," *New York Times,* June 17, 2010.

2. George Osodi, Skype conversation with the author, July 17, 2012.

3. George Osodi, personal communication with the author, July 2008.

4. Other photographers, such as Chaucey Hare, who also document the oil business, have
instead focused on the oil company employees. Allan Sekula, "Dismantling Modernism, Re-
inventing Documentary (Notes on the Politics of Representation)," *Massachusetts Review* 19,
no. 4 (1978); Frank A. O. Ugiomoh, "Pale Reflections and Fables of Life: George Osodi's 'Real
People' of the Niger Delta," *Nka: journal of contemporary African art* 27 (fall 2010).

SOURCES

Anderson, Lisa, and John S. Weber. *Environment and Object : Recent African Art.* New York: Prestel, 2012.

Anderson, Martha G., and Philip M. Peek. "Ways of the Rivers: Arts and Environment of the Niger Delta." *African Arts* 35, no. 1 (2002): 12–25, 93.

———. *Ways of the Rivers: Arts and Environment of the Niger Delta.* Seattle: University of Washington Press, 2002.

Baird, Julia. "Oil's Shame in Africa." *Newsweek* 156, no. 4 (2010): 27.

Krifa, Michket, and Laura Serani. "For a Sustainable World": Rencontres De Bamako, African Photography Biennial, 9th Edition. Paris: Institute Français; and Mali: Malian Ministry of Culture, 2011.

Milbourne, Karen E. *Earth Matters: Land as Material and Metaphor in the Arts of Africa.* New York: Monacelli, 2013.

Nnamdi, Basil Sunday, Obari Gomba, and Frank A. O. Ugiomoh. "Environmental Challenges and Eco-Aesthetics in Nigeria's Niger Delta." *Third Text* 27, no. 1 (2013): 65–75.

Nossiter, Adam. "Far from Gulf, a Spill Scourge 5 Decades Old." *New York Times,* June, 17, 2010, A1.

Olusakin, Ayoka Mopelola. "Peace in the Niger Delta: Economic Development and the Politics of Dependence on Oil." *International Journal on World Peace* 23, no. 2 (2006): 3–34.

Osodi, George. *Delta Nigeria: The Rape of Paradise.* London: Trolley Ltd., 2011.

Saint Léon, Pascal Martin, and N'Goné Fall. *Anthology of African and Indian Ocean Photography.* Paris: Revue noire, 1998.

Sekula, Allan. "Dismantling Modernism, Reinventing Documentary (Notes on the Politics of Representation)." *The Massachusetts Review* 19, no. 4 (1978): 859–83.

Ugiomoh, Frank A. O. "Pale Reflections and Fables of Life: George Osodi's 'Real People' of the Niger Delta." *Nka: journal of contemporary African art* 27 (fall 2010).

25

URSULA BIEMANN

Deep Weather (2013)

The short video essay *Deep Weather* (2013) draws a connection between the relentless reach for fossil resources, its toxic impact on the climate, and its consequences for indigenous populations in remote parts of the world. The video elaborates on oil and water as the two primordial liquids that form the undercurrents of all narrations as they activate profound changes in the planetary ecology. Since the oil peak, ever dirtier, more remote, and deeper layers of carbon resources are being accessed.

The first scene gazes down on a huge open-pit extraction zone for tar sands in the midst of a vast boreal forest of Northern Canada, opening our view into the dark lubricant's geology. Huge amounts of fresh water from the Athabasca River are used to boil the black sand until the oily substance bubbles over the rim of the cauldrons. The waste from this toxic process gets collected in tailing lakes spreading over large areas that only a few years ago were covered by ancient spruce forest and spongy wet moss. Aggressive mining, steam processing, and the trucking around of the tar sands are impinging on environmental and human rights and devastating the living space and hunting territories of First Nations people. In the last few years, the water level of the river has sunk so low that faraway settlements cannot be reached by boat anymore. But for aboriginal folks, practical inconvenience is not everything. Local mythologies and divinities of the biosphere animate the land. The landscape contains both worlds; it is a psycho-social resource. Hence, the noise, subterranean vibrations, and invisible toxic juices seeping into lakes and rivers create not only biological but also mental contamination, forming a hybridized locality. The disaster is under the ground, reaching into deep geological time, down to Cambrian layers of planet formation.

44. Ursula Biemann, *Deep Weather* (video still), 2013. Video, color. Courtesy the artist.

The second part of *Deep Weather* turns to the consequences of the melting Himalayan ice fields, which is causing planetary sea level rise and extreme weather events that increasingly define living conditions in Bangladesh. These changes impose an amphibian lifestyle on the Bangladeshi population, which has begun to devise convertible houses, floating agriculture, and cruising schools. The video documents the gigantic community effort to build protective mud embankments; hands-on work by thousands of people without any mechanical help is what climate change will mean for people in the deltas of the Global South and elsewhere. These are the measures taken by populations who will progressively have to live on water when large parts of their land are submerged. The scenery of collective human action stands in harsh contrast to the one in Alberta, where expensive, large-scale machinery replaces human labor. Fossil fuel replaced slave labor, they say. But it looks rather as if it was simply transferred elsewhere, to places where unpaid labor is necessary for survival. For different but intertwined purposes, massive landscaping is under way on a planetary scale.

26

LUKE SKREBOWSKI

on Tue Greenfort, *Exceeding 2 Degrees* (2007)

Tue Greenfort's work is characterized by its engagement with the contemporary politics of ecology. His practice exemplifies a nascent genre of "eco-institutional critique" wherein the artistic critique of the institution of art addresses its own negative ecological impact.[1] As such, Greenfort's work entwines itself in the broader structural paradoxes that attend third-generation institutional critique, specifically the realization that both the artist and the artwork are now understood as parts of that which they must critique.

Such concerns are manifested by *Exceeding 2 Degrees*, shown by Greenfort at the 8th Sharjah Biennial (2007) in the United Arab Emirates, an exhibition with the theme *Still Life: Art, Ecology, and the Politics of Change*. The installation involved a complex ensemble of elements, with a centerpiece consisting of a large coffee table topped by a thermo-hydrograph (a tool used by conservators to monitor environmental conditions in the gallery space). *Exceeding 2 Degrees* references the artist Hans Haacke's earlier designation of similar equipment as a readymade in his *Recording of Climate in an Art Exhibition* (1969–70); this micro-homage indexes Greenfort's broader debt to Haacke's biological systems and ecosystems works from the 1960s and 1970s.

In *Exceeding 2 Degrees*, however, the table is as significant as the thermo-hydrograph within the work's mise-en-scène. Fabricated from Malaysian hardwood by Japanese craftspeople and bought cheaply by Greenfort in Dubai before being assembled and exhibited in Sharjah, the table embodies the globalized conditions of manufacture, distribution, and consumption characterizing all major contemporary industries, including art.[2] Greenfort's work thus deliberately foregrounds a set of interconnected geographical and

45. Tue Greenfort, *Exceeding 2 Degrees*, 2007. Thermo hydrograph (meteorological instrument), coffee table, Malaysian rubber wood, glass, human hair, plastic membrane, photography, climate diagram, certificate, map. Configuration variable.

social relations that are internal to neoliberal globalization and, more specifically, the (eco)politics of its "spatial fix."[3]

Yet Greenfort also made a self-reflexive and ostensibly compensatory gesture for his work's participation within these circuits. The artist calculated the amount of money that could be saved over the course of his exhibition by allowing the temperature of the exhibition space to rise two degrees centigrade higher than would normally be considered optimal and used the cash value of his projected savings to purchase and protect an area of rainforest in Ecuador using the Danish environmental organization Nepenthes as an intermediary.[4] He then duly set the exhibition space's thermostat higher throughout the biennial, sweating his work's audience for the money saved.

Greenfort thus staged the ambivalent critical character of *Exceeding 2 Degrees* by foregrounding its complicity with the exploitative conditions of globalized commodity production and consumption and their associated ecological impact (as papered over by carbon offsetting). Whereas Haacke's practice in the 1970s regarded ecological artworks as related to the environmental movement but separate from it, Greenfort reconceives this relation, drawing environmentalism into the immanent problematic of the artwork.[5] Greenfort's eco-institutional critique thus insists that the critique of the art institution cannot be decoupled from a broader critique of the globalized—but always specifically ecologically sited—systems of production and exchange that frame any such artistic

critique, facilitating its enunciation and allowing it to circulate. As such, *Exceeding 2 Degrees* also sets up a horizon of expectation that it self-consciously fails to achieve, namely that art might model something other than a capitulation to these conditions.

NOTES

1. As far as I am aware, T. J. Demos was the first to coin the term "eco-institutional critique," and my work here is indebted to his. See T. J. Demos, "Art After Nature," *Artforum* (April 2012): 190–97. For a fuller discussion of the concept and practice of eco-institutional critique, including some of its limitations, see my "After Hans Haacke: Tue Greenfort and Eco-Institutional Critique," *Third Text* 27, no. 1 (January 2013): 115–30, http://dx.doi.org/10.1080/09528822.2 013.753195. My argument here draws on this article.

2. For a discussion of the development of a contemporary art industry, see Peter Osborne, *Anywhere or Not at All: Philosophy of Contemporary Art* (London: Verso, 2013), 163–69.

3. The "spatial fix" is a concept developed by David Harvey to explain how capitalism resolves crises of capital accumulation by geographical expansion. See, for example, David Harvey, *Spaces of Capital: Towards a Critical Geography*, (London, Routledge, 2003), 284–311.

4. A further layer of significance was added to the project and its title by the fact that the *Stern Review* (authored by the economist Nicholas Stern for the British government; copies were distributed around the show) argues that if no concerted global action is taken on carbon dioxide emissions, there is more than a 75 percent chance of global temperatures rising between two and three degrees over the next fifty years. See "At a Glance: The Stern Review," http://news. bbc.co.uk/1/hi/business/6098362.stm.

5. Michael Corris discusses Haacke's relation to the emerging environmental movement of the late 1960s in Michael Corris, "Systems Upgrade (Conceptual Art and the Recoding of Information, Knowledge and Technology)," *Mute* 1, no. 22 (December 10, 2001), http://www. metamute.org/editorial/articles/systems-upgrade-conceptual-art-and-recoding-information-knowledge-and-technology.

27

LIZE MOGEL

Area of Detail (2010)

1. Symbol
The United Nations emblem, white on a blue (PMS 279) background, its centermost longitudinal ring marked with a red circle.

The UN emblem is a world map as seen from its northernmost point. This map is purely symbolic, representing nations without borders, united under common interests—a place of equals, unilateralism, neutrality, harmony. From a design standpoint, however, it's almost impossible to depict the world in a way that does not show dominance. Something or someone is always bigger than the others, at the top, or at the center. The UN emblem, as a traditional composition, has its focal point at its center.

What is at the center? This *area of detail*—the icebound ocean of the Arctic Circle—is a seemingly blank spot that belies the geopolitical realities of the area.

2. Map
A rotating, circular map of the Arctic Ocean and its surrounding landmasses. Lines mark the extent of the summer sea ice now and in fifty years. Hatch patterns mark current and future areas of oil and gas exploration. Concentric circles of text can be read by turning the map.

The Arctic ice is rapidly receding because of climate change, opening up new possibilities for commerce and capital. This pictorial "center of the world" is indeed becoming a focal

46. Lize Mogel, *Area of Detail,* 2010. Courtesy the artist; photo by labor b designbüro.

point, as the surrounding nations of Russia, the United States, Canada, Denmark, and Norway attempt to claim new territory in order to develop potential undersea energy resources (the U.S. Geological Survey estimates that 25 percent of the world's undiscovered oil and gas is under the Arctic seabed) and commercial shipping routes.

3. Law

United Nations Convention on the Law of the Sea, Part Vi, Article 77: rights of the coastal State over the continental shelf. 1. The coastal State exercises over the continental shelf sovereign rights for the purpose of exploring it and exploiting its natural resources.

The UN Convention on the Law of the Sea sets how nations define and exploit their land boundaries, which extend outward two hundred miles into an Economic Zone. This allows a country to anchor, build, fish, drill, dump, and otherwise get economic gain from the waters surrounding its coast. The contraction of Arctic sea ice opens up possibilities for the expansion of this territory.

The five Arctic nations have launched scientific expeditions to explore the physical connections of their landmasses to undersea mountain ranges that stretch across the ocean floor. Under UN regulation, proof of this will help them lay claim to these de facto border lines. This will become the basis of the new map of the Arctic.

4. Document

An archive of documents, including Russia's and Norway's submissions to the UN Commission on the Limits of the Continental Shelf; and other nations' responses to those claims, submitted in writing on official letterhead.

2002: Russia submits documents to the UNCLCS proposing to increase its sovereign territory based on scientific evidence of the undersea extension of its continental shelf.

2006: Norway submits a similar claim, with the remaining Arctic nations expected to follow up by 2015. Other nations' responses are mediated through the language of diplomacy. As of yet, the Commission has not made a decision on any proposal.

2007: Russia uses a deep-sea submersible to plant a flag on the sea floor underneath the North Pole, symbolically claiming the territory from there to its shores. This publicity stunt is a reminder of other ways of laying claim—symbols coupled with brute force.

URBANIZATION WITH NO OUTSIDE

The development, intensification, and worldwide expansion of capitalism produces a vast, variegated terrain of urban(ized) conditions that include yet progressively extend beyond the zones of agglomeration that have long monopolized the attention of urban researchers. . . . This newly consolidated planetary formation of urbanization has blurred, even exploded, long-entrenched sociospatial borders—not only between city and countryside, urban and rural, core and periphery, metropole and colony, society and nature, but also between the urban, regional, national and global scales themselves—thereby creating new formations of a thickly urbanized landscape whose contours are extremely difficult, if not impossible, to theorize, much less to map, on the basis of inherited approaches to urban studies.

NEIL BRENNER (2014)[1]

. . .

Globalization has inexorably changed the meaning of both space and time. Places are no longer "far away." Economic interdependence links populations that were once remote. Is it possible to separate the urban from the rural or the agrarian in the twenty-first century? The essays in this section demonstrate the breakdown of these spatial categories, documenting the production of space within the global economy at the turn of the millennium. A former industrial sector of Shanghai becomes an art world center, as does a remote Thai village.

Gentrification and displacement have rapidly transformed Western urban centers since the 1990s. These phenomena are linked to real estate speculation and the bid to replace manufacturing lost to cheap labor markets overseas with new "creative class" industries: advertising and media outlets that market lifestyles, and arts organizations that traffic in experience. In addition to goods or services, cities in developed nations produce images, experiences, lifestyles—all draws for tourism, another important economic sector. At the same time, a fetishization of agrarian and pastoral space has emerged in tandem with a new rhetoric of sustainability, or "greenwashing"—a form of rebranding, a media phenomenon that promotes a false image of reversible environmental damage and preservationist ethics to market everything from petroleum to dish soap.

Taking a page from the playbook of Western developers, the Chinese government has since the 1990s also deployed culture in the service of economic growth, albeit under the authority of the Communist party, and toward the ends of expanding China's global economic ambitions and increasing real estate values. The usefulness of culture and the rhetoric of sustainability in the production of marketable, consumable spaces, and the role of artists and galleries as the "shock troops" of gentrification (with experimental artistic practices serving as tools of economic development) is an uncomfortable paradox. Evictions of many kinds are required. In China, artists critical of official government policies risk eviction, most famously in the case of the destruction of Ai Weiwei's Shanghai studio. On a mass scale, the displacement of economically disadvantaged populations from newly desirable urban centers, and from agrarian communities to megacities, is a widespread phenomenon tied to globalization.

NOTES

1. Neil Brenner, "Urban Theory Without an Outside," in *Implosions/Explosions: Toward a Study of Planetary Urbanization,* eds. Neil J. Brenner and Christian Schmid (Berlin: Jovis, 2014), 16, 18.

SOURCES FOR FURTHER READING

Actions: What You Can Do With the City. Montréal: Canadian Centre for Architecture, 2008.

Brenner, Neil J., and Christian Schmid, eds. *Implosions/Explosions: Toward a Study of Planetary Urbanization.* Berlin: Jovis, 2014.

Davis, Mike. *Planet of Slums.* London: Verso, 2007.

Doherty, Gareth, and Mohsen Mostafavi, eds. *Ecological Urbanism.* Zurich: Lars Müller, 2010.

Finkelpearl, Tom. "Introduction: the City as Site." In *Dialogues in Public Art,* 2–51. Cambridge, Massachusetts, and London: MIT Press, 2000.

Harvey, David. "The Right to the City." *New Left Review* 53 (September–October 2008): 23–40.

Koolhaas, Rem. "Junkspace." *October* 100 (spring 2002): 175–90.

Lefebvre, Henri. *The Urban Revolution.* Minneapolis: University of Minnesota Press, 2003.

———. "The Worldwide and the Planetary." In *State, Space, World,* eds. Neil Brenner and Stuart Elden, 196–209. Minneapolis: University of Minnesota Press, 2009.

Ley, David. *The New Middle Class and the Remaking of the Central City.* Cambridge, England: Oxford University Press, 1997.

Lowe, Setha, and Neil Smith, eds. *The Politics of Public Space.* New York: Routledge, 2006.

Merrifield, Andy. *The Politics of the Encounter: Urban Theory and Protest Under Planetary Urbanization.* Athens, Georgia: University of Georgia Press, 2013.

Pinder, David. "Arts of Urban Exploration." *Cultural Geographies* 12, no. 4 (October 2005): 383–411.

Rosler, Martha. "Culture Class: Art, Creativity, Urbanism," Parts I–III. *e-flux journal* 21, 23, and 25 (December 2010, March 2011, and May 2011): unpaginated.

Waldheim, Charles, ed. *The Landscape Urbanism Reader.* New York: Princeton Architectural Press, 2006.

Zukin, Sharon. *The Naked City: The Death and Life of Authentic Urban Places.* New York: Oxford University Press, 2010.

28

JANET KRAYNAK

The Land and the Economics of Sustainability

This essay appeared in the winter 2010 issue of Art Journal *within a forum titled "Land Use in Contemporary Art," which formed a basis for this volume. Organized and introduced by Kirsten Swenson, the two other essays comprising the forum were "The Aesthetics of Delay: eteam and International Airport Montello" by Paul Monty Paret and "Field Effects:* Invisible-5's *Illumination of Peripheral Geographies" by Emily Eliza Scott.*

In 1998, the New York-Bangkok-Berlin–based artist Rirkrit Tiravanija and the Thai artist Kamin Lertchaiprasert purchased an area of rice fields near the village of Sanpatong, on the outskirts of the city of Chiang Mai in northern Thailand. Their stated intent was "to cultivate a place of and for social engagement," to be realized through a thread of activities and intersecting practices.[1] Dubbed The Land (an inexact translation of the Thai name, which means "the rice field"), its physical site comprises two working rice fields cultivated by local farmers and students from the nearby university (figure 47). An artist residency program allows students (who stay either at the site or in Chiang Mai) to produce artworks and engage in dialogue with a fluctuating roster of visiting artists and academics, including Tiravanija and, more frequently, Lertchaiprasert, who, unlike his colleague, lives in Thailand full-time.[2] But The Land has become best known for a series of buildings-cum–sculptural and architectural projects produced by a slate of international artists, architects, and designers (figure 48). In addition to structures produced by Tiravanija and Lertchaiprasert are those by Philippe Parreno and François Roche, the Danish collective Superflex, Angkrit Ajchariyasophon, and Tobias Rehberger, among others. Many of the

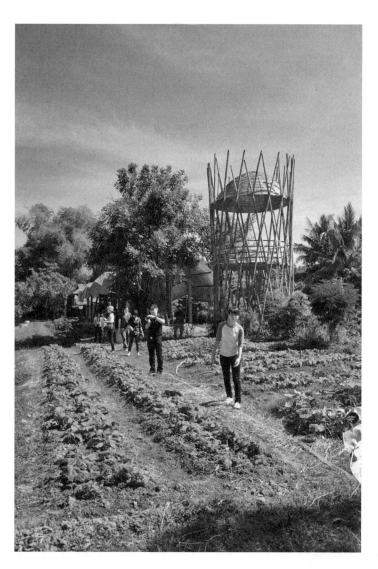

47. The Land, Sanpatong, Thailand. Photo courtesy the Land Foundation.

artists involved with the site have had ongoing professional and personal relationships with one another and are well known for various self-generated projects staged across the geographical reach of contemporary art. The subjects of much recent critical discussion in the sphere of participatory aesthetics, the artists in question have actively sought to extend the contemporary art world's reach beyond the limits of Eurocentrism since the collapse of the Cold War, in the process solidifying individual reputations through the group dynamics of collaboration.

The Land could arguably be described as an extension of now-prevalent exhibition activities that characterize the global contemporary art world, in particular the temporally and spatially open exhibition model, which the curator Hans Ulrich Obrist described as

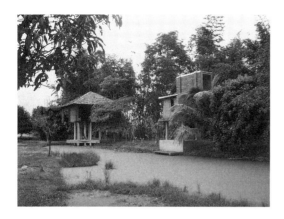

48. The Land, Sanpatong, Thailand, view of the open kitchen designed by Kamin Lertchaiprasert, Rirkrit Tiravanija, Tobias Rehberger, and Superflex (back), and building designed by Rirkrit Tiravanija (front). Photo courtesy the Land Foundation.

the "exhibition as archipelago."³ According to Obrist, this archipelagic structure operates against the notion of globalization "as a homogenizing force," and he cites The Land as exemplary of this trend.⁴ More narrowly, The Land is also a fulfillment of the ambitions of Tiravanija's own long-term practice. From its first appearance in the early 1990s, Tiravanija's work has orchestrated various situations of consumption (drink, food, entertainment, rest) that are predicated on structures of sociability and interaction. By emphasizing use over the modernist conventions of contemplation and by relying on interactive formats in which the audience acts simultaneously as beholder and producer of the work, Tiravanija's projects foreground social relations, and in so doing, the logic follows, putatively operate beyond the bounds of capitalism: Their "sociality," it is maintained, renders them anti-economic.⁵ As reinforced by Obrist's own characterization, The Land can be seen as a culmination and extension of these efforts: a temporally expansive experiment in praxis, where the latter is understood in the Marxian sense of human self-creative activity that produces a world—in this case, a utopic community in Thailand.

When queried about the purpose or guiding philosophy of The Land, Tiravanija (who remains its most visible and prominent spokesperson) refutes both its characterization as art as well as its status within the "art world circuitry," as he terms it, not least due to its geographical remove. Contrasting The Land with land-based practices and Earthworks from the 1960s and 1970s (which were equally beyond the conventional perimeters of art, but often self-consciously and dialectically related, as in Smithson's site/nonsite paradigm), Tiravanija emphasizes the pragmatic orientation of the site: "At this point," he remarks, "we are more interested in sustainable infrastructure than outdoor sculpture."⁶ The limited images available—as The Land's founders are wary of representation, given its tendencies to preclude temporal process and fix meaning—indeed convey the sense of a utopia remote from the governing centers of the art world (or, for that matter, mainstream culture), a utopia in which an experiment in sustainable community and agriculture is taking place. By design, there is no running water, gas, or electricity, so an integral aspect of The Land is the production of energy to satisfy cooking and other

49. Philippe Parreno and François Roche, *Battery House*, 2005. Photo courtesy the Land Foundation.

needs, such as the occasional cell-phone charge. These plans, while integral to its core ideals, are, at the time of this writing, still mostly at the visionary stage, as in a solar energy plant by the artist Arthur Meyer, which is supposedly years from realization, or nonfunctional, as in Parreno and Roche's *Battery House,* which was intended to use buffalo power to produce electricity for the site but has not worked since being produced for Parreno's 2003 film *The Boy from Mars,* and is currently being used for rice storage (figure 49).[7] The only regularly functioning contribution has been the biofuel system produced by Superflex (figure 50) a setup the collective has successfully installed in numerous locales, not just Thailand.

In short, The Land's declared shift from art and representation to community and praxis is largely predicated on the language and ethos of sustainability. The logic of this proposition makes sense on numerous fronts. Given the inherently ethical orientation of sustainable thought, in which economic gain or interest is placed beneath the common good through productive, positive outcomes; given its reliance on shared, collaborative forms of working; and, perhaps most significantly, given its currency as a cultural term, sustainability seems to embody the ambitions of The Land. Furthermore, the project's propinquity to the discourses and practices of architecture and design reinforces these goals, as sustainable thought is now deeply embedded in both fields. Since

50. Superflex, *SUPERGAS/USER/THE LAND*. Photo courtesy and © Superflex.

the term is now as popular as it is ubiquitous, however, the concept of sustainability is far from transparent; rather, it is a complex and even fraught principle that can bear vastly different meanings. Given its profile within The Land (as well as its role as motivation for a range of environmentally oriented or ecological contemporary practices), the term as well as its history demand further scrutiny.

· · ·

The roots of the contemporary sustainability movement can be traced to the late 1980s and the publication of the Brundtland Commission report to the United Nations, which put forth "sustainable development" as the key to alleviating poverty while simultaneously fostering global economic progress. The popularity of the principle of sustainability, however, did not take off in earnest until the 1990s, a period coincident with the collapse of the Cold War and the emergence of a new globalized system. As Hilary F. French explains in her study *Vanishing Borders: Protecting the Planet in the Age of Globalization,* the political and economic international realignments under globalization bore unforeseen environmental consequences: "Globalization is a powerful driving force behind today's unprecedented biological implosion."[8] The principle of sustainability in its present form arose in response to these developments; thus it is deeply embedded with or even a by-product of globalization, where the

latter is defined, to borrow French's words, as "the broad process of societal transformation that encompasses . . . growth in trade, investment, travel, computer networking, and transboundary pollution."[9]

But as Robert Gibson, Selma Hassan, Susan Holtz, James Tansey, and Graham Whitelaw describe in their book *Sustainability Assessment,* the principle of sustainability has been around for hundreds of years, but what prevails now (what they term "new sustainability") departs sharply from what they identify as "old sustainability."[10] Governing traditional societies until the era of industrialization, "old sustainability" was concerned with continuity and preservation, as well as a resistance to—and keen suspicion of—the accumulation of material wealth (which was also associated with power). In "old sustainability," the economic sphere was at the bottom of a structure in which the ecosystem was foremost, and human needs were gauged in response to ecological concerns.[11] World War II was a crucial turning point.[12] Articulating a growing sentiment among industrialized nations, Harry Truman, in his 1949 inaugural address, outlined the "development agenda."[13] Truman argued that economic growth should be exported to the developing world as policy in order to eradicate persistent poverty. With growth, however, came unprecedented stresses on the health of the environment, demanding solutions that were seemingly at odds with each other: "Overcoming poverty demanded expansion of economic activity and opportunity," Gibson and his coauthors write, while "protecting the environment entailed restraint."[14] By the 1970s, the situation had degraded into a widespread crisis, and the independent Brundtland Commission, established in 1983 by the Secretary General of the United Nations, was formed. Its 1987 report, *Our Common Future,* proposed a solution: namely, sustainable development. "The concept of sustainable development became the closest thing to an overnight hit that is imaginable for a product of international diplomacy."[15] Literally within months, institutions from national governments to major corporations embraced the doctrine as a magic bullet that could achieve two seemingly apposite tasks: fostering economic expansion and protecting the planet.[16]

Whereas in the past, sustainable thinking was tied to conservation and stasis, it has now become intertwined with unchecked expansion and continual growth. In short, sustainability has become a central economic concept in contemporary life, one that is geared to gain, return, and expansion. The progressive economist Herman E. Daly ("progressive" due to the degree to which mainstream economic thinking is thoroughly dominated by neoclassical ideology) here distinguishes between what he describes as quantitative "growth" versus qualitative "development." With its view that resources and financial opportunities are infinite, neoclassical economics situates the environment as a subset of the economy, and not the other way around.[17] Gibson and his fellow authors concur that, as a result, sustainability "is a huge success," but also, in an important caveat, "a continuing disappointment." While its very popularity is unquestioned, the term itself is fundamentally vague. There is no consensus about what it means, and, moreover,

competing interests have advocated sharply divergent interpretations; sustainability, they write, was "loose enough to accommodate them all."[18]

On its own, the term "sustainability" thus means very little. To draw on basic semiotics, it is an empty signifier that can be filled with any number of possibilities. Daly himself remarks: "Sustainable development is a term that everyone likes, but nobody is sure of what it means. (At least it sounds better than 'unsustainable nondevelopment.')."[19] At the extreme of its recent manifestations is the now-widespread phenomenon of "greenwashing," in which corporations adapt small-scale or symbolic initiatives while continuing practices that are the main culprits of global climate change. One of the most paradigmatic examples of this trend is British Petroleum's rebranding as BP—"beyond petroleum"—accompanied by a green and yellow sunflower logo (an example that, since this essay's first writing, has become even more painfully ironic given the devastating explosion and oil spill in the Gulf of Mexico).[20] As French emphasizes, multinational corporations and nongovernmental organizations are rapidly replacing autonomous nations, and these international actors have little incentive to respond to the climate crisis. "Nations are granting significant and growing powers to economic institutions such as the WTO and the International Monetary Fund," she writes, "but environmental issues remain mostly an afterthought in these bodies, despite the best efforts of demonstrators and public policy groups."[21]

All of this offers compelling evidence of the extent to which sustainability has become a central business model for the twenty-first century. Going "green" or branding oneself accordingly now bears such a powerful incentive (as French also describes in her article revealingly entitled "The Greening of Wall Street"), that actual adherence and successful outcomes are less at issue than framing oneself in sustainable terms. As the editor of *Dwell* magazine, in an issue devoted to the subject, muses, "I have to admit I'm getting tired of sustainability. . . . What I actually hate is *the spectacle of green's ascent to fad-dom.*" Gibson and his fellow authors concur: "Even when the claims are patently fraudulent, they reveal the power of the notion."[22]

. . .

This history raises an important question: If sustainability is a by-product of the globalization of markets and related systems, and has been correspondingly rewritten according to the logic of neoclassical economy (of quantitative growth and expansion), how then does its adaptation operate philosophically in relation to The Land? As the above studies underscore, the power of the notion is part and parcel a result of its very ambiguity and its status as a polysemous signifier. These elusive qualities are tautologically reflected in The Land's self-presentation as a largely undefined set of expectations and effects, as well as in its resistance to representation and stated meaning.

As Rehberger, the first international artist invited to participate, comments: "It wasn't at all clear to me when Rirkrit approached me eight years ago what this was going to be.

And now, after many visits to the Land, I still don't know exactly what it's all about. . . . Nobody knows what The Land is—and even less what it's going to develop into."[23] For his part, Tiravanija remains firmly noncommittal: "As I've said, we would prefer not to have The Land discussed as yet another project produced by a group of artists, but rather to have it be displaced in people's minds into another condition."[24] Yet, to press this issue, vexing questions regarding its identity and goals remain—and most readily, the dynamics of praxis that it embraces as an antidote to dominant culture. These questions necessarily touch on the project's relationship to the larger sociocultural structures from which it self-consciously sets itself apart, and in particular, to the "broad processes of societal trans- formation," to cite French's words again, that come under the rubric of globalization— both for the bad and for the good. How far is The Land from these conditions, or is it, in fact, curiously, if unintentionally, reminiscent of these very structures? Is The Land an arbiter of transformations in contemporary culture, or is it actively (or passively) resistant to them? What does its distance or proximity say about the very expansive goals of the contemporary art world itself (however we define this entity)?

The question of "how far" is in part rhetorical, as metaphors of distance figure prom- inently in perceptions of The Land and in its critical reception.[25] Speaking of his initial motivations in conceiving the place, Tiravanija describes conversations with his fellow artist-friends (e.g., Pierre Huyghe, Dominique Gonzalez-Foerster, Parreno, and others) about the desire to find "a place, a house, that could be a meeting point and rest stop away from our routines." He continues, "Most of us at that time were very nomadic in work and life, and I think there was a need for *some distance from the circuitry of the art world*— to have a thinking 'site.'"[26] Thailand fulfilled this imperative, not due to anything specific about it as a location, but almost despite of this fact. The interests were decidedly not local, but personal. As Karen Demavivas writes in the catalogue of Tiravanija and Lertchaiprasert's retrospective held in Thailand (titled *Nothing: A Retrospective*), "When Tiravanija and his international friends first conceived of a space like The Land, they were not thinking of a specific site, but rather how any site could be in dialogue with their respective backgrounds and the problems they wished to address."[27]

As a result, The Land's metaphoric distance extends paradoxically to its very locale, as it claims little engagement with the actuality of its site, which is both present and oddly not-present. Despite the art historical tendency to define it as a site-specific project, given its physical-cum-aesthetic strategies of in situ architectural elements and programs, it follows neither 1960s and 1970s precedents of site-specificity (from Michael Heizer's interventions into and framing of the monumental landscape to Mierle Laderman Uke- les's engagement with maintenance cycles of use and decay) nor current site-based criti- cal practices (such as the Center for Land Use Interpretation's multifaceted activities). As a rule, The Land does not respond to either the physical or the sociopolitical and eco- logical conditions of its location: Critique itself is viewed as outside its philosophical bounds. Apart from its devotion to certain Buddhist tenets and the incorporation of indigenous rice farming practices (which are productive, yielding as much as fifteen

hundred kilograms of rice a year, shared by the participants and some local AIDS patients, according to The Land's website), there is little desire to reflect on the conditions of its immediate site. As the critic Ann Coxon, who visited The Land, remarks, "Unlike the politically motivated, environmental statements made by Hans Haacke or Helen Mayer Harrison and Newton Harrison during the '70s, or by Kamol Phaosavasdi in Thailand in the '80s, The Land is not a project initiated in order to draw attention to ecological problems; the primary motivation is *not the will to bring about any specific political change*. Rather, as Tiravanija has stressed, it is about providing an 'open space.'"[28]

In this way, The Land can be set apart from the materialist practice of critical negation, as well as from the tradition of artistic activism that sought to replace objects, however loosely defined, with the orchestration of situations to bring about social change. In contrast, temporal metaphors of openness are invoked as frequently as ones of spatial distance, in order to unhinge the project from any such requisite outcomes as well as to accommodate the nomadic nature of its occupants, structures, and activities. The physical structures that have been erected on The Land demonstrate this fluid approach: The central kitchen (a collaboration by Tiravanija, Rehberger, and Superflex) stemmed from an opportunity to participate in the exhibition *More Works about Buildings and Food*, curated by Pedro Lapas in Lisbon.[29] Tiravanija's house and Rehberger's building were initially conceived for the exhibition *What If: Art on the Verge of Architecture and Design* at the Moderna Museet in Stockholm, and then subsequently transferred to the site in Thailand (photos of Rehberger's house being trucked into The Land appear on its website, an image strikingly contrary to the sustainable goal of reducing fuel emissions). Continuing this dynamic of importation/exportation, all of the built structures at The Land have been envisioned to be intentionally flexible, capable of being dismantled and reassembled in different sites, self-consciously undermining a fixity of place while fulfilling the imperatives of portability and transience of global culture.

In addition, The Land operates as a conceptual filter through which a far-reaching array of international activities takes place, including exhibitions, forums, and lectures in Norway, Japan, and Berlin, among other places: a virtual, temporally open field akin to the global biennial or the "exhibition as archipelago," to recall Obrist's characterization. In this way, The Land functions not simply as a place but as an idea, or, in other terms, as a brand that provides an imprimatur on and lends coherence to a diverse, scattered array of activities. Much in the way Tiravanija's own interactive projects and ongoing collaborative partnerships with other artists (e.g., Parreno, Carsten Höller, Liam Gillick, and Douglas Gordon, among others) both rely on and disseminate his image and name, The Land inevitably circles back to Tiravanija's identity. Collaboration is redefined accordingly: from a form of collectivism in which authorial identity is strategically submerged (historical examples include ACT UP, Gran Fury, Group Material, and the Guerrilla Girls) into a dissemination of that very identity through constant repetition. The establishment of strategic partnerships (with other artists, organizations, institutions) thus fosters socially active, while not necessarily activist, ends.

51. Rirkrit Tiravanija at The Land. Photo courtesy the Land Foundation.

Despite its physical distance, therefore, The Land in these respects is conceptually and operationally squarely within the "art world circuitry," to borrow Tiravanija's words, and in particular within the structural conditions brought about by its recent transformations under globalization. Despite a stated desire to resist its status as an artistic tourist site, The Land has become a drop-in along the many trade routes of contemporary art (or, to cite Demavivas again, "a plug-in of plug-ins in a larger global network").[30] Accordingly, neither Tiravanija nor most of the "resident" students actually live at The Land, but rather occasionally visit as a getaway or for a work-centered activity. The Land's distance fosters a condition of constant travel that is correspondingly a central demand for success and advancement in today's art world. This now-ubiquitous phenomenon, in which cul-

tural capital is built on the (decidedly "un-green") accumulation of frequent flyer miles on airplanes, has been humorously targeted by the artist Gustav Metzger. In a leaflet originally made for Skulptur Projekte Muenster 2007 and reproduced for the exhibition *Greenwashing: Environment: Perils, Promises, and Perplexities* in Turin in 2008, Metzger inscribes the acronym RAF, or Reduce Art Flights, cleverly condensing the shorthand terms for the Royal Air Force and the Red Army Faction.[31]

In these ways, The Land's distance is a less-than-straightforward issue. To return to its second operative metaphor—openness—similar ambiguities arise. The project's website states: "Though initially the action to acquire the rice fields were initiated by two artists from Thailand, the land was initiated with anonymity and without the concept of ownership. The land was to be cultivated as *an open space,* though with certain intentions towards community, towards discussions, and towards experimentation in other fields of thoughts."[32] Openness, like collaboration and self-organization, is here presented as a force that operates against economic concepts of property in favor of those of shared community. Harkening back to the "open-land" communes of the 1960s, The Land's communitarianism depends on such fluidity.[33] Yet this very ideal of an "open" space, as its hosts quickly discovered, was itself hard to maintain. In fact, according to Tiravanija, The Land had to be literally fenced in, as the plants and fruit trees planted in abundance were quickly pillaged by local inhabitants.[34] While one can sympathize with the frustration of this situation, it does underscore the project's somewhat unstable relation to place—and to a concept of localism—that is central to "strong" sustainability.[35]

The fencing is emblematic, however, of the fact that The Land is, for all intents and purposes, a semi-public site, or a "microtopia" (to borrow Nicolas Bourriaud's oft-repeated characterization) that serves a limited community of individuals who share certain connections, ambitions, or bonds. Such microtopias are integral to the new information technologies of global society: Social networks, Twitter, MySpace groups, and customized interfaces forge bonds and networks of communication across temporally and physically disconnected individuals. As in The Land's community of dispersed users, these sites and products are only provisionally public, targeted to self-identified groups who share common interests. Far from the communitarianism of the past, which sought to reintroduce the ethos of "old sustainability" as a counterculture resistance to progress-oriented, market-based culture, The Land's community—its habits of sociality—emerge from the latter's transformed structures and habits.

How, then, should The Land's praxis be assessed? What paradigm of sustainability does it aspire to and, equally significantly, fulfill? To what degree does it overcome the homogenizing forces of globalization when the technological and economic processes that are intrinsic to globalization are formative to its founding? As a model (what the founders describe as a "station") for similar (artistic and curatorial) practices that are increasingly prevalent today, these questions have ramifications beyond The Land as a limiting case—hence my interest here. Equally, as sustainability is a linchpin in

everything from visionary architecture to corporate practices, the pairing of The Land with sustainable infrastructure and agriculture offers an opportunity to delve further into its semiotic and historical terrain. Answers to these and other questions, however, are hard to come by, not least to due to the site's inaccessibility and exclusiveness, and the limited information available about it. Research, as a result, poses unique challenges, raising the question of whether one has to go there and, if so, the implications of such a requirement.[36] (Tiravanija urges "people who are interested in the Land to go there. Find out for yourself firsthand what the conditions are; don't make any plans until you have spent time there.")[37] One effect of this demand for presence is to largely remove—even unintentionally—The Land from the orbit of critical discussion, apart from those few who have the privilege and resources to travel there. Accepting firsthand testimonials as unfettered "truth," however, has its own limitations, as decades of theory and philosophy have taught us. Moreover, such a demand for presence recalls ideologically inflected readings of performance, in which the possibility of unmediated experience remains unquestioned despite convincing arguments to the contrary.[38] Thus, this essay cannot legitimately partake in the conversation, as its author has not been there.[39] Where, then, does that leave even provisional conclusions? This is a question that, for now, will remain "open."

NOTES

1. "About The Land," available online at http://www.thelandfoundation.org/?About_the_land.

2. See Daniel Birnbaum, "The Lay of the Land: An Experiment in Art and Community in Thailand," *Artforum* 43, no. 10 (summer 2005): 271.

3. Obrist in the roundtable discussion "Global Tendencies: Globalism and the Large-Scale Exhibition," *Artforum* (November 2003): 158. His characterization of the exhibition model as an archipelago is inspired by Édouard Glissant, as he notes.

4. Ibid., 159.

5. For an analysis of this claim, see Janet Kraynak, "Rirkrit Tiravanija's Liability," *Documents* 13 (fall 1998): 26–40, reprinted in *The "Do-It-Yourself" Artwork: Participation in Art from Fluxus to Relational Aesthetics,* ed. Anna Dezeuze (Manchester, England: Manchester University Press, 2010), 165–84. Tiravanija reinforced this point regarding The Land's countereconomic status in his Night School at the New Museum seminar devoted to discussion of The Land, which took place at the museum September 25–27, 2008. During the presentation, the artist projected behind himself and his fellow panelists an image of the cover of Superflex's anthology-cum-manifesto *Self-Organisation / Counter-Economic Strategies,* a title that equates the DIY approach with an undermining of capitalist forms of exchange.

6. Claire Bishop, Lynn Cooke, Tim Griffin, Pierre Huyghe, Pamela M. Lee, Rirkrit Tiravanija, and Andrea Zittel, "Remote Possibilities: A Roundtable Discussion on Land Art's Changing Terrain," *Artforum* 43, no. 10 (summer 2005): 292.

7. Email correspondence to the author from The Land Foundation, August 27, 2010.

8. Hilary F. French, *Vanishing Borders: Protecting the Planet in the Age of Globalization* (New York and London: W. W. Norton, 2000), 15.

9. Ibid., 4.

10. Robert Gibson, Selma Hassan, Susan Holtz, James Tansey, and Graham Whitelaw, *Sustainability Assessment: Criteria, Processes, and Applications* (London: Earthscan, 2005).

11. They write, "For most people in most human communities since the dawn of time, the main earthly objective was to continue." Robert Gibson et al., *Sustainability Assessment*, 39.

12. As French explains, "The unparalleled economic expansion after WWII brought with it a burst in the consumption of material goods. . . . The combination of these trends has caused the world economy to push up against the planet's ecological limits." Hilary F. French, *Vanishing Borders*, 8.

13. Robert Gibson et al., *Sustainability Assessment*, 42.

14. Ibid., 48.

15. Ibid.

16. As Gibson et al. explain, "Within months of the report's release, national governments and government jurisdictions began to embrace sustainable development. Sustainability became the featured objective of government pronouncements and development initiatives, domestic program agendas and international aid targets. Major corporations and business associations also claimed adherence." Ibid., 49.

17. Distinguishing between different paradigms of sustainability, Daly writes, "Unlike that of the classical economists, today's standard (neoclassical) economic theory begins with nonphysical parameters (technology, preferences, and distribution of income are all taken as givens) and inquires how the physical variables of quantities of goods produced and resources used must be adjusted to fit an equilibrium (or an equilibrium rate of growth) determined by those nonphysical parameters. The nonphysical, qualitative conditions are given and the physical, quantitative magnitudes must adjust. In neoclassical theory this 'adjustment' always involves growth. Today's newly emerging paradigm (steady-state, sustainable development), however, begins with physical parameters (a finite world, complex ecological interrelations, the laws of thermodynamics) and inquires how the nonphysical variables of technology, preferences, distribution, and lifestyles can be brought into feasible and just equilibrium with the complex biophysical system of which we are a part. . . . This emerging paradigm is more like classical than neoclassical economics in that adjustment is by qualitative development, not quantitative growth." Herman E. Daly, *Beyond Growth: The Economics of Sustainable Development* (Boston: Beacon Press, 1996), 4.

18. Illustrating this point is their "Sustainable Development Multiple Choice" quiz, which under the heading "Sustainable development is . . . " asks the reader to complete the sentence with such varying options as: "an oxymoron, (a self-contradiction) that amounts to believing you can have your cake and eat it too" and "a case of developers getting the noun and environmentalism being left with the adjective." Their study also includes the "Sustainability Spectrum" (1990), a chart that identifies four different positions along a sliding scale from "technocratic" (or "weak") sustainability to "ecocentric" (or "strong") sustainability. Within this schema, everything from an "unfettered free market" to the most eco-conscious acts can be mapped, underscoring the range of meanings and practices united under this umbrella term. Robert Gibson et al., *Sustainability Assessment*, 52–53.

19. Herman E. Daly, *Beyond Growth*, 1.

20. See Jed Greer and Kenny Bruno, *Greenwash: The Reality Behind Corporate Environmentalism* (New York: Apex Press, 1996). The authors analyze twenty case studies of corporate greenwashing—from Royal Dutch Shell to General Motors. They argue, "Transnational corporations, which increasingly dominate the world economy, are preserving and expanding their markets by posing as friends of the environment and leaders in the struggle to eradicate poverty." Jed Greer and Kenny Bruno, *Greenwash*, 11.

21. Hilary F. French, *Vanishing Borders*, 10.

22. Robert Gibson et al., *Sustainability Assessment*, 51.

23. Quoted in Daniel Birnbaum, "The Lay of the Land," 270–71.

24. Claire Bishop et al., "Remote Possibilities," 366. Tiravanija also acknowledges, "We've never wanted to make [The Land] part of the sphere of art—although now we are unable to avoid the discussion, and perhaps we should admit that we are artists, as are most of the participants." Claire Bishop et al., "Remote Possibilities," 291.

25. In response to a query about The Land's remoteness, given that the university in Chiang Mai is close by, Tiravanija responds, "That's right. The Land is twenty minutes outside of Chiang Mai, a provincial city, which is about 450 miles from Bangkok, and so it's no longer a remote place. Many people from the West have been there to work on projects or just to visit. Even so, the distance opens up possibilities." Ibid., 292.

26. Ibid., 291.

27. Karen Demavivas quoted in Ann Coxon, "Field Work," *Art Monthly* (July–August 2005): 10.

28. Ibid., 11, emphasis added.

29. See "About the Land."

30. Karen Demavivas quoted in Ann Coxon, "Field Work," 10.

31. The exhibition took place at the Fondazione Sandretto re Rebaudengo in Turin, Italy, in 2008.

32. "About The Land," emphasis added.

33. Among the open-land communes was Morningstar, near San Francisco, which was offered by the architect Neil Logan as a precedent for The Land during the September 26, 2008, Night School panels at the New Museum, noted above.

34. Tiravanija remarked on the need for fencing in his introduction to the project at the New Museum Night School seminar on September 25, 2008.

35. This is to be contrasted by naive celebrations of the local that equate it with authenticity, but rather refers to localism as form of eco-activism in relation to the industrialization of the land and global agricultural production and the long-term effects of these processes on the health of soil, crops, individuals, and animals.

36. Other writers echo this sentiment: Sue Spaid, who visited The Land for an afternoon, remarks, "How many people are ever going to visit Thailand to see [The Land]? They are likely to go to Bangkok, but not make the extra $100 trek to Sanpatong. Kamin and Rirkrit are of the view that there is only one objective level in art, so there's no reason to exhibit photo-documents, videos, or related products. To see this show, I recommend your taking the time to visit the place. But if you can't manage to get there, you can still appreciate the beauty of it. Like all art, beauty lies in its dependence on the generosity of complete strangers." Sue Spaid, "One Year Project #2," *artUS* 22 (June 19, 2008): 49.

37. Rirkrit Taravanija quoted in Claire Bishop et al., "Remote Possibilities," 366.

38. Among the many who question the premises of presence in contemporary culture is Philip Auslander, in *Liveness: Performance in a Mediated Culture* (London and New York: Routledge, 1999). His argument that even primary experience today is shaped by the accumulation of technologically derived imagery can be convincingly transferred to The Land, in which powerful imagery operates to prepare even firsthand visual experience in ways that might not be anticipated.

39. It should be noted that this is in contrast to most published accounts of the site that I have researched to date. Exceptions may exist, and the author apologizes in advance for any oversights.

29

YING ZHOU

Growing Ecologies of Contemporary Art: Vignettes from Shanghai

The opening of the Power Station of Art on October 1, 2012 (Chinese National Day) to host the 9th Shanghai Biennale epitomized not only the economic re-globalization of Shanghai since marketization began in the early 1990s, but also its growing cultural ambitions (figure 52). The two phenomena cannot be separated. The city's cultural chief proclaimed that the new institution, the first publicly held museum of contemporary art in China, would position Shanghai as *the* hub of contemporary art in East Asia, and that the P.S. Art would be comparable to the Tate Modern of London, among others.

The openings of the Long and De museums of art in Shanghai's West Bund Cultural Corridor, an eight-kilometer southern extension of the World Expo site (designed by the internationally renowned Japanese architect Sou Fujimoto, among others); the conversion of the post-Expo site itself into the largest creative industry cluster in the world; the opening of the Rockbund Art Museum as part of the Bund redevelopment project (by the architect David Chipperfield); and new city-center spaces dedicated to contemporary art consumption such as the K11 Arts Mall and the new Himalayas Art Museum (designed by the architect Arata Isozaki) confirm what both the Western and local media have hailed as China's "museum boom."[1] This spate of openings seemed to contradict, though, the concurrent shutdown of the Weihai 696 art district and the demolition of the studio of the artist Ai Weiwei, underlining the conjunction of cultural cultivation with urban spatial production. Cultural ambition in service of economic growth is selective. And this is never more visible than in the appropriation, commercialization, and gentrification

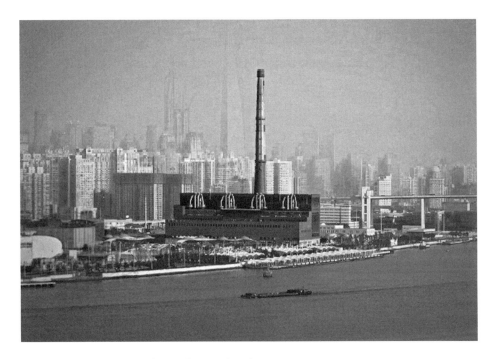

52. Shanghai Power Station of Art architectural rendering.

(on the one hand) and the destruction of urban spaces for contemporary art by the state (on the other).

In the global competition to attract creative talent in the service of city branding, government white papers and urban plans are incubating cultural industries and clustering creative hubs. The push in developing countries for economic transformation from manufacturing to value-added, knowledge-based industries is complemented by an increasing emphasis on cultural production, a distinct subset of "creative economies."[2] To expedite the transition from modernization to internationalization, China's growing economic clout also creates the need for cultural development to bolster its global image. Culture, in addition to politics and economy, is essential to China's "soft power" ascent.[3]

As a recent Artprice.com report shows, the demand side of the global art market has shifted markedly eastward. One of the subheadings for the report states: "New York/ London Gives Way to Beijing / Hong Kong."[4] Almost 50 percent of global contemporary art consumption is taking place in Asia. *The Economist* reported that 30 percent of global art sales in 2011 took place in China, up from 9 percent in 2008.[5] On the supply side, the production of contemporary art has increasingly emerged in China, a country whose transition from a closed, centrally planned economy to one whose growth and global integration has astounded the world. Already showcasing glistening new cities and the domination of manufactured-goods production, the next phase of China's economic transition from progress to prosperity will require the cultivation of a "contemporary arts

ecology." To the next generation of policy makers, urban policies prioritizing the growth of contemporary art are crucial to this latest and most urgent of business opportunities.

The word "ecologies" has been used in East Asian policy-speak to suggest the necessity of an all-encompassing framework for developing the cultural industries. "Ecology" denotes the value chain, from production to consumption, of contemporary art, in spatial and programmatic terms.[6] The use of "ecology" at the same time aligns with the naturally embedded connotations of "sustainability," suggesting a more natural, organic, and thus "sustainable" version of the economic term of the "value chain." Its usage also implies a social dimension in addition to the economic one, imparting a holistic tinge to what would otherwise be growth-pursuing economics. Discussions have hovered over how to cultivate an "ecology of contemporary art" specifically within the Asian context, evolving from the discourse on creative "incubation," where top-down efforts steer the growth of "habitats" for fostering creativity.[7] In the case of contemporary art, what necessary material and immaterial conditions are needed to foster collecting, exhibitions, criticism, education, and the business plans for the financial sustenance of art institutions are challenges still faced by developing economies.

The following vignettes of spatial development in Shanghai over the two decades since economic liberalization began reveal a shift toward state control—the increase of top-down measures of capitalization at the expense of localized cultural developments. The promotion and development of "contemporary art ecologies" is a crucial part of what we might call a growing urban "pro-image coalition"[8] by which the reshaping of urban spaces for contemporary art increasingly serves state control. Even though economic liberalization and global integration seem to signify to the outside world an accompanying loosening of social restraints, the conundrum of increasing state control underlines the authoritarian resilience of what David Harvey has termed "neoliberalism with Chinese characteristics."[9]

FROM CONTESTATION TO APPROPRIATION

The reuse of formerly industrial quarters by artists as studios and for exhibitions is a well-known phenomenon in Western cities.[10] The form it takes in China is related both to deindustrialization and to a fundamental restructuring of the centrally planned socialist units of production. The nation-founding of the People's Republic of China in 1949 began the rule of the vast country by the Chinese Communist Party, a one-party authoritarian regime that premised its first three decades of reign on a Soviet-style centrally planned economy isolated from the world. Under central planning, all units of production were state owned and factories occupied central locations in cities; under central planning, real estate values did not exist. Under Communist ideology, cities were rendered spaces solely for industrial production rather than places for consumption.[11] It was not until the CCP leader Mao Zedong's death at the end of the 1970s that the new leadership initiated economic liberalization, reconnecting China to the world economically, socially, and politically.

Since economic liberalization accelerated in the early 1990s, formerly industrial spaces in inner-city areas, vacated by privatizing state-owned enterprises (SOEs), have been reused by emerging artists who are seeking high-ceilinged, light-filtered, open-plan structures that are also cheap to rent. These artists were the first not only to appreciate the then-undervalued warehouses and factory buildings along the Suzhou River, an area of industrial production since modernity in Shanghai, but also to spearhead their conversion into studio and exhibition spaces. Ding Yi, the Shanghainese abstract artist who was one of the first to move into the area, was followed by friends, including the Swiss gallerist Lorenz Helbling, whose ShanghART gallery opened in 1996, and Li Liang, the Shanghainese artist and gallerist, who returned from a decade-long stint in Australia to open the Eastlink Gallery in 1999. West Suzhou River Road's Number 1131 and 1133 "Red Houses" became an early hub, with studios and galleries holding salons, vernissages, and events that were still largely unknown in a Shanghai that had been culturally dormant since China's isolation from the world in the 1950s. Away from the valuable real estate of new special economic zones (also peripheral from the city center's density), they represented a kind of freedom for questioning, doubting, resisting, and experimenting that was echoed in their spatial activation. The artist studios and galleries also questioned, in their spatial reuse, the prevalent mode of seeing old buildings as disposable.

The Chinese art scene, emerging from the aftermath of the Tiananmen protests in 1989, has been characterized by the art historian and critic Wu Hung as discarding an ideologically driven discourse of social and political change in favor of a pragmatic approach in the context of China's accelerated economic transition.[12] It was in 2000, with the invitation of the curator Hou Hanru, that the Shanghai Biennale became the "first state-sponsored exhibition to host international artists and curators."[13] Hou's earlier work on the international traveling exhibition *Cities on the Move* made him one of the first to highlight the emergence of East Asia to the world and the first Chinese curator of international renown. His appointment in the curation of the Shanghai Biennale was a strategic move supporting the event's growing international image. The art historian Charles Merewether contextualized the Shanghai Biennale within the trajectory of economic liberalization: "The move signaled the government's engagement with a new policy of strategic cultural diplomacy"[14] Held in the Shanghai Art Museum, housed in the former clubhouse of a racecourse that had been transformed into People's Square since liberation, it was a carefully curated affair. Works tended to be by established artists, and were apolitical and free of sexual content.[15]

If the biennial could be read as a turning point for the socialist state appropriating contemporary cultural production to support globalization, then the violent reaction of a select group of Chinese contemporary artists marked a similar turning point for contestation. A parallel event, hosted by the Eastlink gallery in the Red Houses and curated by Ai Weiwei with Feng Boyi, reacted to the state's encroachment on the autonomy of the artists as intellectuals and their implicit acquiescence to capital. They rejected the state's appropriation of contemporary art as an alibi for demonstrating its open-mindedness to

the world and presented the irreverently titled *F*ck Off*. The Chinese version of the show's English-language title, 不合作方式 (*buhezuofangshi*), translates as "the way not to cooperate," or "the un-cooperative approach."[16] One artist, Zhu Ming, floated down the Suzhou River in a plastic bubble wearing only a diaper. Another, the now-famous Yang Fudong (who was largely unknown at the time), had his photographic series *The First Intellectual* (2000) removed by the Cultural Inspection Bureau for its "pornographic" content; one image shows a young man in a torn suit and loosened tie in the middle of a road, his head covered in blood and his hand holding a brick ready to strike. He is standing in front of the then–newly finished Jinmao Tower in the financial district under construction in the Special Economic District of Pudong.[17] Even though it is clear that the image is neither sexual in nature nor aberrant in form, its association of the economically propelled, state-endorsed rapid urban development in Shanghai—represented by the gleaming high-rise against the backdrop of a vast construction site—with violence and injury—represented by the blood-stained young man, who looks like he has either struck himself or was struck by a force outside the frame—was read by authorities as the kind of critique that is barred under the party-state regime. "Pornography," meaning content that is inappropriate and harmful for the public, was used as the pretext to justify their censorship of the art piece.

Taking place in the industrial area of the Suzhou River, the counter-exhibition prompted one official to hint at the need for a "cleanup."[18] In fact, plans for redevelopment in the Suzhou River area were already under way. As the demolition of surrounding warehouse spaces, including the iconic Red Houses, continued, artists and galleries flocked into the last bastion of available space at Moganshan Road Number 50, which had originally been a cotton warehouse in 1933, then a yarn company and a cotton mill before becoming a state-owned textiles factory in 1966. The head of the SOE who became the landlord of the premises was accepting of the vanguard artists as his new tenants.

By the mid-2000s, the convergence of interests by cultural heritage preservationists and creativity-promoting economists became formalized in the state recognition of the cultural rehabilitation of industrial buildings (figure 53). As the surrounding areas were cleared and developed with pencil-tower condos and office buildings, the National Research Center for Historic Sites (NRCHS) was formed in reaction to the wholesale demolition and redevelopment, producing a master plan for the Suzhou River area that kept Number 50 intact. The rising interest in preserving industrial heritage found a great complement in economists' advocacy for creative industries at the Shanghai Academy of Social Sciences. With the establishment, in 2004, of the Shanghai Creative Industry Center (SCIC) under the auspices of the Economic Council, eighteen sites would be designated as creative clusters in 2005, including Number 50. By 2006, this number would grow to eighty-five.[19]

Moganshanlu Number 50 remains occupied by artists, despite discernible signs of commercialization and sanitization. With its rising rents and upgraded, polished spaces, younger vanguard artists can ill afford a studio here. The studios that remain belong to

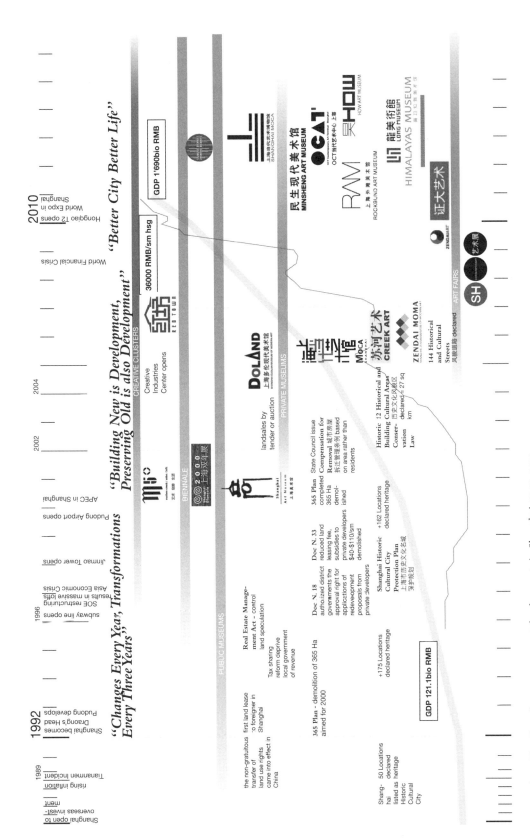

53. Ying Zhou, Timeline of contemporary art developments in Shanghai, 1992–2013.

established, globally known Chinese contemporary artists, including the likes of Ding Yi and Zhang Enli. The initial ambiance of a bottom-up artist quarter with diverse and dilapidated structures has given way to a formalized area with a visible, almost aggressive, branding strategy. With newly paved streets and repainted and restored buildings, the compound is being packaged as "M50." Tagged with yellow plaques delineating their historic uses (though some were actually built as recently as the late 1980s), the built structures have come to represent Shanghai's increasingly scarce and hence precious industrial heritage. A tourist information center and several cafés and stores have been inserted to accommodate the flow of visitors. As the surrounding area is marked for ongoing demolition and development, creative activities are confined to the demarcated M50 area.

Along with highlighting the cultural businesses that are able to afford the tenfold rent increase commanded by M50's industrial heritage, one sign designates it as a triple-A tourist destination. Another plaque indicates that it is also one of the sites of the Pudong Leadership Academy, one of the most important training grounds for top Chinese Communist party (CCP) leaders. Since the acceleration of economic liberalization, the CCP has grappled with the predicament of practicing capitalistic marketization within the continuity of the one-party political system that still pledges its Communist ideology. Western political scientists anticipated that the development of a free market economy would eventually lead to political democracy.[20] Yet an awareness of the decoupling of economic liberalization from political liberalization under the rule of the CCP formed the basis of artists' dissent in 2000 at the same site along the Suzhou River. Legitimized by the dramatic increase in standards of living—the economic success of marketization under single-party rule—the imperative for current CCP leaders is to keep up with the strategies of global capital and its new economies in order to retain their political hegemony.[21] The selection of the artist quarter as one of the locales for the CCP training academy site is instrumental toward these ends. The political need to project an image of openness and cultural understanding to the outside world has made it necessary to embed the academy in what was once a marginal site of cultural dissent. Even though the academy's embedment in M50 could be understood to represent the ultimate form of appropriation, the presence of the academy also assures the place of its economic and physical survival.

Resistance to globalization and commodification like that embodied in the "alternative" to the Shanghai Biennale in 2000 has since been eroded by the state. Demolition of the industrial urban fabric along the Suzhou River, which was the place for the bottom-up creation of an alternate sphere of autonomy by artists, and the confinement and appropriation of a space like M50, physicalize the containment of resistance and subjugation of autonomy. This site, the initial battleground of resistance to appropriation, succumbed to usurpation by the state—undergoing commercialization and gentrification—in the name of its physical preservation.

This model of producing fashionable "creative industry clusters" has since been reproduced throughout the city. Ensuing projects in the mid-2000s pursued a strategy of creative development reusing the SOE structures, many of them former industrial production sites vacated and left behind by marketization and global competition. The Shanghai Redtown Development Corporation took over the property of the former Number 10 Steel Factory, for example, and centers its redevelopment around the Shanghai City Sculpture Center. As the website of the corporation declares, it "focuses on cultural asset investment and management" and pursues an agenda of industrial heritage reuse. With this project, a template for urban development reusing former SOE land has been developed: With the creative industries conferment, a zoning change could be made that facilitates the reuse of industrial heritage into a combination of commercial spaces, along with a centerpiece that is often, but not always, a public institution for contemporary art.[22] Interestingly, the head of ShangTex, the SOE that remains the landlord of M50, is himself today taking art management courses at the Central Academy of Fine Arts in Beijing. He is widely consulted for his expertise in converting industrial structures into creative spaces.[23]

MADE IN CHINA

As the city transitioned from being a place of production under socialism to a place for consumption under capitalism in the mid-2000s, a crop of privately funded museums of contemporary art sprang up and began to redefine public-private alliances. The Duolun Museum of Modern Art (MoMA), the Museum of Contemporary Art (MoCA), and the Zendai all emerged as ostensibly "public" institutions while actually being privately funded. Duolun opened in 2004 and is a museum, because it is approved at the district level,[24] and is considered a state institution even though it is privately run. The MoCA opened in 2005 via donations from a Hong Kong tycoon who was part of the large diaspora that escaped Communist China in 1949. Zendai, which would later reopen as the Himalaya Museum of Art, opened in 2005 as a privately funded institution of the Zendai real estate and financial group. The Shanghai Contemporary art fair that began in 2007 was, for a period, under consideration for potential purchase by Art Basel until the latter finalized the decision to purchase the Hong Kong Art Fair and make Art Basel Hong Kong its Asian hub.[25]

In a political economy in which the propaganda bureau still largely supersedes the cultural ministry, the establishment of MadeIn Company by the conceptual artist Xu Zheng in 2009, one of the original artists still operating out of M50, was a comment on the necessity of blurred boundaries of production, promotion, support, and curation, especially in the local framework of marketization within the state-controlled economy. MadeIn, a spoof on the phrase "Made in China," now synonymous with China's global economic growth and manufacturing prowess while also connoting an inertia—as in the

state of being stuck in the rut of producing for the world—focuses, according to the company website, on the "inner structure of the art system, seeking to expand its working field beyond the mere accumulation of experiences or individual subsistence, and opening a new direction."[26] The between-the-lines vagueness that pervades Chinese expressions in order to bypass censors is part of the ongoing "language game"[27] that simultaneously imitates and, often undetectably, mocks the presiding regime. Often involving younger artists, the trajectory of the "art business" follows a previous venture called BizArt that logically developed from flirtations with the notion of art as a business. The *Art for Sale* exhibition of 1999, co-curated with Yang Zhenzhong and Alexander Brandt in a supermarket, in which BizArt was alluded to, was an illustrious part of *F*ck Off.*

By the time private art museums such as the Minsheng and the Rockbund opened in 2010, coinciding with the opening of the World Expo in Shanghai, a palette of established first-generation Chinese contemporary artists with global reach were being exhibited in, and were pivotal to, the establishment of these new spaces for contemporary art. With names like Cai Guoqiang and Zhang Huan, these vanguards were adept at evoking the specificities of Chineseness: Cai's opening show featured the inventions of Chinese peasants, commenting on the overlooked populace and their current plight,[28] and Zhang Huan's building-scale Confucius statue overpowering the exhibition hall and accompanying pieces alluded to the hierarchical structure of Chinese society.[29] Both fit well the architectural re-adaptation of the former Royal Asiatic Society (RAS) building as a contemporary art museum.

A joint venture between the Rockefeller Group and the Shanghai New Huangpu Group, a development group of the municipal district in which the prominent site is located, the Rockbund Museum is the cultural highlight of a larger redevelopment project on the north Bund, an area that houses a number of British civic buildings remaining from the concession era. Shanghai as a city rose to importance when China was forced to cede a number of important and strategic ports, of which Shanghai was one, to the alliance of foreign forces that defeated the weakened last Chinese ruling dynasty, the Qing, in the First Opium War. The urban areas ceded to foreign sovereignty came to be called "concessions" and were designated "special economic zones" outside the jurisdiction of Chinese sovereignty. They took on functions that met the financial needs of foreign powers entering the vast Chinese market, and the circulation of early-twentieth-century global capital produced Western-style financial and civic buildings. The concessions were regarded by the CCP as representing a kind of foreign domination when it came to power in 1949, but their urban form, with modern street layouts and building types, became increasingly important to Shanghai's re-globalization as economic liberalization accelerated.[30] The transformation of the former RAS building, a concession-era masterpiece, into the Rockbund Art Museum by the British star architect David Chipperfield not only suggests a kind of colonial renaissance of the return of foreign-direct investments, but also its context in the growing local commercial market.[31]

Transnational knowhow and capital fled mainland China after 1949. When economic liberalization first began in the 1980s and then accelerated in the 1990s, the first sources

of "foreign direct investments" for Shanghai came from the proximate Chinese diaspora in Hong Kong, Macau, and Taiwan, who invested in manufacturing facilities, initiated real estate development projects, and facilitated transnational investments that had to also fit into the local political framework. It wasn't until the mid- to late 2000s that the transnational reconnections would move beyond the immediately commercial realms. Exemplary of diasporic investment facilitating the rapid global reintegration of Shanghai is the third-generation Hong Kong tycoon Adrian Cheng's development of the K11 Art Mall, which also displays new ways in which public spaces specific to the contemporary East Asian city can showcase contemporary art. In the podium of the New World Tower, on a prominent stretch of one of the most important commercial thoroughfares in Shanghai, a 2010 renovation allocates an entire floor—three thousand square meters of valuable real estate in the mall—for contemporary art exhibitions. K11's art foundation in Hong Kong, initiated by Cheng, sponsors young artists; its website advertises its collection as "art for the masses." But it is in Shanghai, where the growing demand by local authorities for private commercial developers to provision public amenities such as public infrastructure and open spaces, that art is essential to real estate permission procurement. Permissions for commercial development that are difficult to get from the increasingly stringent local authorities can be expedited if spaces for art exhibition or education are part of the plan. Despite the commercial benefits of inserting art into commerce, the Shanghai curator Leo Xu's initiative for the inaugural show in K11, *Shanghai Surprise,* was nuanced and centered on the specificities of Shanghai and local artists of the region. Distinct from Beijing (the center of the Chinese cultural scene; the capital city's domination of the propaganda apparatus and control of the media industries, along with the provision of cheap spaces, has made places such as 798 and Caochangdi into significant hubs), Shanghai's catchment area, including Hangzhou and the Yangtze Delta region, has always cultivated a subtlety in critique that differs fundamentally from the in-your-face polemics of Beijing.[32]

A 2011 Minsheng show retraced the last two decades of developments in Chinese contemporary video art, demonstrating a new awareness and attention to more recent art historical lineages. The K11 exhibition was similarly held in conjunction with a lecture series that included many stakeholders in the Shanghai contemporary art scene, including discussions with developers for M50 and Red Town as well as artists and curators. An important component of the inaugural show was a physical archival collection of contemporary art from the Shanghai catchment area since the 1990s. The nonprofit art group Artlinkart, collaborators on the archival project, highlighted the difficulty of establishing a physical archive in the quickly changing cities of China.[33] In the face of imminent uncertainty that renders permanence, both physical and procedural, difficult to sustain, even the digital archive project that Artlinkart undertook remains at the discretion of adaptive governance.[34] The only certainty is the perpetual obsolescence, acceleration, and erosion of sites for collective memory at the hands of the neoliberal economic processes that are accommodated and abetted by the state.[35]

The unpredictable and quickly mutating nature of the contemporary physical environment of the city is an underlying theme in many artworks. Xiao Hong's painting of a brick in the K11 exhibition is a reminder of the brick that caused an uproar for the then-unknown Yang Fudong in 2000 at *F*ck Off*—as well as another prominent example of persistent uncertainty: the construction and then destruction of Ai Weiwei's Shanghai studio in 2010.

Ten years after the closing of *F*ck Off* and the formalization of M50, the Chinese government's desire for the prestige represented by an international cultural celebrity such as Ai Weiwei was contradicted by its demand for his artistic and intellectual suppression. The site of Ai Weiwei's Red House, in the vineyards of Dayu Village in Jiading, a northwest suburb of Shanghai, became the interface for an ideological battle over what Ai had deemed a "precious cultural spirit."[36] If the irreverence of the "un-cooperative approach" exemplified Ai's first encounter with Shanghai in his resistance to cultural vulgarization, commodification, and state appropriation, then his second encounter would be the prelude to an evolving negotiation of art with politics in claims to autonomy.

Ai had been issued an invitation to set up the new studio from the district mayor of Jiading township, who in his former role as district mayor of Qingpu had initiated unprecedented deployment of avant-garde architectural designs and cultural engagement to spearhead real estate growth. He was now inviting artists and architects to develop another creative cluster in the vineyards of his new fiefdom in Jiading. Ai's acceptance of the offer came as a surprise to many, as he had repeatedly expressed his dislike of the materialism represented by Shanghai.[37] Nevertheless, Ai discussed the impending construction in an August 2008 interview, concurrently with his about-face toward the Summer Olympics in Beijing, to which he famously contributed the "Bird's Nest" in collaboration with the Swiss architects Herzog & de Meuron.[38] But as the Shanghai studio project developed, the aftermath of the Sichuan Earthquake was unfolding.[39] It was only two days before the earthquake that the district mayor from Shanghai arrived in Beijing to personally invite Ai to build a studio in Shanghai. Collapsed schoolhouses in Sichuan triggered a furor over the local governmental corruption that had resulted in shoddy construction, causing the deaths of children. This tragedy became the subject of a scathing project by Ai that touched many official nerves.[40]

As the Chinese like to say, 缘分, a kind of Chinese version of karma, is everything.[41] The day before it was announced that the 2010 Nobel Peace Prize would be awarded to Liu Xiaobo, authorities declared that Ai's Shanghai studio would need to be demolished because it was illegal. After a bout of negotiation and confirmation, Ai reacted by tweeting an invitation for a party celebrating the end of the building on November 7, 2010, ordering river crabs for the occasion. 河蟹 (*hexie*), the Chinese word for river crab, is homonymous with 和谐 (*hexie*), harmoniousness. The slogan "Harmonious Society" has

been used to brand the stance of the state, encapsulating the leadership's vision for governance, but the same words are also used by the Chinese masses as a euphemism for censorship in China. Ai's play on language, thus, was a direct and unambiguous affront to authority. Despite his almost one thousand RSVPs, Ai was prohibited from attending, the first incidence of his confinement by authorities. Many who attended were asked to "drink tea," a euphemism for police questioning.

In a less storied incident, the studio of Ding Yi, whose occupation of the Red House initiated the art factories on the Suzhou River, was demolished along with that of Ai Weiwei on January 11, 2011. The arrest of Ai at the beginning of April would cause an international outcry and lead to a series of international shows,[42] causing him to be accused (in some quarters) of manipulating events in order to pull off his biggest performance piece to date. Hong Kong artists protesting Ai's imprisonment invoked the "un-cooperative approach" to express what Ai uttered in relation to the original *F*ck Off* show's attitude: "This is a challenge to all powers, authorities, and systems. It is small, yet not to be ignored, like a nail in the eye, a thorn in the flesh, a little grain of sand in the shoe. It reflects a valuable cultural spirit."[43]

On January 12, 2011, the day after extensive international news coverage of the destruction of Ai Weiwei's Red House, the *Wall Street Journal* published an article titled "Whither 696 Weihai Lu?" predicting a similar erasure by demolition, and second-guessing the government's reasons.[44] Since the plaques of the Shanghai Creative Industry Center officially began gracing the entrance to Moganshan Road Number 50 in the mid-2000s, marking its formal recognition, an industrial compound on Weihai Road, in relative proximity to the bustle of Shanghai's commercial drag of Nanjing Road, was initiated. Just as the first pioneers of Chinese contemporary art gave way to the rising generation of younger avant-gardes, so M50 seemed to give way to the new locale of experimentation in the spaces of Weihai 696.

It was in 2006 that the then–CCP party secretary of Shanghai was accused of corruption by the Politburo in Beijing as part of a political purge; the attempt to stem his growing power was premised on Shanghai's commercial success and consequent growing autonomy from the central government. Weihai 696 was under his jurisdiction, and, due to his fall, the premises became accessible for reuse. Under the less-controlling district-level authority of the social security bureau, cheap rents led to the clustering of young artists and gallerists. Thus, the central government's retrieval of autonomy from the seditious commercial city of Shanghai in mid-2000 serendipitously and ironically coincided with the nurturing of new avant-gardes. For half a decade, the network of studios in the lanes of former Number 5 Components Factory, at the center of which is an old British building reputed to have once been an opium warehouse, became Shanghai's city center site of art making and exhibition, a hub of transnational creative types. As the number of official creative clusters rose in the city center along with rental prices, Weihai 696 became the only haven for creative production that remained outside the formality of prescription, with low rents, organic structures, and an informal atmosphere. It was a reminder of what

54. Yang Zhenzhong, *Red Venus Sitting in a Corner,* 2010.

the Red Houses around Moganshan Number 50 had been like a decade earlier. It remains to be seen, however, what new forms the "Red Houses" of the reform era will take.

· · ·

State-sponsored gentrification in the form of endorsing, quarantining, and subsidizing designated cultural districts deviates glaringly from the shutdowns of un-sanctioned art spaces. The demolition of Ai Weiwei's studio and the shutdown of Weihai 696 epitomize the flip side of the effort to grow a so-called "contemporary arts ecology." Their destruction could, on the one hand, be read as a kind of performance in service of the larger

spatial production system that is still largely ambiguous in framework, uncertain in outlook, and discretionary in procedure. On the other hand, what remains certain is the political adaptability of hegemony. After the fallout from these disturbances settled, the art and architecture patron-cum–district mayor who had first invited Ai and then executed the demolition of his studio rose in rank to become the district mayor of one of Shanghai's central districts. Ongoing construction of new spaces continues to occur under his patronage, most notably the cultural highlights of the eight-kilometer-long development in the West Bund Cultural Corridor.

Yang Zhenzhong's 2010 piece *Red Venus Sitting in a Corner* continues the "language game" that toes the fine line between permissible and disqualified (figure 54). The collapsed red star, a clear reference to the Communist star that adorns People's Liberation Army lapels as well as military gateways, poses nuanced questions about institutional frameworks and the fundamental role of this so-called "contemporary art ecology" under the party-state. It fulfills, according to the press release, the artist's urge "to emphasize with an irreverent attitude the many contradictions and derangements of society, aberrations which can only be dealt with by playing with them, turning them into seemingly innocent games or funny scenes."[45] Its inclusion in a 2013 solo show at OCT Contemporary Art Terminal in Shanghai, a well-curated space that is central to the larger real estate project of one of the earliest and most powerful central-government-level SOE developers, illustrates the persistence and necessity of ambiguous links between contemporary art's critique of the authoritarian state and its dependence on the developmental growth regime in the face of authoritarian resilience.

NOTES

1. Holland Cotter, "A Building Boom as Chinese Art Rises in Stature," *New York Times*, March 20, 2013. See also Jo Caird, "The Future of Museums in China," *The Guardian*, (February 4, 2014), http://www.theguardian.com/culture-professionals-network/culture-professionals-blog/2014/feb/06/future-museums-china-cost-attendance.

2. The terms "value-added" and "knowledge-based" have been used by economists for the tertiary industries as indicators for advanced, postindustrial economies that have successfully transitioned to service economies. In developing economies that have strong central states, policy makers believe that provisioning spaces for these value-added knowledge industries would expedite their development, and often promote it.

3. A Communist party delegate said in an interview, "Powerful foreign nations wish to use culture as a weapon against other nations, and for this reason we must work hard to raise our country's soft power." Murray Whyte, "How China Is Using Art (and Artists) to Sell Itself to the World," *Toronto Star*, (December 12, 2009), http://www.thestar.com/news/insight/2009/12/12/how_china_is_using_art_and_artists_to_sell_itself_to_the_world.html.

4. "The Emergence of an Open and Decentralised Asian Art Market in 2012." Report published by Art Stage Singapore (2013).

5. "Auction Houses: From Picasso to Qi Baishi, Christie's and Sotheby's Are Getting a Smaller Share of an Expanding Pie," *The Economist,* (September 29, 2012), http://www.economist.com/node/21563742.

6. Chengqing Jiang, "姜澄清, 艺术生态论纲 (Discussion of Art Ecology)," (贵阳: 贵州人民出版社 Guiyang: Guizhou People's Press, 1994).

7. Feng Jin, 金锋. "怎样理解上海的艺术生态 (How to Understand Shanghai's Art Ecology)," 艺术国际, August 16. 2008, http://review.artintern.net/html.php?id = 2584 [in Chinese].

8. Fayong Shi, "Local Pro-Image Coalition and Urban Governance in China," *Contemporary China Research Papers* no. 1 (Hong Kong: Hong Kong Shue Yan University, 2010).

9. David Harvey, *A Brief History of Neoliberalism* (Oxford, England: Oxford University Press, 2005).

10. Sharon Zukin, "Gentrification: Culture and Capital in the Urban Core," *Annual Review of Sociology* 13 (1987): 129–47. See also David Ley, "Artists, Aestheticisation and the Field of Gentrification," *Urban Studies* 40, no. 12 (2003): 2527–44.

11. Under Communist central planning, the city was depleted of all commerce other than the bare necessities controlled by the state. All resources were directed toward industrial production to achieve economic autonomy cut off from the world economy.

12. Hung Wu, "A Case of Being 'Contemporary': Conditions, Spheres and Narratives of Contemporary Chinese Art," in *Contemporary Art in Asia: A Critical Reader,* eds. Melissa Chiu and Benjamin Genocchio (London: MIT Press, 2011), 391–414. Originally published in *Making History: Wu Hung on Contemporary Art,* (Hong Kong: Timezone 8, 2008).

13. Hanru Hou, "Shanghai, a Naked City: Curatorial Notes, Shanghai Biennale 2000," in *On the Middle Ground* (Hong Kong: Timezone 8, 2002), 230–45.

14. Charles Merewether, "The Freedom of Irreverence: Ai Weiwei," *Art Asia Pacific* (May/June 2007), http://artasiapacific.com/Magazine/53/TheFreedomOfIrreverenceAiWeiwei.

15. "We did not choose works we judged pornographic or with political messages. We also took into consideration the artist's fame and influence," said Li Xu, one of the three curators of the 2000 Biennale, who also helped found the first Shanghai Biennale. See Rebecca Catching, "Why Care About the Shanghai Biennale? How a Shanghai Institution Helped Legalize Avant-Garde Art Practice in the Mid-'90s." (October 22, 2010), http://www.randian-online.com/en/features/features-2010/why-care.html.

16. The curator and critic Feng Boyi, in an interview from October 2000, contextualizes the exhibition in the transition of art from a state of purity that has been eroded by packaging and yield. See "2000–11–4日 不合作方式 (Fuck Off)," 艺术档案 展览回顾 (Art Archive Exhibition Review), (April 2, 2008), http://www.artda.cn/www/14/2008–04/309.html.

17. Chuan Zhao, "Fuck Off: An Uncooperative Approach," *Randian,* November 6, 2010, http://www.artda.cn/www/14/2008–04/309.html.

18. An official hinted at the relation of the space to the events taking place there: "The remoteness of the warehouse area doesn't mean that anybody could freely run amok." "一些在仓库周围上演的作品太出格了..老仓库偏僻的地理位置并不意味着可以任由一些人胡作非为." See Jie Wang, 王捷 and 朱文洁 Wenjie Zhu, 2003, 苏州河仓库艺术变迁 (Suzhou River Art Factory), 東方企業家 (Asian Business Leaders), (February 9, 2003), business.sohu.com/02/99/article206219902.shtml.

19. Sheng Zhong, "From Fabrics to Fine Arts: Urban Restructuring and the Formation of an Art District in Shanghai," *Critical Planning* 16 (2009): 118–37.

20. Sebastian Heilmann and Elizabeth J. Perry, "Embracing Uncertainty: Guerilla Policy Style and Adaptive Governance in China," in *Mao's Invisible Hand: The Political Foundations of Adaptive Governance in China,* eds. Sebastian Heilmann and Elizabeth J. Perry (Cambridge, Massachusetts: Harvard Contemporary China Series, 2011), 1–27.

21. "The Party and the Media: Learning to Spin," *The Economist* (February 8, 2014), http://www.economist.com/news/china/21595925-communist-party-training-school-functionaries-learn-how-handle-more-aggressive-news.

22. Since economic liberalization, the coexistence of land marketization and residual allocations from the planned economy have created a dual land market in China. The first is land that is bought, sold, and exchanged, and is at market price. The second is land that is state-allocated to state institutions and state-owned enterprises, and below the market price. The strict prohibition of use changes of state-allocated land compelled the conception of alternate business plans for feasible functional change. The official recognition of being a "creative industries cluster" was one way by which industrial land could be used for other functions. For more details on the procedural implications, see Ying Zhou, "Small Scale, Bottom-Up: Innovating Creativity in Shanghai's City Center," in *Politics and Aesthetics of Creativity: City, Culture and Space in East Asia,* ed. Lu Pan (Hong Kong: Bridge 21, 2014).

23. "'Shanghai Surprise' Exhibition Lecture Series: From M50 to New Taopu," March 3, 2012, Shanghai K11 Art Mall. [in Chinese]

24. The Shanghai municipality is subdivided into a number of districts that wield power equivalent to that of municipalities in other cities. Thus, approval by the district in Shanghai is important to confer legitimacy on the museum. This aspect of the complexity of the Chinese bureaucracy was recently highlighted in "The Nomenklatura: Vertical Meets Horizontal—Who Really Holds the Power in China?," *The Economist* (December 1, 2012), http://www.economist.com/news/china/21567427-who-really-holds-power-china-vertical-meets-horizontal.

25. Hong Kong remains the exceptional location in China as a Special Administrative Region. Publications banned in China are published in Hong Kong, for example. And despite increasing control by the central government, freedoms of speech, assembly, and protest have remained precious assets even more emphasized in Hong Kong. Many of the institutions established before its return to China in 1997 remain. Compared to the opaque, repressive, and irregular political system of China, which is still largely outside the writ of international regulations, Hong Kong's relatively transparent rule of law and global financial integration provide a stability and confidence that is unique in China.

26. http://www.madeincompany.com.

27. Subtleties in language have been deployed as resistance and critique in China. See Perry Link, *An Anatomy of Chinese: Rhythm, Metaphor, Politics* (Cambridge, Massachusetts: Harvard University Press, 2012).

28. Don J. Cohn, "Shanghai Expo: Cai Guo-Qiang and the Chinese Dreamship," *Art Asia Pacific* (May/June 2010), http://artasiapacific.com/Magazine/68/ShanghaiExpoCaiGuo QiangAndTheChineseDreamship.

29. Alexandra A. Seno, "China's Zhang Turns Ash Into Spectacle," *Wall Street Journal*, October 22, 2012, http://online.wsj.com/news/articles/SB10001424052970203633104576625312822080454.

30. See Ying Zhou, "Cosmopolitan Linkages Re-Globalizing City Center Shanghai," in *Asian Cities: Colonial to Global*, ed. Gregory Bracken (Amsterdam: Amsterdam University Press, forthcoming).

31. The building was originally by Palmer and Turner (P&T), who were Shanghai's premier architects during the Concession era, gracing the city with many classical pieces. Since 1949 P&T has been based in Hong Kong, like many cosmopolitan firms of the era exiled from China.

32. The region around Shanghai has historically been a hub of commercial affluence and literati culture, and is known for its less direct manner of communication that avoids confrontation. This cultural legacy has made the expression of critiques embedded and circuitous rather than explicit. Since modernity, Shanghai is formed by the demographic influx from the region. This inherited legacy of the subtlety of critique is reflected not only in the distinct sorts of "language games" that are played by artists working in the region, but also in the visual metaphors that push the boundaries of censors while seeming to retreat from the forbidden. Xu Zheng's MadeIn and BizArt, for example, are not explicit critiques of commercialization, whereas Ai Weiwei's *F*ck Off* is direct and confrontational. Zhang Huan and Cai Guoqiang's pieces at Rockbund address crucial issues in China's political economy, from social hegemony to rural development, but neither could be seen as confrontational. The Shanghai catchment area is a region that both accommodates and attracts these similarly pragmatic sensibilities. It is for this reason that Ai regards Shanghai as commercial. But it is this pragmatism of working with the restraints of censorship that brought about pieces that are extremely interesting in their between-the-lines subtleties in critique that are multiple in meaning and nuanced in expression.

33. The organizer spoke with enthusiasm about one of the premier institutions of research and criticism, the Asia Art Archive (AAA) of Hong Kong, and envied its context in a relatively more stable institutional framework.

34. Adaptive governance refers to the evolving tactics by the different levels of the state to respond to a rapidly changing society under the transitional economy. Changing authorities, procedures, hierarchies, and "policy-making as a process of ceaseless change, tension management, continual experimentation, and ad-hoc adjustment" explains the enigma of China's economic marketization without political liberalization, and the resilience of its ruling regime under what could otherwise be a precarious and unstable transition economy. Sebastian Heilmann and Elizabeth J. Perry, "Embracing Uncertainty," 2011.

35. Alvin Y. So and Yin-Wah Chu, "The Transition from Neoliberalism to State Neoliberalism in China at the Turn of the Twenty-First Century," in *Developmental Politics in Transition*, eds. Chang Kyung-Sup, Ben Fine, and Linda Weiss (London: Palgrave Macmillan, 2011), 166–87.

36. In an October 2000 interview between Ai and the curator Feng Boyi, Ai said, "与谁也不合作，与什么事都不合作。是对所有权利和权威，所有的体系的挑战。它像是眼中钉，肉中刺，鞋里的一粒小沙子，虽然小，却不能被忽视，体现了一种可贵的文化精神 [This is a challenge to all powers, authorities, and systems. It is small, yet not to be ignored, like a nail in the eye, a thorn in the flesh, a little grain of sand in the shoe. It reflects a precious cultural

spirit." See "2000–11–4日 不合作方式 (Fuck Off)" (April 2, 2008) 艺术档案 展览回顾 (Art Archive Exhibition Review), http://www.artda.cn/www/14/2008–04/309.html [in Chinese].

37. Ai has repeatedly commented on the hollow materialism of Shanghai, which he disdains in his blogs and interviews. It is also distaste for the more indirect, ambiguous, negotiating approach of the artists from around Shanghai, as distinct from that of Beijing artists, among whom Ai is prominent and well known for his outspoken and explicit provocations.

38. In the interview between Zhang Yu with Ai Weiwei, the discussion was mainly about the architectural development of the space for a studio. See Zhang Yu, 张彧, "建筑是生活的自然流露——艾未未上海嘉定大裕村工作室设计访谈 (An Interview with Ai Weiwei About His Workshop Dayu Village, Jiading in Shanghai)," (August 18, 2008), http://aiwwstudy.appspot.com/20001.html [in Chinese].

39. Meanwhile, Ai was documenting and propagating the tribulations of the lawyer Feng Zhenghu—who was repeatedly denied entry by Shanghai and had to live in Narita Airport for one hundred days—and following up on the execution of a Beijing youth named Yang Jia, whose harassment by Shanghai police for riding an unlicensed bicycle and his inability to appeal resulted in his retaliating by killing six police officers.

40. At his Haus der Kunst show in 2009, Ai covered the facade of the building with children's schoolbags, forming a pattern in Chinese characters quoting a mother describing her dead child: 她在这个世界上开心地生活了七年 ("She had lived in this world happily for seven years.") It was also during his stay in Munich that he underwent surgery for the police brutality that had given him a brain hemorrhage.

41. In the negotiations with authorities following the announcement of demolition, the word 缘分 ("karma") repeatedly came up as a subtle hint at the fate of the place rather than as a direct confrontation regarding responsibility for the demolition. The extensive negotiation transcripts, as recorded and disseminated by Ai, are in fact a great study of land procurement, land use change, and building permission procedures in transitional-economy China. See "艾未未上海马陆工作室建拆纪要 (Ai Weiwei Shanghai Malu Studio Construction Demolition Timeline)," http://aiwwstudy.appspot.com/14001.html.

42. Shows opened in Bregenz, Austria, and Winterthur, Switzerland, in July 2011, and in the fall in London, New York, and Taipei.

43. In an October 2000 interview between Ai and the curator Feng Boyi, Ai said, "与谁也不合作，与什么事都不合作。是对所有权利和权威，所有的体系的挑战。它像是眼中钉，肉中刺，鞋里的一粒小沙子，虽然小，却不能被忽视，体现了一种可贵的文化精神." See "2000–11–4日 不合作方式 2000–11–4 Fuck Off," 艺术档案 展览回顾 (Art Archive Exhibition Review), (April 2, 2008), http://www.artda.cn/www/14/2008–04/309.html.

44. Lisa Movius, "Whither 696 Weihai Lu?," *Wall Street Journal,* January 11, 2011, http://blogs.wsj.com/scene/2011/01/11/whither-696-weihai-lu/.

45. http://www.randian-online.com/np_event/trespassing-yang-zhenzhongs-solo-show/.

30

CHUNGHOON SHIN

on FlyingCity, *All-things Park* (2004)

At the turn of the new millennium, a series of South Korean art collectives arose in the context of a growing demand for the reactivation of the oppositional legacy of *minjung* ("common people") art—a politically engaged art movement that had vigorously resisted the oppressive military regime of the 1980s but had fallen into lethargy in the ostensibly democratized 1990s.[1] As one of the leading groups of this "post-*minjung*" turn, flyingCity (founded in 2001) produced multiple works that responded to the Cheonggye Stream Restoration Project (2003–5), a large-scale initiative led by the Seoul Metropolitan Government under the banner of the ecological restoration of an urban waterway. Starting with the removal of the elevated expressway and road that had paved over Cheonggye Stream since the 1960s, the government-led project trumpeted a paradigm shift in the production of space in Seoul. Principles for "modernizing" Seoul during the 1960s, such as efficiency, hygiene, and maximum traffic flow, gave way in the new millennium to what might be construed as antimodernist imperatives, including "environmental friendliness," "quality of life," and "historical preservation." Rather than highlighting or celebrating this shift, however, flyingCity discloses the hidden continuity between these two approaches in terms of their development of the city center for elite socioeconomic classes.

In October 2004, flyingCity unveiled an architectural model titled *All-things Park* in an exhibition hall of Artsonje Center in Seoul. Suspended above the museum floor as if to embody the name of the collective, the "flying" structure manifested its utopian quality. Indeed, it was an independent, visionary proposal for the city government's schematic

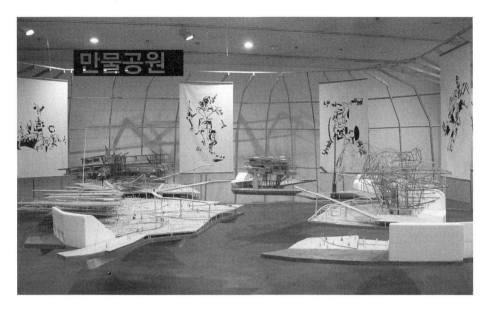

55. FlyingCity, *All-things Park*, 2004. Styrofoam, polycarbonate board, acrylic sheets and bars, aluminum panels and pipes, laminated plywood sheets, dimensions variable. Courtesy the artists.

plan for the conversion of the Dongdaemun Football Stadium (built in 1925) into an urban park in conjunction with the Cheonggye Stream Restoration Project. Given that the stadium was then being used as a temporary flea market for street vendors displaced by the Restoration Project, the government's conversion plan would finalize the eviction process. *All-things Park* directly challenged it by proposing to make the emergency shelter into a permanent workplace for street vendors and other potential evictees, particularly those employed in metal workshops, whose right to the city was threatened by the mega-urban project. Unsurprisingly, *All-things Park* was simply ignored by the Seoul Metropolitan Government, which in 2007 would select Zaha Hadid as the architect for the Dongdaemun Stadium Park Conversion Project in expectation of the "Bilbao Effect."

Made of plywood, Styrofoam, aluminum plates, wires, and other cheap materials, the low-tech structure reflected the material culture of its future users, who are often described as dealing with "all-things" (*manmul* in Korean). *All-things Park*, however, was not merely designed as a physical container for accommodating the evictees. More importantly, it was envisioned as a "theme park" in which the visitor "would participate in designing new artifacts that one imagines" with the help of skilled metalworkers and resourceful street vendors. In this regard, *All-things Park* proposed to revitalize a neglected industry into a new experience economy rather than merely protesting the workers' eviction from the city's geography and economy. As an imaginative but feasible alternative to the current urban transformation, *All-things Park* provided a viable model for an interventionist art practice for the post-*minjung* era.

NOTES

1. On the formation of the notion of *minjung* as true historical subjectivity in postcolonial South Korea, see Namhee Lee, *The Making of Minjung: Democracy and the Politics of Representation in South Korea* (Ithaca, New York, and London: Cornell University Press, 2007).

31

DAVID PINDER

on Nils Norman, *The Contemporary Picturesque* (2001)

Sharp pins protrude from a railing in front of a private office development. Elsewhere, metal studs adorn marble surfaces. Studded paving is laid in front of doorways. Water is sprayed across steps. Bollards, fences, barricades, and planters are positioned in front of public buildings. Anti-climb and anti-sticker paints are applied to walls. Public toilets and trash bins are locked or removed altogether. Bus benches are curved, slanted, divided, or otherwise made deliberately uncomfortable. Surveillance cameras sweep the streets to monitor every movement.

These are some of the scenes in *The Contemporary Picturesque*, a book by the British artist Nils Norman who has long-standing interests in public space, architecture, and urban planning.[1] Through photographs, captions, and brief texts, Norman documents recent transformations in the built environment and street furnishings of cities with a sharp eye for how they both express, and are instruments of, power. He is concerned with how, in subtle and not so subtle ways, and through a myriad of devices, they involve the training, regulating, and ordering of everyday behavior, whether by preventing unsanctioned sitting and sleeping; by blocking, redirecting, or instigating movement; or by otherwise demarcating and targeting "inappropriate" conduct.

Such defensive design initiatives are far from neutral exercises in improving the security of urban public spaces and their "quality of life." Instead they serve to police social-spatial boundaries. They are elements of a "conscious 'hardening' of the city surface against the poor," as the urban historian Mike Davis argued in *City of Quartz*, his vivid account of the restructuring of Los Angeles during the 1980s and 1990s that identified

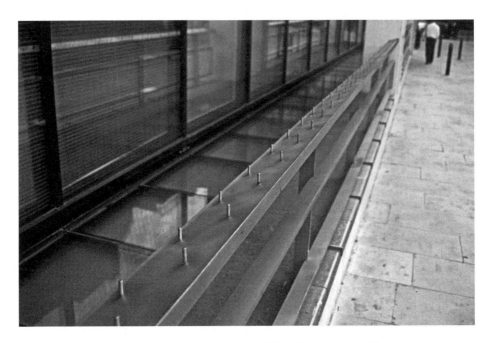

56. Nils Norman, *Bum-free railing, City of London, located behind the Bishopsgate office complex at Liverpool Street*, 2001. Courtesy the artist.

"an unprecedented tendency to merge urban design, architecture, and the police apparatus into a single, comprehensive security effort."[2] The rise of "fortress cities" and "carceral cities" on the ruins of democratic public space, along with the increasing grip of what has been termed a "new military urbanism," have become key dimensions of contemporary urbanization in many parts of the world.[3] Intervening in this terrain, Norman's *The Contemporary Picturesque* adopts a measured tone. His predominantly black-and-white photographs, bound in a plain blue cover, depict street furnishings and security measures arranged by theme and drawn from an extensive and ongoing photographic archive of defensive architecture and design.[4] Many of the images are from contemporary London, specifically its financial district or "ring of steel," as it has been dubbed, but they span wider. An early case is the remaking of Second Empire Paris under Napoleon III and Baron Haussmann, which emphasized security and military considerations as part of that city's spectacular capitalist development and commodification, and that ploughed boulevards through former working-class quarters to enable the swift mobilization of troops.

Norman's project is more than a visual documentation of elements of carceral urbanism. It is distinguished by layers of irony, humor, and reflexivity that are generated by the book's conceptual strategies as it presents its catalogue of security measures as "picturesque." In the process it defamiliarizes aspects of urban environments that are prone to being naturalized and taken for granted, while it resists being assimilated as straightfor-

ward critique.[5] Also significant are the ways in which its images of securitization are juxtaposed with other photographs that depict creative, makeshift, noncommercial, communal, and resistant uses of public space. Presented in color, the latter images interrupt visions of space given over to commercial flow or traffic. They include a car repurposed as a street blockade, protest camps constructed as tree houses, and community gardens based on appropriating spaces and experimenting with permaculture. No argument is explicitly advanced on their behalf. Their presence nevertheless invites consideration of the urban and political conditions that gave rise to such actions. They also provide a counterpoint to the structures of defensive architecture, an antithesis that is developed in Norman's other work, for example in his long-term research interests in adventure playgrounds and playscapes, and his utopian proposals for public spaces.[6] As such, *The Contemporary Picturesque* poses a question that underpins much of Norman's artistic practice and research more widely: What are the prospects for alternative ways of using and producing urban public spaces, both within the cracks of current social formations and beyond them?

NOTES

1. Nils Norman, *The Contemporary Picturesque* (London: Book Works, 2001). Norman began to research the theme after the Oklahoma City bombing of 1995.

2. Mike Davis, *City of Quartz: Excavating the Future in Los Angeles* (London and New York: Verso, 1990), 232, 224.

3. See Edward Soja, *Postmetropolis: Critical Studies of Cities and Regions* (Oxford: Blackwell, 2000), 298–322; Stephen Graham, *Cities Under Siege: The New Military Urbanism* (London and New York: Verso, 2011).

4. See the archive on "defensive architecture" at his website: http://www.dismalgarden.com/archives.

5. See T. J. Demos, "The Cruel Dialectic: On the Work of Nils Norman," *Grey Room* 13 (2003): 32–53.

6. Norman's research into playscapes includes his book *An Architecture of Play: A Survey of London's Adventure Playgrounds* (London: Four Corners Books, 2003) and his ongoing archive at http://www.dismalgarden.com/archives/playscape. Among his projects for urban public spaces is *Tompkins Square Park Monument to Civil Disobedience* (1997), which proposed to construct a tower, treehouses, skywalks, and tunnels in a corner of this park in the Lower East Side of Manhattan so as to enable its users to resist being removed by the police. This was in response to struggles over access to the park as the area underwent rapid gentrification. On the latter topic see Neil Smith, "'Class Struggle on Avenue B': The Lower East Side as Wild Wild West," in his book *The New Urban Frontier: Gentrification and the Revanchist City* (New York and London: Routledge, 1996), 3–29.

32

JENNA M. LOYD AND ANDREW BURRIDGE

on Laura Kurgan and Eric Cadora, *Million Dollar Blocks* (2005)

Most of the more than 2.4 million people who are imprisoned in the United States return to their homes and communities. Recognizing that "like poverty, incarceration is spatially concentrated, much more so than crime," Eric Cadora, a founding member of the Justice Mapping Center (JMC), turned traditional crime mapping on its head. Mapping patterns of incarceration and return revealed what have been called million dollar blocks: "single blocks in inner-city neighborhoods across the country for which upwards of a million dollars are allocated each year to imprison its residents."[1]

The *Million Dollar Blocks* project aims to intervene in the criminal justice policy landscape by visualizing the "geography of incarceration and return."[2] This "city-prison-city-prison migration flow" has not made "high-resettlement neighborhoods" safer, but actually disrupts family, social, and economic networks.[3] *Million Dollar Blocks* therefore seeks to shift funds spent on incarceration toward projects that can create safe and healthy neighborhoods.

In 2005, Eric Cadora and the JMC teamed up with the architect Laura Kurgan, director of the Spatial Information Design Lab (SIDL) based at Columbia University, to produce a series of incarceration maps for several cities across the United States. As Cadora and Kurgan explain: "We propose to treat prisons and jails as an urban exostructure. No matter how physically removed they are from the neighborhoods of the people they hold, they remain firmly rooted as institutions of the city, as everyday parts of life for people, impacting their homes, social networks, and migrations."[4]

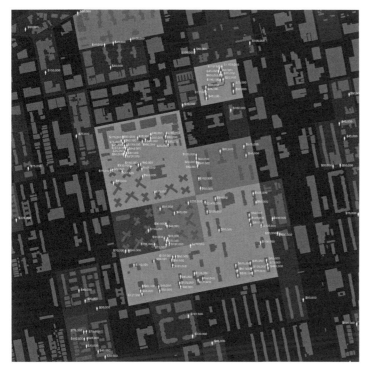

BROWNSVILLE, BROOKLYN

IT COST 17 MILLION DOLLARS TO IMPRISON 109 PEOPLE FROM THESE 17 BLOCKS IN 2003. WE CALL THESE MILLION DOLLAR BLOCKS. ON A FINANCIAL SCALE PRISONS ARE BECOMING THE PREDOMINANT GOVERNING INSTITUTION IN THE NEIGHBORHOOD.

57. Laura Kurgan and Eric Cadora, detail from *Million Dollar Blocks*, 2006. Spatial Information Design Lab, Columbia GSAPP 2006. Project directors: Laura Kurgan, Eric Cadora; research associates: David Reinfurt, Sarah Williams.

Incarceration maps show the uneven impacts of criminal justice policy—policing that targets neighborhoods where the poor and people of color live, compounded by racially disparate crime charges and sentencing—that create patterns of concentrated imprisonment across cities. These maps are also intended to help urban planners, designers, and policy makers understand where community resources have been replaced by the criminal justice system. The intention then is to redirect funding away from the catchall "solution" of prisons and toward rebuilding community infrastructure and local economies, particularly in neighborhoods with million dollar blocks. Justice reinvestment projects are being experimented with in a number of municipalities and states across the United States.

For a nation that deports more than four hundred thousand people annually, we believe that incarceration maps also need to be transnational in scope. Our own book, *Beyond Walls and Cages: Prisons, Borders and Global Crisis* (2012), examines connections between the U.S. prison industrial complex and the expanding reach of immigration policing and detention.[5] The "city-prison-city-prison migration flow" is one that separates families, sometimes permanently, within and beyond U.S. borders. Justice

reinvestment, too, would need to be reconceptualized to move away from punitive immigration policies.

Million Dollar Blocks powerfully re-visualizes prisons as institutions of "coercive mobility"[6] that recycle so-called problem people into and out of so-called problem neighborhoods. Whether justice reinvestment projects will actually shift funds toward rebuilding shredded local economies and social welfare and educational systems, or whether they will expand a "softer" system of state oversight and confinement, lies with the power of the people to reimagine punishment, justice, and freedom beyond the crime and prison paradigms.[7]

NOTES

1. Spatial Information Design Lab, *Architecture and Justice* (New York: Columbia University Graduate School of Architecture, Planning and Preservation, 2006), 12, 18.

2. Ibid., 1.

3. Ibid., 1, 18.

4. Ibid., 20.

5. Jenna M. Loyd, Matt Mitchelson, and Andrew Burridge, eds., *Beyond Walls and Cages: Prisons, Borders and Global Crisis* (Athens Georgia: University of Georgia Press, 2012).

6. Todd R. Clear, Dina R. Rose, Elin Waring, and Kristen Scully, "Coercive Mobility and Crime: A Preliminary Examination of Concentrated Incarceration and Social Disorganization," *Justice Quarterly* 20 no. 1 (2001): 33–64.

7. James Austin, Vanita Gupta, Eric Cadora, Marc Mauer, Todd R. Clear, Nicole Porter, Kara Dansky, Susan Tucker, Judith Greene, and Malcolm C. Young, "Ending Mass Incarceration: Charting a New Justice Reinvestment," American Civil Liberties Union, 2013, http://www.aclu.org/criminal-law-reform/ending-mass-incarceration-charting-new-justice-reinvestment.

33

LIZE MOGEL

on The Center for Urban Pedagogy, *Affordable Housing Toolkit* (2010)

"Affordable housing" is a term used frequently by developers, politicians, and city planners—a promising phrase whose built reality is far more complicated. The Center for Urban Pedagogy's *Affordable Housing Toolkit* is being used by community organizers, housing advocates, planners, and educators to help their constituents understand what the term really means, and explore the important question: "affordable to who?"[1]

The *Affordable Housing Toolkit* (*AHT*) is the first in a series of Envisioning Development Toolkits by the Center for Urban Pedagogy (CUP) designed to help people understand and shape development in their communities. Housed in a bright red plastic case, the *AHT* contains a workshop tool—a large chart printed on felt and multicolored felt squares, dots, and bars that represent units of housing, income ranges, and affordable housing programs—and a "What Is Affordable Housing?" booklet that very clearly answers that question and guides users through workshop activities using the felt chart. An interactive online tool supplements the physical toolkit.[2]

The *AHT* was originally developed for New York, using local data and in collaboration and discussion with more than a dozen community organizations and housing advocates. More than eighty community organizations and groups have used the *Toolkit*, and the online tool has been used by almost one hundred thousand people. CUP is now developing an *AHT* for Chicago that will reflect that city's housing policies.

The workshop tool helps participants learn about the range of affordable housing programs, how affordability is actually calculated, and what that means for the specific demographics and real rents in their neighborhood. The workshop tool delineates the

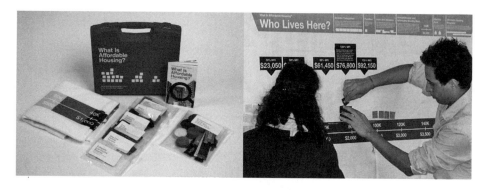

58. The Center for Urban Pedagogy, *Affordable Housing Toolkit: New York City Edition,*
2010. Courtesy Kevin Noble for the Center for Urban Pedagogy, © 2010.

gaps in terms of how much affordable housing is needed and at what rents versus what is actually available.

The booklet describes the range of affordable housing programs available in New York. Older programs include those where the government directly subsidizes landlords (i.e., Section 8); *is* the landlord (public housing); or regulates rents (i.e., rent stabilization) so rents remain affordable over time. These programs, however, are expiring or stagnant. Newer models of affordable housing creation mostly involve subsidies for developers in the form of tax credits and other financial incentives. This housing is usually included as part of a market-rate development, of which the affordable units may constitute around 20 percent. Creating affordable housing in this way adds a significant amount of market-rate apartments—which in itself can factor into an economic and demographic shift in the neighborhood. This type of housing is designated to serve a targeted range of income categories included within the term "affordable," ranging from extremely low to middle income. Housing advocates have found that the minimum income levels to qualify for some of these apartments are actually higher than real household incomes in the surrounding neighborhood, excluding as much as 75 percent of the population.[3]

When there's not enough affordable housing, what happens? Poverty increases, as a large number of people—especially low-income residents—devote more than half of their income to rent.[4] The market also adapts, or mutates. The CUP youth education project "I Have a Basement Apartment, Now What?" explored the complex issues around basements illegally converted into apartments. These provide lower-cost housing where little else exists, but are often overcrowded and in violation of city building and fire safety codes.

The lack of enough truly affordable housing is inexorably changing the demographic and cultural landscapes of cities globally. CUP's *Affordable Housing Toolkit* is an important tool that helps community organizations and their constituents gain expertise so that they can meaningfully engage in planning processes and advocacy, so that the city's transformation over time is more equitable and sustainable.

NOTES

1. According to federal standards, "affordable" rent is defined as no more than 30 percent of a household's income.

2. More information about the *Affordable Housing Toolkit* is on CUP's website: http://www. welcometocup.org/Projects/EnvisioningDevelopment/WhatIsAffordableHousing. The online tool is accessible at http://envisioningdevelopment.net/map.

3. Association for Neighborhood and Housing Development, "Real Affordability: An Evaluation of the Bloomberg Housing Program and Recommendations to Strengthen Housing Policy," 2013, http://www.anhd.org/wp-content/uploads/2011/07/Real-Affordability-Evaluation-of-the-Bloomberg-Housing-Program2.pdf.

4. In 2011, 29 percent of renters and 61 percent of low-income renters paid at least half of their income for housing. Community Service Society, "Making the Rent: Before and After the Recession: Rent Income Pressures on New York City Tenants, 2005–2011," June 2012, http://b.3cdn.net/nycss/852b245452a84929d6_bnm6ibtbd.pdf.

34

ROBBY HERBST

on Olga Koumoundouros, *Notorious Possession* (2012)

In 2012, amid the banking and home-foreclosure crises that came about in the United States through poor practices in the mortgage business and deregulation of the banking industry, Olga Koumoundouros occupied a foreclosed home in her Los Angeles neighborhood. Previously, much of the artist's output had been exhibited as sculpture within the confines of contemporary art spaces. With *Notorious Possession,* much akin to a squatter, she moved into an abandoned property and adversely possessed it. Then, unlike a squatter, she painted the entire exterior of the home gold and, inside, made sculptural installations from the dear artifacts the previous owner had left behind. Through a series of art events that she orchestrated on-site, and their subsequent publicity, *Notorious Possession* became a discursive site in which to ruminate on the nature of land speculation and private property.

Laws are created to maintain culturally ascribed order; they establish boundaries for what is permissible within a given jurisdiction. The artist's job, enshrined within society, is to be an interpreter of subjectivity. At times, artists may find themselves marking the crossings of legal boundaries that the activist's body knows well. The activist squarely addresses the perceived injustices he or she confronts; in this situation, an activist's body becomes a trans-substantiative element personifying the transgression of an improper law. We look to activists to challenge laws. Because artists are the arbiters of subjectivity, we look to them to express the consciousness abutting an improper law, expanding the injustice's psycho-emotional-spatial territory. Koumoundouros commented:

59. Olga Koumoundouros, *Notorious Possession* postcard, 2012. Graphic design by Jessica Fleischmann and Amy Howden Chapman; photo by Monica Nouwens. Courtesy the artist.

I was prepared for a civil defense on the grounds of eviction. I was served bogus and threatening papers the night before. . . that contextualized my understanding of what was to play out. And then was confronted with something else. I was the recipient of a process that serves and protects corporate interest. The language of corporate money is now the voice of the upstanding citizen. Vocal engagement in the social space is increasingly pathologized. We all know this stuff but it's playing out again and again.

In this time of hyphenated identities, Koumoundouros is an artist who declines a hyphen; she wishes her work to be placed strictly within the tradition of sculpture. In her past works, the art-and-life divide had been pierced through the themes of her sculptures (e.g., domesticity, war, economy), although the divide was kept separate, as the artwork was sited within traditional art spaces. With *Notorious Possession*, she stepped beyond the distinct boundary that permits the space for "free speech." In possessing a foreclosed home, using it as a Duchampian readymade, harnessing the foreclosure as a (Joseph) Beuysian "social sculpture," and making art there, Koumoundouros stepped up to the bait of art in the expanded field. The avant-garde movements of the Modernists sought to erase the distinction between life and art, precisely to instigate the sorts of uncomfortable

territories within which Koumoundouros found herself—pressed up against property law and human subjectivity.

Reflecting on her ordeal, when the bank and the state came to repossess her living-sculpture, the artist said (to reiterate): "The language of corporate money is now the voice of the upstanding citizen. Vocal engagement in the social space is increasingly pathologized." What is so interesting about *Notorious Possession* is the way in which she stumbled into these boundaries, as a citizen reflecting on the meaning of the loss of a home. And through her desire to explore this loss, she discovered herself confronting the irrationality of commodity and property law.

35

PAUL MONTY PARET

on eteam, *International Airport Montello* (2005–8)

An experiment in land development, *International Airport Montello (IAM)* began after eteam, the artist pair Franziska Lamprecht and Hajoe Moderegger, purchased land via eBay near the tiny town of Montello in northeastern Nevada. Hovering between fact and fiction, *International Airport Montello* is a parafiction rooted in a real community and built by collective fantasy.

Committed to site-specific research and social practice, eteam has acquired other near-worthless plots of land, "improved" them, and sometimes resold them by connecting these isolated sites to larger systems and networks to which they do not seem to properly belong. In southern Utah, eteam linked their land to a seldom-used stretch of railroad by developing a *Train Stop* snack bar. A row of allotment gardens in eastern Germany was reimagined as an ocean liner in a sea of grain carrying its retired tenants to a mythical American West. In Nevada, the isolation of an unexpected dirt road was resolved through an *Artificial Traffic Jam*. And for *International Airport Montello*, a long-abandoned dirt airstrip was transformed into a major international airport, a job creator and hub of global transportation.

Anchored by two dirt runways still visible in aerial photographs, the airport's reality is supported by the presence of the Pilot Motel, Montello's only lodging, and nearby Pilot Peak, the name of which evokes the mountain's historical function as a navigation landmark. Airport construction depended on the participation of Montello residents (they tell their stories in eteam's video *Truth in Transit*), who approached the project with varying degrees of enthusiasm, friendship, and indifference, and who created their own

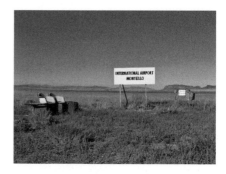

60. eteam, Airport sign from *International Airport Montello*, 2005–8. Courtesy the artists.

roles, notably in the form of jobs: security, baggage handlers, catering, and communications.

Like all airports, *IAM* exists as part of a network of places and events: an airport website; the arrival by van of layover passengers waiting for a flight; directional windsocks hanging outside galleries in New York or Bergen, Norway; a town reconceived as airport infrastructure; a cardboard "plane" emerging from a hangar at Floyd Bennett Field in Brooklyn; Montello-bound passengers waiting in a Chelsea gallery decked out as an airport gate. Not fixed to the literal coordinates of its runways and terminals or the reality of its passengers and freight, *International Airport Montello* is shaped instead by the poetics and politics of air travel and the collective fantasies of its participants.

Most striking about *IAM* is the absurd disconnect between the airport's utopian promise of mobility, development, and global interconnectedness versus the isolation, stasis, and delay of its actual operations: Airplanes neither arrive nor take off, passengers seldom appear, construction rarely begins, jobs are not created, capital does not flow. The idea of delay extends from the airport itself to the depressed reality of Montello, a defunct railroad town with the proud motto "The Town That Refused to Die." Among the first events at the airport was a strike by local residents demanding access to the global economy—"Internationalize This Airstrip!" "We will deliver service if management will let us!"—although no management existed. For Montello, a relic of modernity on the far fringes of globalization, *International Airport Montello* represents an alternate possibility.

At the landing strip, eteam's sign, *International Airport Montello,* marks both the site of the airport and its near-total absence. But no matter. On Nevada State Road 233, the battered "Welcome to Montello" sign lists not only the Cowboy Bar and Montello Gas, but also International Airport Montello.

SOURCES

www.meineigenheim.org
www.internationalairportmontello.org

Driever, Juliane. "On the Solutions-Oriented Approach in Relational Practice." In *Service Media: Is It "Public Art"? Or Is It Art in Public Space?*. Edited by Stuart Keeler. Chicago: Green Lantern Press, 2011.

eteam. *International Airport Montello*. New York: Art in General, 2008.

Hérnandez Chong Cuy, Sofía. "Publicity and Complicity in Contemporary Art." In *Contemporary Art: 1989 to the Present*. Edited by Alexander Dumbadze and Suzanne Hudson. Malden, Massachusetts: Wiley-Blackwell, 2013.

Lambert-Beatty, Carrie. "Make-Believe: Parafiction and Plausibility," *October* 129 (summer 2009): 51–84.

Olsen, Marisa. "Interview with eteam." *Rhizome.org*. October 29, 2008.

Paret, Paul Monty. "The Aesthetics of Delay: eteam and *International Airport Montello*." *Art Journal* 69, no. 4 (winter 2010), 26–37.

36

SALONI MATHUR

on Vivan Sundaram, *Trash* (2005–8)

I first encountered Vivan Sundaram's multidimensional project *Trash* in 2005 during a visit to the artist's studio in the former village of Aya Nagar, now part of the outskirts of India's capital city, New Delhi. The studio is located en route to Gurgaon, a district that has been mutated in the past dozen years by outsourcing, call centers, mega-malls, and a real-estate boom for the Indian middle class. The artist's studio is, in other words, physically located within the kind of frenzied urban expansionism that is thematized in the work. In his studio, Sundaram had constructed a vast urban landscape—or a "post-landscape," in W. J. T. Mitchell's terms—composed entirely of trash collected locally with the help of a group of low-caste ragpicker boys.[1] The garbage city was composed of a multitude of materials, forms, and scenes: towers of tin cans taped together, high-rises and freeways of recycled cardboard and plastic, undulating fields of deflated plastic milk bags, dense neighborhoods of toothbrushes, numerous plastic utensils, and crowds of onlooking recyclables. There were many such vignettes at the micro level; at the macro level, the impression was of ordered chaos, with separate but distinct neighborhoods or communities.

This rubbish-scape studio installation was not the work of art per se, but an ephemeral stage set from which the final product—a video and a series of digitally manipulated photographs that play with false perspectives and modernist moments—was derived, including a high-angled perspectival shot (*Rajpath*), a horizontal depth of field (*Prospect*), and an aerial Google Earth–type overarching view (*Master Plan*). One week after my visit, Sundaram destroyed the entire installation and documented the destruction in a short

61. Vivan Sundaram, *Prospect,* 2008. Digital print. 265.5 × 143.5 cm.

video, titled *Turning* (2008). The demolition was intended, he stated, to highlight that "in poor countries, huge amounts of the population live with an immense sense of instability; from moment to moment, they do not know when they will be destroyed, when their houses will be demolished."[2] If garbage represents here the teleological endpoint of a brutal consumer society, that which is devoured and discarded, leaving others precarious and unstable, then Sundaram's ambitious salvage operation, and his reconstituted urban economy, also foreground the systems of reuse and recycling that are necessary strategies of survival within capitalism.[3]

The anthropologist Mary Douglas was one of the first to observe that if garbage is, by definition, that which is thrown out, then the very existence of garbage implies some cultural understandings about the boundaries between "inside" and "outside."[4] In a similar vein, Sundaram's interest in garbage as a medium is to highlight the boundaries and barriers, both physical and cultural, that separate insiders from outsiders, and separate spaces like the slum or the ghetto from the gated communities or freeway flyovers designed to avoid them, not just in India but in most cities today. His series of photographs bearing the title *Barricades* portrays these divisions explicitly; it also calls up the long history of investment in barriers by urban planners such as Baron Haussmann, or the modern concern with their social consequences by his famous interlocutor, Walter

Benjamin. In fact, Sundaram's work forces the latter's account of the modern city, with its emphasis on the display of images and commodities, and its impact on the viewing subject, into confrontation with a new set of extreme conditions. The shift in focus is not merely from the Benjaminian preoccupation with the activities of consumption to the domain of disposal and waste. It is also from the site of the first-world city to the urban realities of the so-called third world, or from the experience of the nineteenth century to the unfolding crises of the twenty-first. In other words, it is the classic ideal of the city as the embodiment of civil society and the production of high cultural values and good taste that Sundaram's overwrought garbage city—his unwieldy trashopolis—seems to relegate to the waste heap once and for all.

NOTES

1. W. J. T. Mitchell, ed., *Landscape and Power* (Chicago: University of Chicago Press, 2002).

2. Shoma Chaudhury, "Filth Is Something We All Like to Put Our Hands In," interview with Vivan Sundaram, *Tehelka Magazine* 5, no. 35 (September 6, 2008).

3. See Chaitanya Sambrani, *Tracking Trash: Vivan Sundaram and the Turbulent Core of Modernity*, exhibition catalogue (Mumbai, India: Chemould Prescott Road, 2008).

4. Mary Douglas, *Purity and Danger: An Analysis of Concepts of Pollution and Taboo*, rev. ed. (1966; repr., New York and London: Routledge, 2003).

CONTRIBUTORS

EDGAR ARCENEAUX is an artist based in Los Angeles. He is the cofounder of the Watts House Project, a nonprofit neighborhood redevelopment organization in Watts.

AMY BALKIN is an artist whose projects involve land, environmental justice, and the allocation of common-pool resources. She is an associate professor at California College of the Arts in San Francisco.

NUIT BANAI is a professor of contemporary art in the Institute der Historisch-Kulturwissen-schaftlichen Fakultät, Institut für Kunstgeschichte, University of Vienna.

KELLY C. BAUM is the Haskell Curator of Modern and Contemporary Art at the Princeton University Art Museum.

URSULA BIEMANN is an artist, writer, and video essayist. Her artistic practice is strongly research oriented and involves fieldwork in remote locations where she investigates social ecologies and migration. She is a senior researcher at Zurich University of the Arts and has published several books.

AARON BOBROW-STRAIN is an associate professor of politics at Whitman College. He is the author of *White Bread: A Social History of the Store-Bought Loaf* (Beacon, 2012) and *Intimate Enemies: Landowners, Power, and Violence in Chiapas* (Duke University Press, 2007).

NICHOLAS BROWN is an adjunct assistant professor in the Department of American Studies at the University of Iowa as well as a lifelong learner in the Midwest Radical Culture Corridor.

JULIA BRYAN-WILSON is an associate professor of modern and contemporary art at the University of California, Berkeley. She is the author of *Art Workers: Radical Practice in the Vietnam War Era* (University of California, 2009) and the editor of *October Files: Robert Morris* (MIT Press, 2013).

ANDREW BURRIDGE is an associate research fellow in the Department of Geography at the University of Exeter. His research is concerned with undocumented migration and practices of incarceration, deportation, and border security, as well as resistance to such practices. He and Jenna M. Lloyd are the coeditors (with Matt Mitchelson) of *Beyond Walls and Cages: Prisons, Borders and Global Crisis* (University of Georgia Press, 2012).

ASHLEY DAWSON is a professor of English at the Graduate Center, City University of New York (CUNY).

T. J. DEMOS is a professor of history of art and visual culture at the University of California, Santa Cruz.

RUTH ERICKSON is assistant curator at the Institute of Contemporary Art/Boston. She received her PhD in art history from the University of Pennsylvania in 2014.

ROBBY HERBST is an interdisciplinarian broadly interested in sociopolitical formations, behavioral architecture, languages of dissent, and countercultures. He is a writer, artist, teacher, and something other. He cofounded and is the former editor of the *Journal of Aesthetics & Protest,* and he currently instigates the Llano Del Rio Collective's Guides to Los Angeles.

THE INSTITUTE FOR INFINITELY SMALL THINGS conducts creative, participatory research that aims to temporarily transform public spaces and instigate dialogue about democracy, spatial justice, and everyday life. Its projects use performance, conversation, and unexpected interventions to investigate social and political "tiny things." The Institute's project *The Border Crossed Us* (2011) was led by Catherine D'Ignazio, a research assistant at the Center for Civic Media at MIT Media Lab in Boston.

SARAH KANOUSE is an interdisciplinary artist and writer whose research-based creative projects trace the production of landscape through ecological, historical, and legal forces, with particular interest given to the environmental and cultural effects of military activities. An assistant professor of art at the University of Iowa, she teaches courses in video and time-based media, art, and ecology.

YAZAN KHALILI lives and works in and out of Palestine. He is an architect, visual artist, and cultural activist.

DONGSEI KIM is an adjunct assistant professor of architecture at Columbia University, GSAPP, and a founding principal at axu studio. He is a registered architect and urban designer who holds master's degrees from Harvard University's Graduate School of Design and Columbia University's Graduate School of Architecture, Planning and Preservation.

JANET KRAYNAK is an assistant professor of contemporary art history and the associate dean of the School of Art and Design History and Theory at The New School in New York.

SHILOH KRUPAR is an assistant professor of geography and director of the Culture and Politics Program in the Edmund A. Walsh School of Foreign Service at Georgetown University. She is author of *Hot Spotter's Report: Military Fables of Toxic Waste* (University of Minnesota Press, 2013).

JENNA M. LOYD is an assistant professor in the Zilber School of Public Health at the University of Wisconsin, Milwaukee. Her work focuses on health and antiviolence activism in the United States, and the connection between immigration and criminal justice policies.

SALONI MATHUR is an associate professor of art history at the University of California, Los Angeles. She is the author of *India by Design: Colonial History and Cultural Display* (UC Press, 2007), editor of *The Migrant's Time: Rethinking Art History and Diaspora* (Yale University Press and the Clark Art Institute, 2011), and coeditor (with Kavita Singh) of *No Touching, No Spitting, No Praying: Modalities of the Museum in South Asia* (Routledge India, forthcoming).

LIZE MOGEL is an interdisciplinary artist and counter-cartographer. Her work intersects the fields of popular education, cultural production, progressive political advocacy, and mapping. She is the coeditor of the book/map collection *An Atlas of Radical Cartography* (Journal of Aesthetics and Protest Press, 2008).

JULIAN MYERS-SZUPINSKA is an art historian based in Oakland. He is an associate professor at California College of the Arts, and senior editor of *The Exhibitionist*.

JAMES NISBET is an assistant professor of art history at the University of California, Irvine. His work has appeared in *Grey Room, Photography & Culture, X–TRA*, and *Modernism/modernity*. He is the author of *Ecologies, Environments, and Energy Systems in Art of the 1960s and 1970s* (MIT Press, 2014).

TREVOR PAGLEN is a New York–based artist and author whose work deliberately blurs the lines between science, contemporary art, journalism, and other disciplines to construct unfamiliar yet meticulously researched ways to see and interpret the world around us. He holds a BA from the University of California, Berkeley, an MFA from the Art Institute of Chicago, and a PhD in geography from the University of California, Berkeley.

GIULIA PAOLETTI is a PhD candidate in the department of art history at Columbia University with a specialization in African art and photography. She is currently writing her dissertation, *La Connaissance du Réel: Fifty Years of Photography in Senegal (1910–60)*. In 2013–14 she held a J. Clawson Mills Fellowship at the Metropolitan Museum in New York, and in 2013 she was a recipient of the Joan and Stanford Alexander Award for dissertations on the history of photography from the Museum of Fine Arts in Houston.

PAUL MONTY PARET is an associate professor of art history and associate dean of the Honors College at the University of Utah.

LORENZO PEZZANI is a PhD candidate at the Centre for Research Architecture at Goldsmiths and a teaching fellow at the Bartlett School of Architecture at University College London.

DAVID PINDER is a reader in geography at Queen Mary, University of London. His research interests lie in utopianism, art practice, and urban politics, and his publications include *Visions of the City: Utopianism, Power and Politics in Twentieth-Century Urbanism* (Routledge, 2005) and a guest-edited issue of *Cultural Geographies* on "Arts of Urban Exploration" (2005).

EMILY ELIZA SCOTT is a postdoctoral fellow at the Institute for the History and Theory of Architecture at the Swiss Federal Institute of Technology (ETH Zürich) and coeditor of this volume. A founding member of the interdisciplinary art groups the Los Angeles Urban Rangers and World of Matter, she is also a former National Park Service ranger.

CHUNGHOON SHIN is a PhD candidate in the history and theory of art and architecture at the State University of New York at Binghamton. He is currently working on his dissertation, titled *Seoul Art Under Construction: Art, Urbanism, and Spatial Politics in Seoul, Late 1960s to the New Millennium.*

LUKE SKREBOWSKI is a university lecturer in the history of art at the University of Cambridge. He is the coeditor of *Aesthetics and Contemporary Art* (Sternberg Press, 2011) and is currently at work on a book project entitled *The Politics of Anti-Aesthetics: Contesting Conceptual Art.* His work has appeared in *Art History, Grey Room, Manifesta Journal, Tate Papers,* and *Third Text.*

KIRSTEN SWENSON is an assistant professor of contemporary art at the University of Massachusetts, Lowell, and coeditor of this volume. She is also author of *Irrational Judgments: Eva Hesse, Sol LeWitt, and the 1960s* (New Haven, Connecticut: Yale University Press, 2015).

JEANNINE TANG is an art historian teaching as senior academic advisor and LUMA Foundation Fellow at the Center for Curatorial Studies, Bard College.

YING ZHOU is an architect and researcher at the Urban Design Module of the Future Cities Laboratory (FCL), Singapore ETH Center, and was a lecturer and researcher with ETH Studio Basel from 2007 to 2011. She has taught and practiced in New York, Shanghai, Detroit, Boston, and Basel.